THANNHAUSER

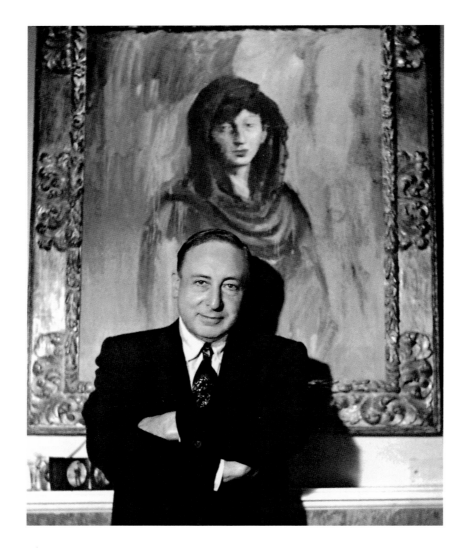

THANNHAUSER

The Thannhauser Collection of the Guggenheim Museum

Edited by Matthew Drutt

GuggenheimMUSEUM

ISBN 0-89207-240-7 (softcover)
ISBN 0-8109-6920-3 (hardcover)

Guggenheim Museum Publications
1071 Fifth Avenue
New York, New York 10128

Hardcover edition distributed by
Harry N. Abrams, Inc.
100 Fifth Avenue
New York, New York 10011

Design: Amy Henderson
Editorial: Jennifer Knox White, Edward Weisberger
Production: Elizabeth Levy, Melissa Secondino

Works of art in the Thannhauser Collection photographed by
David Heald, Carmelo Guadagno, Ellen Labenski, Sally Ritts

Printed in Germany by Cantz

FRONT COVER:
Detail of Pablo Picasso, *Le Moulin de la Galette*, autumn 1900
(cat. no. 25).

BACK COVER:
Pierre Auguste Renoir, *Woman with Parrot*, 1871 (cat. no. 57).

FRONTISPIECE:
Justin Thannhauser in front of Pablo Picasso's *Fernande with a
Black Mantilla*, 1905–06 (cat. no. 33).

CONTENTS

FOREWORD

Lisa Dennison

THE HISTORY OF MODERN ART, in all likelihood, would be written differently today without the contributions made by the Thannhauser family. Renowned art dealer Heinrich Thannhauser founded the Moderne Gallery, Munich, in 1909. His son, Justin, was involved in the activities of the gallery from an early age, and together the Thannhausers built an impressive program, presenting Impressionist and Post-Impressionist exhibitions, as well as the art of the contemporary French and German avant-gardes. Many iconic works of Modern art—for example, Edouard Manet's *A Bar at the Folies-Bergère* and Pablo Picasso's *Family of Saltimbanques*—were handled by the Thannhauser galleries in Munich and later Lucerne and Berlin. Heinrich and Justin presented distinguished exhibitions that helped define the art of the twentieth century, including the first show of Der Blaue Reiter (The Blue Rider) in 1911 and the first major retrospective of Picasso's work in 1913. Their commitment to important early exhibitions of such artists as Vasily Kandinsky, Franz Marc, and Paul Klee paralleled the collecting interests of the Guggenheim's founder, Solomon R. Guggenheim.

In the list of remarkable accomplishments and endeavors that Justin K. Thannhauser will be remembered for, perhaps none is more meaningful, or will have a more lasting affect, than the gift to the Guggenheim of Impressionist, Post-Impressionist, and School of Paris masterpieces, including a concentration of thirty-two works by Picasso. Initially placed on loan to the New York museum in 1963, they were legally transferred to the Solomon R. Guggenheim Foundation in 1978, two years after his death. That the collection has its home at the Guggenheim is thanks to the efforts of Thomas M. Messer, Director from 1961 to 1988, who first won Justin and Hilde Thannhauser's interest and devotion to our institution, as well as to the efforts of Messer's successor, Thomas Krens. Hilde's bequest of ten additional works was received after her death in 1991. Harry F. Guggenheim and Peter Lawson-Johnston, the presidents of the Guggenheim Foundation during these years, both played indispensible roles in securing this legacy, which irrevocably changed the scope and tenor of the museum's collections.

There has been a tendency to view the Thannhauser Collection—with its preponderance of late-nineteenth- and early-twentieth-century art—as a mere prelude, or preamble, to the major currents in twentieth-century art that are at the heart of the Guggenheim's origins as the Museum of Non-Objective Painting. This limited reading encourages the collection to be seen in contrast to our other great collections when in fact they are inextricably linked. The developments that began in the nineteenth century are not just a backdrop for the developments of the twentieth century but are rather their very source, and thus are an integral part of the continuum of Modern art. Alfred H. Barr, Jr., in his 1936 book *Cubism and Abstract Art*, presents Impressionism as the first step toward abstraction, tracing the lineage of abstract art to two main currents, deriving from Impressionism: the intellectual, geometric, classical strain that finds it sources in Paul Cézanne; and the emotional, intuitive, romantic strain that had its principal source in the art and theories of Paul Gauguin and his circle. Both strains are well represented in the collection with examples by Cézanne and Gauguin, as well as Edgar Degas, Manet, Camille Pissarro, Pierre Auguste Renoir, and Vincent van Gogh.

The Thannhauser Collection, housed in its own galleries in Frank Lloyd Wright's Monitor building, which now bears the collection's name, is the only Guggenheim collection on permanent view, a stipulation of the bequest that ensures uninterrupted public access to these holdings. Over the years, the executors of the Thannhauser Estate have generously relaxed some restrictions, enabling works to be shown in the museum's other galleries and on loan. In 1990, when the museum was closed for renovation, thirty works from the Thannhauser Collection were shown at the Palazzo Grassi, Venice; it was the first time these works were seen outside the United States since the 1978 gift. For *Rendezvous: Masterpieces from the Centre Georges Pompidou and the Guggenheim Museums* in 1998–99, Thannhauser treasures were intermingled with works of similarly high quality from the Pompidou's Musée National d'Art Moderne, Paris. In 2000, Picasso's *Moulin de la Galette* was a cornerstone of the exhibition *1900: Art at the Crossroads* at the Royal Academy of Arts, London, and here in New York. For all these opportunities, and for its ongoing extraordinary cooperation, the Guggenheim is indebted to the careful attention, understanding, and guardianship of the Silva-Casa Foundation, Bern, and the Thannhauser Estate. As a representative of the foundation and estate, Max Ludwig has been an essential part of this process, contributing his substantial professional talents and firm belief in the importance of these works of art. We are also indebted to his colleagues Prof. Dr. Ewald R. Weibel and Janet Briner. Finally, in addition to the authors and everyone thanked in the Acknowledgments, we owe a special debt of thanks to Matthew Drutt, Associate Curator for Research, for his essay, which for the first time places the works in a broader historical context, and for overseeing this publication.

ACKNOWLEDGMENTS

Matthew Drutt

WHEN PLANS FOR THIS BOOK were first laid out in 1993, a basic revision of the Guggenheim's previous publication about the Thannhauser Collection was foreseen. Over time, it became apparent that a more ambitious approach was needed. This effort ultimately benefited from new scholarship emerging in the wake of access to libraries and archives in the former Warsaw Pact countries, shedding new light on the galleries of Heinrich and Justin Thannhauser and works handled by them. From the beginning, Max Ludwig and Janet Briner of the Silva-Casa Foundation, Bern, provided unparalleled guidance and insight. I must express my deepest gratitude to them for sharing records relating to Justin's clients and business affairs that had previously been unavailable, as well as providing generous feedback on drafts of my essay.

Aside from *Masterpieces of Modern Art: A Picture Book of Nineteenth and Twentieth Century Masterpieces from the Thannhauser Foundation* (1972), this is the third catalogue of the Thannhauser Collection proper, since Justin's original gift vested to the Guggenheim in 1978, and it is substantially different from its predecessors. *The Guggenheim Museum: Justin K. Thannhauser Collection* (1978) represents the core scholarship, compiled first by Angelica Rudenstine and later by Vivian Endicott Barnett, along with Guggenheim trustee Daniel Catton Rich, who worked closely with Justin. *Guggenheim Museum: Thannhauser Collection* (1992), which followed Hilde Thannhauser's bequest of ten additional works in 1991, is a modest revision, including the first publication of the perceptive essays by Paul Tucker and Fred Licht that are reprinted here. The present volume is an extensive overhaul of both presentation and content, while building upon the work of the earlier books. Provenance, exhibitions, and references for individual works have been brought up to date and errors have been corrected. In place of the texts on each work found in the prior two editions, scholars from around the world were invited to write short essays about fourteen masterpieces, placing these selected works in a broader cultural context. Their essays bring new life to old friends and greatly enrich our understanding of the Thannhauser Collection, and their patience throughout the process of realizing this publication is most appreciated.

My own research, which led to an expanded history of the Thannhauser galleries and collection, could not have been possible without the continued support of my colleagues. Most important, Thomas Krens, Director, and Lisa Dennison, Deputy Director and Chief Curator, must be thanked for providing the tremendous opportunity and framework necessary to realize this book. Vanessa Rocco and later Michelle Foa, Project Curatorial Assistants, were vital to all aspects of the publication. Their research contributions led to corrections and additions in the provenance, exhibition, and bibliographic records, where their patience and attention to detail were exemplary. They were assisted in this effort by Ellen Hymowitz. An army of curatorial interns provided invaluable aid over the years, including Lucia Ybarra Aznar, E. Abigail Durden, Carmen Eschler, Luz Guyalui, Andrea Klepzig, Heather O'Leary, Nana Poll, Sara Recordati, Isabelle Vanhoonacker, and Miren Josune Uribe Zubizaretta. Bridget Alsdorf, Collections Curatorial Assistant, was also helpful at various stages of the project. I am indebted to Ward Jackson, retired Archivist, for his ongoing counsel. Deep thanks are owed to Gillian McMillan, Senior Conservator, who both painstakingly revised condition reports for the collection and has skillfully restored several of the key works to their original beauty. Carol Stringari, Senior Conservator, was also of great assistance throughout the project. I am also most thankful to Paul Schwartzbaum, Chief Conservator, for his ongoing support and advice. I am indebted to Amy Henderson for her beautiful design of this publication, which lends a new clarity and grace to the works in the Thannhauser Collection. Anthony Calnek, Managing Director and Publisher, has once again demonstrated good humor and patience with another complicated publication, and I am most thankful to him for his advice, support, and professionalism. Jennifer Knox White, freelance editor, and Edward Weisberger, Editor, have done an exemplary job of sorting out old and new problems with the content in this book, while Elizabeth Levy, Managing Editor/Manager of Foreign Editions, and Melissa Secondino, Production Associate, skillfully managed its production.

Finally, this project could not have been realized without the assistance of numerous colleagues at the following institutions: Bibliothèque Nationale, Paris; Centre Georges Pompidou, Musée National d'Art Moderne, Paris; The Cleveland Museum of Art; Deutsches Buch- und Schriftmuseum der Deutschen Bücherei, Leipzig; The Fine Arts Museums of San Francisco; Frick Art Reference Library, New York; Library of Congress, Washington, D.C.; Musée Picasso, Paris; Museum of Fine Arts, Boston; The Museum of Modern Art, New York; National Gallery of Art, Washington, D.C.; Staatsbibliothek zu Berlin–Preussischer Kulturbestiz; Stadtarchiv München; State Hermitage Museum, Saint Petersburg; Watson Library, The Metropolitan Museum of Art, New York; and Zentralinstitut für Kunstgeschichte, Munich.

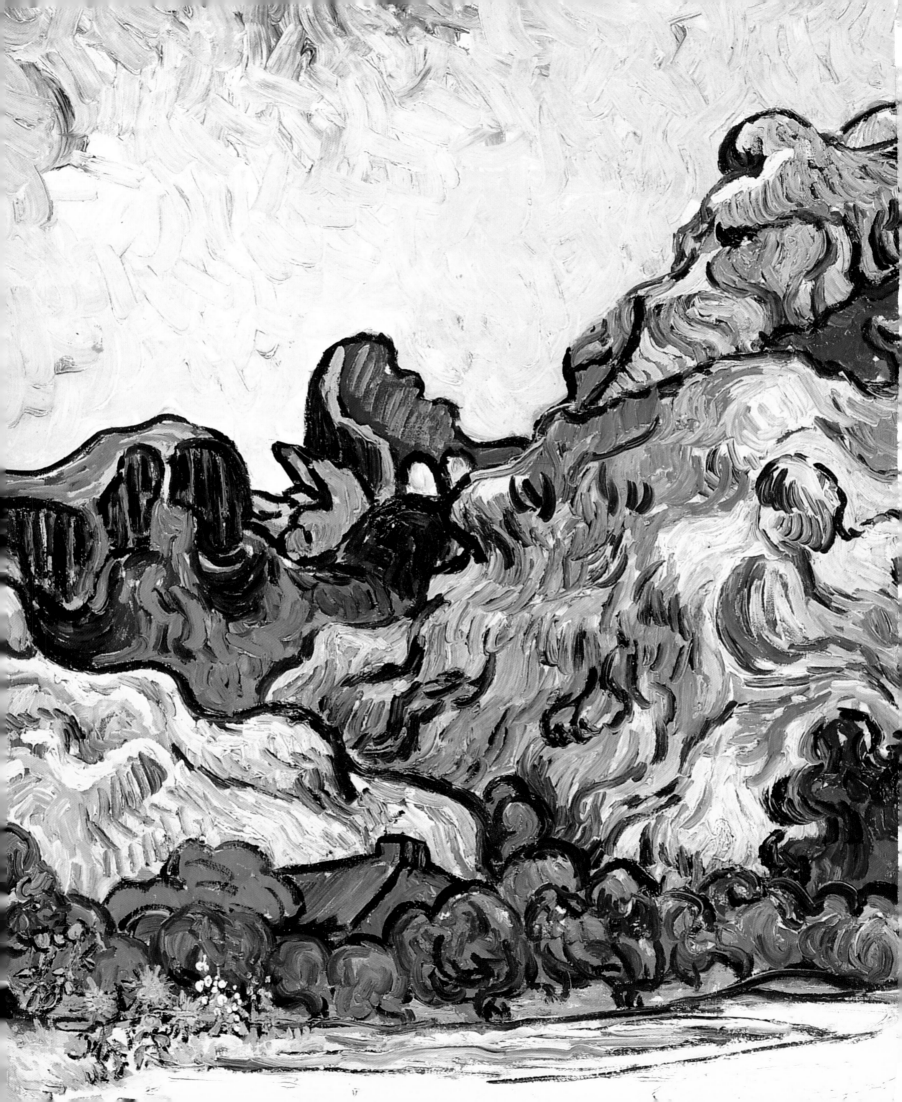

A SHOWCASE FOR MODERN ART: THE THANNHAUSER COLLECTION

Matthew Drutt

ON THE EVENING of April 29, 1965, several hundred distinguished guests from around the world gathered at the Solomon R. Guggenheim Museum for a momentous black-tie affair: the unveiling of a new wing containing one hundred masterpieces of Modern art from the collection of Justin K. and Hilde Thannhauser.[1] It was an evening filled with accolades and a sense of great accomplishment. The Thannhausers had presented a large portion of the works to the Guggenheim as a gift, to be transferred to the museum after Justin's death. For the Guggenheim, this marked the first time that a major private collection had been bequeathed to the institution since Solomon R. Guggenheim's holdings had been endowed to the foundation he established in 1937. Moreover, the gift provided the museum with a core collection of Impressionist, Post-Impressionist, and early School of Paris works, allowing its more expansive holdings of nonobjective art to be seen in a broader historical context and shifting the character of the overall collection.

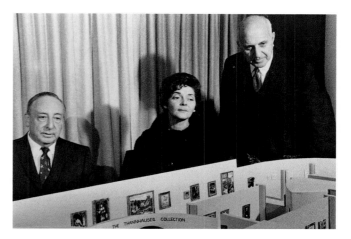

Justin and Hilde Thannhauser with Harry Guggenheim, President of the Solomon R. Guggenheim Foundation, and a model showing the Solomon R. Guggenheim Museum's new Thannhauser Wing, 1963.

FACING PAGE:
Detail of Vincent van Gogh, *Mountains at Saint-Rémy*, July 1889 (cat. no. 68).

For Justin Thannhauser, the bequest to the Guggenheim was his crowning achievement after more than half a century as one of Europe's most influential and distinguished collectors and dealers. His father, Heinrich, had established a gallery in Munich in 1909, and with Justin's involvement the business had flourished, adding branches in Lucerne and Berlin before it had been forced into less conspicuous operation due to Nazi persecution. After years of hardship and uncertainty, the bequest to the Guggenheim guaranteed that the Thannhauser name and reputation would finally be preserved for posterity. Yet in spite of this accomplishment, the occasion carried a trace of melancholy. Justin had no heirs. Both of his children, Heinz and Michel, had died at tragically young ages, and the business that he and his father had built up was now a matter of history. The gift being left to the museum contained brilliant works, but it was a collection formed largely in the aftermath of war, with many great works originally in the collection having been lost or stolen. At the time the gift was announced, in 1963, Justin, ever mindful of the hardships he had endured, observed: "My family, after

I

Heinrich Thannhauser, 1934.

Heinz and Michel Thannhauser,
ca. 1930s.

five hundred years of living in Germany, is now extinguished. That is why I am doing what I am with my collection."[2]

Indeed, the story of the Thannhausers is an odyssey of visionary accomplishments undone by sudden and unexpected tragedy, circumstances common to the European cultural community, which was subjected to the upheavals of two world wars in the space of twenty-odd years. Nonetheless, the Thannhausers wielded enormous influence in their day, and their impact on Modern art persists in public collections around the world that include artworks whose provenance can be traced back to them. For Heinrich and Justin Thannhauser were among the elite cadre of dealers in the early twentieth century—along with Paul Cassirer, Alfred Flechtheim, Daniel-Henry Kahnweiler, Paul and Léonce Rosenberg, Ambroise Vollard, and Herwarth Walden—who helped forge the reputations of Max Beckmann, Paul Cézanne, Edgar Degas, Paul Gauguin, Vasily Kandinsky, Paul Klee, Edouard Manet, Henri Matisse, Pablo Picasso, Pierre Auguste Renoir, and Vincent van Gogh, thus helping to define Modern art as we know it today.

In late 1904, Heinrich Thannhauser, in partnership with his friend Franz Josef Brakl, a local opera singer and cultural impresario, opened the gallery Moderne Kunsthandlung (Brakl und Thannhauser) at Goethestrasse 45.[3] Born in 1859 to Jewish parents, Heinrich had been trained as a tailor and apparently enjoyed a good reputation in this capacity for a number of years.[4] How he made the transition into the art world remains a mystery, but he displayed a swift and enduring talent for the profession. Brakl and Thannhauser's initial program was almost indistinguishable from that of the competition. They specialized in German painting and artists of the Munich Secession, and for a number of years identified themselves as supporters of the so-called Scholl Circle, which included among its members Reinhold Max Eichler, Max Feldbauer, and Adolf Höfer. But by 1908 the gallery had expanded its repertoire to include Neo-Impressionism, offering paintings by Kees van Dongen, Charles Guérin, and Georges Léon Dufrenoy. Brakl and Thannhauser's status grew. In 1908, they held the first solo exhibition of van Gogh's work in Germany; organized by the Paul Cassirer gallery in Berlin in cooperation with Galerie Bernheim-Jeune in Paris, it included around one hundred works formerly from the collection of Theo van Gogh.[5] Moderne Kunsthandlung began to distinguish itself by giving the latest trends in French art a platform alongside German painting, as well as establishing contacts with dealers from across Europe that gave it access to an impressive inventory.

Heinrich Thannhauser ventured out on his own the following year, opening his Moderne Galerie in November 1909. From the beginning he was apparently assisted by Justin, though his son's involvement at this time probably added up to little more than an apprenticeship; born in 1892, Justin would only have been seventeen years old when

the gallery opened.[6] By most accounts, the Moderne Galerie was one of the largest and most beautiful art galleries in Munich, and the reputation that Heinrich had built in partnership with Brakl caused great anticipation in terms of what he would do independently. On the eve of its opening, the local art critic and author Georg Jacob Wolf ventured, "Munich can boast of a distinguished new venue for selling art. To artists it offers a new forum for exhibiting their work, while art lovers will find it an intimate place to study and enjoy truly valuable art from Germany (primarily Munich) and abroad. The interiors of the new gallery are superb."[7] Designed by local architect Paul Wenz, of the firm Heilmann & Littmann, it was located in the grandiose glass-domed Arcopalais at Theatinerstrasse 7 in the heart of Munich's shopping district. It occupied more than 2,600 square feet divided between two floors, with nine exhibition rooms on the ground floor and an open, skylit gallery on the second floor that alone measured about 984 square feet. The physical disposition of the gallery gave Heinrich the flexibility to mount several shows of varying character at the same time, with a number of spaces installed as domestic environments (living rooms, reception rooms, dining rooms) featuring painting, furniture, and decorative objects, as was fashionable at the time, especially among dealers of Modern art, who had to convince collectors that contemporary painting could be as decorative as Old Master works.

Moderne Galerie joined a flourishing community of galleries and exhibition spaces that had been growing since shortly before the turn of the century and that had helped to make Munich one of Germany's great cultural centers. While the Jugendstil aesthetic was propagated through the exhibitions of the Munich Secession held at its exhibition space on Prinz-Regenten-Strasse, the predominant fare in the city's art scene was German academic art and decorative view painting, which appeared at the large annual exhibitions held at Munich's Glaspalast beginning in 1878. Such work was also the predominant offering in private galleries. Among the thirty or so active at the time, Galerie Heinemann was a showcase for Old Masters and the more conservative side of the Munich Secession, featuring artists like Franz von Stuck, Wilhelm Leibl, Franz von Lenbach, and Adolf Hölzel, while E. A. Fleischmann's Kunsthandlung and Wimmer & Co. were devoted to German and "continental" masters.

Moderne Galerie's opening exhibition was a powerful indicator of the versatile program that the Thannhausers would build in the ensuing years. More than two hundred works in painting and sculpture by German and French artists filled the gallery. The Germans were represented by the more classical artists of the period: Fritz Erler, Max Liebermann, Hans Pellar, Leo Putz, Fritz von Uhde, and Hugo von Habermann, among others. But the highlight of the exhibition was fifty-five French Impressionist works, which Heinrich had brought together in cooperation with Rudolf Meyer-Riefstahl in

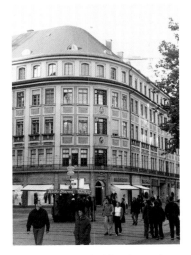

Moderne Galerie, the Thannhausers' Munich gallery from 1909 to 1928, was located in this building, the Arcopalais, at Theatinerstrasse 7; photographed in 1999.

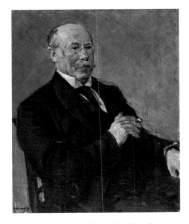

Max Liebermann, *Heinrich Thannhauser*, 1916. Oil on canvas, 92 x 74.9 cm (36 ¼ x 29 ½ inches). Kunstmuseum Bern, Gift, Hilde Thannhauser, Bern.

3

Paris. This was the most comprehensive presentation of French Impressionism to be shown in Munich up to that point, and in the introduction to the special catalogue devoted to this part of the exhibition, Meyer-Riefstahl claimed, "It is no longer necessary to stress the significance of Impressionism to contemporary art. We can now clearly trace its overall development, how it drew inspiration from Rubens, the Venetian painters, Velázquez, and finally Delacroix, and recognized color as its most important means of artistic expression."[8] Included were in-depth selections of masterworks by Mary Cassatt, Degas, Manet (including the sketch for his celebrated *A Bar at the Folies-Bergère*, 1881–82), Claude Monet, Camille Pissarro, Renoir, and Alfred Sisley. The impact of this impressive display did not go unnoticed. As one critic extolled, "We feel like we're in the art-trading department of some worldwide corporation and marvel at the fact that [the gallery] lives up to the expectations of an international audience in a way that is quite unparalleled in Munich. Though it lacks a specific character, especially in terms of local color . . . this has an otherwise fortunate effect, as it introduces us to masters whose works are rarely shown in Munich. . . . It seems poised to quickly develop into an important center of the Munich art market."[9]

In December, Heinrich surprised Munich again, this time not with an overwhelming presentation of French Modernism, but rather with a group of works by Germany's emerging generation of cutting-edge abstract painters, when the gallery hosted the first exhibition of the Neue Künstlervereinigung München (NKVM; New Artists' Association of Munich). Organized under the leadership of Kandinsky, who had originally moved to Munich to study with von Stuck, the group was an early voice of Expressionism, taking Modern German art in a direction influenced by an amalgam of French Fauvism and Bavarian folk art and waging an ideological battle against the sort of conservative trends in Munich seen in the very work that Heinrich had featured so prominently the month before.

Among those included in the NKVM show were founding members Adolf Erbslöh, Alexei von Jawlensky, Kandinsky, Gabriele Münter, and Marianne von Werefkin. The exhibition created an outcry, provoking one critic to write, "It is a sensation, a premature carnival prank in the dead of the pre-Christmas season. The scene may well resemble the Impressionists' first exhibition on the boulevard des Capucines. . . . They are not beginners but completers, students of Gauguin and van Gogh, rebellious, strange students who pick out their teachers' personal expression and repeat it in an impersonal manner."[10] In just two months, Heinrich had captured the local playing field, demonstrating an extraordinary ability to present the highest-quality—if not sometimes controversial— works from a broad and diverse field.

The exhibition calendar for 1910 continued to cast a wide net. Impressive solo

exhibitions were held for German artists Lovis Corinth, Max Klinger, Christian Rohlfs, and Max Slevogt, to name but a few, but the year's highlights belonged again to the French. The year began with a show of young French landscape painters, including Matisse and Maurice de Vlaminck. In May, there was a major Manet exhibition, organized in conjunction with Galerie Bernheim-Jeune and Galerie Durand-Ruel in Paris and Paul Cassirer in Berlin (and shown also at these three venues). Comprised of thirty-five paintings, pastels, and drawings culled from the distinguished Auguste Pellerin collection,[11] the exhibition was an absolute jewel, displaying many of

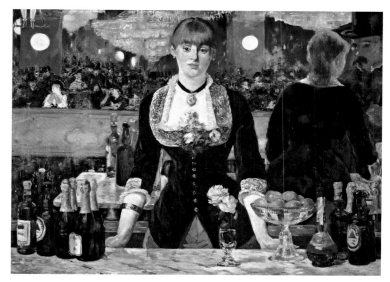

Edouard Manet, *A Bar at the Folies-Bergère*, 1881–82. Oil on canvas, 96 x 130 cm (37 ¾ x 51 ¼ inches). The Courtauld Gallery, London.

the most famous of Manet's paintings, including the finished version of *A Bar at the Folies-Bergère*. A deluxe illustrated catalogue was produced, with an essay by Georg Jacob Wolf, praising Manet as "the founder of an important school"[12] and further distinguishing Heinrich's style of presentation from that of other gallerists in its scholarly emphasis and aspirations to connoisseurship and curatorial acumen. In Munich's cultural press, critic M. K. Rohe wrote of having looked forward to the show "with great anticipation" and described it as "[an exhibition] that should be shown in Berlin, Paris, London and New York."[13] But according to Justin, the exhibition "found the greater part of the visitors, and especially some of the best appreciated art critics, absolutely unprepared to accept [the works] or even to take them seriously."[14] Nonetheless, the Thannhausers sold many of the pictures, including *Luncheon in the Studio* (1868), which was acquired by Munich's Neue Pinakothek, and *A Bar at the Folies-Bergère*, which they placed in the distinguished private collection of Eduard Arnhold in Berlin.[15]

In August, a show of twenty-six works by Gauguin from the private collection of A. W. Heymel was held. In spite of the fact that Gauguin's work had appeared in other Munich galleries, such as Kunsthandel Zimmermann, which had shown a small collection of his work in 1908, the pictures from the Heymel collection struck a revelatory chord. Through these works, Rohe noted, "a fuller picture of this peculiar master emerges. . . . The exhibition is particularly interesting because it documents the immense distance between the master's intensely personal and spiritual manner and all those modern artists who may have learned to emulate his way of clearing his throat and spitting but are entirely devoid of his sublime powers of perception."[16]

The second NKVM exhibition was held in September. By now, the group had expanded its ranks beyond Germany, to include Georges Braque, André Derain, Vlaminck, Picasso, Georges Rouault, and van Dongen, attesting to the importance that

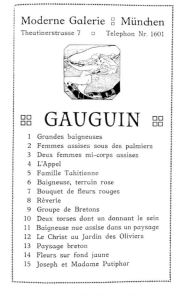

Moderne Galerie □ München
Theatinerstrasse 7 □ Telephon Nr. 1601

⊞ **GAUGUIN** ⊞

1 Grandes baigneuses
2 Femmes assises sous des palmiers
3 Deux femmes mi-corps assises
4 L'Appel
5 Famille Tahitienne
6 Baigneuse, terrain rose
7 Bouquet de fleurs rouges
8 Rêverie
9 Groupe de Bretons
10 Deux torses dont un donnant le sein
11 Baigneuse nue assise dans un paysage
12 Le Christ au Jardin des Oliviers
13 Paysage breton
14 Fleurs sur fond jaune
15 Joseph et Madame Putiphar

Advertisement in *Statdtchronik* 3/4, no. 231 (1910), listing fifteen of the twenty-six works in the Paul Gauguin exhibition at Moderne Galerie, Munich, August 1910.

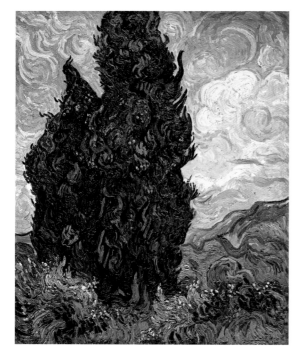

Vincent van Gogh, *Cypresses*, 1889.
Oil on canvas, 93.3 x 74 cm (36 ¼ x
29 ⅛ inches). The Metropolitan Museum
of Art, New York, Rogers Fund, 1949
(49.30).

French art held for German artists as well as signifying the international
spirit that was characteristic of Modernism by this time. Perhaps due
to the presence of the French, who were beginning to be viewed with
derision as the seeds of World War I were being sown, or simply to
shifting winds in a still conservative city, the exhibition was publicly
reviled. Rohe, who had praised previous Thannhauser shows, lambasted
this one as "an absurdity by incurable madmen . . . an event by con artists
who have tried to capitalize on a market trend and enrich themselves
by charging astronomical prices."[17] Kandinsky later recalled, "The press
raged against the exhibition, the public railed, threatened, spat at the
pictures. . . . We exhibitors could not understand this indignation. . . .
We were only amazed that in Munich, the 'city of the art,' nobody
except [Hugo von] Tschudi had given a word of sympathy."[18] Tschudi,
who had purchased Manet's *Luncheon in the Studio* from the Thannhausers
as director of the Neue Pinakothek, had recently been appointed director
of all museums in Bavaria, so his support must have meant more than a little to the
artists and the Thannhausers.

Despite the general derision for the NKVM show, the fall season ended the year
positively on a French note. A large exhibition of work by van Gogh traveled from Paul
Cassirer's Berlin gallery in October. Curiously, even though it contained the artist's
"finest oils and graphics . . . none could be sold . . . in spite of prices of approximately
1000 Dutch guilders for paintings like the Sunflowers, Bedroom in Arles, Zypresses
[*Cypresses*, 1889], etc."[19] Perhaps Munich was experiencing van Gogh overload at this point,
as Brakl had held an exhibition of his work in 1909. Also in the fall, Heinrich paired a
powerful selection of thirty-three works by Pissarro with a dozen paintings by Sisley.
The exhibition, which was held in the spacious second-floor gallery, was praised as "a
collection of consistently first-rate works by the two Paris Impressionists."[20] Amounting
to the first major overview anywhere since the painter's death in 1903, the Pissarro
presentation was especially impressive and favorably reviewed as "a sublime exhibition"[21]
that embodied a "complete penetration to the innermost essence."[22]

During 1911, Moderne Galerie had an even more robust schedule, with exhibitions
of work by Matisse, Franz Marc, Ferdinand Hodler, Liebermann, Käthe Kollwitz, and
Klee. The Klee exhibition, which was held in June and consisted of thirty drawings,
was the artist's debut solo presentation in Germany. The circumstances surrounding its
organization were not entirely to the artist's liking, however. He had apparently
petitioned both Brakl and Thannhauser for the exhibition. In his diaries, he noted,
"The two Hebrews Brakl and Thannhauser find no commercial incentive in my one-man

6

debut. If you are so brash as to stand out from the average, you must at least be famous. . . . To put it briefly and bluntly: the hallway offered by Herr Thannhauser was a little offensive. In consequence, one first had a try at Herr Brakl. . . . In conclusion, this laurel-wreathed ass sent me to Littauer, to Steinecke, to Bertsch, to Putz, etc. . . . Thereupon, we returned ruefully to Thannhauser and contented ourselves with the hallway."[23] In spite of Klee's misgivings, his work would continue to be shown and sold successfully by the Thannhausers over the years, though he soon switched his primary representation to Hans Goltz, whose gallery became the platform for German Expressionism in Munich.[24]

Also in 1911, having established a friendship with Theo van Gogh's widow, Johanna van Gogh-Bonger, and son, Vincent, the Thannhausers mounted another important exhibition of the artist's work, "this time with sales results coming up."[25] The third NKVM exhibition was held in December, but the group's complexion had changed due to a disagreement that had erupted over the issue of abstraction. Otto Fischer led a faction that retreated into Jugendstil and expressive Fauvism, while Kandinsky, Jawlensky, and Münter progressed toward an increasingly abstract mode of painting. Together with Marc,[26] the latter artists had departed and formed a rival group, Der Blaue Reiter (The Blue Rider) that embarked upon a path of Expressionist painting imbued with a more spiritual or metaphysical bent. In a display of mercurial showmanship, Heinrich exhibited the work of the newly formed group alongside the NKVM show, once more demonstrating his capacity for a program embracing opposing aesthetics. The first exhibition of Der Blaue Reiter, which included works by French, German, and Russian artists, was as decidedly international as Moderne Galerie's program. Robert Delaunay, who also lent two works by Henri Rousseau, was the sole living representative from France, attesting to the affinity that his particular approach to Cubism had with German Expressionism.[27]

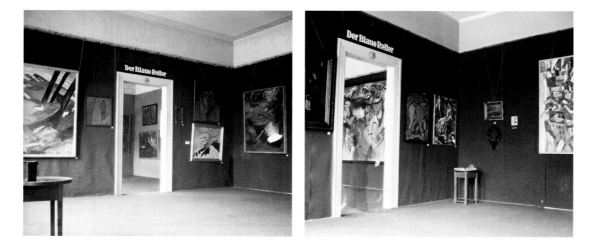

Der Blaue Reiter installation, Moderne Galerie, Munich, December 1911, photographed by Gabriele Münter. In the first view (left), Franz Marc's *Yellow Cow* (1911) is partially visible at the far left, and in the second view, Robert Delaunay's *The City* (1911) is at the far right; both works are now in the collection of the Solomon R. Guggenheim Museum.

That same year, Heinrich sent Justin abroad to further his academic studies in art history, philosophy, and psychology, which he undertook in Munich, Berlin, Florence, and especially Paris. Among those with whom Justin studied were Henri Bergson, Adolf Goldschmidt, and Heinrich Wölfflin. Young Thannhauser befriended and later brought Wölfflin to the Munich gallery for the distinguished historian's first series of private lectures.[28] With other eminent guests from the international community invited to hold similar lectures over the years, Justin helped his father turn Moderne Galerie into a fashionable salon, a crossroads of vanguard culture in provincial Munich. His time abroad also served to enhance business contacts with artists and other dealers, including Kahnweiler and Wilhelm Uhde, many of whom had an auspicious impact on the gallery. Justin's life in Paris is documented in a drawing by Jules Pascin (cat. no. 23), dated December 1911 and given to him at that time. A study in gentlemanly leisure, the drawing depicts Justin at the notorious émigré hangout Café du Dôme, playing cards with the painter Rudolf Lévy, a colleague of Matisse.[29]

Justin returned to Munich in 1912 and began working full-time with his father. A show of forty-one works by Renoir opened the 1912 season, followed by a large exhibition of works by the Norwegian painter Edvard Munch. Further forays into Expressionism continued with an exhibition by Die Brücke (The Bridge) artists Cuno Amiet and Max Pechstein and a solo show by August Macke. The short-lived group Sema, which was devoted to the art of drawing and counted Karl Caspar, Robert Genin, Klee, and Carl Schwalbach among its members, had its first exhibition in the spring. That summer saw the kind of grand survey of Munich Modernism mixed in with French avant-garde painting that the gallery had become known for by that time. But in October and November, the Thannhausers held an unprecedented exhibition—at least insofar as Munich was concerned—of works by the Italian Futurists, represented by Umberto Boccioni, Carlo Carrà, Luigi Russolo, and Gino Severini. Although the show had been

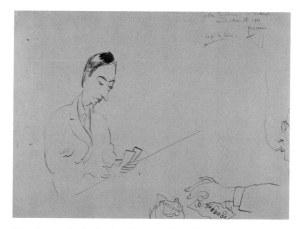

Jules Pascin, *Justin K. Thannhauser and Rudolf Lévy Playing Cards*, December 24, 1911 (cat. no. 23).

put together in Paris by Galerie Bernheim-Jeune and had traveled to Herwarth Walden's Galerie Der Sturm in Berlin, it apparently had also come about through Justin's "relations to [F. T.] Marinetti, their [the Futurists'] leader."[30] Though no reviews have come to light, one can imagine the response. Justin later recalled that there were "many controversies at that time!!"[31] The year ended on a spectacular note: a refined selection of fifteen paintings by Paul Cézanne, along with an exhibition of works by Beckmann.

By the following year, 1913, the gallery was more commonly known as Moderne Galerie Heinrich Thannhauser. Among the notable exhibitions in 1913 were solo presentations by Cézanne, Corinth, Degas,

Hodler, Marc, and van Dongen, and, coming out of left field, a show of Italian Baroque painting. At the invitation of Walt Kuhn and Walter Pach, the Thannhausers also participated in the watershed exhibition that introduced European Modernism to the United States, lending at least eight works to the landmark *International Exhibition of Modern Art* (popularly known as the Armory Show) held in New York before traveling to Boston and Chicago.[32]

However, by far the most important project of the year was the first major exhibition of works by Picasso, from his Blue Period through the latest iterations of Cubism. Held in February and organized with the assistance of Kahnweiler, Picasso's Parisian dealer, the show was not the first exhibition ever of the artist's work, but it was certainly the largest, most comprehensive, and most critically selected to date, with seventy-six paintings and thirty-eight drawings, watercolors, and etchings executed

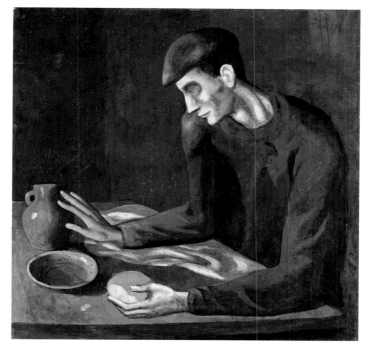

Pablo Picasso, *The Blind Man's Meal*, 1903. Oil on canvas, 95.3 x 94.6 cm (37 ½ x 37 ¼ inches). The Metropolitan Museum of Art, Purchase, Mr. and Mrs. Ira Haupt Gift, 1950 (50.188).

between 1901 and 1912. Justin would recall later that the "show went immediately on to other places like Prague, Cologne, etc. . . . Picasso himself always considered it as the beginning of his appreciation in the world."[33] Justin wrote the introduction to the accompanying catalogue, which positioned Picasso's work as "the first inducement to the whole Expressionist, Cubist, and Futurist movement. Picasso's actual involvement in all that consists in nothing more than having provided the initial inspiration, which also describes the extent to which he wishes to be involved."[34] Among the many works in the exhibition were *Woman Ironing* (1904, cat. no. 32), which Justin eventually acquired in the 1930s for his own collection and kept with him until his bequest to the Guggenheim, and *The Blind Man's Meal*. The exhibition was the beginning of a close personal and professional relationship between Justin and Picasso, which lasted until the artist's death in 1973. Of the seventy-three works now in the Guggenheim's Thannhauser Collection, thirty-two are by Picasso, and these works amply reflect the character of their friendship over the years.

With the outbreak of World War I in 1914, the gallery's vigorous program suddenly came to a relative standstill. Justin was called into military service and returned to Munich shortly after being wounded in 1916.[35] While some exhibitions were held during these years—such as solo shows by Kandinsky and Klee in 1914, an exhibition of war paintings in 1916, and a large survey of late-nineteenth-century Munich artists in 1918—Moderne Galerie Heinrich Thannhauser kept a relatively low profile, gradually downplaying its relationship to French art as it fell increasingly out of favor with a

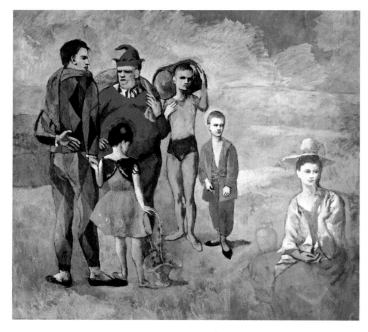

Pablo Picasso, *Family of Saltimbanques*, 1905. Oil on canvas, 212.8 x 229.6 cm (83 ¼ x 90 ⅜ inches). National Gallery of Art, Washington, D.C., Chester Dale Collection.

nationalist German audience. However, of particular note are the three large volumes published by the gallery that catalogued a "very small selection" of inventory (*Nachtragswerke*), which reflected the broad program that Heinrich and Justin had developed in the years preceding the war. The first volume, published in 1916 (the subsequent volumes were published in 1917 and 1918), begins with a twenty-two-page introduction by Wilhelm Hausenstein offering an overview of the gallery's activities to date and providing a historical context for many of the pictures in the inventory. Referring to Moderne Galerie Heinrich Thannhauser as "*das Institut*," Hausenstein celebrated Heinrich's achievement in forming a gallery that was more of a public service than a private business, a place more like a museum or salon, where people could learn and be exposed to great works of art. He also praised Heinrich for having placed so many major works of art in public and private collections, adding to Germany's cultural heritage.[36] The catalogue contains 174 masterpieces of French and German art, including Renoir's *Woman with Parrot* (1871, cat. no. 57), which the Thannhausers had apparently acquired for a short time before selling it, only for Justin to reacquire the work again in the 1920s. The real gem, however, was Picasso's renowned *Family of Saltimbanques* (1905), which Justin acquired for the gallery for the princely sum of 12,500 gold francs in March 1914 at an auction of the Peau de l'Ours collection in Paris.

By 1918, Justin was married to his first wife, Kate, who gave birth to their first child, Heinz, in the same year; their second son, Michel, would be born in 1920. With the political and economic situation in Germany at a crisis point and the market for French art in particular decline, Justin decided to move his family to neutral ground in Switzerland, opening a branch of Moderne Galerie/Thannhauser—as it now came to be known—in Lucerne in 1919. Justin ran that business until 1921, when he was compelled to return to Munich. His father, who had developed a serious condition in his larynx, was forced into sudden retirement and turned over complete control of Moderne Galerie/Thannhauser's operations to Justin. The Lucerne gallery continued to be under Justin's direction until September 1928, when his cousin Siegfried Rosengart assumed control and changed its name to Galerie Rosengart.[37]

While it never boasted as robust an exhibition schedule as the Munich gallery, the Lucerne branch provided a venue that periodically acted as a safe haven for selling works found unfavorable in Germany. Moreover, the notion of an expanded

operation had been on Heinrich's mind as early as 1911, when he entertained plans to open a branch in Cologne, deterred only by limited finances.[38] It would therefore be incorrect to suggest that the notion of expansion was based solely on circumstances created by the war.[39] The Thannhausers were ambitious businessmen, and in the eighteen years following the war, that ambition was to see their business's program and facilities expand far beyond the scope of its prewar operation.

After assuming responsibility for the gallery in Munich, Justin renamed the business Galerien Thannhauser (retaining Moderne Galerie/Thannhauser as the proper name of the Munich headquarters until the end of 1926) to more accurately reflect its multi-operation profile, and he set out to build back the gallery's international program and sales. He moved carefully, however, advertising the business as specializing in graphic art and in German masters, and beginning 1922 with exhibitions of work by Corinth and Emanuel Spitzer, along with other conservative shows of German paintings and works on paper. The gallery's schedule ventured cautiously into the avant-garde with a large Picasso exhibition in February. Accompanied by a catalogue with a ten-page interpretive essay by Paul Rosenberg, who had taken over from Kahnweiler as Picasso's Paris dealer, the exhibition contained forty-five works comprising twenty-seven oil paintings and eighteen pastels, gouaches, and drawings. Moving from synthetic Cubism through the more classical works of the early 1920s, the exhibition picked up where the Thannhausers' previous Picasso project in 1913 had left off, a fitting point of reference for the gallery's postwar resurgence. Justin wrote in the catalogue's preface, "This new opportunity for taking a comprehensive look at [Picasso's] work of the past several years will certainly be welcomed by many devotees of the fine arts."[40] Indeed, Rosenberg's essay situated Picasso at the peak of a high Modernist tradition: "He is enthusiastic about the works of Ingres, Géricault, Delacroix, Corot, Courbet. He is discovering the Impressionists, Cézanne, van Gogh, and Gauguin, whom he's beginning to love with all his soul."[41] Rosenberg went on to offer one of the first comprehensive overviews of the artist's career, tracing the different styles and sources explored by Picasso over the previous twenty-two years, including his interest in the arts of Africa. Thus the exhibition attempted to reestablish the combination of connoisseurship and scholarship that had characterized the Thannhausers' program before the war. In July, Justin mounted a large exhibition of recent works by Kandinsky, some ten years after his first appearance at the gallery. The year closed with exhibitions of drawings, prints, and posters by Henri de Toulouse-Lautrec and a show of thirty paintings and works on paper by Derain, the latter of which passed more or less without notice in the press.

In fact, the program for the ensuing years retreated into the safe haven of mostly German masters, suggesting that the cultural climate in postwar Munich, even more

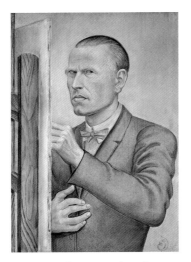

Otto Dix, *Self-Portrait with Easel*, 1926. Oil on canvas, 80 x 55 cm (31 ½ x 21 ¼ inches). Leopold-Hoesch-Museum der Stadt Düren.

conservative than prewar Munich, did not allow for the kind of shows that the Thannhausers had pioneered before 1914. A few exceptions are worth noting, however. Probably in July or August 1923,[42] an exhibition of works by contemporary American artists was held, sponsored by an American, Mrs. E. H. Harriman, and possibly organized as an outgrowth of the Thannhausers' assistance in lending work to the Armory Show in 1913. An exhibition of paintings by Vlaminck took place in 1925. In July and August 1926, Moderne Galerie/Thannhauser was the second venue for a major traveling exhibition of works by Degas, which originated at Flechtheim's Berlin gallery in May and continued on to Galerie Arnold in Dresden in September.[43] Composed of twenty-five pastels and drawings and seventy-two bronzes, it was the largest exhibition of Degas's work since his death in 1917 and the first showing of all of his bronzes, which were cast posthumously from models found in his studio.[44] The sculptures in the Guggenheim's Thannhauser Collection (cat. nos. 9–11) appeared in this show, as did the pastel *Dancers in Green and Yellow* (ca. 1903, cat. no. 12).[45] Also in 1926, Justin held exhibitions of work by George Grosz and Otto Dix. The Dix exhibition, held in June and July and organized in cooperation with Galerie Nierendorf in Berlin, was particularly daring. Of the twenty-five paintings (including *Self-Portrait with Easel*, 1926), fifteen drawings, and twenty-four prints made by the artist between 1913 and 1926, the majority belonged to his phase as an adherent of Neue Sachlichkeit (New Objectivity), the quintessentially Modern form of realism that evolved out of Dada in German painting and photography during the 1920s.[46]

Indeed, the Grosz and Dix exhibitions were a fair indication that Justin still harbored ambitions of supporting the avant-garde. Those ambitions were finally realized in 1927, when he opened a third gallery, this time in Berlin, the center of vanguard activity in Germany during the postwar period. For years, he had been doing business with dealers there—Cassirer, Flechtheim, and Walden among them—all of whom handled the leading Modernists of the period. In a move calculated to reinvigorate his business, Justin staged the first of two *Sonderaustellungen* (special exhibitions) that January, in a temporary space, the Berliner Künstlerhaus (Berlin Artists Association), located at Bellevuestrasse 3 in the city's Tiergarten district. The exhibition was a major undertaking, containing 263 masterpieces of French painting by such artists as Pierre Bonnard, Braque, Cézanne, Gustave Courbet, Degas, Eugène Delacroix, Gauguin, Fernand Léger, Manet, Matisse, Monet, Picasso, Pissarro,

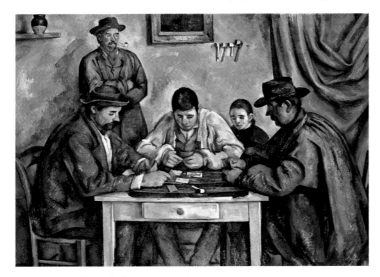

Paul Cézanne, *The Card Players*, 1890–92. Oil on canvas, 134 x 181.5 cm (52 ¼ x 71 ¼ inches). The Barnes Foundation, Merion, Pennsylvania.

Renoir, and van Gogh, to name just the highlights, most of whom were represented in depth. The quality of the works on display and their range were breathtaking, and both the critical and popular response was tremendous. A generously illustrated fifteen-page review by noted art historian Julius Meier-Graefe celebrated the show in the popular art journal *Der Cicerone* in February: "In the home of the Berlin Künstlerhaus, art has made a surprise appearance, sweeping away the clubhouse's evil spirits with one triumphant stroke.... Germany has not seen an exhibition of this caliber since Paul Cassirer's heyday; even in the Paris art trade, events of this magnitude are unusual."[47]

Justin's gamble was off to an excellent start. Many of the works later bequeathed to the Guggenheim appeared in the exhibition, including Manet's *Before the Mirror* (1876, cat. no. 17), Pissarro's *The Hermitage at Pontoise* (ca. 1867, cat. no. 56), Renoir's *Woman with Parrot* and *Still Life: Flowers* (1885, cat. no. 58), and van Gogh's *Mountains at Saint-Rémy* (July 1889, cat. no. 68). There were also numerous works of note that are now in other public collections, including Cézanne's *The Card Players* (1890–92) and the van Gogh *Cypresses* that had been exhibited by Heinrich in 1910. The second *Sonderaustellung* was held from the middle of February through the end of March, and this time a large selection of German art was featured, including works by Corinth, Hodler, Wilhelm Lehmbruck, Liebermann, Adolph von Menzel, Max Slevogt, and Fritz von Uhde. Together, these two major exhibitions—which amounted to a summary of the gallery's original program in Munich—thrust Justin into the midst of Berlin's art world.

Having achieved this success, Justin acquired and renovated an old Berlin mansion just down the block from the Künstlerhaus, opening the Galerien Thannhauser, Berlin, at Bellevuestrasse 13 in June 1927. The inaugural exhibition was an encyclopedic showing of 356 works by mostly German masters, new and old, including Ernst Barlach, Beckmann, Corinth, Dix, Lyonel Feininger, Grosz, Klee, Oskar Kokoschka, Liebermann, Marc, and Menzel.

At the Munich gallery, the *Multinationale Austellung* opened in January 1928. The catalogue included a foreword by Roger Fry, who stated, "For artists and art lovers alike, {national borders} are entirely meaningless: at most, they're an impediment. Of course it is true that art is national in a sense that science is not; but if it is unavoidably national in its results it certainly is not in its intentions."[48] Sponsored by Mrs. E. H. Harriman, the same patron who had assisted Justin with his show of American art in

Two views of *Erste Sonderausstellung in Berlin*, organized by Justin Thannhauser and presented at the Berliner Künstlerhaus, Berlin, 1927.

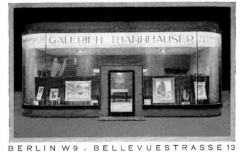

GALERIEN THANNHAUSER

BERLIN W9 / BELLEVUESTRASSE 13

Galerien Thannhauser, Berlin, Bellevuestrasse 13, 1928. The address served as the headquarters for Justin Thannhauser's operations.

1923, this "multinational exhibition" included works by, among others, Arthur B. Davies, Charles Demuth, and Max Weber (United States); Beckmann, Dix, and Pechstein (Germany); Fry, Duncan Grant, and Paul Nash (England); Braque, Derain, and Léger (France); Emil Rivas (Mexico); Albert Kohler (Switzerland); and Picasso and Valentin Zubiaurre (Spain).

The exhibition seemed designed to capitalize on the prior year's successes in Berlin and to steer the Munich gallery toward a less provincial program once more, but this never transpired: the remainder of the year's exhibitions in Munich reverted to the German masters whose works had been featured there for the previous fourteen years. At year's end, the gallery—the toast of the progressive art world in Munich before the war—was finally closed. Justin now focused completely on Berlin, with the branch in Lucerne becoming increasingly independent under Rosengart.

The 1928 season in Berlin began with a major memorial exhibition dedicated to Monet. The exhibition, which opened in February and ran through mid-March, was a major affair, with seventy paintings borrowed from private and public collections, including the Städtische Galerie Frankfurt (*Breakfast*, 1868) and the Musée Luxembourg in Paris (*Regatta in Argenteuil*, 1874, and *Rouen Cathedral*, 1894). The accompanying catalogue noted that the exhibition marked "the first time that works from all periods of the master's oeuvre have been presented in Germany."[49] It was a political coup as well, organized with the assistance of the French ministry of fine arts. Justin later recalled that France's former premier Georges Clemenceau offered to travel to Berlin to deliver a memorial speech at the gallery, only to be prevented at the last minute due to illness.[50] Among the works shown was *The Palazzo Ducale, Seen from San Giorgio Maggiore* (1908, cat. no. 22), which Thannhauser purchased during the course of the exhibition from Wildenstein & Co., New York.[51] According to one review, which took note of the concurrent Manet exhibition being held at Galerie Mathiessen, the overall effect of the presentation captured "the genius of an era." It continued, "When beautiful paintings are shown we delight in the divine gift without first asking questions about the artist's nationality or whether the current political constellation permits our devotion. Above all we experience pure pleasure and for that we are grateful."[52]

The end of the 1928 season was no less spectacular, with a major Gauguin retrospective. Filling the gallery were 230 works, again borrowed from private and public collections, in various mediums and covering every phase of the artist's career, from his first period in Brittany beginning in 1884 through his last sojourn in Tahiti, which ended with his death in 1903. Included was *In the Vanilla Grove, Man and Horse* (1891,

cat. no. 13), which Justin would acquire for his collection in 1942. The catalogue's introduction by Wilhelm Barth, director of the Kunsthalle Basel and a Gauguin scholar, underscored the museumlike status of the exhibition.[53] Justin's unsigned text in the catalogue also reminded audiences of the Thannhausers' commitment to the artist, whose work they had shown in a major presentation twenty years earlier in Munich.[54]

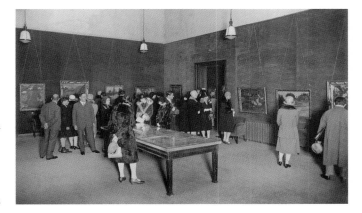

Paul Gauguin exhibition at Galerien Thannhauser, Berlin, 1928. Justin Thannhauser is standing fourth from left.

Nothing is currently known of the 1929 season; no doubt there were exhibitions, but the press records are sparse and ongoing research has failed to turn up events of any significance. Even Justin's own notes mostly skip forward to 1930, for this was the year of his greatest, and perhaps ultimate, achievement in the Berlin space. In February and March, he presented the largest exhibition of works by Matisse ever held in Germany up to that time. With 265 works made between 1896 and 1929, it was the most comprehensive overview of the artist's career yet assembled: eighty-three paintings (including *Decorative Figure on an Ornamental Ground*, [late 1925–spring 1926]), twenty sculptures, fifty-five drawings, and 107 prints. Justin later recalled, "It had a sensational effect everywhere in the [old and new] worlds, and brought—like the other shows—thousands and thousands of visitors; whole classes of students from Germany and other (Scandinavian, etc.) countries."[55] Indeed, the exhibition was noteworthy enough to merit a review in an American periodical, *The Art News*, which raved, "Here is no trickery, no sentimentality, but a freshness and sureness of execution which prove Matisse a master in his chosen field. Indeed, nobody but a master could venture to group such boldly contrasting color structures and such daringly arranged elements of form."[56] Matisse, whom Justin had met as far back as 1911 in Paris, cooperated in the organization of the exhibition, making works from his own collection available; these were shown alongside distinguished examples from other private collections in France and Germany. Hans Purrmann, an artist who had also shown with Justin and who had been deeply influenced by Matisse since meeting him in 1906, wrote a brief but thoughtful introductory essay to the catalogue. Also accompanying the show, a special folio of eighty paintings and drawings, with a text written by Gotthard Jedlicka, was published in an edition of 250 in cooperation with Editions Chronique du Jour in Paris.

It is here that Galerien Thannhauser's history begins to fade for several years. Though the Berlin gallery remained in operation until 1936 or 1937,[57] its activities from this point forward are unknown. In 1932, Justin assisted with two important Picasso exhibitions, one at Galerie Georges Petit—"the first really great Picasso-Show in Paris"[58]—followed by one at the Kunsthaus Zürich, "which we helped anonymously to arrange, —and which had a terrific impact in whole Switzerland."[59] By 1933, the situation

Henri Matisse, *Decorative Figure on an Ornamental Ground*, [late 1925–spring 1926]. Oil on canvas, 130 x 98 cm (51 ¼ x 38 ⅝ inches). Centre Georges Pompidou, Musée National d'Art Moderne, Paris.

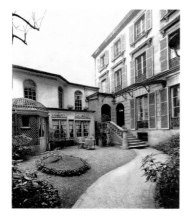

Thannhauser Maison d'Art, 35, rue de Miromesnil, Paris, ca. 1937.

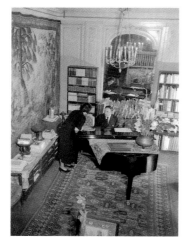

Kate and Justin Thannhauser in the library of their home at 35, rue de Miromesnil, Paris, July 1939.

in Germany had become so difficult that Justin took a small apartment in Paris, which would later serve as the means by which he moved belongings slowly, though legally, out of the country.[60] In 1934, Heinrich, who had lived his entire life in Munich, was persuaded to emigrate to Switzerland and live with Rosengart in Lucerne in order to avoid persecution by the Nazis. He never made it. Apparently harassed as he attempted to cross the border between Germany and Switzerland, he died of a heart attack.[61] That same year in October, Justin helped organize an exhibition of seventy-six works by Picasso for Galeria Mueller in Buenos Aires, consisting of loans from museums around the world as well as from his own collection and those of Kahnweiler and Rosenberg.[62] One wonders if Justin viewed this as a means of exporting certain works out of the country for safekeeping, since in 1939 Galeria Mueller would be a conduit for getting some of his collection into the United States.

In April 1937, when circumstances in Germany were no longer bearable, Justin moved with his wife and two children to Paris. They took up residence in a rented house at 35, rue de Miromesnil, where Justin operated a private gallery until 1939. Having paid a steep export tax, he was permitted to bring with him his library and the gallery's archives dating back to 1909, as well as many important works of Modern art considered *entarte Kunst* (degenerate art) by the Nazi government and therefore of no interest to the German state. However, he was forced to liquidate the family's considerable inventory and collection of classic German art, which had been an important part of the business since its inception, in order to meet the financial demands placed upon him. Thus, one of the defining components of the inventory and collection, which had evolved over nearly thirty years, was simply dispersed.[63]

On October 14, 1937, Justin was voted into the Syndicat des Editeurs d'Art et Négotiants en Tableaux Modernes, the professional society of art dealers active in Paris at the time. The distinguished company he kept as a member of the syndicat is documented in a photograph taken at an official dinner for the group in 1938: it shows Thannhauser surrounded by legends like the Bernheim-Jeunes, Pierre Loeb, and Paul and Léonce Rosenberg, all of whom had become friends and associates over the years. Little else of Justin's years in Paris is known. He continued to lend works and to give other means of assistance to exhibitions in France and elsewhere. He also continued to acquire art, such as two works by Picasso, *Still Life: Flowers in a Vase* (1906, cat. no. 36) and *Woman with Yellow Hair* (December 1931, cat. no. 48), both of which he bought in 1937 from the artist, whom he saw regularly. However, much of what he owned in the way of art, books, musical instruments, and collectible furnishings would soon be lost.

On August 10, 1939, Justin and Kate traveled to Geneva with their friends, the Edward G. Robinsons of Hollywood fame, to see an exhibition of paintings on loan from

the Museo Nacional del Prado in Madrid.[64] While they evidently planned to be there for some time, judging from a postcard Justin sent to Picasso on July 18 in which he invited the artist to join them,[65] they could not have imagined that they would never return to Paris. Following the outbreak of war in September, the Thannhausers took refuge once again in Switzerland. When the Germans occupied France in June 1940, they gave up hope of returning there, and in December they made their way to Lisbon, where they boarded a ship bound for New York. The house in Paris would be completely looted during the war, and the precious

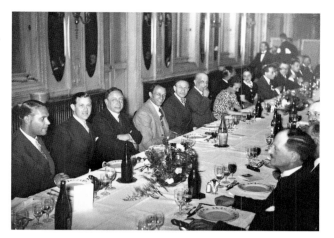

At a 1938 dinner for the Syndicat des Editeurs d'Art et Négotiants en Tableaux Modernes (from left): [Gaston?] Bernheim-Jeune, [Pétridés?], Justin Thannhauser, Pierre Loeb, Léonce Rosenberg, André Schoeller, Mrs. Pierre Loeb, Josse Bernheim-Jeune, Mrs. Guillaume Leray, Paul Rosenberg, and others.

objects in their collection transported back to Germany by Nazi soldiers. The archive of the Galerien Thannhauser dating all the way back to its founding year was largely destroyed.[66] Fortunately, Justin had shipped nine important works to Buenos Aires in May 1939 for an exhibition,[67] and these, along with several others, including Picasso's *Fernande with a Black Mantilla* (1905–06, cat. no. 33), made their way to safety with him in the United States.

Once in New York, the Thannhausers acquired a town house at 165 East Sixty-second Street, and Justin began to operate a private gallery with the intention of building up the business one more time. He maintained contact with his friends in Europe, including Picasso, whom he invited to New York to stay with them at their *"petite maison."*[68] He was counting on his oldest son, Heinz, who had trained as an art historian, to run a gallery with him after the war, as he had done with his own father. But disaster struck on August 15, 1944, when Heinz was killed in combat while fighting with the American Air Force for the liberation of France.[69] Despondent over this loss, still uncertain about the disposition of the house in Paris (which he would only later learn had been looted), and concerned about the health of his younger son, Michel, who was gravely ill and would die in 1952, Justin canceled his immediate plans to open a public gallery. Instead, he placed a large number of works from his collection up for auction at Parke-Bernet Galleries in New York in April 1945.[70] In a letter to the auction house, he wrote, "The great majority of these paintings has not been seen in the United States, as I formerly intended to open an exhibition gallery in New York on (57) Fifty-Seventh Street."[71] The artists whose works were made available ranged from Bonnard, Cézanne, Corot, and Degas to Gauguin, Manet, Matisse, and Picasso, but nothing in the entire lot rivaled the quality of what he had kept for himself. In spite of the grave disappointments encountered at this point in his life, Justin was not without hope; in the same letter, he explained, "I may reorganize this business in the near future on a more restricted scale."[72] Indeed, earlier that year he had helped Curt Valentin's

Justin and Kate Thannhauser in their home at 165 East Sixty-second Street, New York, ca. 1940s.

Sitting room of Justin and Kate Thannhauser's home at 12 East Sixty-seventh Street, New York, ca. 1957.

Buchholz Gallery in New York organize a show of works by Degas,[73] which included the bronze *Seated Woman Wiping Her Left Side* (1896–1911, cat. no. 11).

In 1946, the Thannhausers moved to a larger home at 12 East Sixty-seventh Street, where Justin remained until 1971. While his ambition to open a gallery in the United States would never be realized, he continued to operate privately, and his life was hardly quiet. He traveled frequently to Europe, and continued to assist museums and galleries with exhibitions and acquisitions. The home on Sixty-seventh Street became a meeting place for cultural luminaries from around the world, with frequent soirees and evenings of musical entertainment. The guest books from these years are filled with the names of legends from the worlds of publishing, film, music, art, and international politics, including Leonard Bernstein, Louise Bourgeois, Henri Cartier-Bresson, Pablo Casals, Chester Dale, Marcel Duchamp, Vladimir Horowitz, Philip Johnson, Daniel-Henry Kahnweiler, Henry P. McIlheny, Dorothy Norman, Eugene Ormandy, Amédée Ozenfant, Anthony Quinn, Jean Renoir, John D. Rockefeller, Solomon Schocken, Rudolf Serkin, Arturo Toscanini, Hal Wallis, and many others.[74] Also among the visitors were Peter Lawson-Johnston, then President of the Solomon R. Guggenheim Foundation, and Thomas M. Messer, then Director of the Guggenheim Museum. It was through such visits and a rich correspondence that the seeds for the Thannhauser gift to the Guggenheim were sown.[75]

During his years in the United States, Justin also continued to collect art, acquiring Cézanne's *Still Life: Flask, Glass, and Jug* (ca. 1877, cat. no. 4) and Picasso's *Head of a Woman (Dora Maar)* (March 28, 1939, cat. no. 51) and *Two Doves with Wings Spread* (March 16–19, 1960, cat. no. 54), among other works. Shortly after the Thannhausers purchased the latter picture during a visit to Europe in September 1960, Kate passed away. Justin married Hilde two years later, and in honor of their marriage, Picasso presented them with the painting *Lobster and Cat* (January 11, 1965, cat. no. 55).[76]

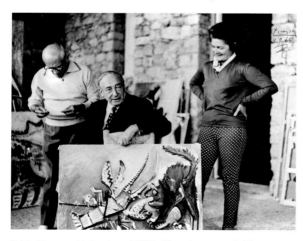

Pablo Picasso with Justin and Hilde Thannhauser, probably at Notre-Dame-de-Vie, Picasso's villa in Mougins, September 8, 1965, photographed by Jacqueline Picasso.

After years of pondering his options, Justin decided in 1963 to bequeath the essential works of his collection to the Guggenheim. It was not the first nor last time he made a gift to a museum; indeed, over the years he had given works to institutions around the world, and, as he later put it, "regretted only where the donations are not being shown."[77] But the bequest to the Guggenheim was different. The number of works and overall quality was unparalleled by any gift he had made or would make again. Moreover, the terms of the bequest

called for the works to be permanently installed in a designated space with tight restrictions on their loan, thus guaranteeing that they would be publicly accessible and would become a destination for visitors from around the world. The announcement of the gift, in October 1963, made the front page of *The New York Times* in an article that highlighted the collection's large number of works by Picasso.[78]

To house the Thannhauser gift, the Guggenheim converted space on the second floor of the Monitor building (the smaller building adjacent to the main rotunda) that had formerly been occupied by the library and administrative offices. When the renovations were completed, in April 1965, the galleries' walls were covered with red brocade, presumably to provide the works on view with a setting synonymous with their distinction as masterpieces, and visitors entered through an archway leading from the museum's rotunda. The critical reception was exactly what Justin and the museum had hoped it would be, one writer exclaiming, "Thannhauser's paintings fit so well into the museum's formerly limited collection that in one stroke they make the Guggenheim a showcase for modern art."[79]

In 1971, Justin and Hilde sold their home in New York and retired to Switzerland, setting up residence in Bern and spending their vacations at their mountain chalet in Gstaad or visiting friends throughout Europe. On May 7, 1972, on the occasion of Justin's eightieth birthday, a party was held for him at the Guggenheim Museum with a special concert given by his friend Rudolf Serkin. Moreover, the wing containing his bequest had been renovated and reinstalled, with the Monitor building's central light well exposed according to Frank Lloyd Wright's original design, the red brocade covering the walls removed in favor of ivory-colored paint, and improved lighting and partitions added. In 1973, Justin gave four masterpieces, including two Picassos, to the Kunstmuseum Bern, honoring the country that had been a safe haven for him throughout difficult points in his life.[80] Having lived to see his family name memorialized and collection celebrated, Justin died in Gstaad on December 26, 1976, at the age of eighty-four.

After Justin's death, Hilde continued the work he had begun and made additional gifts to institutions over the years. Through her efforts, in 1978, the same year that Justin's original gift vested to the Guggenheim, a memorial exhibition was held at the Kunstmuseum Bern, honoring him and his gifts to that institution, along with an additional four works given by Hilde on the occasion of the show, including Ernst Ludwig Kirchner's *Two Female Nudes* (1911).[81] In 1981, Braque's *Guitar, Glass, and Fruit Dish on Sideboard* (early 1919, cat. no. 2) was purchased by the Guggenheim with funds

Thannhauser Wing, Solomon R. Guggenheim Museum, 1965 (top) and 1972.

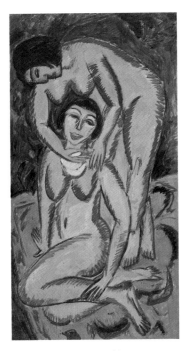

Ernst Ludwig Kirchner, *Two Female Nudes*, 1911. Oil on canvas, 150.5 x 75.5 cm (59 ¼ x 29 ¾ inches). Kunstmuseum Bern, Gift, Hilde Thannhauser, Bern.

made possible by an exchange with Hilde, which she followed up with a gift of two additional works in 1984, van Gogh's *Landscape with Snow* (late February 1888, cat. no. 61) and Picasso's *Still Life: Fruits and Pitcher* (January 22, 1939, cat. no. 50). At that time, Hilde also announced her intention to bequeath ten additional works to the Guggenheim upon her death. In recognition of the distinction and generosity that the Thannhausers' gifts had reflected upon the institution, the Monitor building was named for them in 1989.

On July 25, 1991, Hilde Thannhauser died in Bern. The ten works she bequeathed to the Guggenheim transferred ownership, and when the museum reopened in 1992 after a complete renovation of its Wright building, they were featured in the newly installed and restored Thannhauser galleries. Since that time, they have remained on view in rotation along with Justin's original bequest to the museum (the entire collection is never on view at one time). Though subject to the same restrictions on travel as the works given by Justin, over the years exceptions have been made, and they have joined distinguished exhibitions around the world devoted to artists and movements that were passionately supported by Justin. Otherwise, the Thannhausers' works reside permanently within the museum, a testimony to the spirit and desires of their benefactors. Representing a concentrated, powerful survey of Modernist works by Braque, Cézanne, Degas, Gauguin, Klee, Aristide Maillol, Manet, Matisse, Monet, Pascin, Picasso, Pissarro, Renoir, Toulouse-Lautrec, van Gogh, and Edouard Vuillard, the collection indeed fulfills Justin Thannhauser's wishes, expressed at the time he decided to donate his works, in 1963: "I feel strongly that these . . . pictures represent a unity you do not find in other museums. They cover 75 to 100 years and I see one coming from the other. I want to show them as a unity. . . . I hope it will be appreciated. It's my whole life."[82]

NOTES

Unless otherwise noted, all translations are my own.

1. Justin Thannhauser's gift was announced in October 1963, but the works were not placed on view at the Guggenheim Museum until 1965, when the Thannhauser Wing opened. They were on permanent loan until 1978, two years after Thannhauser's death, when they formally entered the museum's collection. Although there were one hundred works on view when the Thannhauser Wing opened, Justin's bequest contained seventy-four objects. The deed of gift lists seventy-five works, but that is because the two-panel *Place Vintimille* (1908–10, cat. no. 70) by Edouard Vuillard is counted as two separate objects. Since then, fourteen works have been deaccessioned, including twelve that were sold in May 1981 at a special sale held at Sotheby's New York. Three more works were acquired by the museum through Hilde Thannhauser, Justin's second wife, one in 1981 and two in 1984, with another ten works bequeathed in 1991 following her death. Thus the total number of works in the Thannhauser Collection now counts seventy-three. Of these, only seventy are considered in this catalogue; the three omitted works are Amedeo Modigliani's *Caryatid* (n.d.) and Honoré Daumier's *Chess Players* (n.d.), both of whose attributions have been called into question, and *Abstraction* (1945–49), a watercolor by Ida Fischer, who is too minor an artist to merit inclusion.

2. Justin Thannhauser, quoted in Richard F. Shepard, "Collector's Gift Reflects His Life," *The New York Times*, October 25, 1963.

3. There are some discrepancies about the opening date and name of the business, since few fully accurate records have survived. The opening of the gallery is generally given as 1904–05, which I have interpreted to mean opening late in 1904, perhaps December, with an exhibition that continued into 1905. The business was known as Moderne Kunsthandlung, but was also referred to as Brakl und Thannhauser in the press, so at some point the names may have been combined. After Heinrich Thannhauser left to start his own business in 1909, the gallery became known as Brakls Moderne Kunsthandlung. Further confusion was caused by Justin, who later listed the dates for the first Thannhauser gallery as 1906–28; he must have been including his father's association with Brakl within this time frame, albeit incorrectly. See Justin Thannhauser, notes to Guggenheim trustee Daniel Catton Rich, probably 1972, Solomon R. Guggenheim Museum Archive, New York (hereafter cited as Thannhauser, notes). These and other notes in the archive were written by Justin in an informal manner; some are handwritten and others are typescripts with handwritten corrections.

4. This information was culled from Karl-Heinz Meissner, "Der Handel mit Kunst im München," in Rupert Walser and Bernhard Wittenbrink, eds., *Ohne Auftrag: zur Geschichte des Kunsthandels, München* (Munich: Walser & Wittenbrink, 1989), p. 97, n. 81. I have found little else to flesh out Heinrich's biography.

5. Ibid.

6. Writing in the third person, Justin later recalled that his duties included: "Help in organisation of the Exhibitions his father Heinrich undertook in the Munich Galleries. . . . Assistance in such shows since 1909." See Justin Thannhauser, notes.

7. G[eorg] J[acob] W[olf], "Kunst," *München Augsburger Abendzeitung*, November 8, 1909, unpaginated.

8. Rudolf Meyer-Riefstahl, introduction to *Impressionisten-Austellung*, exh. cat. (Munich: Moderne Galerie, 1909), unpaginated.

9. U.–B., "München," *Der Cicerone*, no. 22 (1909), pp. 706–07.

10. F., "München," *Der Cicerone*, no. 1 (1910), p. 30.

11. The catalogue carries entries for works numbered one through thirty-six, but there is no number seven. There were twenty-three oil paintings, ten pastels, and two watercolors in the exhibition. See *Edouard Manet (aus der Sammlung Pellerin)*, exh. cat. (Munich: Moderne Galerie, 1910).

12. Georg Jacob Wolf, in ibid., unpaginated.

13. M. K. R[ohe], "München," *Der Cicerone*, no. 20 (1910), p. 280.

14. Thannhauser, notes.

15. Arnhold owned many of Manet's great works at the time. *Bar at the Folies-Bergère* would reenter the Thannhauser inventory around fourteen years later, appearing regularly in the gallery's sales catalogues until it was eventually sold to Samuel Courtauld in London; it is now in the collection of the Courtauld Institute of Art, London. For more on the work's provenance, see Françoise Cachin and Charles S. Moffett, *Manet 1832–1883*, exh. cat. (New York: Metropolitan Museum of Art, 1983), p. 482.

16. M. K. R[ohe], "München," *Der Cicerone*, no. 41 (1910), p. 565.

17. M. K. Rohe, quoted in Andreas Hüneke, ed., *Der Blaue Reiter: Dokumentation einer geistigen Bewegung* (Leipzig: P. Reclam, 1986), p. 29.

18. Vasily Kandinsky, quoted in translation in Kandinsky and Franz Marc, eds., *The Blue Rider Almanac*, ed. Klaus Lankheit (London: Thames & Hudson, 1974), p. 12.

Justin Thannhauser at his eightieth-birthday celebration, Solomon R. Guggenheim Museum, May 7, 1972.

19. M. K. Rohe, "München," *Der Cicerone*, no. 59 (1910), p. 819.

20. U.–B, "München," *Kunst und Künstler* 9, no. 4 (1911), p. 205.

21. M. K. Rohe, "München," *Der Cicerone*, no. 59 (1910), p. 819.

22. Thannhauser, notes.

23. Paul Klee, *The Diaries of Paul Klee 1898–1918*, ed. Felix Klee (Berkeley and Los Angeles: University of California Press, 1964), pp. 256–58.

24. Goltz was originally a book dealer who worked with another Munich dealer, Ulrich Putze. When Putze died in 1910, Goltz took over the business, Ulrich Putze Nachfolger Hans Goltz, and renamed the gallery Neue Kunst Hans Goltz. Over the years, particularly after World War I, he handled the work of Lothar Bechstein, Lyonel Feininger, George Grosz, Erich Heckel, Klee, Hans Richter, Georg Schrimpf, and other important Expressionists. For more on Goltz's activities, see Meissner, "Der Handel mit Kunst im München," pp. 59–67.

25. With regard to this van Gogh exhibition, Justin continued, "Sale of Arlesienne to Carl Sternheim, 13,000 Mark. He resold it—before the first World war to Mrs. Von Goldschmidt-Rothschild for many times this amount." See Thannhauser, notes.

26. According to various records, Heinrich was responsible for introducing Marc and Kandinsky. Justin later mentioned "whole correspondence from Marc, urging Heinrich to bring him together with Kandinsky—with all his reasons—and after H. T. [Heinrich Thannhauser] had responded and brought them together at his Gallery, letter of profuse thanks by Marc, with numerous highly interesting details"; see Thannhauser, notes. This correspondence is among the materials confiscated by the Nazis in the 1940s and presumed destroyed. Kandinsky stated that he and Marc met as a result of the outrage over the NKVM exhibition in 1910: "[Heinrich] Thannhauser showed us a letter from an unknown Munich painter, who congratulated us on the exhibition and expressed his enthusiasm in eloquent words. This painter was a 'real Bavarian' named Franz Marc"; quoted in Klaus Lankheit, *Franz Marc im Urteilseiner Zeit* (Cologne: Verlag M. Dumont-Schauberg, 1960), p. 46.

27. For more on Delaunay's connections with Germany, see Peter-Klaus Schuster, *Delaunay und Deutschland*, exh. cat. (Munich: Haus der Kunst, 1985), and Matthew Drutt, "Simultaneous Expressions: Robert Delaunay's Early Series," in *Visions of Paris: Robert Delaunay's Early Series*, exh. cat., with an introduction by Mark Rosenthal (New York: Solomon R. Guggenheim Museum, 1998), pp. 24–42.

28. Thannhauser, notes.

29. The drawing was given to Justin as a gift and remained in his possession until he died in 1976; his widow, Hilde Thannhauser, bequeathed it to the Guggenheim in 1991.

30. Thannhauser, notes.

31. Ibid.

32. In his notes in the Solomon R. Guggenheim Museum Archive, Justin claimed that he lent twenty-eight works, but the New York edition of the catalogue lists only eight works as having been lent by him: no. 194, Julius Seyler's *Nordischer Fischerhafen*; no. 238, Charles Camoin's *Moulin Rouge*; no. 243, Julius Hess's *Dame mit gruenem Schirm*; no. 259, Ferdinand Hodler's *Die heilige Stunde (fragment)*; no. 368, Henri Doucet's *Palermo*; no. 400, Max Slevogt's *Weinberg-Arbeiter*; no. 461, Max Mayershofer's *Rennreiter*; and no. 486, an untitled work by Albert Weisgerber (dates are not cited in the exhibition catalogue). See *International Exhibition of Modern Art*, exh. cat. (New York: Association of Painters and Sculptors, 1913). Justin may have been thinking about other pictures in the exhibition that eventually belonged to him, such as van Gogh's *Mountains at Saint-Rémy* (July 1889, which was listed as no. 424, *Collines à Arles*) and Camille Pissarro's *The Hermitage at Pontoise* (ca. 1867, listed as no. 499, *Pontoise*). At any rate, there were far more than the three originally cited by Vivian Endicott Barnett in *Guggenheim Museum: Thannhauser Collection* (New York: Guggenheim Museum, 1992), p. 16.

33. Thannhauser, notes.

34. Justin Thannhauser, introduction to *Pablo Picasso*, exh. cat. (Munich: Moderne Galerie Heinrich Thannhauser, 1913), unpaginated.

35. Most sources give 1918 as Justin's return date, but a brochure distributed by the Silva-Casa Foundation, Bern (dated August 14, 1996/ February 22, 2000), includes a history of the Thannhauser family that lists it as 1916. (After Hilde Thannhauser's death in 1991, the Silva-Casa Foundation was set up as a philanthropy in accordance with her wishes.) In conversation with the author in September 2000, Max Ludwig confirmed the 1916 date; Ludwig, a legal advisor to Justin and Hilde beginning in 1971, is a member of the Silva-Casa Foundation's council and executor of the Thannhauser Estate.

36. Wilhelm Hausenstein, introduction to *Katalog der Modernen Galerie Heinrich Thannhauser München* (Munich: Moderne Galerie Heinrich Thannhauser, 1916), p. VII.

37. See announcement in "Handel and Verkehr," *Luzerner Tagblatt*, September 12, 1928, p. 4. However, see *Henri Matisse*, exh. cat. (Berlin: Galerien Thannhauser, 1930), p. 3, where Lucerne is still listed as part of the Thannhauser network. The Lucerne gallery continues to operate today under the name Angela Rosengart.

38. Mario-Andreas von Lüttichau, "Die Moderne Galerie Heinrich Thannhauser in München," in Henrike Junge, ed., *Avantgarde und Publikum: Zur Rezeption avantgardistischer Kunst in Deutschland 1905–1933* (Cologne: Bohlau, 1992), p. 305. However, the source for this information is undocumented; although an endnote number appears in the text, the corresponding note is omitted. Thus, the information must be treated with caution.

39. E. W. Kornfeld made this incorrect assertion in Kornfeld, "Die Galerie Thannhauser und Justin K. Thannhauser als Sammler," in *Sammlung Justin Thannhauser*, exh. cat. (Bern: Kunstmuseum Bern, 1978), p. 13.

40. Justin Thannhauser, preface to *Pablo Ruiz Picasso*, exh. cat. (Munich: Moderne Galerie/Thannhauser, 1922), p. 3.

41. Ibid., p. 6.

42. The dating for this show is based on research done on behalf of the Guggenheim by Morris and Pearl Appelman in the mid-1970s. However, a fair amount of the information offered by them about the Thannhausers' exhibition history is incorrect. Thus, the date for this show must be substantiated by the catalogue, which I have yet to locate. Justin's notes in the Solomon R. Guggenheim Museum Archive indicate only that a large show of contemporary American artists took place in the 1920s and that it was accompanied by an illustrated catalogue, but he could not remember the names of the artists shown. The Appelman research is contained in the Guggenheim archive.

43. Another Degas exhibition, in 1923, is cited in Walser and Wittenbrink, eds., *Ohne Auftrag: zur Geschichte des Kunsthandels, München*, p. 260. While the documentation in this book is comprehensive, there are occasional errors and omissions, especially in the exhibition histories, so the data must be treated with caution. I have not been able to substantiate whether this second exhibition ever took place.

44. For a concise summary of these circumstances, see Vivian Endicott Barnett, text on *Dancer Moving Forward, Arms Raised*, in *Guggenheim Museum: Thannhauser Collection*, p. 111.

45. See *Edgar Degas Pastelle/Zeichnungen, das plastische Werk*, exh. cat. (Munich: Galerien Thannhauser, 1926).

46. Among the major paintings shown in the Dix exhibition were *The Match Vendor* (1920, Staatsgalerie Stuttgart), *Portrait of the Artist's Parents* (1924, Niedersächsisches Landesmuseum Hanover), and his eerie *Self-Portrait* (1926, Leopold-Hoesch-Museum, Düren). An unusually insightful review of the exhibition was published at the time: Curt Glaser, "Otto Dix," *Kunst und Künstler* 25, no. 1 (1926–27), pp. 130–34.

47. Julius Meier-Graefe, "Die Franzosen in Berlin," *Der Cicerone* 25, no. 2 (1927), p. 43.

48. Roger Fry, foreword to *Multinationale Austellung*, exh. cat. (Munich: Galerien Thannhauser, 1928), unpaginated.

49. *Claude Monet 1840–1926: Gedächtnis-Ausstellung*, exh. cat. (Berlin: Galerien Thannhauser, 1928), p. 4.

50. Thannhauser, notes.

51. Justin paid $5,500 to Wildenstein & Co., New York. See sales receipt, dated February 15, 1928, Silva-Casa Foundation.

52. Karl Scheffler, "Monet: Zur Ausstellung in der Galerie Thannhauser," *Kunst und Künstler* 26, no. 2 (1928), pp. 267–68.

53. Barth was the organizer of a Gauguin exhibition that was shown at the Kunsthalle Basel from July to August the same year. Since there is considerable overlap between the two checklists, it is unclear whether the Thannhauser exhibition was part of this project or an independently organized showing, though in his introduction in the Thannhauser catalogue, Barth constantly referred to the project as *"unser Ausstellung"* (our exhibition); see *Paul Gauguin 1848–1903*, exh. cat. (Berlin: Galerien Thannhauser, 1928), pp. 3–5.

54. [Justin Thannhauser], in ibid., p. 7.

55. Thannhauser, notes.

56. F. T. D., "Thannhauser Shows Matisse," *The Art News*, March 8, 1930, p. 6.

57. In a few notes and pieces of correspondence in the Solomon R. Guggenheim Museum Archive, Justin stated that the galleries in Berlin and Lucerne closed in 1937, but press accounts differ, some dating his departure for France as early as 1933. Barnett, *Guggenheim Museum: Thannhauser Collection*, p. 17, offers the 1937 date, presumably based on the sources in the Guggenheim archive. However, the date is given as 1936 in Kornfeld, "Die Galerie Thannhauser und Justin K. Thannhauser als Sammler," p. 16, and Meissner, "Der Handel mit Kunst im München," p. 54 and p. 99, n. 98. Meissner based his dating on Nazi decrees forbidding Jews from owning or operating businesses. In conversation

with the author in September 2000, Max Ludwig clarified the discrepancies as follows. Justin had a small apartment in Paris, which he used as an address for exporting works from Germany and as a toehold in France. The exact date for when he began to rent his house in Paris, at 35, rue de Miromesnil, is unknown, but it is known that he moved there in April 1937. Galerie Thannhauser in Lucerne was legally operated by Justin until 1928 when Siegfried Rosengart assumed control.

58. Justin Thannhauser to Daniel Catton Rich, March 8, 1974, Solomon R. Guggenheim Museum Archive.

59. Ibid.

60. Kornfeld, "Die Galerie Thannhauser und Justin K. Thannhauser als Sammler," p. 16. Meissner, "Der Handel mit Kunst im München," p. 98, n. 98, does not mention this apartment, but has Justin already installed in his town house at 35, rue de Miromesnil in 1933, where in fact he did not reside until 1937.

61. Kornfeld, "Die Galerie Thannhauser und Justin K. Thannhauser als Sammler," p. 16.

62. See *Picasso*, exh. cat. (Buenos Aires: Galeria Mueller, 1934).

63. The distinction between inventory and collection is important as works in the inventory were for sale and not really considered part of the private collection, but it is often difficult to determine the status of particular works. This is easier to discern for the works that survived, since there tend to be records for many of them indicating their status, than for those that did not.

64. See "Bequests: Redressing a Spiral Showcase," *Time*, May 7, 1965, p. 86.

65. Justin Thannhauser to Pablo Picasso, postcard, July 18, 1939, Dossier Thannhauser, Musée Picasso, Paris.

66. Several pictures and documents that had been in a safe of the Bank Rothschild in Paris were eventually returned to Justin. See Kornfeld, "Die Galerie Thannhauser und Justin K. Thannhauser als Sammler," p. 16.

67. The exhibition, *La pintura francesa de David a nuestros días*, was shown at the Museo Nacional de Bellas Artes, Buenos Aires, July–August 1939, and then traveled to the Ministerio de Instrucción Pública, Montevideo, April–May 1940, and the Museu Nacional de Belas Artes, Rio de Janeiro, June 29–August 15. Among Justin's paintings shipped to Buenos Aires for the exhibition were Gauguin's *Haere Mai* (1891), Monet's *The Palazzo Ducale Seen from San Giorgio Maggiore* (1908), Pissarro's *The Hermitage at Pontoise* (ca. 1867), and Renoir's

Woman with Parrot (1871), all of which are now in the Guggenheim's Thannhauser Collection (cat. nos. 14, 22, 56, and 57, respectively.

68. Justin Thannhauser to Pablo Picasso, postcard, September 27, 1944, Dossier Thannhauser.

69. See Justin Thannhauser to Pablo Picasso, postcard, October 9, 1944, Dossier Thannhauser.

70. See *Modern and Other French Paintings, Drawings, Prints, Bronzes, Property of J. K. Thannhauser, New York* (New York: Parke-Bernet Galleries, 1945).

71. Justin Thannhauser to Parke-Bernet Galleries, Inc., February 15, 1945, ibid., reproduced as frontispiece. In this letter, Justin explained the reasons for his dispersal of the pictures.

72. Ibid.

73. See *Edgar Degas: Bronzes, Drawings, Pastels*, exh. cat. (New York: Buchholz Gallery, 1945).

74. These guest books are in the collection of the Silva-Casa Foundation. There is also an entry in one of the books recording a visit by Diane Waldman, former Senior Curator at the Guggenheim, who visited Justin in the 1960s as a graduate student at New York University along with fellow student Marcia Tucker, former director of the New Museum of Contemporary Art.

75. The correspondence between Messer and Justin Thannhauser is contained in the Thomas Messer Papers, Solomon R. Guggenheim Museum Archive.

76. Justin always noted that Picasso presented *Le Homard et le chat* as a wedding gift, and further, in the letter in which he transferred ownership of the painting to Hilde, he wrote that the painting was a gift to both of them; the letter, dated February 25, 1967, is in the Solomon R. Guggenheim Museum Archive. (Justin made such gifts to Hilde on an annual basis, presumably to avoid estate or inheritance taxes after his death.) Yet in a letter to Justin dated September 6, 1965, Picasso wrote, "I have given my painting 'Homard et chat' to my friend, Justin K. Thannhauser, in appreciation of our old friendship and of his assistance in the acquisition of my painting by the Munich museums." This suggests that the painting may have been given to Justin in lieu of a monetary commission. The letter is in the collection of the Silva-Casa Foundation.

77. Thannhauser, notes.

78. John Canaday, "Guggenheim Gets Major Artworks," *The New York Times*, October 24, 1963, pp. 1, 30.

79. "Bequests: Redressing a Spiral Showcase," p. 86. See also François Daulte, "Une Donation sans

24

Précédent: La Collection Thannhauser," *Connaissance des Arts*, May 1965, pp. 58–69.

80. See *Sammlung Justin Thannhauser*, exh. cat. (Bern: Kunstmuseum Bern, 1978), pp. 8, 19–28. Justin gave the following four works to the Kunstmuseum Bern in 1973: Edgar Degas, *Landscape and Horses* (ca. 1858); Vincent van Gogh, *Tête de Paysanne* (1885); and Pablo Picasso, *Dans la Loge* (1921) and *La Famille* (1923). Additional works were placed on extended loan.

81. See ibid. In addition to the Kirchner, Hilde gave the following three works to the Kunstmuseum Bern in 1978: Pablo Picasso, *Femme assise, les mains croisées* (1922); Pierre Auguste Renoir, *Femme nue accoudée* (ca. 1884–85); and Henri Toulouse-Lautrec, *Mme Misia Natanson* (1897). Five additional works were donated to the Kunstmuseum Bern following Hilde's death in 1991: Paul Cézanne, *Chatea de Marines* (1888–90); Max Liebermann, *Portrait of Heinrich Thannhauser* (1916); Pablo Picasso, *Femme assise en bleu et rose* (1923) and *Menerbes* (1946); and Louis Valtat, *Louis Valtat et son fils* (1909). These gifts were made with the advice of Max Ludwig.

82. Shepard, "Collector's Gift Reflects His Life."

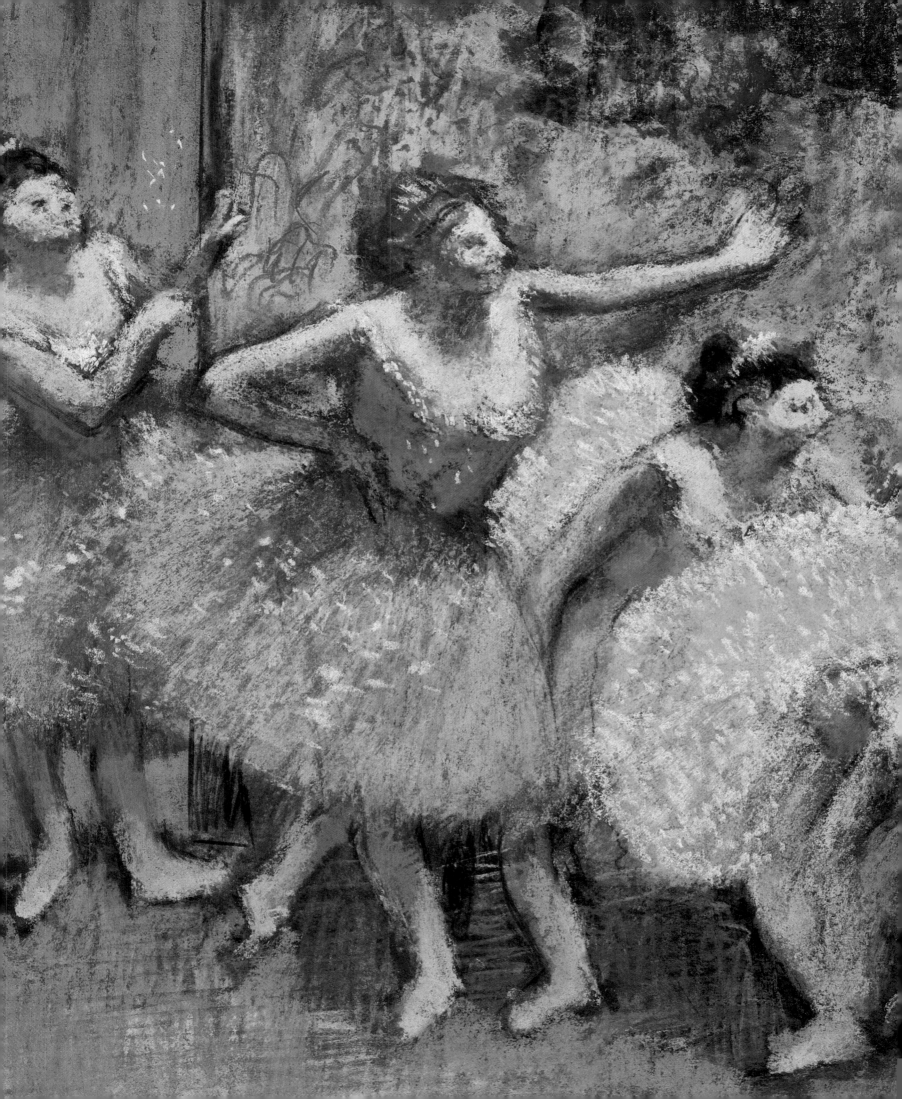

THE MAKINGS AND REMAKINGS OF
MODERNIST ART IN FRANCE, 1860–1900

Paul Tucker

IN 1926, BY WHICH TIME Justin K. Thannhauser had acquired Edgar Degas's *Dancers in Green and Yellow* (ca. 1903, cat. no. 12), one of the first works by a Modern French artist of the late nineteenth century to enter his collection, he never could have envisioned the status that Degas and his contemporaries would achieve over the course of the twentieth century. No one could have predicted it. Yet today, this art, popularly known as Impressionism and Post-Impressionism, has captured the imagination of a public that spans the globe.

The ironies of this abound. First and foremost, the heralded position that these French movements have come to enjoy is not only different from their status during Thannhauser's early years as a collector; it is far from what they were awarded at the outset. Indeed, the very paintings that are now revered as icons of the West's artistic patrimony—such as Degas's brilliant pastel or the many other late-nineteenth- and early-twentieth-century masterpieces in the Guggenheim Museum's Thannhauser Collection—were frequently the victims of public satire and outright condemnation when they were initially exhibited. The tales of the vituperative reactions to the first Impressionist exhibition held in Paris in 1874, for example, are almost legendary, as are those concerning Vincent van Gogh's plight, particularly his inability to sell more than one or two paintings to the public during the course of his short and tragic life. All of these now-celebrated artists experienced economic hardship at certain points in their careers. Some, like Camille Pissarro, were forced to sell paintings for as little as fifty francs—several hundred dollars in today's currency—a paltry sum considering the fortunes Impressionist paintings have come to command. What is also ironic is that this art was intended by its makers to be controversial if not actually adversarial, which is one of the reasons it provoked such negative responses when it first appeared. Now it is accepted as the norm and endowed with special privileges. No other movement in the history of art can claim such a shift in status and none can assert such evident power.[1]

Why this reversal occurred is not easy to explain. It probably has something to do with the way time softens the impact of the unfamiliar. It is also related to

FACING PAGE:
Detail of Edgar Degas, *Dancers in Green and Yellow*, ca. 1903 (cat. no. 12).

27

developments in the history of art subsequent to the Impressionists' revolution, specifically to the even more forceful assault artists waged on traditions and public taste from the first decade of the twentieth century onward. This attack, initially mounted by Fauve and Cubist artists and pursued by a succession of Modern movements that lead up to those of our own day, resulted in works that made Impressionist and Post-Impressionist art look increasingly attractive. The broken brushwork and heightened color of Claude Monet and his contemporaries, for example, may have upset conservative viewers in the 1860s and 1870s, but those formal departures from accepted practice were tame in comparison to what Henri Matisse and his fellow Fauves inflicted upon their public in 1905 and thereafter. Similarly, the flattened forms and "primitive," often non-Western subjects of Paul Gauguin and his followers, so radical for the 1880s and 1890s, were soon regarded as far more palatable than what Pablo Picasso and the Cubists or Piet Mondrian and other abstract artists served up two and three decades later.

The change in status of late-nineteenth- and early-twentieth-century French painting also has something to do with national economies and shifting world relations. It is not coincidental, for example, that Americans began actively collecting Impressionist art in the 1890s, a time when they started to dominate international trade and enjoy enormous prosperity, just as it is no surprise that Arab collectors became important figures in the market in the 1970s, when oil became so precious, or that Japanese buyers assumed a significant position in the 1980s, when their economy was one of the strongest in the world. The Americans who initiated this interest found a variety of attractive values in Impressionist and Post-Impressionist art—boldness, brashness, novelty, and conviction—all of which seemed to coincide with those held dear in "the land of the Yankees," as Monet referred to the United States in the 1880s.[2] Americans had also been nurtured from the 1850s onward on Barbizon art and were prepared to graduate to the next level of Modernist production by the end of the century, especially when the story of the Impressionists' struggles so paralleled their own as laissez-faire capitalists competing against established monopolies. In addition, they held in high esteem France's ability to maintain her position at the forefront of world culture and coveted that leading role for themselves and their country. They soon staked their claims to it by amassing impressive collections of Western art and building museums across the nation to house them. Once Americans focused their attention on these prizes, particularly Impressionist and Post-Impressionist painting and sculpture, collectors from around the world followed suit.

All of this came at the expense of the nation that had been the home to these late-nineteenth-century artists, France. Today, French visitors to museums outside their country, especially museums in America, often feel a sense of loss when they see

Impressionist and Post-Impressionist art hanging so far from its place of origin, as if part of the country's patrimony had been sacrificed. Traditionally, it has been said that this was the fault of Parisian collectors and museum curators who were so appalled at what these Modern artists were producing in the last forty years of the nineteenth century that they obscured its merits, to the detriment of future generations. There is much evidence to support this contention; one need only glance at the press of the period and note the barrage of negative reactions to Impressionist and Post-Impressionist exhibitions. Indeed, the critical acclaim of people interested in the arts at the time was bestowed on the technically proficient but often rather unadventurous work produced by mainstream academic artists who exhibited at the annual Salon in Paris and who for the most part are now all but forgotten. Some of these artists were cultural standard-bearers of their day, such as Albert Besnard, Jean-Léon Gérôme, Ernest Meissonier, and Henri Regnault, and most commanded huge sums for their work.

It is therefore not surprising that the story of late-nineteenth-century French art has usually been written along the lines of this broad division between the Impressionist/Post-Impressionist avant-garde and the academic artists and their supportive public. There are several problems with this story, however, not the least of which is its simplistic analysis, reducing a complex interplay of forces to the age-old struggle of the "good guys" of the avant-garde against the "bad guys" of the entrenched system. In the 1970s, the tale was opened up and revised slightly by a reconsideration of the so-called Salon artists, who produced what the public in the nineteenth century had so warmly welcomed. The emphasis shifted from the combat of fringe groups against the mainstream to a more nuanced appreciation of what these more conservative artists and their followers had both defended and achieved. It also entailed a deeper awareness that the Impressionists and Post-Impressionists had actually been dealing with some of the same formal issues that they had been said to have scorned and forsaken and that their academic contemporaries had so ardently advocated. All of a sudden, the bad guys did not seem as bad, and the good guys, while still the victors, were not as shining in their success as they once had been; nor were they as removed from what other less-heralded artists of the time could now be said to have accomplished. More recently, the story has been made even richer and more complex by considerations of the context in which the Impressionist and Post-Impressionist works were produced, bringing to bear social and political issues that once seemed alien to the world of the arts but which actually reveal the multiple levels on which these cultural expressions operate. The expansion of the story has also been greatly aided by scholarly inquiries into questions about gender and psychology, and science and biography, which in the last few decades have likewise yielded pertinent results.

Another problem with the tale is that these avant-garde artists were not as uniformly rejected by their countrymen and women as we have been led to believe. Otherwise, they truly would have starved or taken up other jobs, which they did not. Although they experienced real difficulties, particularly the Impressionists in the 1860s, they were able to survive by selling their paintings (in van Gogh's case, only to his saintly dealer-brother Theo). By the early 1870s, however, the thirty-year-old Monet, for example, was making more than 10,000 francs a year, which exceeded what doctors and lawyers earned in Paris. By the 1890s, that had increased twentyfold to 200,000 francs, a sum that allowed him to live extremely well on his Giverny estate. Pierre Auguste Renoir was nearly as successful by then, receiving a commission from the French government in 1891 and buying his house in Essoyes in 1897 for an impressive sum while maintaining an apartment and two studios in Paris. In addition, the influence of Impressionism as a style was so prevalent by the middle of the 1890s that there were those who believed it had become something of a national style, a point underscored at the end of the decade by Monet's elevation to the status of one of the country's great national artists and Renoir's nomination to chevalier in the French Legion of Honor. Thus, while based in part on certain verifiable instances, the notion of the Impressionists' lifelong plight is largely the creation of twentieth-century observers who wanted to assert the superiority of their tastes over those of their predecessors.

A final problem with this tale is the implication that the Impressionists and Post-Impressionists were two solidly united groups of artists who steadfastly maintained their cohesiveness in order to preserve their avant-garde identity, articulate their commitment to controversial principles, buoy their spirits, and defray the cost of mounting group shows. This too is only partly true. Aside from agreeing to practical matters related to their joint exhibitions, the Impressionists and Post-Impressionists were not stalwart bands of inseparable rebels. Each of these groups was a diverse collection of distinctive individuals whose interests, strengths, and opinions were as varied as their biographies, oeuvres, and legacies. Some, such as Pissarro, were strong family men; others, like Gauguin, ardent male chauvinists. Some, such as Paul Cézanne, enjoyed independent means and did not exhibit on a regular basis. Others, such as Monet, were deft marketers of their own work. Some were interested in plein-air painting, others in creating works from memory in the quiet of their studios. They also did not always get along. Monet and Pissarro, for example, had a painful falling-out in the mid-1880s that lasted until the early 1890s. Neither of them liked Gauguin's work and both at various times made every effort to avoid contact with Renoir. Degas developed a profound disdain for Pissarro, had few good things to say about Monet's series paintings of the 1890s, and could not stomach Renoir's work after 1880. Edouard

Manet had reservations about Renoir's achievements prior to 1880, just as he had about the independent exhibitions that the Impressionists mounted beginning in 1874. Indeed, he refused to participate in any of their shows, preferring instead to follow the more traditional route of negotiating his work into the annual Salon.

If the cohesiveness of these groups is a problem with this story, so too is pinning down an accurate definition of "Impressionist" or "Post-Impressionist," as Manet's lack of cooperation suggests. Clearly, he did not want to be listed on anyone's roster as one of the former, although his innovations of the 1860s were essential to the group's orientation; and his work of the 1870s was strongly influenced by the Impressionists' heightened color and leisure subjects, which is why he was placed in their camp during his own lifetime. Even the terms "Impressionist" and "Impressionism" are problematic. They are often said to have been derived from Monet's painting *Impression, Sunrise* (1872, Musée Marmottan, Paris) which a critic lambasted in a review of the first Impressionist exhibition in 1874 in which the canvas appeared. This explanation is not entirely true, as the term "Impression" had been in use long before that show. In addition, the show itself was not called the First Impressionist Exhibition but rather the first exhibition presented by a "Société Anonyme des artistes, peintres, sculpteurs, graveurs, etc.," suggesting the organizers' much more neutral stance. In fact, we know there was little interest on the part of any of the original participants to be called "Impressionists" in 1874 and that it was not until two years later, during their second exhibition, that they employed the name—although not for the catalogue or the announcements for the show, a restraint they followed for all eight of their gatherings and accompanying publications. The catalogues of those shows also reveal that the people we now consider to be the essential Impressionists (which would include Gustave Caillebotte, Degas, Monet, Berthe Morisot, Pissarro, Renoir, and Alfred Sisley) did not participate in all eight of the independent exhibitions; indeed, only Pissarro could claim that honor. Degas joined in seven, as did Morisot; but Caillebotte and Monet showed in only five, while Renoir and Sisley participated in just four. Those shows themselves are also unfaithful guides to a definition of the group because they included dozens of artists who had little to do with the novel strategies of the core members and who had been invited to participate because they were friends of certain Impressionists or because they were useful to the group's cause—people such as the Léopold Levert, Ottins, Henri Rouart, Charles Tillot, and Victor Vignon, among the many who have long fallen into obscurity.

The designation "Post-Impressionist" is even more perplexing, primarily because it is so amorphous. Today it is generally understood to refer to the four major figures in French art who succeeded the Impressionists—Cézanne, Gauguin, Georges Seurat, and van Gogh—but these four artists and their followers could hardly be considered a

homogeneous group. Besides being widely different in terms of styles and aesthetics, they never exhibited together and had little to do with each other (except for the brief and ill-fated association between Gauguin and van Gogh in the South of France, which was riddled with argument and which ended with Gauguin's hasty departure and van Gogh's infamous severing of his earlobe). In addition, the term was never used by any of the artists who now fall under its banner, and indeed was never even employed during any of their lifetimes. It entered the lexicon only in 1910, when renowned early twentieth-century English critic Roger Fry organized an exhibition that included their work and called them "Post-Impressionists" rather than "Expressionists" or "Synthetists" because it was less specific. Unfortunately, it stuck.

Where does all of this leave us? It should be evident that what had appeared to be relatively accessible art produced by clearly defined groups of uniform practitioners, operating with simple agendas under straightforward circumstances, turns out to be something quite the opposite. We are dealing instead with highly individualistic, multileveled cultural productions that are replete with ironies and inconsistencies, the former suggesting significant trends or idiosyncrasies, the latter revealing almost unresolvable problems. Thus, we should be cautious when approaching the history of late-nineteenth- and early-twentieth-century French painting and sculpture as so richly represented by the Thannhauser Collection. It is not necessarily what it seems to be.

Nowhere is this clearer than when considering the ways those works generally seduce their audience—with brilliant color, bold brushwork, and enviable moments in time seemingly snipped haphazardly from a broad array of contemporary events, mostly involved with the pursuit of pleasure. As we look at the paintings, these formal factors often coalesce to suggest that the works are the product of naive, though highly sensitive, artists operating in uncomplicated worlds in which freedom and experience are cherished and beauty and harmony reign. Understood as such, it is little wonder that these works are some of the most popular of our time; they are the perfect antidote to the complexities and contradictions that our increasingly dislocated age has experienced. Yet here too there is more than what meets the eye. First, these paintings are not spontaneous. Instead, they are carefully planned and artfully executed; they merely create the illusion of the momentary to make us believe that they are products of pure inspiration during single working sessions, even though usually nothing could be further from the truth. These paintings also depict subjects that are a part of a time that seems quite removed from our own. But those subjects too were carefully chosen for the meanings they carried and the ways they revealed the artist's attitudes about art and life. In addition, they are not so removed from realities we know all too well, for more often than not they suggest a world that was fractured and groping like our own,

a world that was filled with confidence but that was equally fragile and constantly haunted by doubt. Thus, the harmony these artists appear to achieve spontaneously was actually wrought from struggle, just as the beauty they suggest was selective and the bliss they propagate fugitive.

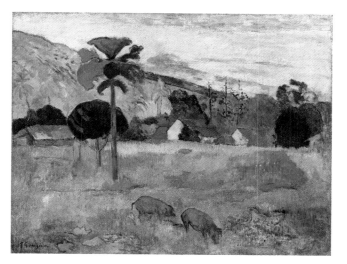

Paul Gauguin, *Haere Mai*, 1891 (cat. no. 14).

What is most striking, perhaps, is that many of these subjects hardly seem to have merited being elevated into art in the first place—the group of gawking and unceremoniously posed ballerinas behind the stage curtain in Degas's pastel, for example, or the substantial, semidressed woman adjusting her bodice in Manet's *Before the Mirror* (1876, cat. no. 17), or the relatively undistinguished woman feeding a parrot in Renoir's *Woman with Parrot* (1871, cat. no. 57). What could be less appropriate for aesthetic wonder or edification than the swine in Gauguin's *Haere Mai* (1891, cat. no. 14) or less interesting than van Gogh's *Roadway with Underpass* (1887, cat. no. 60), a view of an unassuming tunnel under a roadway we do not see in the middle of an unprepossessing place? Yet all of these subjects, together with those depicted in the other superb paintings in the Thannhauser Collection, tell us much about the artists who painted them and the worlds from which they were drawn. And it is to those works and their stories that we can now turn.

ADVANCED ARTISTS OF THE LATE NINETEENTH and early twentieth centuries, for all of their diversity and contentiousness, their contradictions and compromises, as well as their frequent attempts to manipulate their own histories, concentrated above all on producing works that would appeal to a public whose thinking about art was as advanced as their own and that would be considered modern by contemporary standards or by any that might follow. What "advanced" and "modern" actually meant varied from artist to artist and from decade to decade, just as the standards that would be used to judge the works they produced changed over time. But for those artists who were born in the 1830s and 1840s and who would enter the ranks of what we now refer to as the avant-garde—artists such as Degas, Manet, Pissarro, and Renoir, all well represented in the Thannhauser Collection—one clarion call dominated the others. And that was the era's imperative, "Il faut être de son temps" (It is necessary to be of one's time). Uttered by Romantic artists and writers earlier in the century, this demand became the rallying cry of the so-called Realist painters and sculptors of the 1840s and 1850s, the predecessors to Manet and his cohorts.[3] It was they who enthusiastically turned to quotidian events as subject matter and produced an outpouring of works that depicted peasants, farm animals, shopkeepers and factory workers, middle- and lower-class urban

dwellers engaged in daily activities, tavern scenes, church ceremonies, small-town festivals, and sympathetic views of rural menial labor. Realists who were historically inclined and fortunate enough to receive commissions from the state turned out paintings of contemporary events that government ministers deemed sufficiently important to immortalize: Napoleon III's conquests on the battlefields, the emperor's visits to sites around the country (often to aid victims of natural disasters), state occasions, even the pope blessing a railroad. With the exception perhaps of Gustave Courbet, all of these artists followed the prescribed aesthetic decorum for painting by consistently favoring relatively smooth surfaces, clearly rendered forms, restrained color, and balanced compositions. Their concentration on lowly aspects of contemporary life came at the expense of subjects that had traditionally preoccupied artists who aspired to the heights of their profession—historical events drawn from the past, religious scenes taken from the Bible, mythological stories based on the classics, or literary subjects derived from the accepted canon of eminent Western authors. These subjects had been at the top of the Academy's hierarchy over a period of centuries for obvious reasons: they were thought to represent the most significant moments or ideas in history and thus were the very foundations on which civilization stood. Paintings of everyday life were deemed trivial and thus occupied the lowest rung of the Academy's order. But beginning with the French Revolution of 1789, when it was felt that art should speak more directly to its public, that hierarchy came under fierce attack. By the middle of the nineteenth century, it had essentially been leveled.

Claiming the everyday to be equal to the greatest achievements of human history had grave implications in France, where art had long been accorded an important role in the life of the nation. Considered to be one of the most refined products of the human spirit, art carried a heavy responsibility as the very embodiment of everything the nation cherished. Not surprisingly, therefore, the upending of the country's time-honored traditions by the Realists did not meet with universal approval. Many observers and practicing artists bemoaned the turn of events and pleaded against "that deplorable tendency to put art at the service of fashion or the caprices of the day." But they were often seen to be unnecessarily worried or overly conservative. Even the minister of state who made the above complaint in 1857 could claim, "At no time has France furnished more ample material for the chisel and brush of her artists."[4] Although his interest was in contemporary history, not in subjects randomly selected from mundane existence, he was clearly trying to direct, rather than stem, a tide whose force was much more powerful than he or his administration.

Ironically, his remarks echoed those issued about a decade earlier by the much more liberal poet and critic Charles Baudelaire, who had written his now-famous Salon

review of 1846, one section of which was entitled "On the Heroism of Modern Life." In this essay, revised and reprinted in 1863 under the title "The Painter of Modern Life," Baudelaire stated "that our age is no less fertile in sublime themes than past ages," and argued for an artist who could show how "the pageant of fashionable life and the thousands of floating existences . . . all prove to us that we have only to open our eyes to recognize our heroism."[5] Baudelaire was not interested in preserving history painting or the old hierarchy of genres. Instead, he wanted artists "to distill the eternal from the transitory" and to seek "the distinguishing character of that quality . . . we have called 'modernity,'" which meant focusing on subjects that would reveal "the amazing harmony of life in the capital cities, a harmony so providentially maintained amid the turmoil of human freedom."[6] For Baudelaire, that required training one's eyes on the multiple perspectives of the burgeoning city of Paris.

Paris and its surrounding suburbs most fully embodied the mysterious novelty of modern existence, primarily because they had undergone extraordinary change in the first half of the nineteenth century, doubling in population between 1830 and 1850 and then increasing again by another 30 percent over the next twenty years. This unprecedented growth caused by rural workers streaming into the capital region in search of better jobs created innumerable housing, health, and security problems. For people like Baudelaire, however, it also offered a wonderfully diversified and endlessly fascinating spectacle, one that became both clearer and more confusing beginning in 1853. It was in that year that Napoleon III and his prefect of the Seine, Baron Georges-Eugène Haussmann, initiated the largest urban renovation project of their time: the massive rebuilding of the French capital. Over the course of the next seventeen years, until the outbreak of the Franco-Prussian War in 1870, construction crews demolished more than 24,000 old buildings to erect 100,000 new ones, laid over three hundred miles of new water and sewer pipes, built more than fifty-seven miles of new streets, installed more than 15,000 new streetlights, and planted thousands and thousands of new trees. The stinking, filthy, medieval ghetto that had been Paris for centuries was transformed, overnight it seemed, into the "city of light" as we know it today, earning this sobriquet at the end of the 1860s as it turned into the crowning jewel of Europe.[7]

The new Paris, with its broad boulevards, captivating street life, and abundance of leisure attractions, became the focus of the generation of artists who had been born in the 1830s and 1840s and who had been nurtured on the Realists' responses to the contemporary world. Maturing during the very years the capital was being transformed— Renoir's apartment building was one of the thousands that were knocked down during the renovations—these younger artists substituted the city and its new intrigues for the Realists' concentration on less up-to-date matters. And beginning in the 1860s, they set

out to alter the course of French art in ways that even Baudelaire could not have predicted, and which we are still trying to understand today.

The first manifestations of this new art came from the hand of Manet, who was singled out for his efforts in his Salon debut in 1861 as an artist to be reckoned with, for better or worse. Some hailed him as a talented individual who could breathe new life into his country's moribund art; others condemned him as a daubing provocateur, incapable of rational judgment and unable to follow prescribed norms—a polarity of opinion that would be repeated nearly every time Manet put his work in front of the public. What was upsetting to conservative critics was the way Manet flaunted his virtuosity while consistently refusing to make evident his knowledge, training, or personal discipline. "The fine brush strokes, . . . caked and plastered on, are like mortar on top of mortar," complained one writer in 1861. "He begins and does not finish; as soon as his paintings have reached a certain point, he leaves them incomplete," decried another critic almost fifteen years later. "Neither drawing nor modeling count for him."[8] Many felt his talent was being squandered, others that he was establishing "dangerous" precedents. If fellow artists followed his deviant example, what would become of the practice of painting? Conservatives shuddered to think.

It was not that Manet's shorthand was totally novel. There were plenty of prior examples in Spanish art, particularly in Diego Velázquez and Francisco de Goya (whom Manet copied), precedents that contemporary observers often noted. Courbet was also cited as one of Manet's touchstones, for Courbet, unlike most of his fellow Realists, had consciously allowed his paintings to bear evident witness to the materials from which they were made, just as he consistently drew attention to the formal strategies he employed and to the coarse and challenging subjects he selected. In addition, all of these critics knew that even Salon artists painted pictures with similar freedom, and that such a technique was actually taught in the classrooms of the Academy. But in the eyes of conservative viewers, Manet made the technique his entire art, thus taking those precedents and pushing them to an extreme. However much some of the paintings done by Salon artists may have looked like Manet's in their disregard for detail and control, they were never considered finished; they were merely sketches, dashed off to capture a particular effect or to examine a specific visual problem. Finished paintings or true art had to be more refined, studied, and labored. They had to reveal a mastery of the conventions of painting and an inventiveness that would still abide by the rules governing that practice. Everything else was slapdash, mere child's play, hardly worth serious attention (unless, of course, a work was going to be judged according to the tenets applicable to sketching, which were decidedly less rigorous and less elevated than those for the more revered task of producing completed pictures). It was the contention

of Manet and his followers that freer works brought one closer to the very nexus of creativity, that they required equal patience and care to produce, and that they underscored the continuing vitality of the tradition in which they were engaged. Paintings that were finished in accord with academic principles, in their opinion, were sapped of spontaneity and thus ended up too predictable and lifeless.

Another problem conservative critics had with Manet's work was their inability to fit his paintings neatly into established categories: history, mythology, religion, everyday life, portrait, still life, landscape, or figure study. This was particularly true when they were confronted with works such as Manet's *Le Déjeuner sur l'herbe* (1863), whose original title of *Le Bain* made it difficult to identify the roles of the various figures in the scene and to determine what kind of painting it was supposed to be. Was it a genre picture or a landscape, a group portrait or a modern mythological scene? What were these people doing and why was the woman stark naked and staring at us so defiantly? In addition, like Courbet before him, Manet often reversed the normal code of using certain sizes of canvases for particular kinds of subjects—larger ones for history, religion, or mythology, and smaller ones for all others. *Le Déjeuner sur l'herbe*, like most of his paintings of the 1860s, was on a canvas that was considered much too big for the subject it supported and thus contributed to its apparent pretentiousness and impropriety.

Despite drawing fire on these counts, Manet soon saw other young artists adopt his subversive strategies. In 1865–66, the twenty-five-year-old Monet, after receiving high praise for two seascapes in his promising Salon debut that year, set out to renovate Manet's *Le Déjeuner sur l'herbe*. In his even more modern version of the same subject, the upstart younger artist removed Manet's references to past precedents and set a more unified group of properly dressed men and women in a more legible, light-filled environment. Rooting his work more in the realities of experience and less in the artifices of art, Monet heightened the impact of his scene of consummate leisure by choosing a canvas that was twice the size of Manet's and employing brushstrokes that likewise far exceeded those the older artist used.

The equally youthful Renoir followed suit. His *Woman with Parrot*, while somewhat reminiscent of genre pictures by more accepted artists at the time, such as the Belgian society painter Alfred Stevens, is in many ways an updated version of Manet's canvas of five years earlier, *Woman with a Parrot* (1866). Renoir too has given Manet's treatment of the subject a more contemporary look. He has placed his fashionably dressed woman in a room complete with wall-to-wall carpeting, floral wall covering, and well-tended plants. Like Monet's transcription, there seems to be a consistency to this setting

Edouard Manet, *Le Déjeuner sur l'herbe*, 1863. Oil on canvas, 208 x 264.5 cm (81 ¾ x 104 ⅛ inches). Musée d'Orsay, Paris.

Claude Monet, *Le Déjeuner sur l'herbe*, 1865–66 (central fragment). Oil on canvas, 248 x 217 cm (97 ⅝ x 85 ⅜ inches). Musée d'Orsay, Paris.

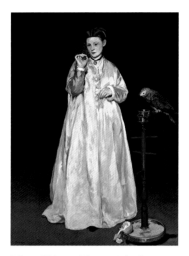

Edouard Manet, *Woman with a Parrot*, 1866. Oil on canvas, 185.1 x 128.6 cm (72 ⅞ x 50 ⅝ inches). The Metropolitan Museum of Art, New York, Gift of Erwin Davis, 1889 (89.21.3).

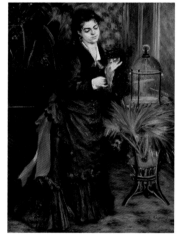

Pierre Auguste Renoir, *Woman with Parrot*, 1871 (cat. no. 57).

and a plausibility about its parts that contrast with the ill-defined, stagelike space in which Manet's more enigmatic figure stands. There also appears to be little question about the identity of this person; initially at least, she seems to be the woman of the house. The figure in Manet's painting is not given a specific role. Indeed, we do not know what she is doing besides holding a flower to her nose, twirling a monocle, and staring straight at us with an inquisitive but ambiguous look. Renoir's woman appears quite innocent by comparison, engaged as she is with the pet that is perched on her gently extended index finger and nibbling a treat. The common nature of Renoir's subject is echoed in the unpretentiousness of his model who, while à la mode in terms of costume, is rather plain in terms of looks, something Renoir underscores by applying his paint in multiple layers to her pallid face and hands and making them contrast radically with the darker dress and room. She does not seem to be endowed with mystery or airs, unlike Manet's actress, just as the room appears to be her own, not one that was snipped from Velázquez or Bartolomé Esteban Murillo.

The contrast may not be quite as clear-cut as that, but the apparent allegiance to direct observation advocated by Manet and his followers appealed to more liberal critics—such as Zacharie Astruc, Jules Antoine Castagnary, Edmond Duranty, Théodore Duret, Arsène Houssaye, Stéphane Mallarmé, Théophile Thoré, and Emile Zola, to name but a few—who in the 1860s and 1870s defended these artists against conservative bombast. Their support is often given less attention than the meaner remarks made by more conservative writers, which tends to make our picture of the struggling artists bleaker and to confirm our appreciation of their heroic efforts. But this support was significant and strongly stated. For in contrast to their conservative colleagues, these men of letters appreciated the audacity Manet and his followers exhibited, not only in choice of subjects but also in handling, claiming, as Thoré did in 1864, that Manet in particular "has the qualities of a magician, luminous effects, flamboyant hues, copied from Velasquez [sic] and Goya, his favorite masters."[9] Zola likewise trumpeted Manet's cause while supporting Monet and Renoir, who in his opinion formed a group he labeled "Les Actualistes," who "try above all to penetrate the exact sense of things" and whose "works are alive because they have taken them from life and because they have painted them with all of the love that they feel for modern subjects."[10]

The enthusiasm of these open-minded observers was whetted by almost everything these young artists produced, including the seemingly less contemporary scenes of country life that formed the core of Pissarro's output during the 1860s and 1870s, such as *The Hermitage at Pontoise* (ca. 1867, cat. no. 56). Their interest was more than justified, given this painting's extraordinary qualities, from its rich color scheme, simplicity, and directness to its evocative light, seductive touch, and surprisingly

complex internal relations. Note the subtle way the land rises and falls, for example, or how the path leads from the quiet and uncluttered right-hand corner to the more forceful planes of the houses on the left, which it then skirts as it turns to climb to the two more-isolated white houses on the right. Note as well how the hill in the background on the left leads down to those two houses on the right, only to be stopped by the foliage of a tree that breaks the horizon behind the darker structure on the far right, a vertical gesture that also appears to push the stream of clouds up and out of the scene. Pissarro's love of contrasting forms is evident here as well—the

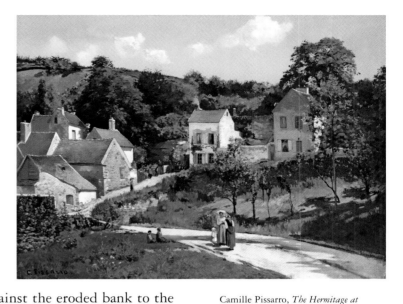

Camille Pissarro, *The Hermitage at Pontoise*, ca. 1867 (cat. no. 56).

stone wall on the left, for example, which he plays off against the eroded bank to the right, and above that wall the darker roofs that stand out against the lighter facades below, or the three large wedges of land that head right, left, and then right again as they move from foreground to middle ground to background. Filled with the freshness of a summer's day and all of the empathy Pissarro felt for the humble aspects of rural France, paintings like this rightfully inspired Zola to exclaim, "What vibrant earth, what greenery full of vitality, what a vast horizon! After studying . . . for several minutes, I thought I saw the very countryside open up before me."[11] Like contemporaneous paintings by Manet, Monet, and Renoir, this picture unites the empiricism of Courbet and his Realist contemporaries with a love for natural light and for clear, resonating color, all set down with conviction and bravura. Little wonder that Zola asserted that these artists "are at the forefront of the modern movement and that one day we will have to reckon with them."[12]

Although Manet set the pace among his colleagues for the changes that occurred in French art in the 1860s, he increasingly adopted the strategies of his friends and associates in the 1870s. After the disastrous defeat of the French at the hands of the Prussians and the bloody repression of the Commune insurrection in 1870 and 1871, Manet essentially abandoned his more historically oriented work for subjects that were taken directly from the contemporary social fabric, much as Monet, Pissarro, and Renoir had been doing in the previous decade. He also began to render these more consistently modern subjects with the heightened palette of his friends, although he still maintained his interest in motifs that were riddled with ambiguity and could be read on various levels. Few paintings demonstrate this better than *Before the Mirror*, a work that Manet included in his last solo exhibition (held in the offices of the Parisian newspaper *La Vie moderne* in 1880) and which remained in the artist's possession until his death in 1883.

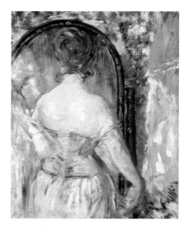

Edouard Manet, *Before the Mirror*, 1876
(cat. no. 17).

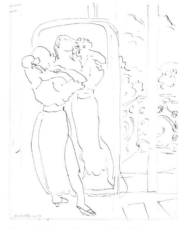

Henri Matisse, *Woman Before Mirror*,
November 1939 (cat. no. 21).

It is perhaps not surprising that it did not find a buyer given the challenges it poses, beginning with its apparent subject: a woman in her undergarments seen from the rear, standing in front of a mirror in what is presumably her private dressing or bedroom space. It is not the subject per se that is so striking; such scenes were common in earlier art, particularly in the French Rococo of the eighteenth century, when the boudoir became the standard setting for much steamier encounters. What is remarkable is Manet's treatment of the motif. Most of his predecessors, for example, provided some storytelling elements and insisted on some distance between the viewer and the action. Here, there is only a single figure whose features are obscured despite the presence of the mirror. Her actions are also extremely limited if they are definable at all. Besides looking at herself (as we would like to believe she is), she simply appears to be adjusting her bodice, although it is impossible to say whether she is loosening it or tightening it. Her reflection in the mirror is of little help; indeed, it only contributes to our confusion, as it hardly appears to be a reflection at all. The smeared array of hues vaguely recalls those of her shoulders and garments, but they tell us nothing about this woman. They also seem to be too far to the left, if she is supposed to be standing in front of the mirror and if the mirror is supposed to be parallel to the floral-covered wall behind it. But perhaps these too are false assumptions, something the cropping of the mirror frame on the left suggests together with the larger amount of the frame that we see as it emerges from the left and curves up to the top.

Apparently, nothing is for certain here. For example, what is the blue-and-white form on the right—a window curtain restrained by a cord, or a section of a sheer canopy hanging from an unseen bedpost? Why is it two different colors (the same two as the woman's garment), and why do the colors change just where the cord disappears, which is where the finial of the mirror ends as well? There are no sure answers to any of these questions, just as there are no indications as to what our role is supposed to be in the scene. Are we related to this woman? If so, is it by blood, marriage, or temporary consent? Are we even in the room with her? If we are, we are sitting or lying down or else very short. Because of our low vantage point, we could actually be voyeurs outside her space and peering in at her through some kind of keyholelike opening, although once again the painting does not permit us to draw firm conclusions. It is even difficult to determine whether she knows we are looking at her. She makes no concessions to us and seems completely self-absorbed; even her body is contained within the boundaries of the mirror, whose rounded top gently arcs over her similarly colored hair while imitating the outline of her rising hips below. Yet there is a hint—in her slightly turned head, cocked ear, and frozen action—that she is aware of us, something her right arm implies as well, as it breaks out of the confines of the mirror, permitting

her wrist to touch the boldly lit material on the right and her hand to attract or dispel the staccato strokes in the lower corner on that side.

Those strokes are deftly applied, like all of the touches that cover this canvas. They are also surprisingly varied, from the blocklike, opaque highlights on the material at the right and the whisper-thin, almost combed, sections of blue-gray in the mirror to the flurry of strokes in the background and the pasty buildup of paint on the woman's shoulders and back. In most areas, the strokes are distinct and separate, both individually and as groups. While describing the image and increasing its immediacy, they are often so self-evident as touches of paint that they constantly call attention to themselves as a rich, thick impasto, thus reaffirming Manet's working method as part of the aesthetic of the image instead of convincing us of the veracity of the scene they evoke.

It is the extraordinary alliance of all of those marks, however, together with the ambiguity of the forms they barely describe that make this painting at once so forceful and fragile, so convincing and unnerving, an effect that can be underscored by comparing the painting to works that it ultimately leads to, such as Matisse's drawings *Male Model* (ca. 1900, cat. no. 20) and *Woman Before Mirror* (November 1939, cat. no. 21).

These drawings are radically different from each other. One is energized by fierce crosshatching and a rough play of light and shade; the other is airy, lyrical, and evanescent. But they are both the product of a man who has learned his lessons well, informed as they are by a host of precedents, from Greek vase painting of the fifth century B.C. (as in the case of *Woman Before Mirror*) to Michelangelo, Jean-Auguste-Dominique Ingres, Auguste Rodin, and Picasso, as well as to Matisse's own earlier work. But in many ways, neither would have been possible without Manet's example, as it is Manet's freedom of handling, his obsession with form, and his keen interest in the elements of his craft that allow him to stake out a position between description and abstraction, knowledge and naïveté. But neither of these drawings possesses the ambiguity and tentativeness that seem to haunt Manet's painting. They are only drawings, of course, and thus less labored and plastic. But Matisse's basic urge to extract harmony from whatever he encountered, so evident in both of these drawings, seems remarkably absent from Manet's painting, despite the concordance of forms, the synchronized strokes, and the pleasing coordination of related colors. Every element in this painting seems to be part of a deliberate strategy to only *approximate* clarity and resolution, as if such goals were unachievable or perhaps not even desired.

One could make much of this, for it does not appear to be simply the result of Manet's interest in capturing a particular moment in time. Nor is it due to oversight or lack of talent, as conservative critics in the 1870s might have claimed. It is also not because the picture was a sketch. Manet seems to have considered it to be finished,

having reworked the woman's right hand, signed the canvas, and included it in his 1880 exhibition without any qualifying additions to the title, as artists often did if the work were not actually complete.

Clues to resolving this quandary are suggested by critics who praised the paintings of Manet and his friends, for many of these critics found something more there than mere aesthetic novelty or technical brilliance, something that spoke to them about life itself, as Baudelaire and Zola had suggested in their writings in the 1860s. These connections were made more frequently beginning in 1874 with the first Impressionist exhibition, when the participants were generally called the "Intransigeants." This was a label critics appropriated from the political sphere, where it referred to Spanish anarchists who in 1873 had initiated a civil war in their country in an attempt to topple their Bourbon monarch. Although the coup had been crushed, their goals were familiar to most French citizens. The name Intransigeants, therefore, would have been quite pungent when applied to the "independent" society of artists who staged their first public show the year after the rebellion collapsed. It suggested the group's adversarial position in relation to the artistic establishment while implying that the Impressionists had a revolutionary if not a lawless bent. Some of the Impressionists would not have appreciated this association, but it seemed appropriate to most early reviewers whether they supported the show or not, since so many used it.[13]

The boldly painted works the Impressionists produced in the 1870s were linked specifically to conditions in France by Mallarmé, who in 1876 went so far as to assert that the art of Manet and his followers would be a beacon for the disenfranchised classes in the country. This startling assertion was predicated on the poet's acute sensitivity to the simplicity, honesty, and directness of the Impressionists' work, which he claimed were parallel to the principles governing popular art. He also saw the artists' interest in casting off the shackles of the Academy and starting anew as equivalent to the political aspirations of all workers in France. Even the lack of traditional finish in the Impressionists' paintings was a sign of their independence and their quest for truth, which he felt was similar to the way the multitude demanded "to see with its own eyes."[14] Although members of the group would not necessarily have agreed with Mallarmé, his reading was one more example of how their work was wedded to their times whether they liked it or not.

One of the most succinct and revealing connections between this new art and its particular historical moment was made by Frédéric Chevalier when he reviewed the third Impressionist exhibition of 1877. "The disturbing ensemble of contradictory qualities . . . which distinguish . . . the Impressionists," he observed, "the crude application of paint, the down to earth subjects . . . the appearance of spontaneity . . . the conscious

incoherence, the bold colors, the contempt for form, the childish naïveté that they mix heedlessly with exquisite refinements . . . all of this is not without analogy to the chaos of contradictory forces that trouble our era."[15] Although we will never know precisely what Chevalier meant by this remarkable bit of criticism, his enumeration of the Impressionists' formal innovations indicates his familiarity with their strategies and the ways that those innovations suggested salient characteristics of contemporary life.

Chevalier's observations about that life were reiterated by innumerable other commentators, for by the 1870s Baudelaire's magical city of Paris had long been haunted by contradictions. The broad new boulevards, imposing new structures, and swirling public life, while novel and exhilarating, were also alienating and disconcerting. Most residents, although they could understand the changes as the effects of progress, were profoundly affected by the radical transformation of the city. What had once been a collection of virtually independent, self-sustaining neighborhoods had been forced into a new configuration, one that had obvious advantages—access was much easier, for example—but which was strained beyond the tolerable to many who lived there. Bonds that had been established with neighbors and places, for instance, now seemed compromised by the hordes of new people who moved into the town houses and apartment buildings that were dutifully aligned along the sidewalks in the recently devised order of the renovated areas. While everyone could welcome the light, air, and running water, there were plenty of people who felt they had lost their past, that the city no longer belonged to them. Through forces much larger than themselves— government power and private capital—all under the name of progress, Paris had been snatched from their grasp, seemingly forever. Many people thus felt estranged in their once familiar surroundings, adrift and yet an intimate part of this newly constituted body, isolated even though they were surrounded by thousands like themselves. Those who felt this most poignantly were the thousands who were actually forced out of their dwellings either by increased rents or by losing their homes to the demolition. They were obliged to relocate, generally in different neighborhoods if they stayed in the city at all. Many left the capital for cheaper housing in the suburbs.

But Paris continued to grow as an arena for amusement and spectacle. Indeed, with a swollen population and an increased need for leisure distractions, the spectacle spilled out from its more confined spaces into the broader public arena: the huge new outdoor cafés, for example, and the numerous new parks, particularly the Bois de Boulogne, which was annexed to the city in 1848 and entirely reconfigured between 1852 and 1858. It also stretched out into the surrounding countryside, primarily because more and more people moved there, transforming those once agrarian areas into modern suburbs complete with new streets and sewer systems, recently built single-family

houses on individual plots of land, and leisure activities such as gardening and pleasure boating. While the suburbs and their offerings could seem some distance from Paris, they were actually linked to the city by social customs, work, and the recently constructed railroad, thus making one space merely an extension of the other.

It was this spectacle—in city and suburb—that the Impressionists rendered over and over again in the 1860s and 1870s, immortalizing places where the social swirl occurred: the cafés, restaurants, racecourses, and circuses in the city, for example, and the outdoor pleasure spots, backyards, and boat-filled stretches of the Seine in the suburbs. When people gathered in those places they bore witness to their time, as they generally were men and women who seemed both carefree and wary, self-sufficient and dependent, people who out of necessity put a premium on posturing, such as the nude in Manet's *Le Déjeuner sur l'herbe*, or his semidressed female in front of her mirror. They were people whom the Impressionists would catch unawares in private moments of reflection, like Renoir's woman with her parrot, people whose identities could shift if placed in a different context or painted in a different style, just as the places themselves could be understood to be quite different if the larger environment was revealed.

Renoir's *Woman with Parrot* is a case in point, for it is actually not as straightforward as it initially appears. The room is an unlikely combination of a conservatory and a living room that is spatially peculiar, particularly in the area behind the figure. Renoir reinforces this spatial ambiguity by consciously disrupting the perspective lines on the right, where the edge of the plant stand breaks the wainscoting and wall pattern. The stand is also impossibly rendered, with its turned legs seemingly unconnected to its distorted top. And the woman herself may be less innocent than one assumes, judging from such details as the brilliant red plumage of her sash, the charged extension of the potted plant's foliage, and the dark lushness of the arcing plants behind her. Perhaps most significant are certain analogies between the woman and the parrot, particularly the way that Renoir has her gazing at the bird just as we look at her in the painting. Even the folds in the middle of her dress imitate the parrot's layers of feathers, while the pleats at the bottom of her gown echo those at the feet of the plant stand supporting the cage, and the gold of her earring is the same color that highlights the parrot, the stand, and the cage. Thus, the figure who had appeared to be a typical middle-class woman in her own well-cared-for house could instead be someone imitating that societal type. All of a sudden, she becomes less an independent creature and more a kind of tropical species who has alighted in this hothouse environment either for her passing pleasure or for someone else's. As in Manet's painting, Renoir seems to be suggesting that nothing is ultimately secure in this late-nineteenth-century world, a world in which values are as fluid as the paint on the canvas, just as personal

facades are as interchangeable as the categories of painting that this work could occupy. Such ambiguity was a constant issue in these Impressionist paintings, whether they critiqued, embraced, or disguised it.

While evident most often in Manet's work, this sense of a fractured, contradictory world at once fascinating and unnerving is suggested even in paintings that are seemingly free of such concerns, such as the still lifes in the Thannhauser Collection that Cézanne produced at the very same time as Manet's *Before the Mirror*. Although these canvases could hardly have been realized without the example of someone such as Jean-Baptiste-Siméon Chardin, whose achievements in the genre in the eighteenth century were touchstones for all who followed, Chardin could never have conceived of arrangements like these, for his preindustrial world was too hierarchical and forthright. The world Cézanne appears to be rendering is filled with tensions—of folds pulling against tabletops, of fruits competing for positions, of objects appearing to be on different levels even though they are supposed to be sitting on continuous flat surfaces, of one reality (the still-life arrangements) set off against another (the artfully composed wall coverings in the backgrounds). Unlike in Chardin's paintings, ambiguities abound in these works. Is the brown triangle in the lower right of *Still Life: Flask, Glass, and Jug* (ca. 1877, cat. no. 4) the dropped leaf of the table or part of the wall behind it? Why does the edge of the table in this picture change several times, and how does the cloth extend out so rigidly on the right? Why do we see so far into the glass in the center, and why is the reflection in that glass a blue-white stripe? Why do the vase and jug cast no shadows while seeming to float on green touches of paint? In *Still Life: Plate of Peaches*, (1879–80, cat. no. 5) how can the tablecloth stick out so sharply on the left? Why does the background wall change between the bottom-left quadrant and the area under the table? And why does the dark form in the center of this still life appear to be trying to maintain a hold on the blue plate by means of the extended green stem? Everything is as tentative and perplexing as it is stable and tangible, a contradiction that is underscored in *Still Life: Plate of Peaches* by the way forms appear to be going in different directions or contained in distinctly separate spheres, all held together by the sheer force of Cézanne's aesthetic will.

Those contradictions would be taken to their logical extreme in the first two decades of the twentieth century when Georges Braque and Picasso systematically dismantled and then reconstructed pictorial reality in the form of Analytic and Synthetic Cubism, resulting in works such as Braque's *Guitar, Glass, and Fruit Dish on Sideboard* (early 1919, cat. no. 2). The crisp, clear-cut forms in this picture are far from Cézanne's painterly ensemble; but Braque's arbitrary lighting, multiple perspectives, and cropped and flattened shapes rigorously integrated to suggest a tentative but

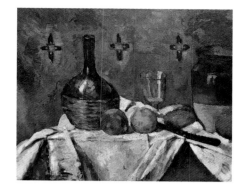

Paul Cézanne, *Still Life: Flask, Glass, and Jug*, ca. 1877 (cat. no. 4).

Paul Cézanne, *Still Life: Plate of Peaches*, 1879–80 (cat. no. 5).

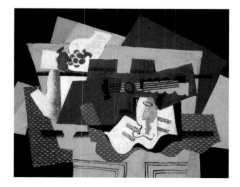

Georges Braque, *Guitar, Glass, and Fruit Dish on Sideboard*, early 1919 (cat. no. 2).

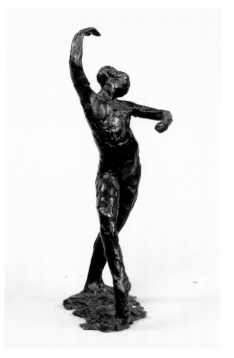

Edgar Degas, *Spanish Dance*, 1896–1911 (cat. no. 10).

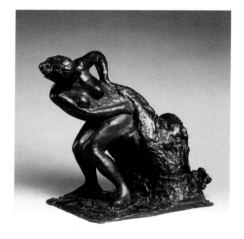

Edgar Degas, *Seated Woman, Wiping Her Left Side*, 1896–1911 (cat. no. 11).

believable structure all ultimately derive from Cézanne's initiatives. In addition, Braque's architectonics, so artfully concocted by setting up a counterpoint of shapes and colors using his keen sense of a form's weight and measure, is the product of a similar urge to negotiate a truce between opposing factions and to find order and meaning in an apparently disorderly world.

One senses this same struggle in much of the work of these Impressionist artists, despite the accessibility of their subjects or the apparent beauty they seem to describe. It is even evident in Degas's sculptures, for these works too are studies in contrast. In *Dancer Moving Forward, Arms Raised* (1882–95, cat. no. 9), note the woman's ascending upper torso along with the weightiness of the figure, the gracefulness of her gestures along with the roughness of her form, and the classical prototypes she suggests along with her inevitable roots in the late nineteenth century (down to her "primitive"-looking face and her distorted cranium). The figure in *Spanish Dance* (1896–1911, cat. no. 10) is thinner and more elongated than her mate, but she is endowed with even more perplexing features. She confidently assumes the classical fourth position, but her equilibrium appears threatened by the arc of her body and her exaggerated contrapposto. Her right leg strains to achieve full extension, while her left struggles to maintain its rigid position with the foot flat on the ground. Her two arms, tightly held in opposing planes, echo her taut legs. The arms appear to define counterbalancing spaces that she stretches to possess in order to accentuate the tensions in the work between masses and voids, tentativeness and resolution. *Seated Woman Wiping Her Left Side* (1896–1911, cat. no. 11) carries these contrasts and rhythms to their logical extreme. How awkwardly posed this poor woman is and how unfairly she is caught in such a private moment. Yet how remarkable she is to be able to remain as a whole. For although her feet are firmly planted and her thighs and buttocks rest on a stump for support, she seems to be trying to extricate herself from the mass of material behind her as much as she is drying herself off. One senses this in the diagonal thrust of her torso, the triangle of her bent left arm, and her turned and lowered head. It is also evident in the rough texture of the towel and the stump, which are the opposite of her smoother, rounder form. Voids compete with masses here. Certain elements defy reason, such as the extension of the towel off the base, an artful ploy that recalls the tablecloths in Cézanne's still lifes, just as Degas's manipulated surface and sense of ambiguity hark back to Manet's *Before the Mirror*. The latter qualities are even more evident in Degas's *Dancers in Green and Yellow*.

In this magisterial pastel, Degas permits all of his powers to flourish, from his masterful draftsmanship and sensitivity to color to his painterly inclinations and jarring compositional strategies, all of which both support and compete with each other, just

as Manet had allowed in his earlier painting. The figures of the four dancers are evoked by a raw chiaroscuro and by boldly applied outlines of murky gray-browns, blacks, and blues. But how ill-defined their forms and facial features are, how pasty and unattractive is their skin, and how awkward and ungainly are their stances, especially the positions of the two dancers on the right. The latter squats so low she is barely discernible; her tutu is quite separate from the front of her slumped body, her head unmercifully cut off by the edge of the paper. The curtain behind them is an aesthetic tour de force. Its blotchy, overlaid marks and moments of surprising calligraphy extend the kind of marks Degas employed to describe the dancers and their costumes, while its freedom and ambiguity underscore the unresolved qualities of the work as a whole. Three of the four women rest their hands on the curtain and push it back as if to see beyond it; but it remains for them, as it does for us, a critical element in the scene as well as a kind of obstacle to awareness, something the last dancer tries to overcome by sticking her head around it. What she and her colleagues seek with such intensity is left to our imagination, but it surely has to do with the nature of their enterprise: the pursuit of approval and success through the creation of something desirable. In their case, it is the creation of a world of grace and order wrought without apparent effort from the mastery of their bodies and the perfection of their craft. That such attractive features are essentially absent or only inferred here is not surprising, as Degas, like Manet and the other Impressionists, clearly sought to question rather than affirm the unconditional existence of such a world. Degas emphasizes this by taking us backstage and reversing the normal relationship of the spectator to the performance, revealing behind the scenes the humanness of the dancers' enterprise and the conflicts of their existence. He also allows us to ponder the realities of his own struggles as an artist in the twilight of a long career. Little wonder, therefore, that the picture is so open-ended or that Degas has disguised nothing, not even the pieces of paper he added at the top and bottom of the sheet or the multiple layers of transparent touches with which he built up the image.

Also made just after the turn of the century, but so different from Degas's dancers, is Aristide Maillol's *Woman with Crab* (ca. 1902[?]–05, cat. no. 16). Although she appears as involved in what she is doing, and though she squats in an uncomplimentary fashion like the last dancer on Degas's stage, Maillol's woman appears much calmer and more restrained, more playful and innocent. She also seems unconcerned about anything outside of her sphere, as if she were circumscribed by the rectangular shape of her base. Fuller and more classical, she does not have to struggle for existence in the same manner as Degas's ballerinas or bather, for she is a kind of earth goddess, weighty but removed, recognizable but otherworldly, someone who reminds us of our humanity but also of our origins and long-lost ideals.

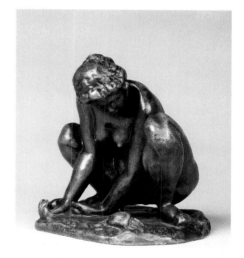

Aristide Maillol, *Woman with Crab*, ca. 1902(?)–05 (cat. no. 16).

These opposing works could have been done in nearly the same year primarily because they were the products of artists of two quite different generations. Born in 1834, Degas was more than twenty-five years older than Maillol, who was born in 1861, the year of Manet's debut at the Paris Salon. Coming long after the call to be of one's time had been uttered and answered, Maillol turned not to the contradictions of his particular moment in time but to the classical world of the past as a kind of escape from those forces that Degas and the Impressionists had been attempting to describe. It was a way of finding solace and purity, qualities that many others in addition to Maillol had begun to claim were necessary antidotes to the pressures of modern life and its wholehearted embrace of the ideals of progress.

This questioning had actually begun among the Impressionists themselves in the late 1870s, when, for example, Monet abandoned Paris and its suburbs where he had lived for nearly twenty years, moving first to Vétheuil and then to Giverny. Over the course of the next four decades, he concentrated primarily on views of unaltered nature. In 1880, Monet even returned to the Salon, as did Renoir, who soon thereafter claimed he had "wrung Impressionism dry" and went off to Italy to study Raphael and antiquity.[16] The results for Renoir were paintings such as *Still Life: Flowers* (1885, cat. no. 58), whose precise, chalky touch is just the opposite of the liquid surfaces of his earlier work. There are no ambiguities, disruptions, or imbalances here, no sense of the dilemmas of modern life—only a scaffolding of strong horizontals and verticals that constitutes a rigorous new order, enhanced by a slightly irregular but still highly regimented decorative patterning. The painting breathes an air of distilled confidence, as if this is what Cézanne's earlier still lifes aspired to but never would have accommodated, given his desire to grapple with the mythologies of such a tempered, exacting balance. This desire is suggested even more emphatically in *Madame Cézanne* (1885–87, cat. no. 7), a portrait of his wife, Hortense, painted by Cézanne at nearly the same time as Renoir's still life.

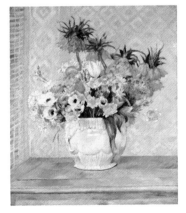

Pierre Auguste Renoir, *Still Life: Flowers*, 1885 (cat. no. 58).

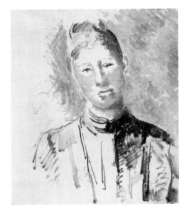

Paul Cézanne, *Madame Cézanne*, 1885–87 (cat. no. 7).

Whereas Renoir propagates the recovery of the past and a strict adherence to its higher principles, Cézanne implies in this touching image the near impossibility of even envisioning such a renaissance. Though the product of a single working session—and thus not a finished painting, according to standard definitions—and though informed by his own problematic relationship with his wife, Cézanne's portrait in many ways is a complete statement not only about his personal travails as a husband and a father but also about the conditions of the late nineteenth century. For Hortense in this portrait is like Degas's dancers or bather; she too is isolated and yet connected, searching for meaning without knowing where or whether it exists. One senses this in her forlorn but penetrating stare, her tilted but firmly supported head, and the highlights that boldly illuminate her before clashing so forcefully with the resulting shadows. One also senses

it from the way Cézanne subtly divides her in two along a central vertical axis. On the left, where the light is strongest, she appears Botticelli-like, almost angelic, with features such as her eye and nostril sharply defined. On the right, everything becomes darker and more careworn. Her eyelid hangs heavier, her nostril is flared, and her lip turns up in an unpleasant snarl. Her hair is more tightly compressed against her head on this side, while the brushwork in the background is at once more agitated and regularized than on the left. It is as if we are seeing two sides of this complicated woman, or two sides of Cézanne or the modern individual. Whatever the case, there appears to be no resolution, no apparent middle ground between what Cézanne suggests to be familiar oppositions of desire and rejection, involvement and independence, or between being a lover and a victim, a saint and a sinner. With the truths of the past long lost to the present, the only thing one can be assured of, Cézanne seems to be asserting, is the existence of this dialectic, something Matisse would reiterate in his *Portrait of Mme. Matisse, The Green Line* (1905), whose similar divisions and even bolder colors and strokes is the twentieth-century version of Cézanne's prescient formulation of the modern condition.

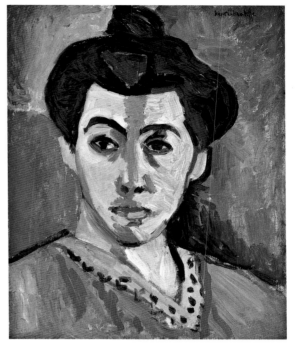

Henri Matisse, *Portrait of Mme. Matisse, The Green Line*, 1905. Oil on canvas, 40.5 x 32.5 cm (15 ¾ x 12 ⅞ inches). Statens Museum for Kunst, Copenhagen.

When rooted in more specific realities of the late nineteenth century, this dialectical phenomenon could become both more graphic and more pathetic, especially when an artist such as Henri de Toulouse-Lautrec takes us into the airless salons of Paris brothels, as he does in *In the Salon* (1893, cat. no. 59). Isolated within their own worlds, though connected by circumstances and Toulouse-Lautrec's artful formal arrangement, the three women in this scene have nothing to say to each other and, for the moment, do nothing except stare off into space. Nothing is happening here; no sound disturbs the silence, no sense of urgency disrupts the ennui. All of the mystery and potential of Manet's *Before the Mirror*, all of the eagerness and inquisitiveness of Degas's *Dancers in Green and Yellow* are gone. Instead, the weight of fate hangs over the scene, permitting none of the women to rise without being cut off by the frame. Compressed into their restricted space, the women become reflective but forsaken occupants of this well-appointed space, stuck by necessity or volition in a system of exchange that requires their submission. Pleasure is not a factor here; aspirations and meaning have apparently evaporated.

However, artists could find meaning in making art about this loss of innocence and the apparent decline of modern life, as Toulouse-Lautrec and others did around the turn of the century, fulfilling in their own manner the same imperative that had motivated their Realist and Impressionist predecessors thirty and forty years before.

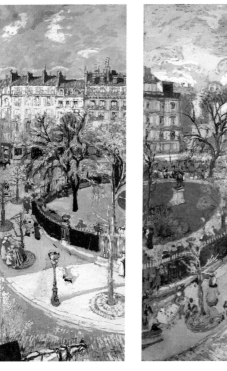

Edouard Vuillard, *Place Vintimille*, 1908–10 (cat. no. 70).

Henri Matisse, *View of Notre Dame*, spring 1914. Oil on canvas, 147.3 x 94.3 cm (58 x 37 ¼ inches). The Museum of Modern Art, New York, Acquired through the Lillie P. Bliss Bequest, and the Henry Ittleson, A. Conger Goodyear, Mr. and Mrs. Robert Sinclair funds, and the Anna Erickson Levene Bequest given in memory of her husband, Dr. Phoebus Aaron Theodor Levene.

Some artists took certain subjects, such as the streets of Paris, that had preoccupied those earlier generations of avant-garde artists and reconstituted them in ways that would extend the possibilities of painting while affirming the continuing vitality of modern urban life, whether or not it was still accurate. Few artists were more up to this task than Edouard Vuillard, whose views of the capital, such *Place Vintimille* (1908–10, cat. no. 70), look back to images of the city by Monet and the Impressionists but also stake out quite different territory. Indeed, the Impressionists' prototypes from the 1860s and 1870s seem almost finicky by comparison to these tall, broadly painted panels. Their decorative qualities suggest Vuillard's novel attempt to domesticate the urban environment and seduce his audience by the sheer artifice of his craft, an option that Matisse took to its logical extreme in his views of Notre Dame.

But, ironically, the one subject that attracted the most interest during this period was the one that was the most traditional, or the least modern, and that was landscape. It is ironic because it would seem that nature, whether it was spoiled, untamed, familiar, or exotic, was too timeless and unpresupposing to bear the weight of contemporary concerns. Yet over and over again it provided avant-garde as well as Salon artists with the means to express what van Gogh described in a letter of April 1888 (cat. no. 62) as "something passionate and eternal."[17] One senses much of this in van Gogh's own landscapes, for example, the strong perspective lines and distant mountains in *Landscape with Snow* (late February 1888, cat. no. 61), the quivering trees and intense sun in *The Road to Tarascon* (late July–early August 1888, cat. no. 66), and the seething forms in *Mountains at Saint-Rémy* (July 1889, cat. no. 68). How vital these images are; how impregnated with feeling and how novel are their surfaces. Van Gogh had learned his lessons well during the year he spent in Paris prior to producing these works, as is evident when they are compared with his *Roadway with Underpass* of 1887. In this work, his former Dutch palette of earth tones and surface of caked-on paint have been abandoned for higher-valued hues and a mixture of Impressionist and Divisionist techniques. Unlike the later pictures, however, everything in this view of a road near the boundary of the capital speaks about restraint and oppositions: sidewalks and trees, verdant banks and dry stone, bold strokes of paint and tight stippled marks. The strong geometric shapes—of the roadway and tunnel, the groomed banks and protruding chimneys—attest to the fact that almost everything in the scene has been manipulated by human hands, even though the human is only marginally present here. In contrast, everything in the later views emphasizes the

profundity of the rural world and the fundamental importance of maintaining close contact with nature. Van Gogh suggests this most forcefully in *Mountains at Saint-Rémy*, not only through the extraordinary rise and fall of the wavelike forms of the mountains but also by nestling the small house in the very trough of that activity, screening it from the road by the sentinel line of bulbous trees.

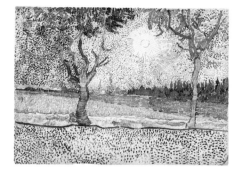

Vincent van Gogh, *The Road to Tarascon*, late July–early August 1888 (cat. no. 66).

"It seems to me almost impossible to work in Paris," van Gogh declared to his brother in 1888 after leaving the capital for the beauties of the South of France, "unless one has some place of retreat where one can recuperate and get one's tranquillity and poise back. Without that, one would get hopelessly stultified."[18] And for van Gogh that retreat meant nature, the place where one could find one's primitive roots and ultimately oneself. Many artists in the last two decades of the nineteenth century felt this way, though none perhaps more strongly than Cézanne, Monet, and van Gogh. "We must not . . . be satisfied with retaining the beautiful formulas of our illustrious predecessors," Cézanne told the painter Emile Bernard in 1905. "Let us go forth to study beautiful nature, let us try to free our minds from them, let us strive to express ourselves according to our personal temperaments."[19] Like van Gogh and the dozens of artists who left Paris for the south—Henri-Edmond Cross, Matisse, and Paul Signac among them— Cézanne devoted much of his later work to an ardent dialogue with the beauties of his native Provence, returning time and again to paint emotionally charged sites, such as the majestic Mont Sainte-Victoire or the ancient Bibémus quarry outside his home in Aix. The results were canvases such as *Bibémus* (ca. 1894–95, cat. no. 8), a seemingly simple image of the quarry's elemental forms—earth, air, light, and water—which in Cézanne's hands become richly nuanced and filled with wonder. Shapes expand, contract, and slide across the surface of this painting, echoing and tugging with each other while affirming and denying the existence of space or any secure definition to the scene as a whole. Everything is at once immutable and in flux, ordinary and cryptic, as if nature and Cézanne's process of translating his sensations into paint still held deep mysteries and could continue to testify to the existence of significant meaning, both in art and in life.

Vincent van Gogh, *Roadway with Underpass*, 1887 (cat. no. 60).

One had to believe in that possibility at the end of the century in order to maintain some kind of stability, as well as to move forward; the world was simply becoming too disorderly and disturbing. Unless, of course, one retreated into a world that was truly of one's own making, a world in which imagination took precedence over vision, and artfulness usurped the place of experience. A growing number of artists in the 1880s and 1890s, led by people such as Maurice Denis, Gauguin, Odilon Redon, and Paul Sérusier, argued vigorously for such a withdrawal into the imaginative realm and for cutting ties to the visible and the known, claiming that such allegiances were inhibiting and thus expendable. "The Impressionists . . . look and perceive harmoniously,

but without any aim. . . . They heed only the eye and neglect the mysterious centers of thought," Gauguin asserted in 1896–97. "They are the officials of tomorrow, as bad as the officials of yesterday. . . . When they speak of their art, what is it? A purely superficial art, full of affectations and purely material."[20] To Gauguin and his fellow Symbolists (as they soon became known), art had to be based on things of the mind, on thoughts, dreams, memories, and intuition, with abstract elements of line, color, shape, and surface dominating plastic form or spatial illusion. For some of these fin-de-siècle artists, this was a way of fulfilling religious aspirations; for others, it was a means of appropriating for painting the abstract powers of music and asserting the superiority of their particular art form; for still others, it was simply a way of staying at the forefront of French cultural production. Whatever the motivation, most of these Symbolists wanted to suggest something purer and more refined than anything that existed in the world and thereby empower painting (and themselves) to reveal higher truths. They had concluded that verisimilitude was a shackle, and so was the world, which was too rife with corruption and too riddled with inconsistencies to merit their faith, as Gauguin constantly charged. "A terrible epoch is brewing in Europe for the coming generation: the kingdom of gold," he wrote. "Everything is putrefied, even men, even the arts."[21]

Their only alternative, they decided, was to retreat into the mind or into some form of mysticism—a path followed by Redon and the Nabis (Denis, Sérusier, etc.)—or to leave the environment that had bred the unhealthy worship of progress in the first place. But for Gauguin, who chose to go, fleeing Paris for the sun-filled South of France or the wilds of Brittany was not enough; one had to cross oceans and continents and find a place untainted by the West. After a visit to Martinique, Gauguin sailed off to the South Sea islands, settling in Tahiti in 1891 and finally in the Marquesas Islands, where he died in 1903. It was there, among "uncivilized" peoples, he said, "Far from that European struggle for money. . . . I shall be able to listen to the sweet murmuring music of my heart's beating, in amorous harmony with the mysterious beings of my environment."[22] And it was there that he attempted to renew Modernist art with paintings such as *In the Vanilla Grove, Man and Horse* (cat. no. 13) and *Haere Mai*, both from 1891. These works consciously defy many of the time-honored techniques of painting. Modeling is abandoned in these pictures for a more random play of chiaroscuro, resulting in flatter forms and seemingly arbitrary patterns; space is suggested not by Renaissance perspective but by cruder overlapping and vertical arrangements of simple shapes; color is employed for its evocative rather than its descriptive power; and no concern appears to be paid to harmonizing the conflicting, disassociative marks of the brush or to coordinating the forms into a more balanced composition. Even the supports are unsophisticated, for Gauguin painted these scenes on rough burlap, the surfaces of

which establish their own patterns distinct from the image, particularly in *Haere Mai*. Like the frankness with which Gauguin employs the elements at his disposal, these patterns call attention to themselves and to the artifice inherent in the traditions of Western picture-making.

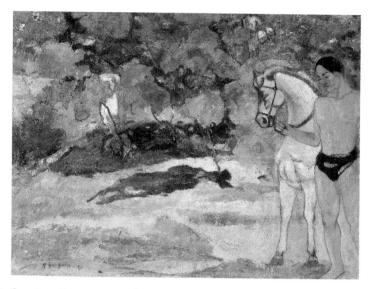

Paul Gauguin, *In the Vanilla Grove, Man and Horse*, 1891 (cat. no. 13).

While extraordinarily fruitful, Gauguin's flight from civilization was filled with irony, for the West had discovered the South Sea islands long before this self-proclaimed savage artist arrived. Much to his consternation, natives had already been converted to Christianity by zealous missionaries; old tribal customs had been compromised by European officials who had imposed new administrative and legal systems; even part of the once tropical jungle had been developed into a club for the distraction of French officers. The islands still possessed a lush beauty and a primitive charm, but they were not as pure as Gauguin—or as most French men and women—had been led to believe. Gauguin did nothing to alter those perceptions. Indeed, he wholeheartedly continued to propagate the myths of tropical splendor that had brought him there, heightening the exotic appeal of his paintings by employing such fanciful colors as the pinks, blues, lime-yellows, and oranges that appear in the two Thannhauser pictures. He also gave his paintings Tahitian titles, such as *Haere Mai*, even though he did not speak the language at the time. ("Haere mai" translates simply as "Come here!" and thus may be meaningless in terms of what the painting depicts.) In addition, he often based his images not so much on what he may have seen or experienced in his adopted paradise but on elements derived from his Western heritage. The man and horse of *In the Vanilla Grove*, for example, are Gauguin's island versions of similar figures in the Panathenaic frieze from the Parthenon in Athens.

On one level, all of this could be seen as a pathetic charade, made worse by the fact that Gauguin freely dispensed the Western disease of syphilis to Tahitian women who succumbed to his sexual advances. However, on another level, his venture into what inevitably proved to be a paradise lost—and the enormously rich body of work that resulted—was the ultimate culmination of the century's attempt to redefine itself before it closed and to try to discover new value in human existence beyond the material rewards of capital. Although that attempt was only partially successful, just as Gauguin's quest was only partially fulfilled, it was a logical and necessary process for people concerned about the future to go through, particularly those living and working in France, the cultural leader of Europe at the time. That such a search would pull people like Gauguin so far from France's shores also stands to reason. Even van Gogh felt

that "the future of painting is in the tropics, either in Java or Martinique, Brazil or Australia."[23] The Western world appeared to them to be too old and misguided to have the vision or stamina to be able to make meaningful art out of life.

Van Gogh and others were wrong in this regard, although the "primitive" forms of African, Oceanic, and Iberian sculpture would help renovate Western art in the early twentieth century. Van Gogh was also incorrect when he assessed his own posterity. In his typical self-deprecating fashion, he declared that neither he nor Gauguin would be "the men of that future," although he was certain that such people existed and that they were practicing their craft as he wrote.[24] He was correct on that count, for when he was penning those hopeful lines to his brother, Theo, in June 1890—just a few weeks before he put a gun to his head to end his life—the twenty-one-year-old Matisse and the nine-year-old Picasso were completing their very first paintings. Although Matisse was working in Bohain-en-Vermandois outside Saint-Quentin in northern France and Picasso in Málaga on the southern coast of Spain, they would ultimately converge on the same French capital that had nurtured the Impressionists and their Post-Impressionist heirs and that would do the same for these two nascent giants. It was there that they, like so many other artists of their generation, would learn the lessons of their Modernist predecessors and carry their innovations—and their struggles—into the even more complex and contradictory twentieth century.

NOTES

1. For the reactions to the so-called first Impressionist exhibition see Jacques Letheve, *Impressionnistes et symbolistes devant la presse* (Paris, 1959), pp. 59–70; Hélène Adhémar and Sylvie Gache, "L'exposition de 1874 chez Nadar," *Centenaire de l'impressionnisme*, exh. cat. (Paris: Grand Palais, 1974), pp. 221–70; Ian Dunlop, "The First Impressionist Exhibition," *The Shock of the New* (New York, 1972), pp. 54–87; Paul Tucker, "The First Impressionist Exhibition in Context," *The New Painting: Impressionism 1874–1886*, exh. cat. (The Fine Arts Museums of San Francisco, 1986), pp. 92–117; and Paul Tucker, "The First Impressionist Exhibition and Monet's 'Impression: Sunrise': A Tale of Timing, Commerce, and Patriotism," *Art History* 7 (December 1984), pp. 465–76. On van Gogh's plight and legend, see Carol M. Zemel, *The Formation of a Legend: Van Gogh Criticism, 1890–1920* (Ann Arbor, 1980). The conversion of old French francs to present United States currency is tricky business. In most of the literature on Impressionism, the price of Impressionist paintings is converted at five francs to a dollar. However, this is woefully inaccurate, as it takes few economic factors into consideration, such as the relative value of the franc at the time, inflation, and the eventual devaluation of the French currency. My conversion is extremely crude, but it is an attempt to redress the notion that these paintings were almost valueless. It is based on the fact that doctors and lawyers in Paris in the 1870s were earning approximately 10,000 francs a year; workers made 2–3,000. One hundred francs, therefore, would have been a more substantial sum to either group than has been generally admitted. Today, those professionals make considerably more than their nineteenth-century counterparts. If one used the same ratio of a hundred francs as 1 percent of a professional's annual income in 1870 and took $40–50,000 as a minimum salary for a professional today, that hundred francs would be the equivalent of four to five hundred dollars. Obviously, there are problems with such ratio applications, but the final figure of several hundred dollars suggests something closer to the relative value of these paintings than what formerly has been asserted.

2. See Claude Monet letter to Durand-Ruel, July 28, 1885, as quoted in Daniel Wildenstein, *Claude Monet: Biographie et catalogue raisonné*, vol. 2, 1882–1886 (Lausanne, 1979), pp. 260–61. On America's enthusiasm for Impressionist art, see Hans Huth, "Impressionism Comes to America," *Gazette des Beaux-Arts* 29 (April 1946), pp. 225–52; and Frances Weitzenhoffer, *The Havemeyers: Impressionism Comes to America* (New York, 1986).

3. On this imperative, see George Boas, "Il faut être de son temps," *Journal of Aesthetics and Ideas* 1 (1941), pp. 52–65; and Linda Nochlin, *Realism* (Harmondsworth, 1971), chapter 3. Also see Thomas Crow, "Modernism and Mass Culture in the Visual Arts," *Modernism and Modernity* (Halifax, 1983), pp. 215–64.

4. See *Explication des Ouvrages de Peinture, Sculpture, Gravure, Lithographie et Architecture des Artistes vivants, exposés au Palais des Champs-Elysées* (Paris, 1859), pp. ix, x, as quoted in Anne Coffin Hanson, *Edouard Manet 1832–1883*, exh. cat. (Philadelphia Museum of Art, 1966), p. 15.

5. See Charles Baudelaire, *Art in Paris 1845–1862: Salons and Other Exhibitions*, trans. and ed. Jonathan Mayne (London, 1965), pp. 117–19.

6. See Charles Baudelaire, *The Painter of Modern Life and Other Essays*, trans. and ed. Jonathan Mayne (London, 1964), pp. 11–12.

7. On the transformation of Paris, see David H. Pinkney, *Napoleon III and the Rebuilding of Paris* (Princeton, 1972); Louis Chevalier, *La Formation de la population parisienne aux XIXe siècle* (Paris, 1946); and T. J. Clark, *The Painting of Modern Life: Paris in the Art of Manet and His Followers* (New York, 1984), especially chapter 1.

8. See Hector de Callias in *L'Artiste*, July 1, 1861; and Francion in *L'Illustration*, May 29, 1875, as quoted in George Heard Hamilton, *Manet and his Critics* (New Haven, 1954), p. 26 and p. 191.

9. See Théophile Thoré-Bürger in *L'Indépendence belge*, June 15, 1864, as quoted in Hamilton, *Manet* (see note 8), p. 61.

10. Emile Zola, "Mon salon: IV. Les Actualistes," *L'Evénement illustré*, May 24, 1868. English translation by the author.

11. See Emile Zola, "Les Naturalistes," *L'Evénement illustré*, May 19, 1868 in *Oeuvres complètes*, vol. 12 (Paris, 1969), pp. 866–69. English translation in Pissarro entry in this book, p. 163.

12. See Emile Zola, "Les Naturalistes," *L'Evénement illustré*, May 19, 1868 in *Oeuvres complètes*, vol. 12 (Paris, 1969), pp. 866–69. English translation by the author.

13. On the Intransigeants, see Stephen F. Eisenman, "The Intransigent Artist or How the Impressionists Got Their Name," *The New Painting* (see note 1), pp. 51–60.

14. Stéphane Mallarmé, "The Impressionists and Edouard Manet," *Art Monthly Review*, September 30, 1876. Also see Jean C. Harris, "A Little-Known Essay on Manet by Stéphane Mallarmé," *The Art Bulletin* 46 (December, 1964), pp. 559–63; and Crow, "Modernism" (see note 3).

15. Frédéric Chevalier, "Les Impressionnistes," *L'Artiste*, May 1, 1877, p. 331, as quoted in Paul Tucker, *Monet at Argenteuil* (London, 1982), p. 2.

16. See Barbara Ehrlich White, "The Bathers of 1887 and Renoir's Anti-Impressionism," *The Art Bulletin* 55 (March 1973), pp. 106–26; and Joel Isaacson, *The Crisis of Impressionism: 1878–1882*, exh. cat. (Ann Arbor: The University of Michigan, 1980).

17. Vincent van Gogh to Theo van Gogh, April 1888, letter no. 477a in *The Complete Letters of Vincent van Gogh*, vol. 2 (Greenwich, Conn., 1958), pp. 546–47.

18. Vincent van Gogh to Theo van Gogh, February [21] 1888, letter no. 463 in ibid., p. 525.

19. Paul Cézanne to Emile Bernard, n.d. [1905], letter no. 183 in *Paul Cézanne: Letters*, ed. John Rewald (London, 1941), p. 250.

20. From "Diverses Choses, 1896–1897," an unpublished manuscript by Paul Gauguin that appears in part in Jean de Rotonchamp, *Paul Gauguin, 1848–1903* (Paris, 1925), excerpts from which are translated in Herschel B. Chipp, *Theories of Modern Art: A Source Book by Artists and Critics* (Berkeley, 1968), p. 65.

21. Paul Gauguin to J. F. Willumsen, autumn 1890, as quoted and translated in Chipp, *Theories* (see note 20), p. 79.

22. Paul Gauguin to his wife Mette, n.d. [February 1890], ibid.

23. Vincent van Gogh to Theo van Gogh, June 17, 1890, letter no. 642 in *The Complete Letters*, vol. 3 (see note 17), p. 284.

24. Ibid.

THE THANNHAUSER PICASSOS

Fred Licht

"ALL EUROPE CONTRIBUTED to the making of Kurtz," the novelist Joseph Conrad said of one of his most powerful characters. The same is true of Pablo Picasso, but in addition to Europe we should also include Africa, Asia, and the Americas. Out of an ever-bewildering and fascinating diversity of sources, Picasso forged an oeuvre that is autonomous. Among these sources, Diego Velázquez, Henri de Toulouse-Lautrec, Matthias Grünewald, Henri Matisse, Greek vase-painters, and Oceanic craftsmen caught his interest at various moments of his long career. Although this startling range may be of interest to the historian of art, we must beware of regarding art-historical exercises as in any way defining or interpreting the quality of Picasso's work, just as the multicolored bands of the spectrum in no way prepare us for the experience of sunlight.

If one considers all of the Picassos that passed through Justin K. Thannhauser's hands during his long career as an art dealer, it is tempting to think that those he kept for his own collection represent the "French" Picasso, for they seem to be a fairly natural extension of the French Impressionist and Post-Impressionist works that he collected for himself. Yet to group these Picassos as all "French" does not really hold true. This artist's paintings always provoke and then elude such classifications. Nevertheless, there does seem to be a coherent logic behind the choices made by Thannhauser when keeping certain Picassos for his collection. It is this logic that lends an additional fascination to any thoughtful visit to the Thannhauser galleries of the Guggenheim Museum. Indeed, a study of the entire collection would reveal the taste and the thinking that guided one of the century's most important art dealers—a man who deeply and lastingly influenced public perception of Modern art. It could be said that the dealer is to the art of our century what patronage was to the Middle Ages, the Renaissance, and the Baroque. Yet, while we have superb studies of the patronage of the Medici, the popes of Counter-Reformation Rome, and the French monarchy, there is no adequate analysis of the twentieth-century art market. The Picassos in the Thannhauser donation will play an important role in such a study. Meanwhile, one is justified in enjoying this extraordinary series of Picassos for what they have to offer as individual works of art.

FACING PAGE:
Detail of Pablo Picasso, *Woman with Yellow Hair*, December 1931 (cat. no. 48).

57

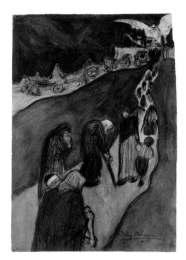

Pablo Picasso, *The End of the Road*,
1898–99 (cat. no. 24).

Picasso's respect for past tradition remained with him throughout his life,
although he extended that tradition toward the most audaciously advanced positions
of his own time. During the various stages of his career he continually relied on
the authority of the past. Iberian and African art as well as eighteenth- and nineteenth-
century philosophical speculation on the nature of space were stimuli for the earliest
phases of Cubism; Italian classical principles were given new life by Picasso in his
paintings of the early twenties; the ideals and experiments of French and German
Romanticism were deeply intertwined with his painting during the phase of his life
that, for lack of a better term, is generally called his Surrealist period. Still more
important, I believe, was his continued reliance on the traditions and underlying
principles that lend to the whole gamut of Spanish art such surprising coherence. The
uncompromising Spanish passion for discovering metaphysical depths while abiding
by the pragmatic testimony of surface appearances must always be kept in mind
when looking at Picasso.

The subject matter, theme, and range of color of *The End of the Road* (1898–99,
cat. no. 24), the earliest of Picasso's works in the Guggenheim Museum's Thannhauser
Collection, clearly mark it as still thoroughly imbued with the artist's origins. Here,
Picasso has depicted two separate processions of people toward a cemetery, above
which hovers a winged figure of Death. Vivian Endicott Barnett has quite rightly
associated this work with several similar images made around the same time. It is the
most developed of this group of related works, and the only one that is in a vertical
format, which Picasso uses to underscore humankind's arduous ascent through life
toward its ultimate destination. He has also added a typically sardonic social comment:
while the mass of impoverished humanity struggles steeply upward and on foot, the
wealthy citizens travel toward the tomb comfortably by coach on a more level road.

The theme of *The End of the Road* is derived from a conception of death that
received its first great expression at the beginning of the modern epoch in Antonio
Canova's *Tomb of the Archduchess Maria Christina* (1798–1805). Of course, the theme of
traveling the inevitable road toward death is at least as old as the Book of Ecclesiastes
and finds its greatest flowering in the many "Dance of Death" depictions of the late
Middle Ages. Death was the great leveler who prepared all men and women to pass
before the Last Judgment, where they learned their subsequent fate among the damned
or the saved. During the Renaissance and Baroque periods, the implied future of the
individual beyond the tomb became the focal point of all funerary or death imagery,
and, up to the last decade of the eighteenth century, death was increasingly regarded as
a mere transition during which the soul ascends to life everlasting. The great revolutions
after 1780 instituted a secular, pragmatic vision and abruptly curtailed the comforting

hope formerly held out by Christian doctrine. Before Canova, all tomb figures had faced toward the spectator to celebrate the deceased and to extol the virtues that lent distinction to his earthly life. Canova reversed this convention in a single revolutionary stroke by turning his figures away rather than toward us. All we can do, all we eventually must do, is join the solemn cortege toward implacable darkness. This theme of death bereft of words of comfort was repeated throughout the nineteenth century in hundreds of printed broadsides, illustrations, paintings, and sculptures that ring their variations on Canova's vision. The last and most impressive of these, Albert Bartholomé's *Monument aux morts* (1899) at Père-Lachaise cemetery in Paris, was surely known to Picasso.

The consciousness of tradition evident in *The End of the Road* is allied with some of the most daring contemporary visual experiments. Picasso's sharp distortion of perspective in this painting demonstrates his familiarity with and understanding of many novel approaches to perspectival space, just as the very narrow range of emotion-charged color associates his picture with Symbolism and the Nabis. Above all, there are strong links to the kind of atmospheric, spontaneous use of lithography that had begun with Francisco de Goya, became the dominant mode of popular graphic expression with Honoré Daumier, and continued in the most original graphics at the turn of the century. From the start, Picasso was thoroughly alert to the lessons that could be gleaned from the great illustrators of his time.

Picasso once said that he had been born knowing how to draw like Raphael. He must have realized from the start that such a great gift could lead to stagnation if the artist was not ready at every moment to challenge himself and challenge above all the nature of such an inherited (as opposed to an acquired) gift. Much has been written about Picasso's "primitivism" and about the tendency toward discovering and exploiting the art of "primitive" or exotic cultures in the decade and a half before the outbreak of World War I. It is wise to keep in mind that "primitive" does not necessarily refer to Oceanic tribes or Cycladic idols. It refers first and foremost to the mysterious urge to husband those mysterious extrasensory faculties (which are nevertheless linked to the five senses) that enable us to re-create in image, word, or sound the forms and forces that dwell within and outside us. It is this urge and this power that Picasso forced himself to penetrate, as did the Romantics before him. In his search, he took what he needed from the wealth of sources that surrounded him, whether an Oceanic mask, Michelangelo, or an exceptionally inventive contemporary. This quest, of course, deflected Picasso from his innate gift of being able to "draw like Raphael," although it is precisely this

Antonio Canova, *Tomb of the Archduchess Maria Christina*, 1798–1805. Church of the Augustinians, Vienna.

prodigious ability of knowing everything that Raphael knew that allowed him ultimately to set before us the discoveries and encounters made during his voyage to the realm of primordial impulses. These conflicting ways and means were already thoroughly developed when he arrived in Paris in 1900. In Barcelona he had proved to himself and to his restricted public his proficiency and inventiveness as a full-fledged artist. It was Paris that made him aware of how much he still had to learn and how much he still had to discover before he could come into his own. Within a dozen years it was perfectly clear that Picasso had met the challenge. Although Paris had subtly changed him, he was consistently true to himself and would remain so to the end of his life. But the Paris art world would never be the same, for Picasso had redefined the making, the perceiving, and the understanding of art in the twentieth century.

Just as *The End of the Road* has a fundamental precedent in Canova's *Tomb of the Archduchess Maria Christina*, Picasso's painting of a dance-hall scene, *Le Moulin de la Galette* (autumn 1900, cat. no. 25), goes back to Edouard Manet's *Masked Ball at the Opera*

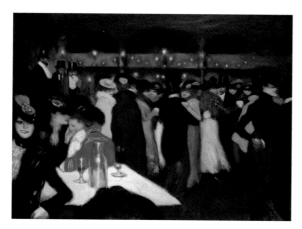

Pablo Picasso, *Le Moulin de la Galette*, autumn 1900 (cat. no. 25).

(1873) in its sensibility and in the kind of social conditions and the interpretation of worldly phenomena that Manet introduced there. Both paintings are based on a powerful rhythm produced by vertical blacks (the gentlemen in evening dress) alternating with vertical bands of intense colors. However, where Manet absorbs this syncopated beat of black and saturated colors in an atmosphere of garish artificial light, Picasso keeps the yellows, plums, greens, blues, and reds from blending together into an impression of shimmering surface and forces each color area into a specific location within a generally somber ambience. Manet's painting purports to be the dispassionate view of a detached but acute observer. Picasso, by emphasizing the isolating function of the somber setting, evokes a far more emotional intensity, one that springs from the contradiction between an attraction to and simultaneous condemnation of the dance hall's pleasures.

Of the many versions of this celebrated Montmartre dancing spot, the best known is Pierre Auguste Renoir's great masterpiece of 1876, *Dancing at the Moulin de la Galette* (1876). But Picasso's Moulin de la Galette is far removed from Renoir's. In fact, one might conceive of the Picasso as a flat and forceful contradiction to all that Renoir's depiction of the same location stands for. What few touches of black there are in the Renoir (and most of the time what one perceives as black is only a deep cobalt blue) have a cheerful, decorative quality and pertain to the coquettish toilettes of the dancing ladies. Picasso, fresh from Spain

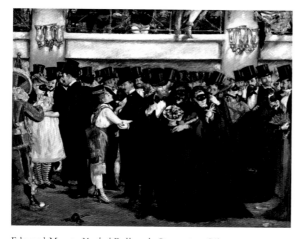

Edouard Manet, *Masked Ball at the Opera*, 1873. Oil on canvas, 59 x 72.5 cm (23 ¼ x 28 ½ inches). National Gallery of Art, Washington, D.C., Gift of Mrs. Horace Havemeyer in memory of her mother-in-law, Louisine W. Havemeyer.

and thoroughly imbued with the social and moral speculations of the Barcelona intelligentsia, breaks away from the color, illumination, brushwork, mood, emotional response, and scattered composition of the Impressionist masterpiece. It is as if he were deliberately demolishing Impressionist ideals.

The contrast with a similar social scene, this one indoors, by Toulouse-Lautrec, whose oeuvre is dominated by his vision of the seamier side of Parisian night life, is just as marked. In *At the Moulin Rouge* (1892–95), Toulouse-Lautrec's spectacular foreshortenings, eccentric handling of illumination, and discontinuous, speedy brushwork catapult us directly into the midst of the hectic scene. Toulouse-Lautrec is fully conscious of the tawdriness, the feverish artificiality of the dance halls he paints but he is also inextricably caught up in it. The pathos that underlies his interpretations (see *In the Salon*, 1893, cat. no. 59) arises from his being wounded by life himself as much as the protagonists in his dance-hall and bordello scenes were wounded by it themselves. Toulouse-Lautrec transmits his state of helpless addiction to the kind of life represented there, and, like all addicts, he simultaneously worships and abominates his enslavement.

Picasso's *Le Moulin de la Galette*, probably the most ambitious and most accomplished composition of the Spaniard's young but already rich career, is based on premises that are radically different. The dark lower zone of the painting, with the exception of the white glove on the extreme left, acts as a threshold that we as spectators hesitate to cross. It is from this privileged position that we view the scene that is at once captivating and lurid. Beginning with the group of figures in the left foreground, with its focal points of intense color, the eye is propelled toward the crowd of dancers in the middle ground and the garlands of lights just beyond, until it is brought to a full stop by the yawning, sinister, flattened arches above them, in the murky darkness of the extreme upper border. A carefully measured equipoise of spontaneity and artifice, of active and static, lends tension to every part of the composition and challenges us to a decision that we need not usually make in Manet, Renoir, or Toulouse-Lautrec: Shall we or shall we not enter the scene before us? Shall we yield to its appeal or not? With typically Spanish impartiality, Picasso challenges us to come to a decision without indicating his own choice.

To place the picture in its proper context, we must also consider the influence of Parisian graphic arts as a great stimulus on Picasso during this phase of his life. Théophile-Alexandre Steinlen played an important role in enabling Picasso to seize the

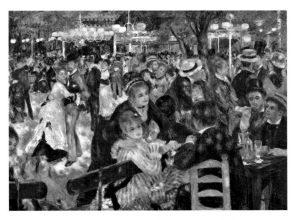

Pierre Auguste Renoir, *Dancing at the Moulin de la Galette*, 1876. Oil on canvas, 131 x 175 cm (51 ⅝ x 68 ⅞ inches). Musée d'Orsay, Paris.

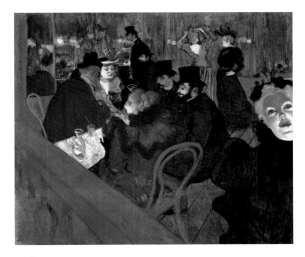

Henri de Toulouse-Lautrec, *At the Moulin Rouge*, 1893–95. Oil on canvas, 123 x 141 cm (48 ⅜ x 55 ½ inches). The Art Institute of Chicago, Helen Birch Bartlett Memorial Collection 1928.610.

Félix Vallotton, *The Charge*, 1893.
Woodcut; composition: 20 x 26 cm
(7 ¾ x 10 ¼ inches). The Museum of
Modern Art, New York, Larry Aldrich
Fund.

enormous variety and vitality of novel Parisian visual opportunities. Félix Vallotton, Steinlen's great Swiss compatriot, who was active in Paris for decades by the time Picasso settled there, probably counts even more strongly in confirming and encouraging Picasso's intuitions. Vallotton has generally failed ever to attain more than a marginal popularity; only his haunting woodcuts, such as *The Charge* (1893), enjoy sporadic moments of public interest, above all for their magnificently designed compositions, eloquent patterning, and daring syncopations. He was one of the most talented of the Nabis and shared their religious enthusiasm as well as their goal of a moral revival in the arts. Unlike his confreres, however, Vallotton brought to the regenerative program of the Nabis a Calvinist rather than a Catholic background and was obsessed by humankind's perverse capacity for evil. This awareness of cruelty, sin, and injustice gave much of Vallotton's work an implicit moralizing slant as well as an overt interest in social and political reform that is absent from other French painters of nocturnal life but very much present in Picasso's *Le Moulin de la Galette*. Also, the predominance of black in Vallotton's prints and paintings is not just a matter of aesthetic strategy or a device to heighten suspense. Black for Vallotton becomes an active narrative element and sometimes even the major protagonist of the social and political dramas he portrayed—a brooding presence in the midst of ostensibly normal or fashionable social situations. It is much the same quality that gives the darkness in Picasso's *Le Moulin de la Galette* the upper hand in spite of the flashing highlights of red, blue, yellow, green, and white. Something clandestine makes itself felt and makes us wary of crossing the barrier into the world of the dancing and flirting couples.

Here, as in all other cases of apparent similarity, one must attribute influence with caution. Picasso had an uncanny faculty for absorbing ideas and transforming them to suit his purposes. He himself was fully conscious of his ability to metamorphose the art of others into something uniquely his own. "No matter what anyone thinks or says, we always imitate something, even when we don't know we're doing it. And when we abandon nude models hired at so many francs an hour, we 'pose' all sorts of other things." Or: "What does it mean," said Picasso, "for a painter to paint in the manner of So-and-So or to actually imitate somebody else? What's wrong with that? On the contrary, it's a good idea. You should constantly try to paint like someone else. But the thing is, you can't!"

Le Moulin de la Galette demonstrates Picasso's ability to capture typically French themes that follow French stylistic precedents but are expressed with a somewhat Spanish inflection. Even more idiosyncratic is the miniature masterpiece in pastel on a Spanish theme, *The Picador* (1900, cat. no. 26), translated into an obviously French visual idiom. The sketchy setting highly stylized into an insistent pattern (noticeable

especially in the handling of the arena's barrier) derives directly from the circus scenes of Georges Seurat and Toulouse-Lautrec. The casual, seemingly uncomposed grouping of bullfighters and bull goes back even further to the example of Manet, as do the flat perspective and the strong colors.

Pablo Picasso, *The Picador*, 1900 (cat. no. 26).

Looked at a little more attentively, these French elements reveal themselves as an imposed veneer. Swinging counter to the large red arc of the arena's barrier and cutting across it is a large dark curve, which is the actual controlling element of the entire composition. It is the edge between *sol y sombra*, between light and shadow, and it provides the dramatic background against which the bullfight attains its true intensity. *Sol y sombra* is not only indicative of a social division between rich and poor (the prices for seats in the shade being more expensive) but also represents the shadow of death at the very heart of the bullfight itself. *Sol y sombra* is a metaphor of uncompromisingly opposed forces pitted against each other without the possibility of any neutral ground between them. The ominous note of the spectacle's deeply religious significance lends the picture a depth of drama that has no counterpart in French painting. Other departures from Gallic practice are the bold

Pablo Picasso, *The Fourteenth of July*, 1901 (cat. no. 28).

chromatic scheme and the manipulation of the pastel medium. One would look in vain for similar coloristic juxtaposition of dark violets, greens, and ochers with black and red in even the most audacious Fauve painting. As for the pastels, instead of being used with the light, evanescent touch of French pastels, Picasso achieves an obdurate, material density in his use of the medium that is reminiscent of the impenetrable physicality of seventeenth-century Spanish still lifes.

Except for its relatively small size, *The Fourteenth of July* (1901, cat. no. 28), is the perfect counterpart to *Le Moulin de la Galette* and illustrates the extremes of style, mood, and traditions that leavened Picasso's imagination during those heady early years in Paris. The space created in *Le Moulin de la Galette* draws us forward; in *The Fourteenth of July* everything seems to be hurtling toward us. In the earlier painting, color is contained within clearly outlined and relatively small areas; here color explodes as freely as the firecrackers set off by the festive crowd. But the composition, far from being cheerfully scattered, is masterfully disciplined. The figures streaming toward us at the lower left are counterbalanced by the wedge-shaped crowd on the right and the steady beat of the stepped roof lines in back. Picasso emphasizes the counterpoint of the two groups by making nearly all the figures on the right blend into an indistinguishable blur of colors (primarily red and blue) while the figures on the left are treated with

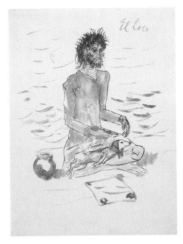

Pablo Picasso, *The Madman*, 1903–04
(cat. no. 30).

Diego Velázquez, *Francisco Lezcano*,
ca. 1636. Oil on canvas, 107 x 83 cm
(42 ⅛ x 32 ⅝ inches). Museo Nacional
del Prado, Madrid.

far more individuality. Many of the faces of the figures on the left are limned with
heavy black outlines, and those in the foreground have been given recognizable features
and even a certain level of expression. The man in a white shirt with his chin supported
on his fist makes a sullen impression similar in mood (and in technique as well)
to Daumier's *The Third-Class Carriage* (ca. 1862, National Gallery of Canada, Ottawa;
another version from 1863–65, The Metropolitan Museum of Art, New York).
Throughout the group on the left, Picasso has highlighted the red and blue with
contrasting patches of white, yellow, green, pink, and pale blue. This relatively modest
painting encompasses both the general cheer of official holidays as well as the mournful
exceptions that are the inevitable concomitant of public festivals. Like Manet in his
The Rue Mosnier with Flags (1878, The J. Paul Getty Museum, Los Angeles), which also
depicts a national celebration, Picasso adds a throb of melancholy in the midst of the
gay celebrations. It is impossible to prove that Picasso knew the picture by Manet. But
with Picasso it is always safer to assume that he knew more than one supposes.

A certain sociopolitical bias is constantly at work in Picasso at this time, the
kind of attitude one finds in Rainer Maria Rilke's oft-quoted, somewhat sentimental
"Armut ist ein grosser Glanz von Innen" (Poverty is a great interior radiance). In
Picasso's imagery, this mood gradually consolidates into a universal symbol of existence
at the extreme margins of human society. It is a theme that is quintessential to all
Spanish painting; we encounter it just as unequivocally in the royal personages and
minions of Velázquez's *Las Meninas* (1656, Museo Nacional del Prado, Madrid) as we do
in José de Ribera's *The Beggar*, also known as *Club-foot* (1642, Musée du Louvre, Paris).

Certainly it is this quality that moved Picasso in 1903 to make a drawing based
on Eugène Carrière's painting *The Artist with His Wife and Their Son* (1895–96, National
Gallery of Canada, Ottawa). Stylistically related to another of his drawings, the
somewhat more picturesque *In the Café* (1901, cat. no. 27), Picasso's *Woman and Child*
(1903, cat. no. 29) aims at a deeper pathos and intends to involve us with the disinherited
of our society. In a watercolor from 1903–04, *The Madman* (cat. no. 30), the still somewhat
inchoate mood takes on a more concretely symbolic appearance. There can be little
doubt that Velázquez's series of dwarfs and idiots is related in some tenuous way to this
staring beggar accompanied by his scrawny dog. Yet one wonders whether it is not
simply a kind of reflex on our part that automatically associates the work of two great
Spanish masters. Velázquez represents his crouching fools, for example *Francisco Lezcano*
(ca. 1636), as if he were bearing witness in a court of law to something he had observed.
Picasso completely transfigures his lonely, emaciated beggar into a prophetic figure
devoid of corporeal density, rapt in an incommunicable vision. *The Madman* is essentially
whimsical. It gains in importance, however, by being a link in the chain that leads from

Picasso's earlier formalism toward an emotionally charged style that perfectly balances personal sentiment with social considerations. The work that is fully emblematic of this development in Picasso's art is the painting *Woman Ironing* (1904, cat. no. 32).

Although Pierre Puvis de Chavannes may have been far from Picasso's consciousness when he worked on *Woman Ironing*, his work in some respects prefigured Picasso's so-called Blue Period. Puvis, always thought of as an academic or at the very least as an establishment painter, was actually self-taught, but by the 1880s he came to be recognized as a central figure in French art. The avant-garde, especially Gauguin, admired him for his directness, the authenticity of his vision, and his innovative compositions apparent in such works as *The Poor Fisherman* (1881). The leaders of the Beaux-Arts wing saw in him an artist who defended the fundamental values of art in accordance with the ideals of French classicism. Auguste Rodin recognized in him a colleague who was doing in painting what he himself was doing in sculpture: reconciling past and present, creating a profoundly national French art that would serve to unify a country threatened by unscrupulous social and political traitors. For anyone interested in seizing the most irreducible essence of everything that was French in French art, Puvis could serve as a catalyst.

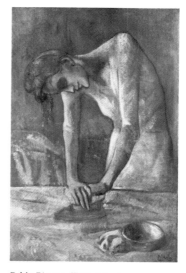

Pablo Picasso, *Woman Ironing*, 1904 (cat. no. 32).

Picasso may have found certain aspects of Puvis's style especially resonant for him at that time. Puvis used an extremely restrained palette—blues, grays, and whites accented by infinitesimal touches of dusty yellow and red—to evoke a veiled, milky atmosphere in which the austere outlines of all forms achieved a highly persuasive, elegiac note. This amorphous space without volumetric definition contributes to the dreamlike, incorporeal, supremely composed mood. The generalized tranquility of Puvis's visions is heightened into a sensation of irremediable loneliness. Willful distortions create dramatic tensions without the necessity of narrative or realistic descriptions of modeled volumes. In Picasso's hands, however, the slightly anemic coloring is given greater expressive force by being brushed on with calligraphic boldness utterly foreign to Puvis and far more reminiscent of Edgar Degas. Unforeseeable at the time but certainly noticeable in retrospect, Picasso's handling of space began to take on a new direction. The depth-progressions of Puvis's paintings were achieved by setting register after register of alternating values of a single hue. Picasso's suggestion of space is just that: a suggestion. Here again, his Spanish background comes into play. In such passages as the heaped linens on the left in *Woman Ironing*, one can sense the indistinct world of Goya's *Los Caprichos* etchings (published 1799). The linens, separated by a strong horizontal line from the ironing table,

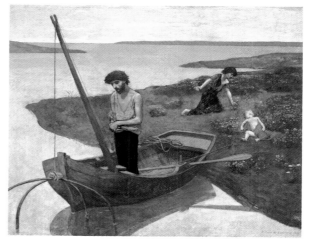

Pierre Puvis de Chavannes, *The Poor Fisherman*, 1881. Oil on canvas, 155.5 x 192.5 cm (61 ¼ x 75 ¾ inches). Musée d'Orsay, Paris.

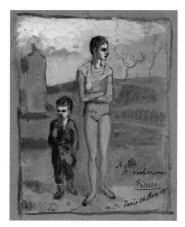

Pablo Picasso, *Young Acrobat and Child*,
March 26, 1905 (cat. no. 34).

do not actually appear as existing behind it but instead seem to rise like mountains above a horizon. By means of this ambiguity of scale, Picasso achieves a monumentality of space that is appropriate to the looming, haggard figure of the laundress who also appears larger than life. Indeed, following the same strategies used by Goya, Picasso treats her occupation not only as a subject of social compassion but elevates it to the level of a universal symbol. The woman's drudgery, which evokes the plight of an urban proletariat, also assumes a biblical ring akin to the injunction of eternal toil with which God curses mankind in Genesis and which is described with almost unbearable majesty in Ecclesiastes.

It is one of the joys of the Thannhauser Collection that one is afforded a step-by-step documentation of Picasso's development during this heroic period of Modern art. *The Madman* introduces the theme of existential isolation by depicting the specific situation of a beggar, with his bowl, his dog, and the placard on which his appeal for alms is inscribed. *Woman Ironing* transforms the theme into a monumental statement of the human condition, while *Young Acrobat and Child* (March 26, 1905, cat. no. 34) modulates toward a more pensive, lyrical conception. The two uncostumed circus figures in this painting seem to be associated in some vague way, yet they are disconnected. Within their acute isolation—suggested by the desolate landscape, the bleak house in the distance, the barren trees—they turn away from one another, following their own strains of melancholy. Still, it is here far more than in the *Woman Ironing* that Picasso willingly relinquishes thematic considerations in order to emphasize questions of style. As always happens after Picasso arrives at a great solution, he impatiently moves on in a divergent direction. Linear outlines are erratic and involuntarily tense. Picasso's hand seems to move with the distracted compulsion of a nervous doodler. The choice of color is of a deliberate refinement reminiscent of the most sensuous moments of French Rococo art. In fact the dominant hue is not just "rose," as Gertrude Stein's description of this particular phase of Picasso's work would have it. It is a specific rose that is called *rose pompadour*, or *rose fané*, capable of conveying the warmth but also the sadness of love.

Picasso translates this vision of solitude onto a personal level in many of his portraits around this time. With deft touches of almost maudlin surface description, he delineates a sharply drawn portrait in *Profile of Woman with a Chignon* (1904, cat. no. 31). Yet his draftsmanship possesses a magical ambiguity. Almost every line in this profile can be read simultaneously as contour outline, as modeling line, or as an autonomous conductor of energy. In *Fernande with a Black Mantilla* (1905–06, cat. no. 33), Picasso delves further inward. The possibility of expressing the innermost moods of a portrait sitter by means of the surrounding landscape originated with Leonardo da Vinci and made his Mona Lisa the authoritative ancestor of all portraiture that goes beyond

physiognomic description. In Picasso's tenderly enigmatic portrait of Fernande Olivier, his mistress during the early Parisian years, he develops Leonardo's strategy. But instead of containing the landscape in back of his sitter as Leonardo did, he makes of the surrounding atmosphere a fluctuating, veiled matrix that no longer appears as a background but envelops the entire figure, interposing itself between us and the sitter. Emotionally, the effect is similar to Correggio's *Jupiter and Io* (ca. 1532, Kunsthistorisches Museum, Vienna), in which an amorous cloud wraps the central figure in its embrace.

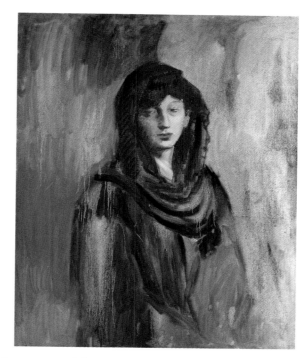

Pablo Picasso, *Fernande with a Black Mantilla*, 1905–06 (cat. no. 33).

Fernande appears before us almost like a wraith materializing out of the insubstantial mist that surrounds her. The technique points to some of Picasso's future experiments during the Analytic phase of Cubism. The periphery of the painting is nothing but canvas rubbed over with thin washes of lightly brushed-in grays. This formless, coordinateless field cannot really be spoken of as a background of the figure but is instead the very matrix from which the figure condenses in the center of the canvas, much as the facets and polygonal forms of Cubism condense toward the center of the canvas out of the deliberately amorphous realities of the painter: brush, pigment, and canvas. Of particular interest here is Picasso's freedom in handling the paint, as shown in his depiction of the right shoulder and arms, where he has thinned the paint and allowed it to drip in accordance with the force of gravity. But there is more to it than that. The streamers of trickling paint originate well above the shoulder, at first adhering to the canvas behind the shoulder and then trickling down to cover it so that an effect of ambiguous, nonperspectival space is created as the paint courses downward.

More than any other painting in the Thannhauser Collection, *Fernande with a Black Mantilla*, in spite of its almost monochrome palette, documents the importance of Fauvism during Picasso's early career. *The Fourteenth of July*, with its bright colors, would seem to indicate that in 1901 Picasso was already investigating areas of what a few years later would be Fauvist theory. Yet *The Fourteenth of July*'s calligraphic brushwork, textural evocations, and patterning of brushstrokes link it to a tradition that begins with Vincent van Gogh and may have been transmitted to Picasso by such artists as Pierre Bonnard or Edouard Vuillard. Fauvism, especially as it appears in the major works by Matisse, militates against calligraphy and against the textural differentiation of which oil paint is capable. Color itself, freed from brushwork and detached from textural description, is the very soul of Fauvism. Line is evoked only where color areas become tangential, and there are frequent deliberately smudgy passages attesting to the free rein that is given to the flow of color or the way it is absorbed and spread by the ground to

which it is applied. It is this new, risky manner of paint application that must have attracted Picasso while at work on the portrait of Fernande.

The great Italian, Flemish, and Dutch portraitists introduce us to their sitters by revealing the sitters' personalities to us in various ways. In the hands of Peter Paul Rubens, for instance, such introductions are always delightful; and in the case of Rembrandt, they can be overwhelming and unsettling. Spanish painters, for the most part, refrain from revealing their sitters. Respectful of the vulnerable, fragile nature of all men and women, they represent their sitters with utmost reserve. Raphael, Rubens, and Rembrandt predetermine our response to their sitters; Velázquez withdraws and insists that we ourselves unravel the enigma of the sitter's individuality. It is much the same in the case of Picasso's portraits, especially in 1906, the *anno mirabilis* of Picasso's life, when he gradually left his apprenticeship behind (an apprenticeship that produced some masterpieces but that is still strongly marked by his assimilation of all the ferment of contemporary French art) and came into his own. It is the year in which he prepared, as the Gósol sketchbooks (Musée Picasso, Paris) prove, the ground for that triumphant but unending battleground that is *Les Demoiselles d'Avignon* (1907, The Museum of Modern Art, New York).

BEFORE MODERNISM, still life was practiced in France primarily for the opportunities it afforded to display brilliant virtuosity. In Flanders and especially in the Netherlands, virtuosity also counted for much but was inflected in the direction of social commentary, bearing witness to the wealth and taste of a sophisticated patronage. In Italy, still life, though occasionally practiced with magisterial skill, never attained great importance and was once again considered a perfect vehicle for decorative and technical virtuosity. Only in Spain did still life transcend both decorative and technical values. It is also in Spain that still life instead of being a more or less secondary field of endeavor rose to the same heights as other genres. Spanish still life evokes the tragic dimension of our existence as isolated individuals in the world. In Jean-Baptiste-Siméon Chardin, in Willem Kalf, in Caravaggio, plums are paired with glasses of water, worm-eaten apples strike an accord with wilted vine leaves, beautifully fashioned crystal vessels are made to suggest even greater luxury by being shown with exotic fruit. In the still lifes of Spain, the proudly tragic isolation of each element

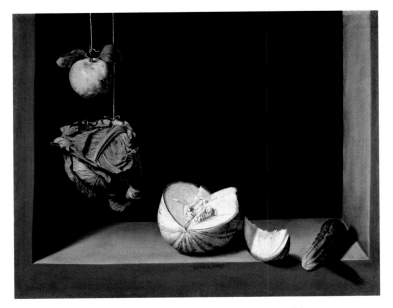

Juan Sánchez Cotán, *Quince, Cabbage, Melon and Cucumber*, ca. 1602. Oil on canvas, 69 x 84.5 cm (27 ¼ x 33 ¼ inches). San Diego Museum of Art, Gift of Anne R. and Amy Putnam 1945:043.

rises to the solemnity and expressive power of the most complex religious paintings, as evident in works such as Juan Sánchez Cotán's *Quince, Cabbage, Melon and Cucumber* (ca. 1602). It is not surprising that Picasso should have sought in still lifes something that goes far beyond innovative harmonies, novel relationships, or carefully elaborated formal solutions, although all of these possibilities are also present.

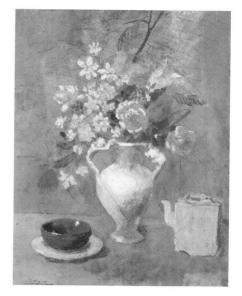

Pablo Picasso, *Still Life: Flowers in a Vase*, 1906 (cat. no. 36).

If we remember that the period from 1900 to circa 1906 is a period of assimilation for Picasso, *Vase of Flowers* (cat. no. 35), an ink drawing from 1905–06—the earliest of the still lifes in the Thannhauser Collection—comes as no surprise. The influence of van Gogh has often been remarked on, but the drawings of Vuillard, with their discontinuous flecks and sharply varying densities of atmosphere, are perhaps even closer to this early Picasso than are the works of the great Dutch master. The gouache *Still Life: Flowers in a Vase* (1906, cat. no. 36), for all its surface appeal and apparent conventionality, presents a series of perplexities. The nature of Picasso's flowers, the space they inhabit, and their relationship to the other objects all have a suspended, undefined air about them. Whereas Renoir's *Still Life: Flowers* (1885, cat. no. 58) appears convincingly naturalistic, Picasso's attention is focused on creating ambiguities. Indeed, the branch of yellow flowers at the top could easily be read as being not part of the bouquet but a decorative element of the wallpaper just behind it. But is that pink background anything as substantial as wallpaper, or is it a vaporous cloud of rose-colored light? In these respects, the still lifes of Odilon Redon must have been of prime importance to Picasso during the brief span of the Rose Period.

Another puzzle in this still life is the random scoring of the surface by means of two different instruments. Did the artist wish to destroy his picture after he had finished it? He would hardly have bothered then to scratch it rather delicately with both a blunt point and a sharp point. Or did he wish to give it the look of an etching plate from which all the impressions had been pulled—that is, is the scoring an indication of being finished with the gouache's lyricism and sensuous indulgences? Equally puzzling are the two forms that flank the central motif of the vase of flowers. They are a startling instance of Picasso's penchant for juxtaposing in a single canvas forms that belong to radically different traditions and emotional intensities. The dark-green bowl on the left, which seems to have been transported from an early Velázquez still life, is earthy and dense, an aggressive contrast to the pervasive pink atmosphere. The chocolate pot on the right, however, appears almost transparent in the way its hues mimic the colors immediately surrounding it and merge with the overall tonality of the picture. This ability to bring contradictory styles and divergent degrees of finish together within the confines of a single painting became one of the dominant principles of Picasso's artistic conception, perhaps most notably in *Les Demoiselles d'Avignon* and in his Synthetic Cubist works.

69

The later still lifes in the collection all depend to some degree on the Cubist revolution wrought by Braque and Picasso during the six years before the outbreak of World War I. But Thannhauser seems to have been more interested, at least as far as his personal collection was concerned, in the postwar transformations of Cubism than with Analytic Cubism itself. *The Table* (December 24, 1922, cat. no. 44), is a good example of how Picasso adapted Cubist techniques in his Synthetic Cubist works. Here, space is represented as a variable entity that insinuates itself between forms, and recognizable objects such as the tabletop or the glasses set out on it have a now-you-see-it-now-you-don't ambiguity. Many forms "bleed" into a contiguous but very different object. Take for instance the glass with a diamond decoration etched on its side. The right side of its base is not completely defined but merges with the area surrounding it, as the white on the interior of the glass appears to drain into the white of the tablecloth. This use of Cubist *passage* has a clear precursor in *Before the Mirror* (1876, cat. no. 17) by Manet. In the Manet, the woman's left shoulder strap tilts toward the mirror and at a certain point the shoulder and its reflection, though belonging to two different levels of reality and to two different positions in space, are subsumed by a series of autonomous brushstrokes that can be interpreted as representing the shoulder, the reflection of the shoulder, or a pictorial definition of the actual canvas surface of the painting in which the shoulder and its reflection are both absorbed. What is just a small visual incident in Manet becomes a frequent effect in Paul Cézanne and a ruling principle of Cubism. Depicted reality, the reflection of depicted reality, and adherence of both these illusions to the physical realities of canvas and pigment are paramount concerns of Cubism. This already vertiginous juggling is compounded in Cubist collage, which introduces random bits of extraneous reality (newspaper clippings, etc.) into the interplay of varying levels of pictorial illusion.

Pablo Picasso, *The Table*, December 24, 1922 (cat. no. 44).

These fundamental elaborations of Cubism are given a new monumentality in two still lifes of the late 1930s, *Still Life: Fruit Dish and Pitcher* (January 21–22, 1937, cat. no. 49) and *Still Life: Fruits and Pitcher* (January 22, 1939, cat. no. 50). The latter is a lyrical hymn to joie de vivre, which in retrospect derives a particular poignancy from having been painted just a few months before the outbreak of World War II. More imposing is the earlier still life, with its ample geometry and its resonant colors. The table and the objects on it are presented as if they are surging forward on the crest of a wave. The effect is in part due to the daringly simple construction of the background, divided into two halves of slightly different brown hues, against which the vividly colored table and objects appear to float. This evocation of a space dynamically

Pablo Picasso, *Still Life: Fruits and Pitcher*, January 22, 1939 (cat. no. 50).

moving forward is not arrived at by any kind of calculated perspectival construction but depends on the interaction of all the colors and forms of the painting. The conjunction of the two brown "walls" clearly dictates the color shifts that occur in the two nearly symmetrical halves of the image and sets the objects into sharp relief; and at the same time, it creates the illusion of separating the fruit dish and pitcher, an isolating effect that is in full accord with the tradition of Spanish still life.

Jean-Baptiste-Siméon Chardin, *The Ray*, 1728. Oil on canvas, 114 x 146 cm (44 ⅞ x 57 ½ inches). Musée du Louvre, Paris.

The latest of Picasso's works in the Thannhauser Collection, *Lobster and Cat* (January 11, 1965, cat. no. 35), attests to his unbroken creative energy during the last years of his life. The painting demonstrates Picasso's ability to derive serious implications from what is essentially humorous. The subject of the lobster and cat refers to one of the most beloved paintings of French art, Chardin's *The Ray* (1728). In both paintings, a cat is aroused to vicious hissing by the menacing aspect of an item of seafood that is as delicious to the palate as it is horrendous to the eye. What is so astonishing in Picasso's painting is that he is able to retain the humorously anecdotal premise of the eighteenth-century painting while simultaneously heightening the encounter between cat and lobster into a miniature but extremely effective metaphor of aggression aroused by fear. It is a theme that preoccupied Picasso. If one makes all due allowances for the differences

Pablo Picasso, *Lobster and Cat*, January 11, 1965 (cat. no. 55).

between the categories of miniature and monumental expression, it is a theme that also occurs in *Guernica* (1937, Museo Nacional del Prado, Madrid). The comparison strikes an absurd note until one remembers Picasso's frequent shifts from monumental to miniature, from trifling to significant and back again. These ostensibly erratic whimsicalities aim at an ironic demonstration of the artificial conventions of our thought and of our feelings. Here again, as in *Lobster and Cat* and in so much of Picasso's work, it is impossible to assign unequivocal ethical values to the animal protagonists. Just as it is impossible to think of *Guernica*'s bull and horse as being either all good or all evil, so is it impossible (on quite a different level of seriousness, of course) to come to a clear decision regarding the lobster and the cat in the Thannhauser painting. Both animals are potentially as innocent as they are dangerous.

IN PICASSO'S CAREER, the Rose Period represents a time in which the artist indulged personal whims before turning to the most audacious and demanding adventure in the history of twentieth-century art: Cubism. However, even during the 1910s and 1920s, in which his work was dominated by Analytic and Synthetic Cubism, there were frequent

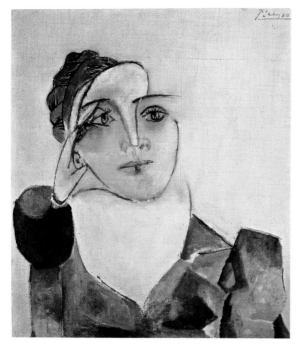

Pablo Picasso, *Portrait of Dora Maar*, 1936. Oil on canvas, 65 x 54 cm (25 % x 21 ¼ inches). Private collection.

returns to classicism in his drawings and his paintings. Picasso's classicism can be studied in its purest form in two paintings of small dimensions but of monumental effect: *Three Bathers* (August 1920, cat. no. 40) and *Woman in an Armchair* (1922, cat. no. 42). Both belong to a stage of the artist's career that indicates a joyful relaxation after the violent years of World War I. Powerfully persuasive modeling, melodically long outlines, vigorous earth colors, and a noble harmony between spirit and carnality prove that there was nothing vain in Picasso's claim of kinship with Raphael.

PICASSO'S APPROACH TO PORTRAITURE evolved continuously throughout his career. By the 1930s, neither the consistency of a given personality nor the description of an individual's physiognomy was the primary goal of his portraits, even though he continued to produce such intimate likenesses as *Portrait of Dora Maar* (1936). In *Head of a Woman (Dora Maar)* (March 28, 1939, cat. no. 51), Picasso penetrates to yet another dimension of portraiture. Here, through the effect of powerful patterning and clamorous colors, Picasso expresses a generalized state of existence comparable in some ways to the medieval notions of the humors or temperaments, in which individuality is subsumed in the psychological and existential type. The confident forthrightness and self-possessed dignity of the sitter radiate from this intricately composed portrait.

The vital characterization of works such as *Still Life: Fruit Dish and Pitcher* or *Still Life: Fruits and Pitcher*, in which apples or crockery have the presence of fully developed dramatis personae, has its concomitant in several of Picasso's figure paintings, such as the most celebrated and appealing of the Picassos in the Thannhauser Collection, *Woman with Yellow Hair* (December 1931, cat. no. 48), a portrait of Marie-Thérèse Walter sleeping. She is cradled within the gentle perimeter of her arms; contained and container are compactly one, like the germ within a seed. In sleep, she is liberated from the need to recognize and react to the world. Nothing impinges on the figure from the outside. In many of his paintings, drawings, and etchings, Picasso represented the drama that binds artist and model, autonomous personalities that are nevertheless incomplete without the other. The model in most of these artist-and-model images is usually depicted as the detached and triumphantly innocent partner. Although she herself remains passive, she induces a dynamic transformation, a creative reaction within the fantasy and intuition of the artist. In *Woman with Yellow Hair*, the artist seems to vanish altogether. The painting emanates a serene chastity that can only be the attribute of the unobserved. How Picasso arrived at making manifest this sense of unconditional

Pablo Picasso, *Head of a Woman (Dora Maar)*, March 28, 1939 (cat. no. 51).

intimacy without violating the intimacy by the very act of painting it is the supreme secret of his art.

A long tradition extends behind this remarkable painting. Picasso, always conscious of living and working at the point at which past and future intersect, was certainly fully aware of this tradition, which begins with Giorgione's *Sleeping Venus* (ca. 1510, Gemäldegalerie, Dresden) and which always contains the double theme of chastity and fecundity. Without recourse to the symbolic language of mysticism (best exemplified by the biblical Song of Songs) this pictorial tradition reconciles physical opulence with utmost purity. It is apparent that Picasso willingly associated himself with this tradition, which includes Eugène Delacroix, Jean-Auguste-Dominique Ingres, Matisse, and Rembrandt but which definitely excludes Rubens— or rather, the kind of Rubens that Picasso imagined when he spoke disparagingly of the great Flemish master. It is in rare moments such as the one represented by *Woman with Yellow Hair* that Picasso rescues for our time an optimism that would seem to be precluded by the harsh and cruel realities of the century. We need only glance at *Girl Before a Mirror* (1932, The Museum of Modern Art, New York), to realize that Picasso knows all the poisons of our epoch—poisons that fragment the personality and turn our inmost selves into savage battlefields. But for each poison, he also finds the antidote. One cannot help but sense the healing quality that emanates from such a masterpiece.

Every moment of our lives turns into memory. It is one of the great powers of true artists to endow memory with permanence. No artist of our century was possessed of a more prodigious memory or of a more persuasive power to bring life to what he remembered than Picasso. By that token, Picasso extended not only our memories but our lives. No wonder that his very name continues to cast a spell of admiration and gratitude over us all.

CATALOGUE

Georges Braque

LANDSCAPE NEAR ANTWERP

(PAYSAGE PRÈS D'ANVERS)

1906
Oil on canvas, 60 x 81 cm (23 ⅝ x 31 ⅞ inches)

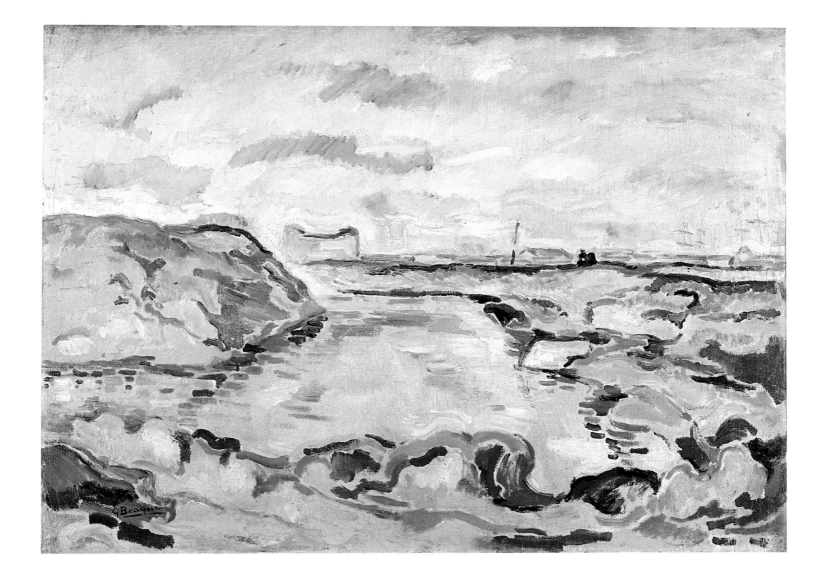

Georges Braque

LANDSCAPE NEAR ANTWERP

by Jack Flam

IN MARCH 1906, GEORGES BRAQUE exhibited his work publicly for the first time, at the Salon des Indépendants in Paris. The seven paintings he showed there—which he later destroyed—were done in a style that combined naturalistic color with Impressionist brushstrokes.[1] At the exhibitors' opening, he met André Derain and Henri Matisse, whose work was considerably more advanced than his.[2] Derain showed three forceful pictures at that Salon, and Matisse exhibited his revolutionary *Le Bonheur de vivre* (1905–06, Barnes Foundation, Merion, Pennsylvania); concurrently, the Galerie Druet mounted a Matisse retrospective that included some of his most radical Fauve paintings.

These brightly colored and vigorously painted Fauve works disquieted Braque and gave him much to think about when he returned home to Le Havre later that spring. "The painting of the Fauves had impressed me because of what was new in it," he later remembered, "and that was what I needed."[3] Along with two of his fellow Havrais painters, Raoul Dufy and Emile-Othon Friesz, he helped to organize the Cercle d'Art Moderne du Havre, whose exhibition at the Hôtel de Ville that May provided a local forum for progressive painting.

In June, Braque and Friesz traveled to Antwerp, one of the most active ports in Europe, where Friesz had worked the previous summer. The Flemish-speaking city was in some ways like a larger version of Le Havre, so it offered the advantage of providing familiar motifs while being foreign enough to give them the feeling of being abroad. This sense of displacement may well have encouraged them to take greater liberties in their paintings.

Braque and Friesz were in Antwerp from June 12 until September 11.[4] They stayed on the less built-up left bank of the Scheldt River, from which they usually painted scenes of the busier main port across the way,[5] such as Braque's *The Port of Antwerp*. Probably one of

the first paintings that Braque did in Antwerp was *Window Overlooking the Scheldt* (location unknown), in which the composition and brushwork are clearly indebted to Matisse's already well-known *Open Window, Collioure* (1905, National Gallery of Art, Washington, D.C.), which Braque had recently seen in Paris.[6] Only gradually, in paintings such as *Landscape near Antwerp*, was Braque able to distance himself from the naturalistic color and Impressionistic rendering of his previous paintings and to take his own measure in relation to the Fauves.

The setting of *Landscape near Antwerp* is the dunes on the left bank of the Scheldt.[7] The view, which faces in a northeasterly direction toward the right bank, includes a body of brackish water and the surrounding dune and marsh area. On the opposite bank, we can see one of the large commercial buildings and some of the smaller houses along the embankment. Near the center of the painting is the brightly colored spar of a sailboat, and in the distance off to the right are the more elaborate masts of a group of schooners.

The color scheme reflects Braque's interest in the chromatic boldness of Fauve painting. The dominant harmony is based on a triad of near-complementaries—green, red/reddish violet, and yellow—which are set against each other in a subtle and luminous way. If this and related paintings can be said to have initiated Braque's Fauve period, it is not only because of their imaginative color, but also because of the emphasis that Braque gave to the patterning of forms on the surface of the canvas. The remarkable progress that Braque made during his stay in Antwerp is evident if we compare this painting to another rendering of the same view, also entitled *Landscape near Antwerp* (private collection, Paris), which was painted earlier and on a smaller canvas.[8] This smaller painting is somewhat darker, and the greater amount of blue in it lessens the vibrant effect produced by the fresh, near-complementary colors in the Thannhauser painting.

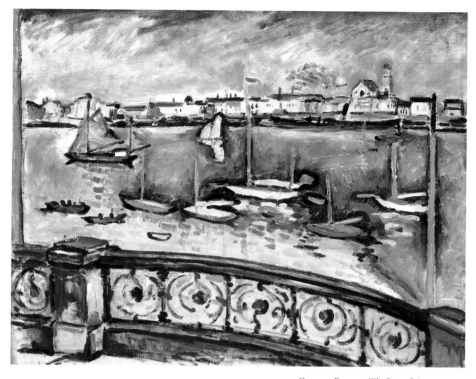

Georges Braque, *The Port of Antwerp*, 1906. Oil on canvas, 49.8 x 61.2 cm (19 ⅞ x 24 ⅛ inches). National Gallery of Canada, Ottawa, Purchased, 1951.

The smaller version appears to have been painted directly from nature, while the Thannhauser painting appears to have been done as a variation on it rather than directly from the landscape.[9] The brushstrokes in the smaller painting are more angular, more spontaneous, and less systematic. Moreover, the composition in the smaller painting is considerably less structured. It has a lower horizon line and a more dramatically rendered sky, and the body of water that dominates the lower half is rendered in a more generalized way. The Thannhauser painting, by contrast, seems more effortless and calculated and contains a finer balance between the representation of the motif and the exigencies of the pictorial construction. The picture is lightly painted with a good deal of the canvas ground left showing, and there is no evidence of preliminary pencil drawing. Rather, it was executed following Paul Cézanne's practice of painting and drawing at the same time.[10] It also employs a carefully

considered dialogue between curved and straight lines, which is especially telling at the edges of the body of water. The wedgelike form of the water has the interesting effect of seeming to follow a one-point perspective into deep space while at the same time asserting itself very strongly as a finely designed flat shape. This tension between surface and depth is maintained by the dotted accents of color in the water: they articulate the depth of the area near the mound of earth, but at the same time they strongly restate the surface of the picture. These are stylistic innovations that Braque first worked out in Antwerp and that he would continue to develop the following fall while working on the Mediterranean coast at La Ciotat and L'Estaque.

A second related painting, misleadingly titled *The Bay of Antwerp* (private collection, Liechtenstein),[11] is usually assumed to be of the same motif as in the two versions of *Landscape near Antwerp*, except that the artist is said to have added a dock and "omitted the large background building."[12] In fact, the presence of the dock in the foreground, and of the houses on the near side of the river (as well as the somewhat different shape of the mound of earth), indicate that this painting was probably done from a nearby but different location in the dune area.

Landscape near Antwerp is an especially interesting transitional work, which appears to have been done fairly late in Braque's stay there, when he and Friesz were living in the Saint Anna district. In its finely balanced color harmonies and inventive brushwork, and in the attention that Braque gave to its underlying structure, it anticipates the more fully realized paintings that he would do at L'Estaque the following fall.

This painting also makes us reconsider the recently developed notion that the specific geographical locations in which Fauve paintings were done exerted a great deal of influence on the way in which they were rendered.[13] For although it was in Antwerp that Braque made the coloristic breakthrough that would have such a determining effect on his subsequent painting, the city itself has been characterized as being notable for its "urban grayness."[14] Braque did not discover Fauve color in Antwerp itself, but in the Fauve paintings that he had seen before he went there. Later that year, when he decided to go to the south of France, it was in order to have the actual landscape be more of a help, rather than a hindrance, to what he wanted to accomplish with color. As he later told Jacques Lassaigne, he went to L'Estaque "with an idea already formed in my mind. I can actually say that I had devised my first pictures of L'Estaque before I left."[15] Something similar could be said of his experience in Antwerp. Braque went there to absorb the chromatic and structural innovations of Fauve painting that had so challenged him during the previous months. In works such as *Landscape near Antwerp*, he began to consider the structures of his paintings as parallels to nature rather than imitations of it. This was the basic insight that paved the way not only to his subsequent Fauve paintings but also to Cubism.

NOTES

1. On Braque's early style and the destruction of these paintings, see Nadine Pouillon and Isabelle Monod-Fontaine, *Braque: Oeuvres de Georges Braque (1882–1963)* (Paris, 1982), p. 18; and Bernard Zurcher, *Georges Braque: Life and Work* (New York, 1988), p. 284. The titles of the works that Braque exhibited in the 1906 Salon des Indépendants are given in Judith Cousins, "Documentary Chronology," in William Rubin, *Picasso and Braque: Pioneering Cubism*, exh. cat. (New York: The Museum of Modern Art, 1989), p. 341.

2. See Judi Freeman, *The Fauve Landscape*, exh. cat. (Los Angeles: Los Angeles County Art Museum; New York: Abbeville Press, 1990), p. 86.

3. Dora Vallier, "Braque, la peinture et nous," *Cahiers d'Art* 29, no. 1 (October 1954), pp. 13–24; quoted in Zurcher, *Georges Braque: Life and Work*, p. 17.

4. Until fairly recently, it was believed that Braque and Friesz were in Antwerp only toward the end of the summer. Pouillon and Monod-Fontaine date their stay from August 14 to September 11 (*Braque: Oeuvres de Georges Braque*, p. 18), as do Jean Leymarie (*Georges Braque*, exh. cat. [New York: Guggenheim Museum/Prestel, 1988], cat. no. 3) and Zurcher (*Georges Braque: Life and Work*, p. 284). But Cousins discovered that the Laurens archives contain Braque's receipts for hotel bills in Antwerp, which cover the periods from June 12 to July 12 and August 11 to September 11 ("Documentary Chronology," p. 434). Subsequently, Freeman notes that in addition to Braque's hotel receipts, correspondence from the two artists clearly indicates that they were in Antwerp for the whole period from June 12 to September 11 (*The Fauve Landscape*, pp. 202–03).

5. Braque and Friesz stayed first at the Lusthof Frascati, Vlaamsch-Hoofd bij Antwerp (June 12–July 12); later, they were at the Pension Rosalie van der Auwera, Saint Anna, Vlaamsch-Hoofd (August 11–September 11). Where they stayed from July 13 to August 10 is not known. See Freeman, *The Fauve Landscape*, p. 92 and p. 213, n. 31. Vivian Endicott Barnett says that they rented an abandoned casino on the banks of the Scheldt as a studio, from which they had a view of the harbor and river traffic ("*Landscape near Antwerp*," in *Guggenheim Museum: Thannhauser Collection* [New York, 1978; rev. ed. 1992], p. 99). Barnett's account is based on Henry R. Hope, *Georges Braque*, exh. cat. (New York: The Museum of Modern Art, 1949), p. 23, and on Ellen C. Oppler, *Fauvism Reexamined* (New York, 1976), p. 51, n. 3; Oppler mentions a Friesz picture of a "scene from the abandoned casino which he and Braque rented as a studio."

6. When Matisse's *Open Window, Collioure* was first shown—at the 1905 Salon d'Automne in Paris—it was reproduced in a double-page spread in the November 4, 1905 issue of *L'Illustration*; the painting was shown again in the 1906 retrospective at Galerie Druet.

7. See Freeman, *The Fauve Landscape*, p. 203. This area is visible on the lower right of the map of Antwerp reproduced in Freeman, p. 202, plate 211; it was apparently a short distance east of the pension in which Braque and Friesz were staying.

8. The painting measures 42 x 50 cm (16 ⁹⁄₁₆ x 19 ¹¹⁄₁₆ inches).

9. This was suggested by Nicole de Romilly, who concurred with Barnett that the Thannhauser picture was done after the smaller painting and was probably not done directly from nature. See Barnett, "*Landscape near Antwerp*," pp. 99–100. Barnett also cites Margaret Potter's belief that the Thannhauser picture, which is larger than any of the other canvases that Braque worked on in Antwerp, was painted in his studio after he returned to France. Although this cannot be entirely ruled out, it seems unlikely since Braque tended to paint his immediate surroundings. The question has also been raised as to whether the actual motif is someplace other than Antwerp; but when Robert Lebel brought the painting to Braque around 1935 after he had purchased it, no question was raised about the title. (According to Lebel, the painting was unsigned when he acquired it. Shortly afterward, he took it to Braque, who "signed it right away and nearly cried while recalling the hard time he had at the period this work was painted" [Lebel to Guggenheim trustee Daniel Cotton Rich, March 22, 1974, curatorial file, Guggenheim Museum, New York].) The picture is not as tightly composed as the paintings that Braque did in L'Estaque the following fall, and the color is also softer and less dense; so if it was painted afterward, it would have been during Braque's short stay in Paris early that fall. Regarding the size, it should be noted that Friesz worked on larger canvases in Antwerp, so there is no reason to believe that Braque would have been constrained not to do so.

10. A dozen works by Cézanne had been shown at the Galerie Vollard in Paris in March, and Braque's interest in Cézanne dates from this time.

11. This painting measures 50 x 61 cm (19 ¹¹⁄₁₆ x 24 inches).

12. Barnett, "*Landscape near Antwerp*," p. 99. Leymarie makes a similar assumption, saying that the Thannhauser painting is "a variant" of the other, except that "elements of the composition have been modified: buildings have been added in the background on the opposite shore, and the dock in the foreground has been left out" (*Georges Braque*, cat. no. 4).

13. See, for example, Freeman, *The Fauve Landscape*, and James D. Herbert, *Fauve Painting: The Making of Cultural Politics* (New Haven, 1992).

14. Freeman, *The Fauve Landscape*, p. 207.

15. Jacques Lassaigne, "Un Entretien avec Georges Braque," *XXe Siècle* 35, no. 41 (December 1973), pp. 4–9; quoted in Zurcher, *Georges Braque: Life and Work*, p. 17.

Georges Braque

GUITAR, GLASS, AND FRUIT DISH ON SIDEBOARD
(GUITARE, VERRE ET COMPOTIER SUR UN BUFFET)

early 1919
Oil on canvas, 81 x 100.3 cm (31 ⅞ x 39 ½ inches)

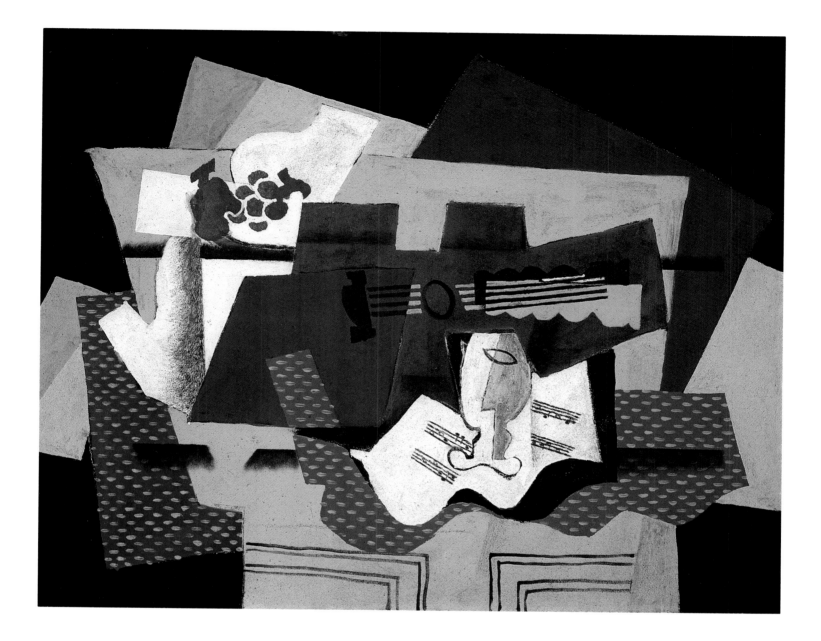

3

Georges Braque

TEAPOT ON YELLOW GROUND

(THÉIÈRE SUR FOND JAUNE)

1955

Oil on canvas, 35 x 65 cm (13 ¼ x 25 ⅝ inches)

4
Paul Cézanne

STILL LIFE: FLASK, GLASS, AND JUG
(FIASQUE, VERRE ET POTERIE)

ca. 1877
Oil on canvas, 45.7 x 55.3 cm (18 x 21 ¾ inches)

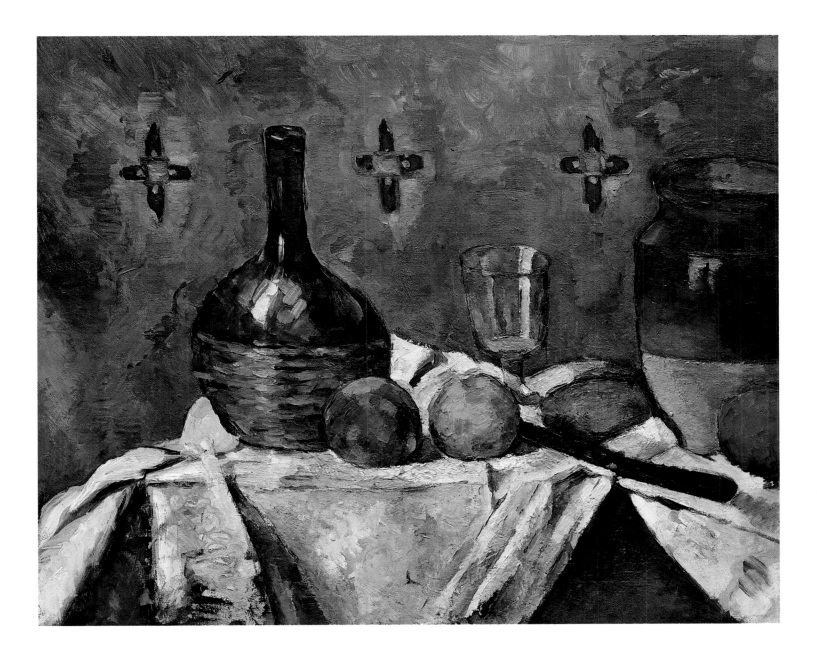

Paul Cézanne

STILL LIFE: FLASK, GLASS, AND JUG

by Richard Shiff

For Paul Cézanne, 1877 was a moment of unusual confidence. In 1876, he had abstained from the second of the Impressionists' independent exhibitions, but the following year he entered sixteen works, his largest public showing until 1895. His rapid technical development through the mid-1870s was profiting from his close association with Camille Pissarro. Beginning in 1872, the two had worked in concert in Auvers and Pontoise, not far from Paris. Each was mastering an Impressionist practice, retaining, as Pissarro later stated, the personal "sensation."[1] Cézanne's *Still Life: Flask, Glass, and Jug* derived from their association.

The catalogue of the 1877 Impressionists' exhibition lists Cézanne's address as 67, rue de l'Ouest.[2] He occupied that Paris residence from late 1876 through early 1878, and again briefly in 1879. A long tradition of scholarship identifies this studio with the yellowish olive-green wallpaper punctuated by blue lozenges seen in *Still Life: Flask, Glass, and Jug*. In related paintings, the same pattern sometimes includes traces of diagonal bars connecting the lozenges. Given styles of wallpaper of the era, it is likely that the actual pattern was still more complicated, Cézanne having abstracted or eliminated elements to suit his individual compositions. Although identification of the wallpaper motif with the 1877 studio therefore remains circumstantial, the date "circa 1877" has been assigned to *Still Life: Flask, Glass, and Jug* in all recent publications, and there is no clear reason to doubt it.[3]

A witness to Pissarro and Cézanne at work during the 1870s described the difference between the two: Pissarro "dabbed" (*piquait*) with the brush, whereas Cézanne "plastered" (*plaquait*), laying the paint on heavily (see Pissarro's *The Potato Harvest*, 1874, and Cézanne's *Small Houses at Auvers*, ca. 1873–74, where the two techniques nevertheless seem to converge).[4] Obviously, Cézanne's technique was the less

Camille Pissarro, *The Potato Harvest*, 1874. Oil on canvas, 33 x 41 cm (13 x 16 inches). Private collection, London.

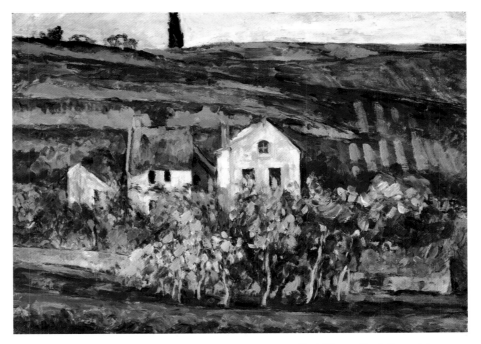

Paul Cézanne, *Small Houses at Auvers*, ca. 1873–74. Oil on canvas, 39.4 x 53.3 cm (15 ½ x 21 inches). Fogg Art Museum, Harvard University Art Museums, Cambridge, Massachusetts, Bequest of Annie Swan Coburn.

refined, the more extreme variant on the Impressionist method. Both painters, however, allowed the evidence of their brushwork to remain aggressively obvious; they avoided bringing their paintings to a traditional degree of finish. Their purpose was to connote naive vision, the primacy of immediate experience. Each stroke of paint, individually visible, seems to reflect the direct observation of a spot of light or color. With their heavy, perhaps awkward "plastering," the surfaces of Cézanne's paintings give the effect of agitation as much as of construction. This complexity appears in *Still Life: Flask, Glass, and Jug*, where the facture ranges from a taut but viscous network of rectilinear marks in the apples, to a rather chaotic distribution of flowing color in the background.

One background cluster of paint strokes is especially informative as to Cézanne's method. Just to the left of the bulge of the flask, the artist applied his paint loosely, allowing several wet colors to combine not only on the canvas surface, but on the brush itself. Inspection of the marks shows that the dull greens, brownish yellows, and grayish violets resulted from mixtures of brighter primary and secondary colors, including brilliant reds. These pure colors of the palette—"spectral" colors associated with natural light—remain visible in the trackings of Cézanne's brush, some of their traces being little more than a brush hair in width. This type of detail (found throughout this painting and, for example, in Pissarro's *Still Life with Apples and Pitcher*, ca. 1872) reveals the essence of the Impressionist practice that Pissarro and Cézanne were developing. During the 1870s, they gradually came to rely on a limited number of brilliant mineral and synthetic pigments as their base for mixing all their nuanced variations, including neutral browns and grays; they sometimes retained the use of black pigments and earth colors, but to a much lesser extent than was customary in traditional practice.[5] In *Still Life: Flask, Glass, and Jug*, a grayish tone is likely to consist of some combination of red, green, yellow, and blue, not simply black and white. The advantage to this method was that it achieved a striking, even jarring, brilliance that yet retained harmony because a relatively small number of pigments were being used to create all coloristic effects. Cézanne was alluding to the variety and purity of nature's color as well as to the capacity of nature's light to reunify what it first differentiates.

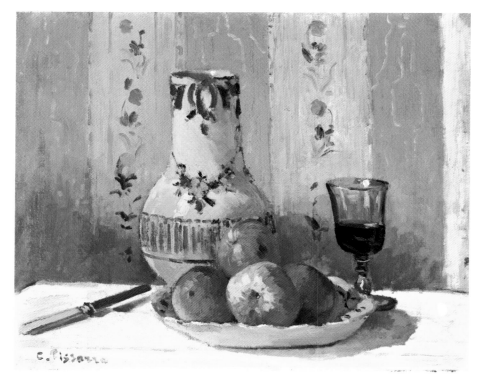

Camille Pissarro, *Still Life with Apples and Pitcher*, ca. 1872. Oil on canvas, 46.4 x 56.5 cm (18 ¼ x 22 ¼ inches). The Metropolitan Museum of Art, New York, Mr. and Mrs. Richard J. Bernhard Gift, by exchange, 1983 (1983.166).

Cézanne, like Pissarro, avoided the pigments conventionally used to establish strong shadows. The chiaroscuro effect of dark against light was specifically associated with the traditional artist's studio, where objects were arranged to catch the light in a dramatic (hence, artificial) manner. In 1874 and 1876, Cézanne wrote to Pissarro of their mutual interest in replacing a dark-and-light structure with a color structure.[6] Accordingly, the very straightforward composition of *Still Life: Flask, Glass, and Jug* does not rely on patterns of chiaroscuro. Instead, the light seems evenly distributed throughout the image, and the shadows themselves tend to be chromatically blue rather than black. Volumetric objects, such as the apples, shift in hue as much as in value.

Still Life: Flask, Glass, and Jug is unfinished, even by an Impressionist's liberal standards, as indicated by the diffuse areas of pigment in the upper background and the insubstantial flourishes of blue and green at the lower left. It is not clear how the first recorded owner, Eugène Murer, a resident of Auvers, acquired this work. Cézanne, perhaps not ready to give it up, did not sign it, as he usually did when he presented or sold a painting to an admirer. (All of the other Cézannes that have been securely identified with Murer's collection are signed.)[7] Yet incompletion was typical of Cézanne and never detracted from the expressive power that struck his viewers. When a Japanese painter first saw Cézanne's art in 1907, he had the same response that Pissarro and others had experienced: "The impression is everywhere, everywhere fresh, and it is as if each place, each instant shows a continuing sense of newly, freshly touching some thing One forgets the many faults . . . having been drawn into the midst of [the painter's] personality."[8]

NOTES

1. Camille Pissarro to Lucien Pissarro, Paris, November 22, 1895, in *Correspondance de Camille Pissarro*, ed. Janine Bailly-Herzberg, 5 vols. (Paris, 1980–91), vol. 4, p. 121.

2. See Charles S. Moffett, ed., *The New Painting: Impressionism 1874–1876*, exh. cat. (San Francisco: The Fine Arts Museums of San Francisco, 1986), p. 204.

3. See John Rewald, *The Paintings of Paul Cézanne: A Catalogue Raisonné*, 2 vols. (New York, 1996), vol. 1, pp. 217–18.

4. Gustave Coquiot, *Paul Cézanne* (Paris, 1919), p. 61.

5. See Richard Shiff, *Cézanne and the End of Impressionism* (Chicago, 1984), pp. 204–08.

6. Cézanne to Pissarro, June 24, 1874, and July 2, 1876, in *Paul Cézanne, Correspondence*, ed. John Rewald (Paris, 1978), pp. 147, 152.

7. See Robert William Ratcliffe, "Cézanne's Working Methods and Their Theoretical Background," Ph.D. diss., Courtauld Institute of Art, University of London, 1961, pp. 216–65.

8. Ikuma Arishima, "The Painter Paul Cézanne," *Shirakaba* 1 (June 1910), p. 41; translated and quoted in Takanori Nagaï, "An Aspect of Cézanne's Reception in Japan," *Aesthetics* 8 (March 1998), p. 80.

5

Paul Cézanne

STILL LIFE: PLATE OF PEACHES

(ASSIETTE DE PÊCHES)

1879–80

Oil on canvas, 59.7 x 73.3 cm (23 ½ x 28 ¾ inches)

6

Paul Cézanne

THE NEIGHBORHOOD OF JAS DE BOUFFAN

(ENVIRONS DU JAS DE BOUFFAN)

1885–87

Oil on canvas, 65 x 81 cm (25 ⁹⁄₁₆ x 31 ⅞ inches)

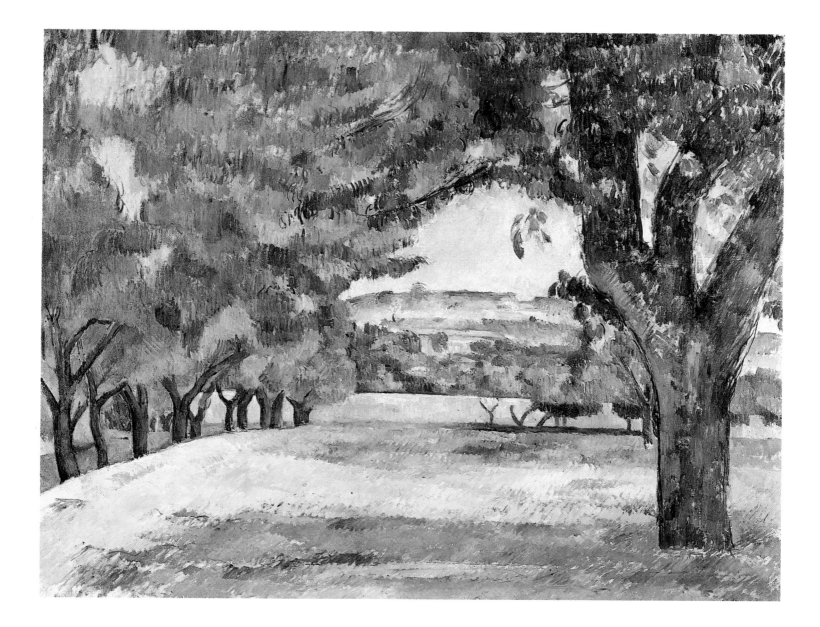

Paul Cézanne
THE NEIGHBORHOOD OF JAS DE BOUFFAN

by Theodore Reff

IN SEPTEMBER 1859, Paul Cézanne's father, a prosperous banker in Aix-en-Provence, bought a large country house and farm, called the Jas de Bouffan, just outside the city.[1] For the next forty years, until it was sold in September 1899, "This peaceful estate—with its large eighteenth-century house, its alley of old chestnut trees, its pool, its farmhouses, its low walls, beyond which on one side appeared Mont Sainte-Victoire and on the other, fields of a gently rolling terrain as far as one could see—offered the artist subjects of which he never seemed to tire."[2] Along with Mont Sainte-Victoire, the Jas de Bouffan was indeed one of Cézanne's favorite sites, and not simply because it was always at hand, but because it represented for him a humanized, classical landscape congenial to the classical temper of his art, one in which the forms of nature and the forms created by men had coexisted harmoniously for centuries.

No fewer than thirty-seven oils and sixteen watercolors of the Jas de Bouffan, its grounds, and its immediate environment have been catalogued.[3] But far from being evenly distributed over the four decades in question, they are concentrated in certain periods. In the 1860s, when Cézanne's family seems to have used the somewhat dilapidated house infrequently (his father may have bought it primarily to cancel its bankrupt owner's large debt to him),[4] the young artist was more interested in painting murals inside than views of the grounds outside.[5] It was only in the mid-1870s, when landscape became a major theme in his art, that Cézanne began to explore the varied motifs offered by the manor and its grounds and extensive environs; and it was only in the mid- and late 1880s that he explored these in real depth. Almost half of all the works he painted at the Jas de Bouffan, including the present one, are generally dated to the few years between 1885

and 1888. And since Cézanne is known to have spent much time at L'Estaque and Gardanne in 1885 and the first half of 1886, partly to avoid his family during a period of emotional agitation,[6] the time he spent working at the Jas de Bouffan can probably be defined more precisely as the second half of 1886 through 1888, and especially the period after his father's death in October 1886, when Cézanne would surely have felt freer, at long last, to live and work there without the anxiety that his father's presence had always induced in him.

Most of the thirty-seven oil paintings of the Jas de Bouffan show the manor or adjacent farmhouses, the reflecting pool, or the alley of chestnut trees, which provided motifs of limited depth and complex surface design. Apart from *The Neighborhood of Jas de Bouffan*, only two other works show the deeper, more open vistas afforded by the fields beyond the walled grounds of the estate, an apparently simpler composition: *Toward the Exit of Jas de Bouffan* (1885–86), which likewise dates from the mid-1880s, and *Vue prise du Jas de Bouffan* (1875–76, location unknown),[7] which is closer to the Thannhauser painting in composition but dates from a decade earlier. *The Neighborhood of Jas de Bouffan* has a traditional design, with a large foreground tree at one side and a clump of smaller trees at the other framing a distant view in the center; but in Cézanne's scrupulous and loving adaptation, it becomes an image of a particular place beyond the walls of his family estate, seen in the warm light of Provence on a cloudless summer day. Although no corresponding watercolor is known, there is a pencil drawing that was undoubtedly made in preparation,[8] confirming the appeal of this view for Cézanne and the deliberateness of his approach. This is equally apparent in the lucid organization of alternately light and dark horizontal planes to articulate depth and in the almost uniformly fine parallel brushstrokes visible throughout the painting—a screen of

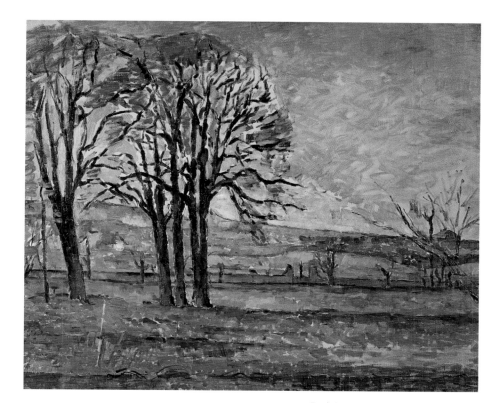

Paul Cézanne, *Toward the Exit of Jas de Bouffan*, 1885–86. Oil on canvas, 60.3 x 73 cm (23 ⅞ x 28 ¾ inches). The National Museum of Western Art, Tokyo.

flickering touches at once suggestive of air and light and constructive of a painterly surface, not unlike the exactly contemporaneous Pointillism of Georges Seurat.

Both the sense of order and the sense of isolation that emanate from this serenely balanced yet uninhabited and somewhat empty landscape convey very well what must have been the artist's dominant mood in the summer of 1887 or 1888—calm but resigned, with his frustrated affair of 1885 as well as his loveless marriage, the death of his domineering father, and his break with his boyhood friend Emile Zola in 1886 all now behind him. He summed up this mood of resignation, coupled with a deep immersion in nature, in a letter to the collector Victor Chocquet written in May 1886: "I should have wished to possess the intellectual

equilibrium that characterizes you and allows you to achieve with certainty the desired end. . . . Fate has not endowed me with an equal stability, that is the only regret I have about the things of this earth. As for the rest, I have nothing to complain about. Always the sky, the boundless things of nature, attract me and give me the chance to look with pleasure." And continuing in a vein that seems still more appropriate to *The Neighborhood of Jas de Bouffan*, he adopted an allegorical style: "I had a few vineyards, but unexpected frosts came and cut the thread of hope. And my wish would have been, on the contrary, to see them grow well; and so I can only wish you success for your plantations and a good development of your vegetation; green being one of the gayest colors which does the most good to the eyes."[9]

That Cézanne too could achieve such a development, if not in life, at least in art, is evident from *The Neighborhood of Jas de Bouffan*, in which the vibrant color harmony is dominated by a rich variety of greens, modulating in one sense toward yellow and ocher, in the other toward blue and violet, in a manner at once descriptive and abstract that does indeed do "the most good to the eyes."

NOTES

1. Two myths concerning the Jas de Bouffan have recently been demolished: that the name derives from the Provençal for "sheepfold of the winds" (it more likely derives from the name of the first owner of the property in the seventeenth century); and that the imposing manor was built for the Duc de Villars, governor of Provence (it was more likely built for Gaspard Truphème, a wealthy merchant, and it remained in that family's possession until it was purchased by Cézanne's father). See Jean Boyer, "Le Véritable Histoire du Jas de Bouffan," in *{Actes du} Colloque Rewald Cézanne* (Aix-en-Provence, 1997), pp. 53–63.

2. John Rewald, *The Paintings of Paul Cézanne: A Catalogue Raisonné*, 2 vols. (New York, 1996), vol. 1, no. 63. On the purchase and later sale of the Jas de Bouffan, see Isabelle Cahn, "Chronologie," in *Cézanne*, exh. cat. (Paris: Réunion des Musées Nationaux, 1995), pp. 530, 557–58.

3. Rewald, *The Paintings of Paul Cézanne*, nos. 62–65, 156, 158, 234, 267–71, 278, 294, 350, 379–81, 521, 523, 542, 528, 538, 546, 547, 551, 552, 566, 567, 595, 596, 600, 603, 611, 617, 687, and 688; and John Rewald, *Paul Cézanne: The Watercolors* (Boston, 1983), nos. 18, 20, 22, 92, 110–14, 155, 183a, 244, 256, 257, 321, and 396, and perhaps also nos. 5 and 397.

4. See Boyer, "Le Véritable Histoire du Jas de Bouffan," p. 53.

5. See Rewald, *The Paintings of Paul Cézanne*, nos. 4–7, 23, 28–31, 34–41, 95, 141, and 145–46. On the works that Cézanne painted at the Jas de Bouffan, both indoors and outdoors, see Jean Arrouye, *La Provence de Cézanne* (Aix-en-Provence, 1982), pp. 39–41.

6. See Cahn, "Chronologie," pp. 546–47, which cites Cézanne's relevant letters.

7. Rewald, *The Paintings of Paul Cézanne*, nos. 552 and 270, respectively.

8. Adrien Chappuis, *The Drawings of Paul Cézanne: A Catalogue Raisonné*, 2 vols. (Greenwich, 1973), no. 904 (dated ca. 1886).

9. Paul Cézanne, *Letters*, ed. John Rewald, trans. Marguerite Kay, fourth rev. ed. (New York, 1976), pp. 224–25.

7

Paul Cézanne

MADAME CÉZANNE

1885–87

Oil on canvas, 55.6 x 45.7 cm (21 ⅞ x 18 inches)

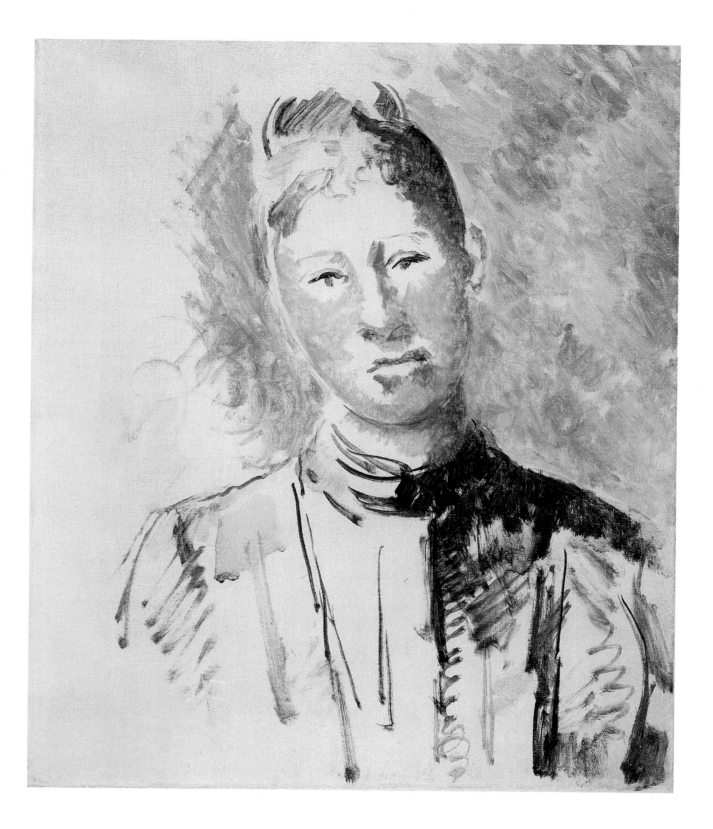

8

Paul Cézanne

BIBÉMUS

ca. 1894–95
Oil on canvas, 71.5 x 89.8 cm (28 ⅛ x 35 ⅛ inches)

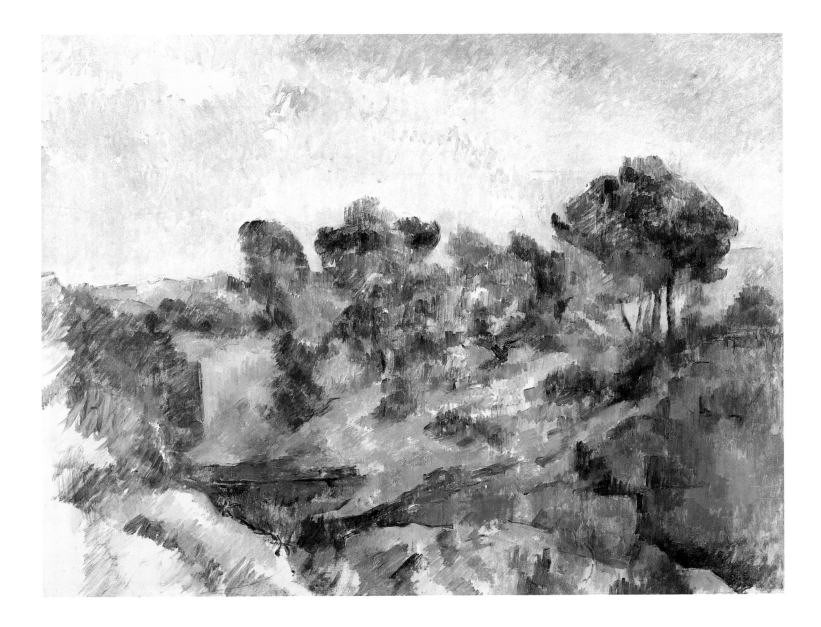

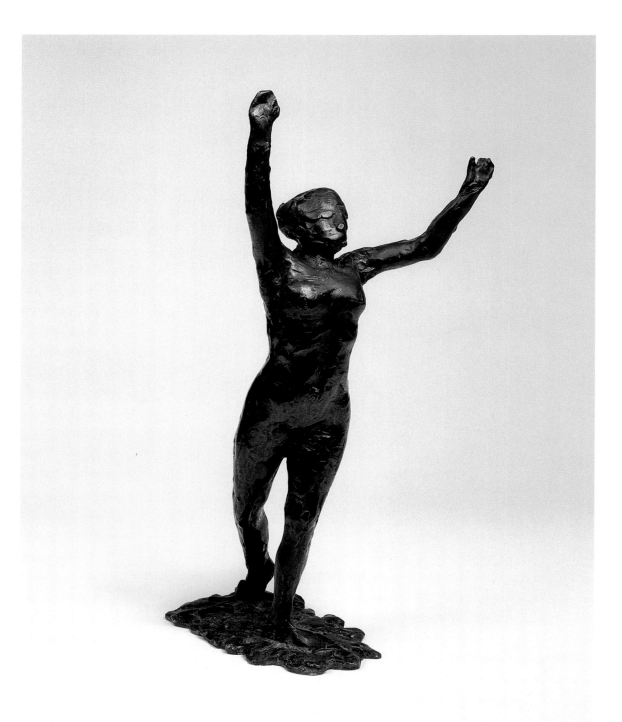

9

Edgar Degas

DANCER MOVING FORWARD, ARMS RAISED

(DANSEUSE S'AVANÇANT, LES BRAS LEVÉS)

1882–95

Bronze, 35.3 x 15.3 x 16.5 cm (13 ⅞ x 6 x 6 ½ inches)

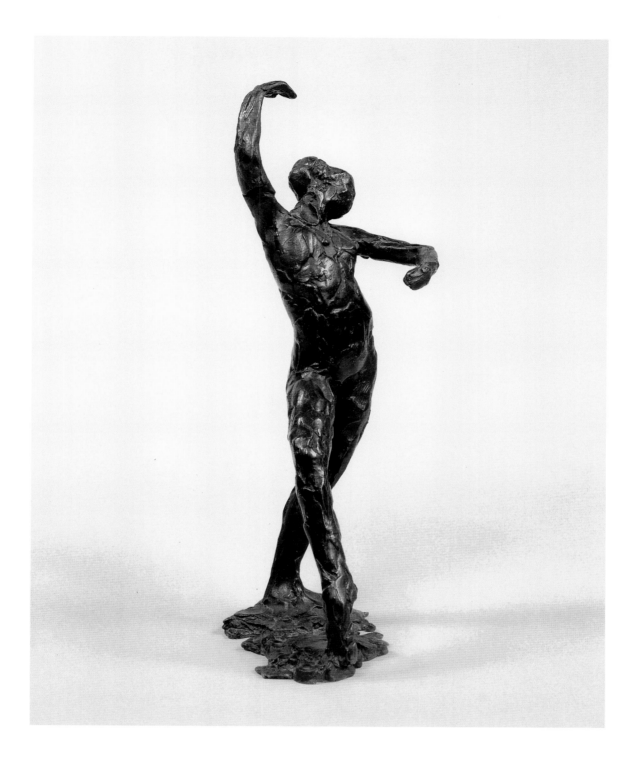

10

Edgar Degas

SPANISH DANCE (DANSE ESPAGNOLE)

1896–1911

Bronze, 40.4 x 16.5 x 17.8 cm (15 ⅞ x 6 ½ x 7 inches)

II

Edgar Degas

SEATED WOMAN, WIPING HER LEFT SIDE

(FEMME ASSISE, S'ESSUYANT LE CÔTÉ GAUCHE)

1896–1911
Bronze, 35.6 x 35.9 x 23.5 cm (14 x 14 ⅛ x 9 ¼ inches)

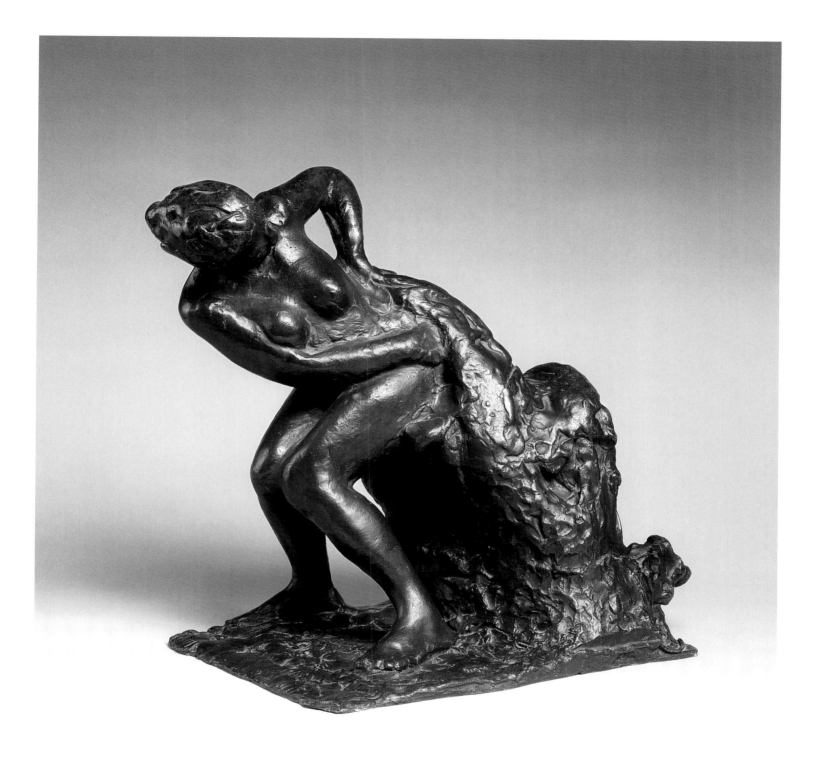

Edgar Degas

DANCERS IN GREEN AND YELLOW
(DANSEUSES VERTES ET JAUNES)

ca. 1903
Pastel on several pieces of paper, mounted on board,
98.8 x 71.5 cm (38 ⅞ x 28 ⅛ inches)

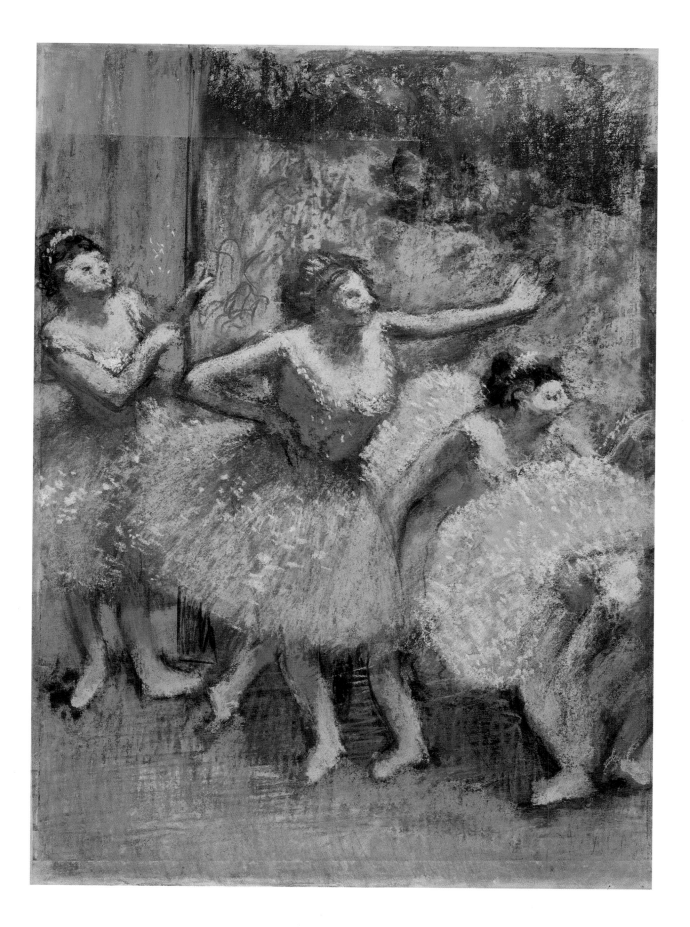

Edgar Degas

DANCERS IN GREEN AND YELLOW

by Ann Dumas

WHEN LOUISINE HAVEMEYER, one of Edgar Degas's first patrons, asked him, "Why, monsieur, do you always do ballet dancers?," he replied, "Because, madame, it is all that is left of the combined movement of the Greeks."[1] This somewhat enigmatic observation, made late in Degas's career, suggests his interest in the classical, formal character of dance. Movement and gesture are at the core of Degas's art. In his work of the 1870s and early 1880s, he was fascinated with gesture as a revealer of character and personality. But in his later work, from around 1886 to the point when failing eyesight brought a halt to his creativity, probably around 1910–12, he was less interested in modernity and the observation of the here and now; his art turned inward and became increasingly self-referential. Toward the end of his working life, Degas's obsession with dance dominated all other subjects and became a pretext for a repeated investigation of a few movements and gestures, largely for their abstract qualities of line, form, light, and color.

Dancers in Green and Yellow is one of a large number of drawings and pastels in which Degas explored the theme of a group of dancers in different poses behind a stage flat; these works culminated in the monumental oil painting *Four Dancers* (ca. 1899, National Gallery of Art, Washington, D.C.). It is impossible to date Degas's late works precisely, but those treating this theme are generally accepted as dating from the late 1890s and early 1900s, most recently by Richard Kendall, who dates *Dancers in Green and Yellow* to ca. 1899–1904.[2] Degas had first experimented with the subject many years before, in *Dancers Preparing for the Ballet* (1872–76, The Art Institute of Chicago), but whereas in this earlier work the dancers' features are so individualized as to be almost portraits and the details of the stage and theatrical setting are realistically described, in *Dancers in Green and Yellow* the faces are reduced to masklike anonymity and the background is

nonspecific and timeless. By the late 1890s, Degas had long since ceased to attend the Paris Opéra,[3] and although, on occasion, ballerinas would come to pose for him as hired models in his studio, his complex, late dancer compositions such as this one have little to do with direct observation. They are largely the product of a collaboration between imagination and memory, but also of the vast reference bank of drawings, pastels, and monotypes that he had by then accumulated and retained in his studio.

Tracing was crucial to the process of Degas's late image-making. Frequently, by this means a particular figure was recycled from one image to another and united with others that had migrated from different compositions. A number of other pastels and charcoal drawings show Degas exploring the same compositional arrangement as in *Dancers in Green and Yellow*, but the number of figures and the way in which they are grouped varies in each work. *Dancers in Yellow* (location unknown) is the most similar to *Dancers in Green and Yellow*; not only do the works both have a glowing orange and yellow palette, but the poses of the figures are identical. *Four Dancers in the Wings* (location unknown) shares the vertical format of the Thannhauser pastel, which Degas achieved in both works by attaching additional strips to the top and bottom of the original sheet of paper. The remaining four pastels in this group of related works are more horizontal in format.[4]

A number of charcoal drawings can also be connected to *Dancers in Green and Yellow*. *Dancers in Leotards* (location unknown) includes all four figures and is so close to the Thannhauser pastel that, given Degas's working methods, it seems more than likely that the pastel was traced from it. In *Three Nude Dancers* (Arkansas Art Center, Little Rock), which shows the three figures that appear on the right of *Dancers in Green and Yellow*, Degas altered the charcoal line with the result that the poses of the figures are the same in both works. *Three Dancers in Leotards* (location unknown) includes only the left three figures,

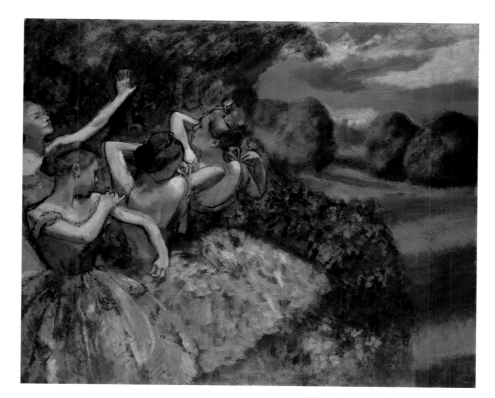

again with *pentimenti*, and might also be a preparatory work for the Thannhauser pastel.[5]

The genesis of *Dancers in Green and Yellow* springs also from another, fascinating source. The central dancer with her left arm stretched up, grasping the stage flat, and her right hand on her hip derives from a photograph, *Dancer from the Corps de Ballet* (ca. 1896, Bibliothèque Nationale, Paris). The photograph, which shows a dancer with her left arm holding a stage flat but with her right arm folded against her chest, is one of a group of anonymous images of dancers in a variety of poses that were donated to the Bibliothèque Nationale in Paris by Degas's brother René. As is well known, Degas was an accomplished photographer and produced a number of portrait photographs of friends, and although it has never been absolutely established that he was the author of these photographs, it seems virtually certain that he was.[6] However, there is no doubt that the photographs inspired a number of his late

Edgar Degas, *Four Dancers*, ca. 1899. Oil on canvas, 151 x 180 cm (59 ¼ x 71 inches). National Gallery of Art, Washington, D.C., Chester Dale Collection.

dancer compositions, and that this particular pose was one he found so compelling that he used it repeatedly in his late pastels, charcoal drawings, and paintings, either alone or combined with other figures.

In *Dancers in Green and Yellow*, this figure is accompanied by three other dancers. The cadence of their densely overlapping forms is checked by the dancer at the far right, whose head is abruptly sliced off by the picture's edge. The frieze of figures here suggests the phases of a movement made by a single figure, unfolding sequentially through space. Since the 1870s, when he had been intrigued by Eadweard Muybridge's serial photographs recording the actions of a horse in motion, Degas had been interested in flux and the perception of movement through time. He was in touch with late-nineteenth-century theories of motion and time,[7] and such ideas lie to some extent behind his late works (as they do also in the work of some of his contemporaries, such as the serial paintings by Claude Monet).

Dancers in Green and Yellow is an outstanding example of the almost visionary intensity that Degas could achieve in his late pastels. From 1886, when he showed a suite of glowing pastel nudes at the eighth and last Impressionist exhibition, pastel became Degas's principal medium and he almost completely abandoned oil painting. He had worked in pastel in the the 1850s and early 1860s, but in his late work his extraordinary technical inventiveness transformed this traditional technique into a means of great expressiveness. Pastel enabled him to literally draw with color, uniting his lifelong passion for drawing with his discovery of the opulent color that characterizes his late work. In addition, the freedom of expression and ease of handling that pastel permitted suited an artist whose eyesight was failing and who was compelled to revise and rework continually.

Degas was extremely free and experimental in his work in pastel and combined a variety of techniques. For example, he would often use his fingers to blend and soften colors and outlines and to manipulate the chalks to form surfaces of encrusted, dappled impasto. As was his usual practice, in *Dancers in Green and Yellow* Degas first laid onto the tracing paper the figures in bold charcoal lines—in this case in gray-browns, blues, and blacks. Dissatisfied with the original relationship of the figures to the surrounding space, he added extra strips of paper to the original sheet—ten centimeters at the top and three centimeters along the bottom. Such adjustments to the format are common throughout Degas's oeuvre, but in his late pastels they are almost the rule.

Once Degas had established a monotone base in his pastels, the tracing paper would be glued to a mount of thick paper or card; sometimes this was done by Degas himself, but there is also evidence that he used a professional mounter.[8] Visitors to Degas's studio observed his habit of pinning the tracing-paper drawings to cardboard placed on easels, before he worked them up in pastel.[9] Often he would work simultaneously on a number of related traced drawings.[10] The poet Paul Valéry described Degas's working method: "At times he turns back to these trial sketches, adding colors, mingling pastel with charcoal; in one version the petticoats may be yellow, in another purple. But the prose, the line and movement are always implicit, essential, distinguishable, usable in other designs."[11]

In *Dancers in Green and Yellow*, Degas achieved extraordinarily rich textural effects. The ground is built up of horizontal lines in brown-black overlaid with broad vertical strokes of soft, powdery blue. The handling of the pastel in the stage flat is especially free—a torrent of dabs, squiggles, scratches, and dashes vaguely suggests painted foliage—while the texture and glowing colors of the dancers' tutus are built up with multiple veils of shimmering

pastel that allow one layer of color to show through the next. Color became especially rich in Degas's late work, and it is no coincidence that at that time—in the 1890s—he was buying for his own art collection works by the great colorist Eugène Delacroix, whom he had long admired. Like many of his contemporaries, Degas was fascinated by the theories on complementary color that Delacroix discussed in his journal, which was published in 1893, and he even acquired some of his mentor's paper palettes so that he could analyze his color combinations. The composition in *Dancers in Green and Yellow* revolves around cool and hot colors—acid blue-greens and coral pinks in the tutus and deeper, brick-orange in the bodices— that suggest the heightened artificial lighting of the stage.

In creating his late pastels, Degas emulated the glazing techniques of Old Master oil painting by fixing each layer of pastel with a special fixative of his own devising, the composition of which has never been fully discovered.[12] This technique permitted him to build up a jewel-like surface with layers of transparent color. *Dancers in Green and Yellow* conforms to this technique: the darker colors in the underlayers of the composition have been fixed with a spray-applied fixative, and the brighter hues—yellows, greens, and pinks— have been applied over the darker layers and fixed again. In raking light, the underlayers of fixed pastel gleam, suggesting that Degas may have burnished these, as was often his practice. Frequently, the penultimate layer of pastel was sealed with fixative and, as in *Dancers in Green and Yellow*, a spangled, magical effect achieved by a final scattering of unfixed pastel.[13]

Although Degas brought the Thannhauser pastel to a very high degree of finish, he never sold it. It was with the hundreds of other works that remained in his studio at his death in 1917, and which were auctioned at four sales during the following year, when the full extent and range of his output were for the first time revealed to the public.

NOTES

1. Louisine Havemeyer, *Sixteen to Sixty: Memoirs of a Collector* (New York, 1961), p. 256.

2. Richard Kendall, *Degas: Beyond Impressionism*, exh. cat. (London: National Gallery; Chicago: Art Institute of Chicago, 1996), cat. no. 27.

3. Degas rarely attended the ballet after the late 1880s. See Henri Loyrette, "Degas à l'Opéra," in *Degas inédit: Actes du colloque Degas* (Paris: Musée d'Orsay, 1989), pp. 47–63.

4. The six related works are nos. 1431 bis, 1431 ter, 1432, 1433, 1434, and 1435 in P. A. Lemoisne, *Degas et son oeuvre*, 4 vols. (Paris, 1946–49).

5. These three drawings are nos. 319, 322, and 318, respectively, in *Catalogue des tableaux, pastels et dessins par Edgar Degas et provenant de son atelier*, the catalogue accompanying the First Sale of Degas's Studio at Galerie Georges Petit, Paris, May 6–8, 1918.

6. Conversation with Malcolm Daniel, Curator of Photography at the Metropolitan Museum of Art, New York, December 1998.

7. See Kirk Varnedoe, "The Ideology of Time: Degas and Photography," *Art in America* 68, no. 6 (summer 1980), pp. 96–110.

8. Anne F. Maheux, *Degas Pastels* (Ottawa: National Gallery of Canada, 1988), p. 45.

9. See Alice Michel, "Degas et son modèle," *Mercure de France*, February 16, 1919, pp. 631–32; and Etienne Moreau-Nélaton, "Deux heures avec Degas," *L'Amour de l'Art* 12 (July 1931), pp. 267–70, cited in Maheux, *Degas Pastels*, pp. 45 and 82, n. 61.

10. Kendall, *Degas: Beyond Impressionism*, p. 188.

11. Paul Valéry, *Degas, danse, dessin* (Paris, 1934); published in English as "Degas, Dance, Drawing" (trans. David Paul), in *Degas, Manet, Morisot* (New York, 1960), p. 39.

12. Denis Rouart, a painter and an authority on Degas's technique and the grandson of Degas's great friend the collector Henri Rouart, explained this in *Degas: A la recherche de sa technique* (Paris, 1945), p. 16.

13. The comments on Degas's technique in the Thannhauser pastel are based on the report made by Harriet Stratis of the Paper Conservation Department of the Art Institute of Chicago in April 1996 when the work was loaned to the exhibition *Degas: Beyond Impressionism* at the National Gallery, London, and the Art Institute of Chicago.

13

Paul Gauguin

IN THE VANILLA GROVE, MAN AND HORSE

(DANS LA VANILLÈRE, HOMME ET CHEVAL)

1891

Oil on burlap, 73 x 92 cm (28 ¼ x 36 ¼ inches)

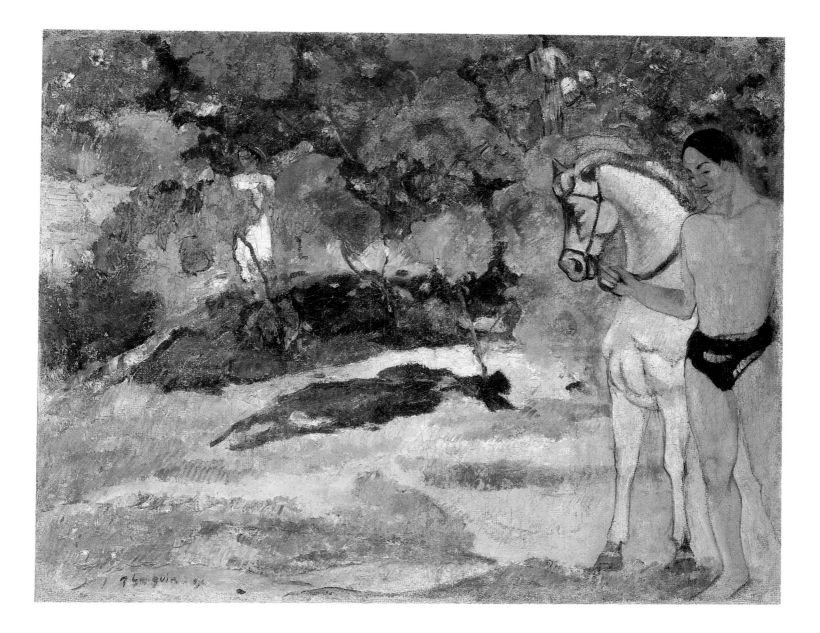

Paul Gauguin
IN THE VANILLA GROVE, MAN AND HORSE

by Belinda Thomson

IN THE VANILLA GROVE, *Man and Horse* can be seen as one of Paul Gauguin's first attempts to produce a considered Oceanic subject that goes beyond the simple recording of daily life and to treat the luxuriant Tahitian setting essentially as decor for a silent narrative. It was painted in October or November 1891,[1] some months after the artist's arrival in Tahiti that June.

The shrill intensity of the painting's colors has a flattening effect, despite the contrast between the open, sunlit foreground and the confused, shadowy grove beyond. The closely hatched, diagonal weave of brushstrokes in the lower half of the composition harks back to Gauguin's earlier Impressionistic treatment of Martinique, and differs from the somewhat clotted appearance of the vegetation in the upper section, which may suggest reworking. The decentralized focus of attention is the man with the white horse, who seems to be entering the scene from the right. He is being watched from the undergrowth by two half-hidden female figures, one of whom carries a basket. It seems plausible to read the painting as some sort of tryst, which is implied by the work's alternative title *Le Rendez-Vous*.[2] Indeed, Gauguin's interest in transforming an otherwise straightforward local scene into an enigmatic encounter between the sexes is consistent with various of the Breton and Arles landscapes he had painted shortly before—such as the confrontation between male artist and female peasant in *Bonjour M. Gauguin* (1889, Narodni Gallery, Prague)—and with similar strategies in some of Camille Pissarro's peasant paintings.

Gauguin had come to Tahiti fully intending to explore its legends and myths—its otherness. It took him some months to establish himself in a part of the island conducive to his work. Shunning the sullied and Westernized capital, Papeete, he eventually settled in the remoter

village of Mataiea. But by the time he painted *In the Vanilla Grove* in 1891, he had yet to find any kind of access to the ancient Maori religion, which had been largely wiped out by zealous Western missionaries. Not until March 1892, when he discovered J. A. Moerenhout's two-volume account of South Sea cults,[3] did he begin to explore more complex Tahitian themes. Gauguin also had certain official obligations to fulfill while he was in Tahiti, since he had undertaken to study the country's customs and landscapes from an artistic point of view in order to qualify for governmental support for his mission. Yet if any government official had sought to learn from Gauguin's painting how vanilla grows or is harvested, he would have been disappointed: its attractive curvaceous, segmented growth pattern of alternating leaves is scarcely identifiable here, nor are its dangling pods or habit of attaching itself to other trees.

For the somewhat stiff, hieratic poses of the man and horse in this painting, Gauguin unquestionably turned to a sculpted classical source. We know that he left France for Tahiti armed with source material in the form of "photographs and drawings, a whole little world of friends" who would converse with him every day.[4] But the precise identity of his sculptural source—whether Roman or Greek—has puzzled all who have written about this painting. Whereas earlier writers agreed that it was based on a segment of Trajan's Column in Rome—specifically, two peripheral figures in the scene showing Trajan sacrificing[5]—more recent writers have argued that it was a segment of the Parthenon frieze that served as the source.[6] To my mind, there is a stronger visual case for believing that the horse, which is seen in three-quarter view, its head stiffly held, neck firmly arched, shoulders strongly defined, and forelegs slightly splayed, derives from the Trajan's Column frieze. Moreover, the taut stance and muscular bare torso of the Tahitian also appear

Segment of Trajan's Column, Rome, showing sacrificial scene with Emperor Trajan making a libation.

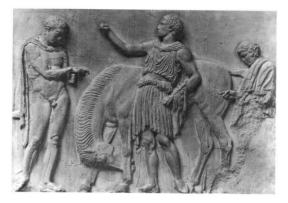

Cast of segment of the west frieze of the Parthenon, Athens, showing horseman hastening to join procession.

to have come from this frieze—specifically, from a man who stands with a horse to the left of the main group. The contours of the Tahitian's legs, however, seem to owe more to one of the Parthenon horsemen, suggesting that Gauguin combined elements from both friezes.

What is not in dispute is that the common factor lying behind the artist's familiarity with these classical examples was Gustave Arosa, Gauguin's patron, guardian, and father figure during the 1860s and 1870s. Arosa not only provided Gauguin with an introduction to his first employer, Bertin, he also gave him an entrée, through his vast and eclectic collection and through his contacts, to the world of art (notably introducing him to Pissarro). It was also through Arosa that Gauguin had access to high-quality reproductions; using a newly patented phototype process, Arosa documented such monuments as the Parthenon frieze and Trajan's Column, disseminating the resulting images through albums and monographic publications.[7] Arosa would have been working on a five-volume album dedicated to Trajan's Column while Gauguin was living with him, prior to his marriage in 1873.[8] Gauguin possessed photographs from these publications, and on the reverse of one of his Trajan's Column photographs he drew "an admirable study of a Tahitian."[9]

The facial features and smooth, centrally parted hair of the Tahitian in *In the Vanilla Grove* link this work with *Man with an Axe* (1891, private collection, New York), for which Gauguin surely used the same local model, possibly the young lissome man named Jotefa whom Gauguin described, not without a hint of eroticism, in *Noa Noa*.[10] As many writers have commented, male figures are a rarity in Gauguin's Tahitian paintings. But this figure does not belong with the later male representations by Gauguin that, Stephen Eisenman has recently argued, demonstrate his alertness both to the contemporary French fascination with the androgyne and to the existence in Tahiti of a specific category of man-woman of somewhat ambiguous gender characteristics.[11] The taut muscularity of the figure is clearly masculine, and comes directly from the refined Greek prototype; the close connection of the poses in *Man with an Axe* and the Thannhauser painting to those in the Parthenon frieze is irrefutable.

The question remains as to why Gauguin, a self-proclaimed "primitive," resorted here to such august classical motifs and in what ways he intended them to inflect his art. This early period in Tahiti was a time of exploration. Gauguin was familiarizing himself with his new physical surroundings and observing the native islanders in a wealth of drawings. At the same time, he was trying to devise a means of presenting novel and exotic elements in a form that would be acceptable, but not too acceptable, to Western audiences. To this end, he made use of various "primitive" sources, such as photographs of carved reliefs from the Javanese Borobudur shrine, Egyptian wall paintings, and the Breton carvings that had inspired some of his earlier work. But he also trawled through his Western classical heritage, and in doing so, paradoxically, he came dangerously close to the very conservative stratagems routinely practiced by the academically trained history painters whom he despised. For example, an intriguing parallel can be made between *In the Vanilla Grove* and a mural painting by the Symbolist René Ménard, *The Golden Age* (1908, Musée d'Orsay, Paris), for a diptych decoration of the Salle des Actes in the Faculté de Droit at the Sorbonne, Paris. The source for this latter work was, once again, the Parthenon frieze.[12]

The timeless, monumental quality of Gauguin's best Tahitian work is the result of just the kind of imaginative reinterpretation exemplified by *In the Vanilla Grove*, in which hieratic sculptural poses are recast in glowing tropical colors. Perhaps the distance that he had put between himself and Europe gave Gauguin fewer inhibitions about quoting the classical. In the sustained attack he mounted on naturalism, which can be seen as one of the principal motivations of his mature career, Gauguin delighted in contriving marriages between seeming opposites: the barbarous primitive and the ultrarefined classical.

NOTES

1. Richard Field, "Paul Gauguin: The Paintings of the First Voyage to Tahiti" (Ph.D. diss., Harvard University, Cambridge, Mass., 1963), pp. 21, 38–41, 304, 312. Field suggests this date due to the as yet not fully crystallized shapes and unstructured space.

2. Georges Wildenstein uses this title in his catalogue raisonné of Gauguin's work: Wildenstein, *Gauguin*, ed. Raymond Cogniat and Daniel Wildenstein, vol. 1 (Paris, 1964), p. 175, no. 443.

3. J. A. Moerenhout, *Voyage aux Iles du Grand Océan*, 2 vols. (Paris, 1873). This account of Tahitian lore, language, and culture, which Gauguin borrowed from a fellow colonial, provided the key for his exploration of Tahitian religious themes.

4. Gauguin to Odilon Redon, September 1890, in *Lettres . . . à Odilon Redon*, ed. Roseline Bacou (Paris, 1960), p. 193.

5. See Bernard Dorival, "Sources of the Art of Gauguin from Java, Egypt and Ancient Greece," *The Burlington Magazine* 93 (April 1951), pp. 118–22; William Kane, "Gauguin's *Le Cheval Blanc*: Sources and Syncretic Meanings," *The Burlington Magazine* 108 (July 1966), pp. 352–62, ill. 28; and Field, "Paul Gauguin: The Paintings of the First Voyage to Tahiti," pp. 38–41.

6. See, for example, Vivian Endicott Barnett, "*In the Vanilla Grove, Man and Horse*," in *Guggenheim Museum: Thannhauser Collection* (New York, 1978; rev. ed. 1992), p. 116. This is the most thorough discussion of the painting to date.

7. See, for example, Charles Yriarte, *Les Frises du Parthénon par Phidias, vingt-deux planches reproduites par le procédé de phototypie de Tessié du Motay et Maréchal par G. Aroza {sic} & Cie.* (Paris, 1868); W. Fröhner, *La Colonne Trajane, interpretée par . . . Reproduction en gravure phototypique par G. Arosa*, 3 vols. (Paris, 1870); and W. Fröhner, *La Colonne Trajane, d'après le surmoulage éxécuté à Rome en 1861–2, reproduite en phototypographie par G. Arosa, 220 planches imprimées en couleur avec texte ornée de nombreuses vignettes*, 5 vols. (Paris, 1872–74). Trajan's Column, of which casts had been made in 1861–62, was made accessible to artists and scholars through the latter two publications. The specific plate that Gauguin referred to while painting *In the Vanilla Grove*—which shows the scene of Trajan Sacrificing—appears as Planche 120 in the second of these albums.

8. David Sweetman, *Paul Gauguin: A Complete Life* (London, 1995), pp. 47–49.

9. Dorival, "Sources of the Art of Gauguin," p. 121; unfortunately, the drawing is not reproduced.

10. *Noa Noa* is the partly factual, partly imaginary account Gauguin wrote of his first voyage to Tahiti, intended to serve as a literary counterpart to and publicity boost for his new paintings. The original manuscript, drafted in 1893, was not published until 1954 (Paris: Sagot-Le Garrec). An expanded version, with additional visual material by Gauguin and written material by the poet Charles Morice, was excerpted in *La Revue blanche* in 1897 and published in 1901 (Paris: La Plume). Nicholas Wadley, ed., *Noa Noa, Gauguin's Tahiti* (Oxford: Phaidon, 1985) includes the original manuscript (trans. Jonathan Griffin) and explains the difference between this and the expanded version. In the passage concerning Jotefa, Gauguin gives a sensuous description of a jungle walk he takes with his young woodcutter friend in search of wood to carve; he plays upon the idea of homoeroticism here, an aspect to which both Sweetman (*Paul Gauguin: A Complete Life*, pp. 316–19) and Stephen F. Eisenman (*Gauguin's Skirt* [London, 1997], pp. 113–19) have recently drawn attention.

11. Eisenman, *Gauguin's Skirt*, pp. 101–05.

12. The source is the segment of the Parthenon frieze known in Yriarte, *Les Frises du Parthénon par Phidias*, as Slab N. The parallel between the frieze and Ménard's mural was drawn to my attention by my husband, Richard Thomson.

14

Paul Gauguin

HAERE MAI

1891

Oil on burlap, 72.4 x 91.4 cm (28 ½ x 36 inches)

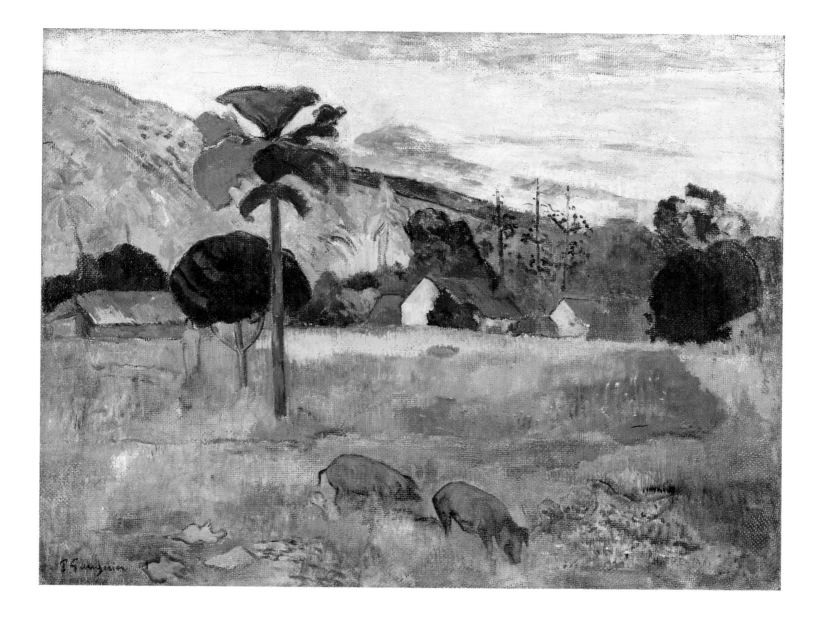

Paul Klee

JUMPING JACK (HAMPELMANN)

1919
Pencil, oil transfer drawing, and watercolor on paper, mounted on cardboard,
28.4 x 22 cm (11 ³/₁₆ x 8 ¹¹/₁₆ inches)

1919. 214.

16

Aristide Maillol

WOMAN WITH CRAB (LA FEMME AU CRABE)

ca. 1902(?)–05

Bronze, 15.2 x 14.6 x 12.1 cm (6 x 5 ¼ x 4 ¾ inches)

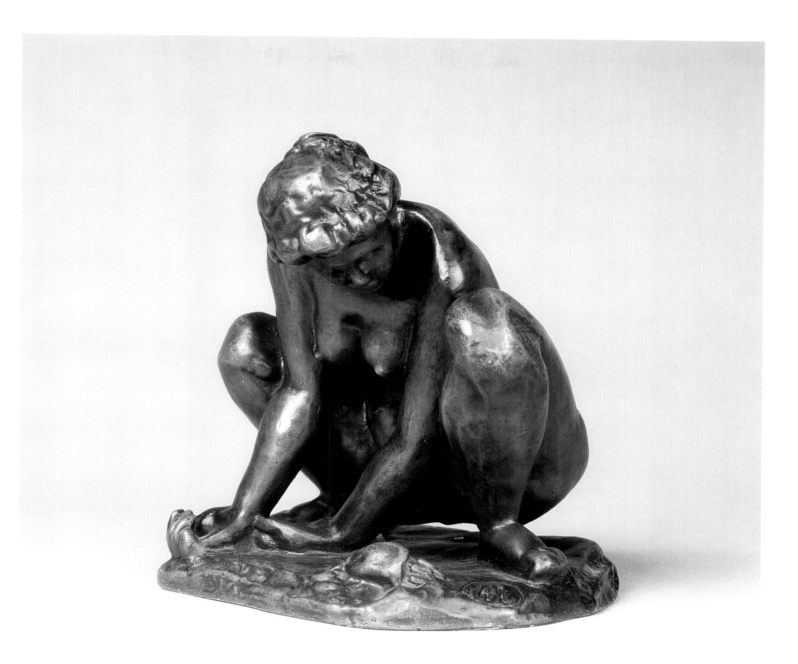

17

Edouard Manet

BEFORE THE MIRROR (DEVANT LA GLACE)

1876

Oil on canvas, 92.1 x 71.4 cm (36 ¼ x 28 ⅛ inches)

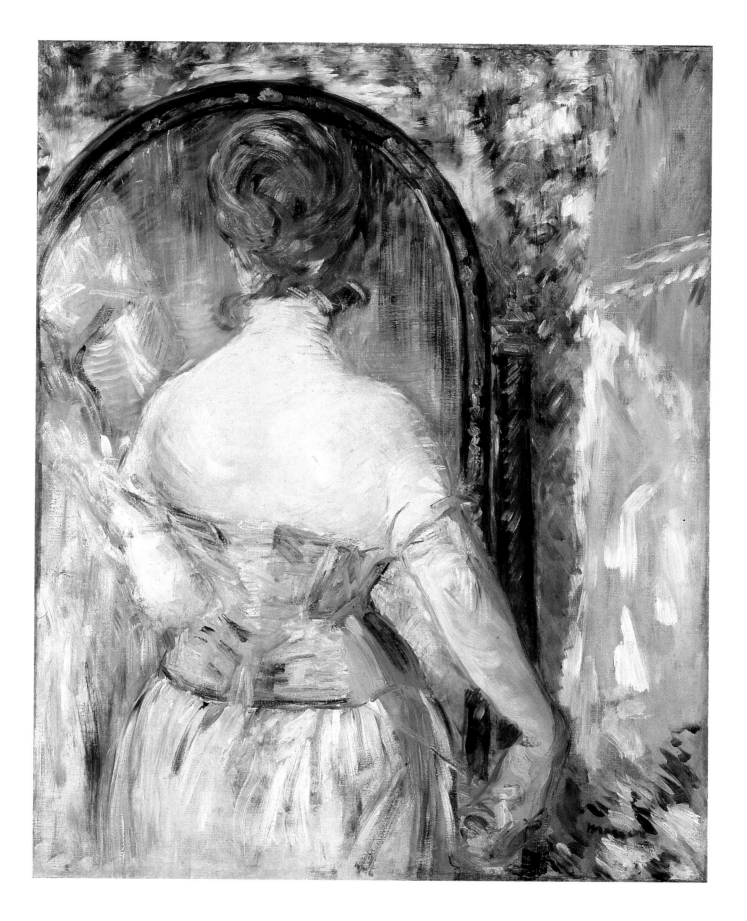

Edouard Manet

BEFORE THE MIRROR

by Beth Archer Brombert

BY THE TIME EDOUARD MANET painted *Before the Mirror* in 1876, Paris had been the reigning queen of pleasure for the better part of the nineteenth century. With its balls and dance halls, theaters and cafés, racecourses and public gardens, made all the more seductive by the vast choice of available women, "Paris had become the amusement park of Europe."[1] Princes, gay young blades, captains of industry, bankers, writers, artists, foreign visitors, all were fascinated by the city's ladies of the night. The *grand monde* was as much at home in the demimonde as in the royal palaces and mansions of the capital. "At no other time and place in history has the reading and theatre-going public manifested such an obsession with the specific constellation of evil and pleasure represented by the prostitute."[2] By official count, there were some ten thousand registered prostitutes in Paris in the 1870s, but that does not begin to account for the others who were not registered with the police, either because they were too high or too low.

For the men who could afford it—and many could in that era of big spenders—a new style of prostitution evolved in the 1870s that superseded the more traditional Parisian bordellos (although 152 of these were still functioning in 1870, a number of them reflecting the luxurious tastes of a newly enriched clientele). The *insoumise*—the independent, unregistered professional who received her clients more privately in small hotels—could graduate to the rank of *lorette* (a name coined for those women who were kept in the pleasant apartments of the new quarter of Notre Dame de Lorette) if she had some luck and some talent. If she was outstanding for her beauty as well as her performing ability, she could aspire to becoming a *lionne*, a courtesan of note who might one day be the mistress of a prince.[3]

Edouard Manet, *Woman with Fans, Portrait of Nina de Callias*, 1873–74. Oil on canvas, 113 x 166 cm (44 ½ x 65 ⅜ inches). Musée d'Orsay, Paris.

The model for *Before the Mirror*, Henriette Hauser, was just such a woman. Hauser was a sometime soubrette and the longtime mistress of the Prince of Orange, son of the Netherlands' reigning king. Known as Prince Citron in the demimonde, to which he devoted much of his fortune and most of his energies, he died three years or so after his lovely mistress was immortalized by Manet in this painting. Hauser has been described as having the body of an antique Venus, a Regency head, skin tones of amber and honey borrowed from Titian, and the ageless youth of a fairy.[4] More than just a modern version of Venus, she characterized her period in the way that Jean-Auguste-Dominique Ingres's portrait of Louis François Bertin typified for Manet the bourgeoisie of 1820 to 1850. "Ingres chose old man Bertin to stylize an epoch," Manet said. "He made of him the Buddha of the prosperous, overfed, triumphant bourgeoisie."[5]

As the Second Empire passed into the Third Republic in 1871, the erotic imagination came to be more aroused by partial dress than by nudity. The perfect forms of the classic nude were now as cold as their ancient marble. The "whipped cream goddesses"[6] of a painter like Adolphe William Bouguereau might still appear in the yearly Salons, but a new style of portraying the eternal feminine had come into fashion, drawing on late-eighteenth-century boudoir scenes, in which the corset was paramount,[7] and suggesting voyeuristic intimacy with the figure portrayed. Manet stated his predilection for a certain type of woman: "I did not do the woman of the Second Empire, but rather the woman who came after—Mme de Callias [for example, *Woman with Fans, Portrait of Nina de Callias*, 1873–74] . . . Henriette Hauser . . . Ellen Andrée, and a lot of others, each of whom has her own character."[8] All of Manet's female subjects are totally distinct—unlike Edgar Degas's dancers, who are as interchangeable as Claude Monet's haystacks—and most of them are demimondaines of the 1870s, a type that became the icon of the period: "Surrounded by the

Edouard Manet, *Nana*, 1877. Oil on canvas, 154 x 115 cm
(60 ⅝ x 45 ¼ inches). Kunsthalle, Hamburg.

most ostentatious luxury, the *grande horizontale*
leads an indolent life principally devoted to
dressing and making up."[9]

The viewers of Manet's day instantly
recognized this type in *Before the Mirror*. Hauser
wears the same blue corset she wore when she
posed for the artist's *Nana* (1877). She stands
before a *psyché*, a large freestanding mirror that
allows the viewer to tilt the glass for a full or
partial view, an essential accessory of the
nineteenth-century boudoir. This *psyché* was part
of Manet's studio furnishings, whereas the
smaller version and the Louis XV furniture seen
in *Nana* were borrowed as props. Left undated,
there is no way of knowing whether *Before the
Mirror* was finished before or after *Nana*, but the
two appear to be contemporaneous. The sittings
for *Nana* were begun in the fall of 1876 and
continued into the winter, obliging Manet to
provide adequate heating for his scantily clad
model, who was accustomed to more sumptuous

surroundings than an artist's studio. The artist
can reasonably be assumed to have worked on
both paintings while Hauser was in the studio
wearing the corset. The importance of this piece
of feminine attire is evident in a remark that
Manet made to a journalist in 1881, a year after
Before the Mirror was shown in an exhibition of
his recent works: "The satin corset may be the
nude of our era."[10]

In both *Before the Mirror* and *Nana*, Manet
portrayed a specifically *modern* type, just as he
had a decade earlier in his paintings depicting
beggars. Hauser represented this type, the
grande courtisane, who had become the feminine
paragon of the day for the men who kept her
and for the women who envied her. For artists of
the brush and the pen, she replaced the mythical
and literary ideals of the past. In *Before the
Mirror*, we are offered a privileged view of this
woman, as though we had penetrated the
intimacy of her boudoir, to which only her lover
and her personal maid should have access.
This is a far more intimate view than we have
of Nana, who is aware of our presence and
moreover is observed from within the scene by
her "Arthur" (the "john" of his day). In *Before the
Mirror*, we are alone with this lovely *cocotte*, who
is no longer a modern Venus, like the reclining
nude in Manet's *Olympia* (1863, Musée d'Orsay,
Paris), but a completely new manifestation of
feminine beauty—self-possessed, self-admiring,
and clothed. Here, she is seen entirely enclosed
within her own environment, she alone looking
at herself, even tightening the laces of her
corset herself.

Manet not only offers us a modern subject,
but also a modern treatment. What we see is
not a picture rich in detail and meticulously
finished, but rather the new genre of the sketch
as finished painting, in which gilded light on
a bare back and rapid strokes of blue and white
evoke more than they depict. We are left with
the breathless sensation of having stolen a
glance, as though by accident—a fleeting vision
that we can never forget.

NOTES

1. Hervé Maneglier, *Paris Impérial, La Vie Quotidienne sous le Second Empire* (Paris, 1990), p. 94. This and all following translations are by the author.

2. Beatrice Farwell, *Manet and the Nude: A Study in Iconography in the Second Empire* (New York, 1981), pp. 135–36.

3. For a summary of the hierarchy of and conditions for nineteenth-century prostitutes, see Beth Archer Brombert, *Edouard Manet: Rebel in a Frock Coat* (New York, 1996), pp. 138–44.

4. Auriant, "Le Modéle de Nana de Manet," *Mercure de France*, March 15, 1934, pp. 668–69. "Regency" refers to the dissolute period from 1715 to 1723, when Philippe II duc d'Orléans ruled as regent during the minority of Louis XV.

5. Antonin Proust, *Edouard Manet: Souvenirs* (Caen, 1988), p. 51.

6. Edmond Bazire, *Edouard Manet* (Paris, 1884), p. 100; quoted in Brombert, *Edouard Manet: Rebel in a Frock Coat*, p. 390.

7. David Kunzle, "The Corset as Erotic Alchemy: From Rococo Galanterie to Montaut's Physiologies," *Art News Annual* 38 (1972), p. 95.

8. Proust, *Edouard Manet: Souvenirs*, p. 51. Nina de Callias posed for *Woman with Fans* (1873–74, Musée d'Orsay, Paris); apart from *Before the Mirror* and *Nana* (1877, Kunsthalle, Hamburg), Hauser was also the model for *Skating* (1877, Fogg Art Museum, Cambridge, Massachusetts); Ellen Andrée is seen in *The Plum* (1877, National Gallery of Art, Washington, D.C.). Among Manet's other models was Méry Laurent, who sat for many works, including *Autumn* (1881, Musée des Beaux Arts, Nancy) and a series of portraits.

9. Alain Corbin, *Filles de Noce: Misère sexuelle et Prostitutes au 19e et 20e siècles* (Paris, 1978), p. 201.

10. C. Delaville, "Edouard Manet," *L'Evénement*, May 31, 1881.

18

Edouard Manet

WOMAN IN EVENING DRESS

(FEMME EN ROBE DE SOIRÉE)

1877–80

Oil on canvas, 174.3 x 83.5 cm (68 ⅛ x 32 ⅞ inches)

19

Edouard Manet

PORTRAIT OF COUNTESS ALBAZZI

(PORTRAIT DE LA COMTESSE ALBAZZI)

1880

Pastel on primed canvas, 56.5 x 46.5 cm (22 ¼ x 18 ⁵⁄₁₆ inches)

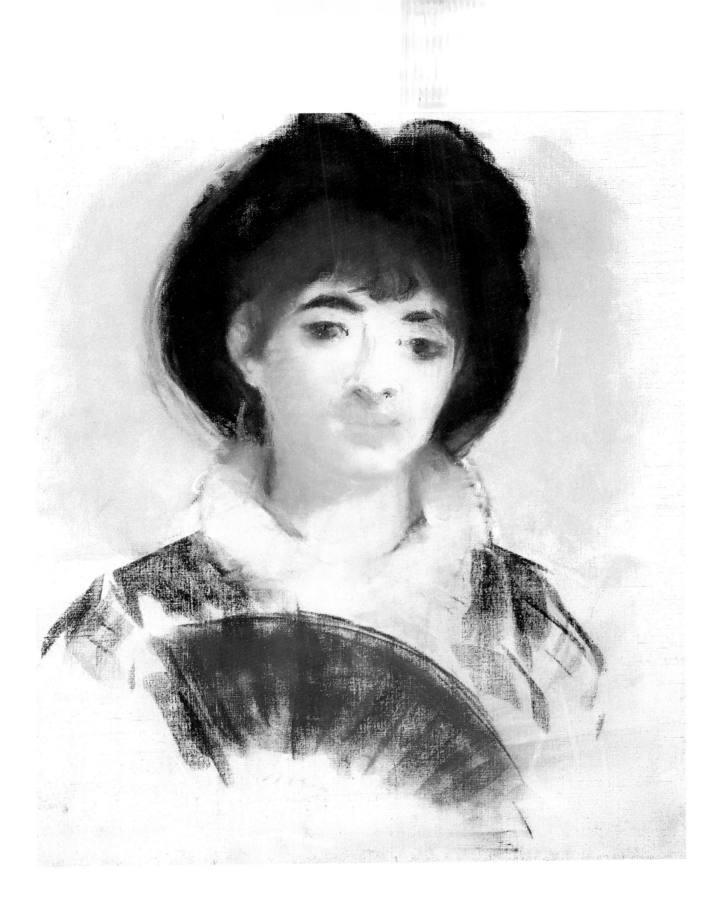

20

Henri Matisse

MALE MODEL (HOMME NU DEBOUT)

ca. 1900

India ink on wove paper, 31.3 x 26.5 cm (12 ⅜ x 10 ⅜ inches)

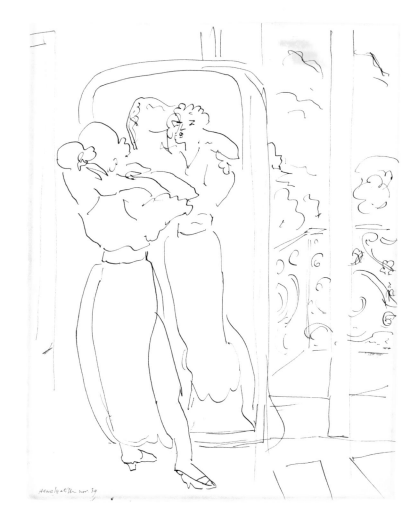

21

Henri Matisse

WOMAN BEFORE MIRROR

(JEUNE FEMME DEVANT UN MIROIR)

November 1939

India ink on wove paper, 38.1 x 28.3 cm (15 x 11 ⅛ inches)

22

Claude Monet

**THE PALAZZO DUCALE,
SEEN FROM SAN GIORGIO MAGGIORE**
(LE PALAIS DUCAL
VU DE SAINT-GEORGES MAJEUR)

1908
Oil on canvas, 65 x 100.5 cm (25 ⁵⁄₈ x 39 ⁵⁄₈ inches)

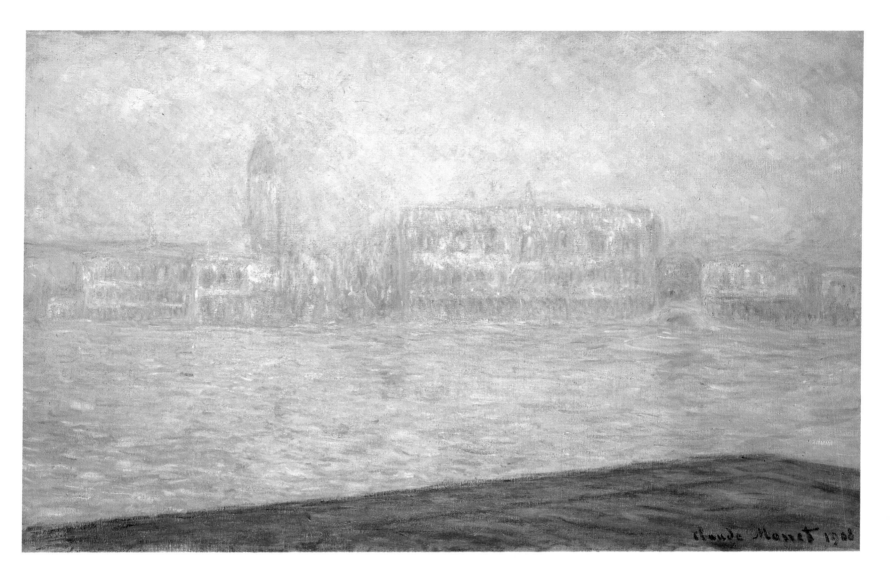

Claude Monet
THE PALAZZO DUCALE, SEEN FROM SAN GIORGIO MAGGIORE

by Joachim Pissarro

CLAUDE MONET'S PREPONDERANT ROLE in the development of Impressionism tends to overshadow the fact that his views of Venice, made in the first decade of the twentieth century, were directly contemporaneous with one of the most crucial moments in the history of Modernism: Pablo Picasso's passage to Cubism in 1907–08. Similarly, it is easy to forget that Monet's Venetian paintings succeeded by just a couple of years the full-fledged explosion of colors that took place at the hands of André Derain, Henri Matisse, and Maurice de Vlaminck during their short-lived Fauve episode in 1905–06. Arguably, Monet's high-pitched and color-saturated views of Venice owe more to Derain's paintings of London of 1905–06 (such as *Big Ben*, 1905), than to his own early Impressionist scenes of that city, made in 1870–71. Reciprocally, these paintings by Derain had been prompted by Monet's views of the Thames (for example, *Houses of Parliament, London*, 1900–01), begun in 1899 and exhibited at the Galerie Durand-Ruel in Paris in 1904.[1] These mutual interactions, which paved the way toward the series of views of Venice, situate Monet's artistic production at the dawn of the twentieth century within a broad Modernist canon—rather than in a languishing and aging Impressionist idiom.

Yet for the most part, Monet is distanced from Picasso, Derain, and Matisse in critical writings on these artists.[2] Monet and Picasso especially seem to have stood for directly opposite aesthetic beliefs. It is probable that they largely ignored each other, even though their artistic careers overlapped for more than a quarter of a century. But the presence in the Thannhauser Collection of Monet's *The Palazzo Ducale Seen from San Giorgio Maggiore* together with Picasso's *Fernande with a Black Mantilla* (1905–06, cat. no. 33) and *Woman with Yellow Hair* (1931, cat. no. 48)—and the fact that these

works were evidently intended by Justin Thannhauser to be seen in the close vicinity of one another—prompts us to question the position of Monet in the first decades of the twentieth century. In their own ways, the collections of Sergei Shchukin and Albert Barnes address analogous questions, since both collectors also held important works by Monet as well as major works by Matisse and Picasso.[3]

Thankfully, the role of Monet's views of Venice within the context of early Modernism was made especially clear at the time of their first public viewing. Of the three dozen paintings that he produced in Venice in 1908, twenty-nine were exhibited for the first time as a series—or, more accurately, as a group of series—at the gallery Bernheim-Jeune in Paris from May 28 to June 8, 1912. The title of the exhibition was elliptic but said it all— "Monet Venise."

Only a few months before, Monet's dealers, the Bernheim-Jeune brothers, had organized another, very different exhibition, though with Italy also at its core: the first group exhibition of works by the Futurists to be shown outside Italy.[4] Bernheim-Jeune's regular visitors would therefore have seen Monet's Venetian views only *after* they had discovered the pioneering works by the Futurists. A roaring success, Monet's exhibition was hailed as a "*coup de gloire*" (triumph) by most critics,[5] who did not fail to draw a connection between his work and early Modernism. This connection is all the more significant as it soon became lost to commentators of the post–World War I generation and was not revived until after World War II, chiefly by American critics.[6]

Guillaume Apollinaire, the poet, art critic, and great champion of Cubism, visited the Monet and Futurist exhibitions at Bernheim-Jeune and reviewed both successively in 1912. Ironically, the poet was quite laudatory about Monet, but far less so about Umberto Boccioni, Filippo Tommaso Marinetti, and Gino Severini.

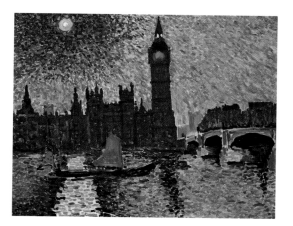

André Derain, *Big Ben*, 1905. Oil on canvas, 79 x 98 cm (31 ¼ x 38 ⅝ inches). Musée d'Art Moderne de Troyes, Gift, Pierre and Denise Lévy.

He bluntly took credit for having introduced the theoretical writings of the "new French painters" (the Cubists) to the Futurists,[7] but found that the Futurists did not live up to their readings and were "scattered." While he detected a "rigorous discipline" at the heart of the Cubists' art, he found that "randomness" was the rule that governed the art of the Futurists. He described their work as "popular and boisterous," in contrast to Cubism, which to his eye was a "pure and lucid" art, "the noblest and highest art that exists today."[8] The basis for this hyperbole was the fact that Cubism did not attempt to transmit a "visual perception" of any object, but "to give an idea, i.e., the objective truth" of that object.[9]

Ironically, it was also around the notion of "truthfulness" that Apollinaire praised Monet's views of Venice. He wrote that Monet's "concern for truth" led the viewer to understand that Venice was "no longer the Gate of the Orient"; the city lost its mythical status and was reduced to its truth: canals seen through mist or haze.[10] The idea that Monet was debunking an old myth by having grappled with Venice was

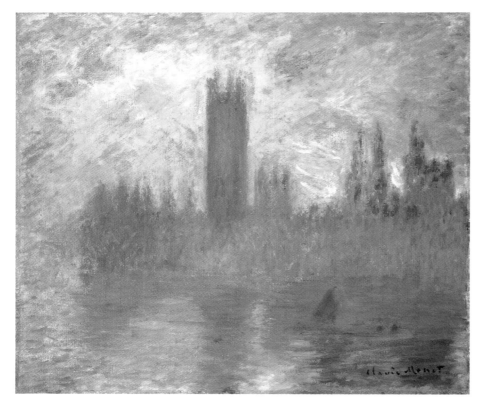

Claude Monet, *Houses of Parliament,
London*, 1900–01. Oil on canvas,
81 x 92 cm (31 ⅞ x 36 ¼ inches). The Art
Institute of Chicago, Mr. and Mrs.
Martin A. Ryerson Collection 1933.1164.

not just Apollinaire's idea. Several critics had
noted that, until Monet came and saved the city
from the weight of its kitsch perception, Venice
was no longer simply a town, for it had been
drowned by its own myth, its reputation, its
universal image: "Venice has sunk under the
weight of the imbeciles," wrote Octave Mirbeau
in his review of Monet's views of Venice.
"Venice is nothing more than a color postcard."[11]
Apollinaire echoed this thought: "Until now
Venice was for artists a kind of mirage conjured
up by Morgan Le Fay, who threw in there some
high-pitched hues above the Adriatic. Claude
Monet has done away with this prestige, but the
new Venice extolled by his truthful art . . . is no

less beautiful than the city with rainbow colors
that we had dreamed."[12]

Truth, in Apollinaire's eye, is what makes
Monet's Venice so beautiful, and it is also, in
the critical language of the poet, the link
between Monet and Picasso. Monet's views of
Venice are animated by the artist's desire to get
down to the bare essentials of what he selected
to look at. Just like his famed *"paysages d'eau"*
(waterscapes), Venice was, for him, a return to
basic materials—stones, light, water, mist—
each interacting with the other to produce a
mosaic of suffused iridescent hues that saturate
the entire surface of the canvas. Never before
had Venice been so severely stripped of all its
mythical attributes; never before, arguably,
did it look as gloriously beautiful, in its self-
reflecting, though banal, reality. Never had
the materiality of the air and the haze and their
colors coalesced into something as real—as
truthful—as they did in Monet's paintings.

Monet set out his intentions some years
before he painted the Venice series, stating,
"The subject is secondary for me; what I wish to
reproduce is what exists between myself and the
subject."[13] Between him and things was the real
truth—the air, the famous haze, the atmosphere
recomposed by the artist through his own
highly idiosyncratic palette. That truth was
articulated by the need felt by the artist to strip
the real of all its unnecessary paraphernalia of
postcardlike perceptions. This novel truth, it
must be said, was also the product of a forceful
artistic individuality, who arguably was
projecting himself through every brushstroke
he applied on the canvas. In this subtle and
complex dynamic, even though Monet's
pictorial language was notably different from
Picasso's and Matisse's, the aging Impressionist
was indeed standing not far from them, on the
ground of high Modernism.

NOTES

1. Derain explained: "[Vollard] sent me [to London] with the hope that I would be able to completely revive the striking image presented by Claude Monet and that had made such an enormous impression in Paris some years before." André Derain to Ronald Alley, May 15, 1953, in *André Derain, le peintre du "trouble modern"*, exh. cat. (Paris: Musée d'Art Moderne de la Ville de Paris, 1994), p. 140. (English translation by Ellen Sowchek.)

2. This point is defended by Pierre Daix in the entry on Monet in his *Dictionnaire Picasso* (Paris, 1995), p. 600: "Although they coexisted as artists for a quarter of a century, and although the World's Fair of 1900 had confirmed Monet's celebrity, Picasso and Monet did not know each other. The mature Monet's effusions of color represented everything that Picasso was rebelling against and it is probable that the elderly painter of Giverny paid not the least bit of attention to his turbulent young colleague." (English translation by Ellen Sowchek.)

3. Shchukin's collection is now divided between the Hermitage Museum in Saint Petersburg and the Pushkin Museum of Fine Arts in Moscow. Barnes's is housed in the Barnes Foundation, Merion, Pennsylvania.

4. *Les Peintres futuristes italiens* was shown at Bernheim-Jeune from February 5 to 24, 1912. The catalogue included the French translation of the "Manifesto of Futurist Painters" (pp. 15–22).

5. See the chapter entitled "Monet's Mediterranean and His Critics," in Joachim Pissarro, *Monet and the Mediterranean*, exh. cat. (New York: Brooklyn Museum of Art; Fort Worth: Kimbell Art Museum, 1997), pp. 55–68.

6. On this issue, see Romy Golan, "Oceanic Sensations; Monet's *Grandes Décorations* and Mural Painting in France from 1927 to 1952," and Michael Leja, "The Monet Revival and New York School Abstraction," in *Monet in the Twentieth Century*, exh. cat. (Boston: Museum of Fine Arts; London: Royal Academy of Arts, 1998), pp. 86–97 and 98–108.

7. See Guillaume Apollinaire, "Le Futurisme" (1912), in Apollinaire, *Chroniques d'art (1902–1918)* (Paris, 1960), pp. 262–63. (English translation by the author.)

8. Ibid.

9. Apollinaire, "La Peinture moderne" (1913), in *Chroniques d'art*, pp. 272–73.

10. Apollinaire, "Claude Monet" (1912), in *Chroniques d'art*, p. 250.

11. Octave Mirbeau, "Les 'Venise' de Cl. Monet," *L'Art Moderne*, June 2, 1912, pp. 167–68. (English translation by the author.)

12. Apollinaire, "Claude Monet," p. 250.

13. Quoted in an anonymous article published in *Dagbladet*, April 4, 1895. A French translation of the article is published in French in Jean-Pierre Hoschedé, *Claude Monet, ce mal connu*, 2 vols. (Geneva, 1960), vol. 2, pp. 209–10; quoted in Daniel Wildenstein, *Claude Monet. Biographie et catalogue raisonné* (Lausanne and Paris, 1979), vol. 3, p. 65. (English translation by Ellen Sowchek.)

23

Jules Pascin

JUSTIN K. THANNHAUSER
AND RUDOLF LÉVY PLAYING CARDS
(JUSTIN K. THANNHAUSER
ET RUDOLF LÉVY JOUANT AUX CARTES)

December 24, 1911
India ink and colored pencil on paper, 23 x 29 cm (9 ⅟₁₆ x 11 ⅟₁₆ inches)

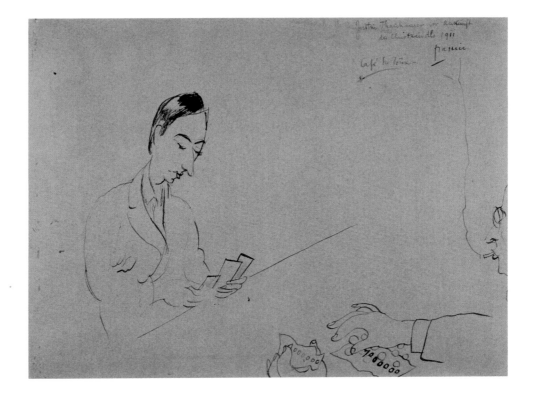

24

Pablo Picasso

THE END OF THE ROAD (AU BOUT DE LA ROUTE)

1898–99

Oil washes and conté crayon on laid paper, 47.1 x 30.8 cm (18 ⁵⁄₁₆ x 12 ⅛ inches)

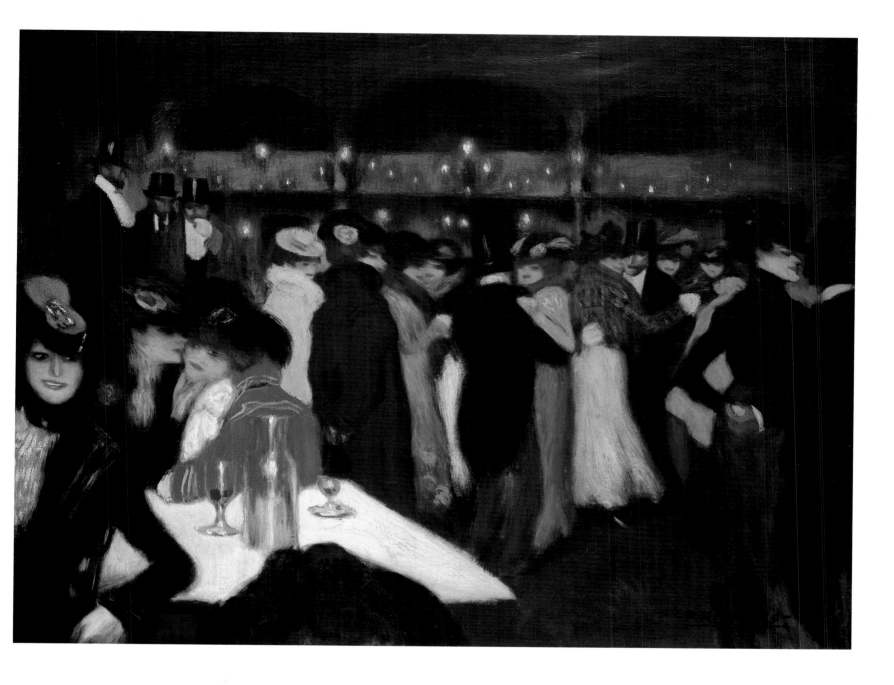

25

Pablo Picasso

LE MOULIN DE LA GALETTE

autumn 1900

Oil on canvas, 88.2 x 115.5 cm (34 ¾ x 45 ½ inches)

26

Pablo Picasso

THE PICADOR (LE PICADOR)

1900

Pastel on paper, 19 x 27 cm (7 $\frac{7}{16}$ x 10 $\frac{5}{8}$ inches)

27

Pablo Picasso

IN THE CAFÉ (AU CAFÉ)

1901

Charcoal on paper, 21.4 x 25.6 cm (8 ⁷⁄₁₆ x 10 ⁷⁄₁₆ inches)

28

Pablo Picasso

THE FOURTEENTH OF JULY (LE QUATORZE JUILLET)

1901

Oil on cardboard, mounted on canvas, 48 x 62.8 cm (18 ⅞ x 24 ¼ inches)

29

Pablo Picasso

WOMAN AND CHILD (FEMME ET ENFANT)

1903

Conté crayon on wove paper, 33.7 x 23.2 cm (13 ¼ x 9 ⅛ inches)

D'Eugéne Carrière

Picasso

30

Pablo Picasso

THE MADMAN (EL LOCO)

1903–04
Watercolor on wove paper, 32.6 x 23.2 cm (12 ¹⁵⁄₁₆ x 9 ⅛ inches)

31

Pablo Picasso

PROFILE OF WOMAN WITH A CHIGNON
(PROFIL DE FEMME AU CHIGNON)

1904
Pencil, india ink, charcoal, and blue wash on paper, 37 x 26.7 cm (14 ⅝ x 10 ½ inches)

32

Pablo Picasso

WOMAN IRONING (LA REPASSEUSE)

1904

Oil on canvas, 116.2 x 73 cm (45 ¾ x 28 ¾ inches)

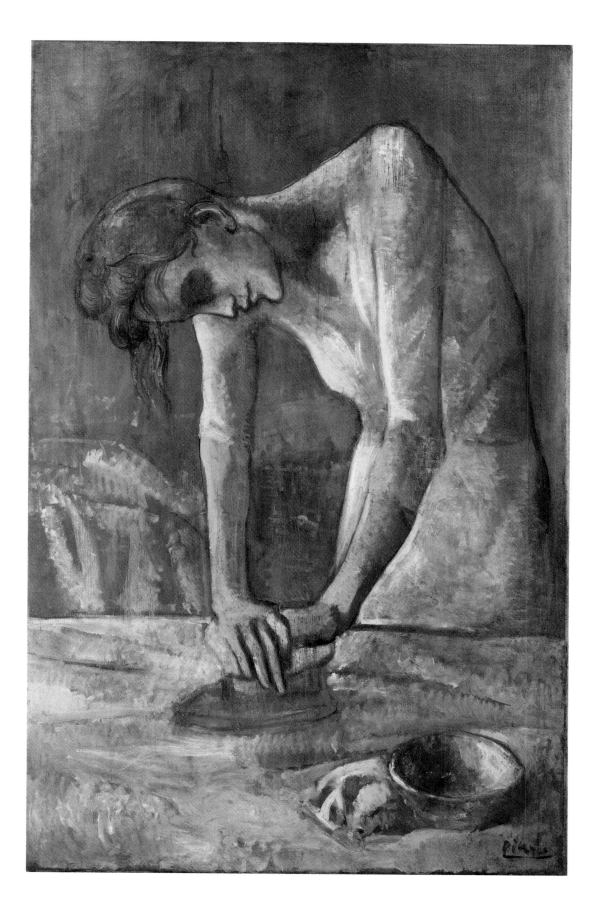

33
Pablo Picasso

FERNANDE WITH A BLACK MANTILLA

(FERNANDE À LA MANTILLE NOIR)

1905–06
Oil on canvas, 100 x 81 cm (39 ⅜ x 31 ⅞ inches)

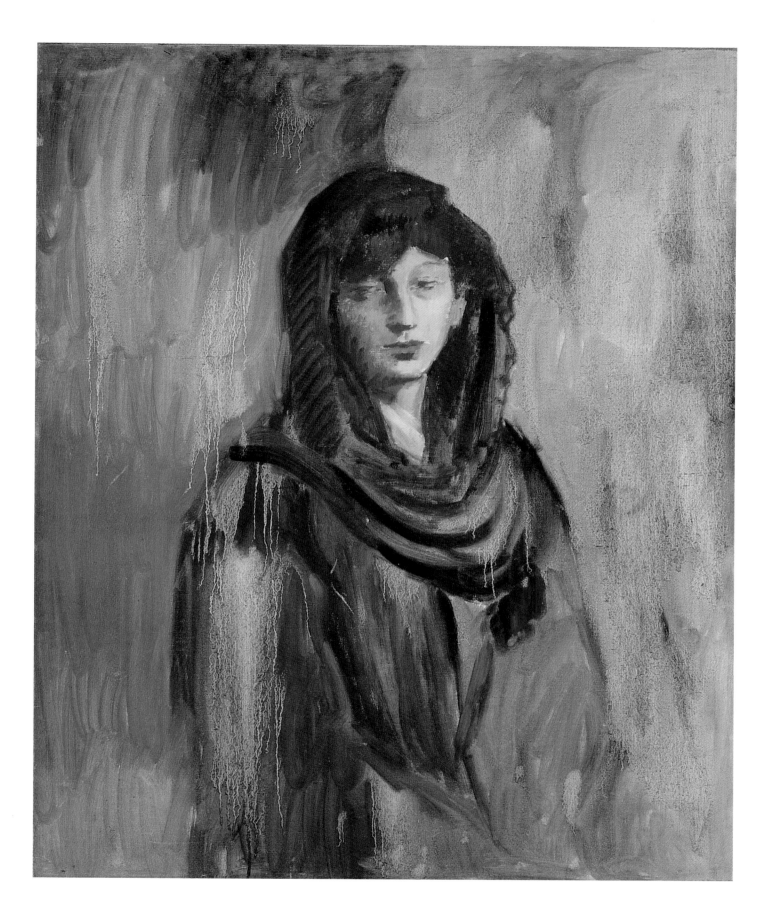

Pablo Picasso

FERNANDE WITH A BLACK MANTILLA

by Robert Rosenblum

OF THE LIFELONG SEQUENCE of women—
mistresses and wives—who would serve as the
most readily available muses for Picasso's
art, Fernande Olivier was the first to become
the catalyst for the master's full range of
metamorphic power.[1] From their initial meeting
in August 1904 to their breakup in 1912, she was
a constant presence in his life; and in his work,
she played roles that began with a sleeping,
Ariadne-like figure tenderly contemplated by a
lover[2] and ended with a craggy giantess whose
distinctive features, fractured by the accelerating
momentum of Cubism, would ultimately
become illegible.[3]

Fernande with a Black Mantilla has an early
position in this series of fantastic transformations
of an ordinary mortal, a Parisian who was born
in the same year as Picasso, 1881; who shared
with him the company of a bohemian who's who
that ranged from Georges Braque to Alice B.
Toklas; who then fell on much harder times and
in 1933 published memoirs of her youth, *Picasso
et ses amis*,[4] which the artist tried to suppress;[5]
and who died—poor, old, and ugly—in Paris in
1966, only seven years before the death of her
lover. However, the dating of the portrait, like
the work itself, has received relatively little
attention in the vast Picasso literature. Christian
Zervos, in his pioneering catalogue of 1932,
dated it 1905; but in the undated second edition,
he changed it to 1906.[6] This vacillation marks
other catalogues and captions, including
the Guggenheim Museum's, where the date
traditionally given, 1905/1906?, strides the
chronological fence. Yet elsewhere 1906 has most
often won out.[7] The reason may lie in Fernande's
mantilla, the signature headdress of Spain.
Presumably, she would have been more likely to
wear this in the summer of 1906 during a
sojourn with Picasso in the Pyrenean village of
Gósol, where the artist's national roots were

reawakened (witness his frequent inclusion of the local drinking vessel, the *porrón*, in still lifes from these months).[8] But there is nothing else about the portrait that corresponds to the earthy, sunbaked, and elemental forms that dominate the Gósol period. On the contrary, Fernande's presence is almost more of a mirage than a palpable fact; and the restriction to translucent tones of black (the red lips excepted) radiates a somber, introspective mood at odds with the firm Mediterranean balance of mind and body that characterizes the many depictions of Fernande at Gósol.

The closest companion to the Thannhauser painting, in fact, is Picasso's *Portrait of Mrs. Canals* (1905), a portrayal of Fernande's close friend, Benedetta Coletti,[9] a Roman who had once modeled for Edgar Degas and had married an old Barcelona friend of Picasso's, the artist Ricard Canals.[10] Although the head and neck are more firmly modeled and contoured in the painting of Benedetta than they are in Fernande's portrait, the overall mood is similarly veiled and mysterious; and its extraordinary experimentation with thinly painted scribbles and patches of paint that undermine the figure's stable, tangible presence makes it almost a twin to the darker image of Fernande. The two women were actually paired in a costume photograph taken in Canals's Paris studio in 1904, where they both wear mantillas and assume the postures of fashionable spectators at a bullfight.[11] It is tempting to think that Picasso's painted portraits of them, once more in mantillas, offer a reprise of this earlier Spanish masquerade.

Moreover, both portraits also seem to relate to Picasso's first efforts at making a monotype under the guidance of Canals, who had early served as Picasso's tutor in printmaking (see *Portrait of a Woman with Mantilla*, 1905).[12] Here again, we see a woman with a strongly modeled nose and somewhat dour expression who wears

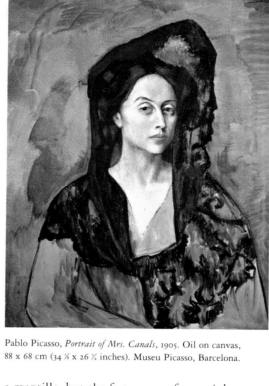

Pablo Picasso, *Portrait of Mrs. Canals*, 1905. Oil on canvas, 88 x 68 cm (34 ⅝ x 26 ¾ inches). Museu Picasso, Barcelona.

Pablo Picasso, *Portrait of a Woman with Mantilla*, 1905. Monotype on printed glass with ink and black oil paint on paper, 52 x 30 cm (20 ½ x 11 ¾ inches). Private collection.

a mantilla, but the features are far too ink-smudged to permit positive identification as either Benedetta or Fernande.[13] Perhaps, as he was so often to do in his later portraits, Picasso fused the features of the two women. And it should be noted, too, that the seemingly accidental effects of blotted ink and wildly irregular hatchings in the monotype are amplified in the more calculatedly spontaneous paint surfaces of *Fernande with a Black Mantilla*. Here Picasso magnifies this language of impulse and chance in the large areas of trickled and broadly brushed paint that destroy conventions of preordained clarity and finish. In any case, the date traditionally assigned to both the painted portrait of Benedetta and the monotype is fall 1905, soon after Picasso's return from the Netherlands, making the probability strong that the Thannhauser painting should bear the same date.[14]

Looking at the Thannhauser portrait from the broader vantage point of how it fits into Picasso's ever-expanding universe, we may also read it as summary and prophecy. In an extended discussion of the painting,[15] Fred Licht points out how, for all its monochrome palette, *Fernande with a Black Mantilla* reflects those liberations of paint handling familiar to the upheavals running from Vincent van Gogh through to Henri Matisse, namely a rejection of linear boundaries in favor of a free use of thinned or thickened oil paint to engulf an image; he also notes how the insubstantiality of the painting looks forward to the strange world of Analytic Cubism. Indeed, the sense of Fernande's simultaneously coalescing and dissolving like a phantom, and the curious ambiguities of her relationship to the restless background, which almost effaces the volume of her right arm, provide a preview of Cubist effects, as does the monastic restriction to a shadowy darkness shot through with glimmers of light. And of course the portrait's monochromy also recalls Picasso's recurrent fascination with working within a single hue or value, apparent in both the melancholic paintings of the Blue Period and the pervasive terra-cotta palette that dominates the Gósol sojourn of summer 1906.

Looked at from quite a different angle, Picasso's Spanish disguise for his French girlfriend strikes another note; for here, as elsewhere, Picasso the Spaniard enjoyed "hispanicizing" his foreign women not only in their dress, but in their art-historical allusions. So it was that in Gósol, Picasso would represent

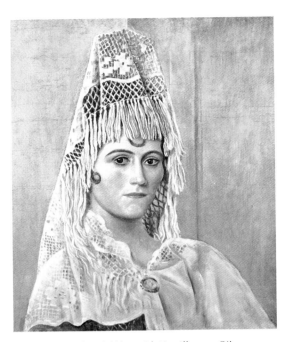

Pablo Picasso, *Olga Khokhlova with Mantilla*, 1917. Oil on canvas, 64 x 53 cm (25 ¼ x 20 ⅞ inches). Collection of Christine Ruiz-Picasso, on extended loan to Fundación Paul, Christine y Bernard Ruiz-Picasso.

Fernande, naked except for the scarf she seems to have worn so often, as the reincarnation of Goya's Maja Desnuda;[16] and that later, in 1917, he would resurrect the mantilla for his wife-to-be, the Russian Olga Khokhlova.[17] Even decades after, in prints made in the 1950s, he would disguise his second wife, the French Jacqueline Roque as both the Spanish dancer Lola Valence (taken from Edouard Manet's portrait) and a Spanish Virgin of Sorrows.[18] For a fictional moment, at least, all of these women became Señora Picasso. Typically possessive, he could even impose his own nationality upon his foreign affairs.

As for proud possessors, it should be mentioned finally that Justin Thannhauser bought Fernande's portrait from the Feilchenfeldt family in 1956. As is evident in a photograph of him posing before this canvas (see the frontispiece of this publication), he must have considered its acquisition a major triumph.

NOTES

1. Of the many presentations of Fernande's character, the liveliest and most succinct is found in John Richardson, *A Life of Picasso*, vol. 1, 1881–1906 (New York, 1991), chapter 20.

2. In two 1904 watercolors, illustrated, ibid., p. 316.

3. For an excellent account of the evolution of the Fernande portraits, see Pierre Daix, "Portraiture in Picasso's Primitivism and Cubism," in William Rubin, ed., *Picasso and Portraiture*, exh. cat. (New York: The Museum of Modern Art, 1996), pp. 255ff.

4. These vivid memoirs were originally published as separate articles in *Mercure de France* in 1931, and were then compiled as a book (Paris, 1933). The book was translated into English as *Picasso and His Friends* (New York, 1965). For further memoirs, see Fernande Olivier, *Souvenirs intimes* (Paris, 1988).

5. On this, see Pierre Daix, *Picasso: Life and Art* (New York, 1987), p. 238.

6. Christian Zervos, *Pablo Picasso* (Paris, 1932), vol. I, no. 253; second edition (Paris, n.d.), vol. I, no. 253.

7. For bibliographical references to *Fernande with a Black Mantilla*, see "Catalogue Entries" in this publication.

8. For more on Picasso's Spanish choices, see Robert Rosenblum, "The Spanishness of Picasso's Still Lifes," in Jonathan Brown, ed., *Picasso and the Spanish Tradition* (New Haven and London, 1996), chapter 3.

9. The connection between the two portraits was first made in Josep Palau i Fabre, *Picasso: The Early Years: 1881–1907* (New York, 1981), p. 424, where the painting is dated Paris 1905.

10. For more on Canals, see Richardson, *A Life of Picasso*, especially pp. 134–38.

11. For more on this photograph and the painting by Canals that stems from it, see ibid., pp. 312–13.

12. On this monotype, see *Picasso 1905–1906: From the Rose Period to the Ochres of Gósol* (Barcelona, 1992), p. 260.

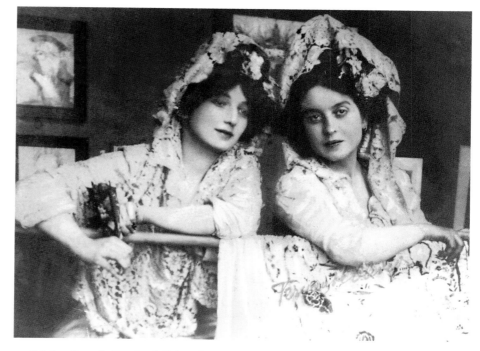

Fernande Olivier and Benedetta Canals in Ricard Canals's studio, Paris, 1904.

12. Brigitte Baer, in Bernhard Geiser, *Picasso peintre-graveur*, corrected edition with supplement (Bern, 1990), p. 401.

14. Marilyn McCully was kind enough to send me her own opinion about the dating of the Thannhauser painting (fax, July 12, 1999); she agrees that it does not belong to the Gósol period, but should be pushed back to fall or winter 1905–06.

15. See Fred Licht, "The Thannhauser Picassos," in this publication, pp. 66–67; originally published in *Guggenheim Museum: Thannhauser Collection* (New York, 1992), pp. 81–82.

16. On this parody, see Robert Rosenblum, "Picasso in Gósol: The Calm before the Storm," in Marilyn McCully, ed., *Picasso: The Early Years, 1892–1906*, exh. cat. (Washington, D.C.: National Gallery of Art, 1997), p. 267.

17. On the portrait and related works by Picasso and Rafael Padilla, see Michael FitzGerald, "The Modernists' Dilemma: Neoclassicism and the Portrayal of Olga Khokhlova," in Rubin, ed., *Picasso and Portraiture*, pp. 304–06.

18. Both these prints are illustrated in Rubin, ed., *Picasso and Portraiture*, pp. 458 and 464.

34

Pablo Picasso

YOUNG ACROBAT AND CHILD

(JEUNE ACROBATE ET ENFANT)

March 26, 1905

Ink and gouache on gray cardboard, 31.3 x 25.1 cm (12 ⅜ x 9 ⅞ inches)

35
Pablo Picasso
VASE OF FLOWERS (VASE DE FLEURS)

1905–06
India ink on wove paper, 26.7 x 19.7 cm (10 ½ x 7 ¾ inches)

36

Pablo Picasso

STILL LIFE: FLOWERS IN A VASE

(NATURE MORTE: FLEURS DANS UN VASE)

1906

Gouache on cardboard, 72.1 x 55.9 cm (28 ⅜ x 22 inches)

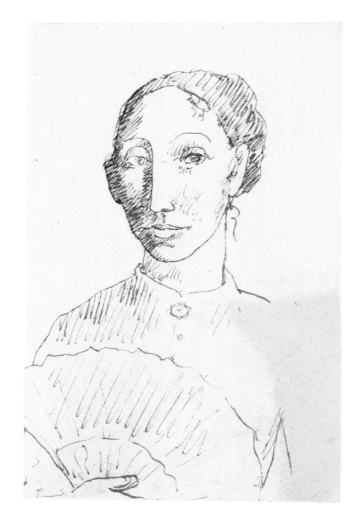

37

Pablo Picasso

WOMAN WITH OPEN FAN

(FEMME À L'ÉVENTAIL)

1906

Ink on wove paper, 17.1 x 11 cm (6 ¾ x 4 ⁵⁄₁₆ inches)

38
Pablo Picasso
WOMAN AND DEVIL (FEMME ET DIABLE)
1906
India ink on laid paper, 30.8 x 23.2 cm (12 ⅛ x 9 ⅛ inches)

39
Pablo Picasso

GLASS, PIPE, AND PACKET OF TOBACCO
(VERRE, PIPE ET PAQUET DE TABAC)

1914
Gouache and pencil on wove brown paper, 19.8 x 29.7 cm (7 ⁱ³⁄₁₆ x 11 ⁷⁄₁₆ inches)

40

Pablo Picasso

THREE BATHERS (TROIS BAIGNEUSES)

August 1920

Pastel with oil and pencil on laid paper, 47.8 x 61.4 cm (18 ¹⁵⁄₁₆ x 24 ¹⁄₁₆ inches)

41

Pablo Picasso

DINARD

summer 1922

Pencil on wove gray-blue paper, 42.2 x 29.4 cm (16 ⅝ x 11 ⁹⁄₁₆ inches)

42

Pablo Picasso

WOMAN IN AN ARMCHAIR

(FEMME DANS UN FAUTEUIL)

1922

Oil on canvas, 91.5 x 62.5 cm (36 x 24 ⅝ inches)

43

Pablo Picasso

TABLE BEFORE THE WINDOW

(TABLE DEVANT LA FENÊTRE)

1922

Watercolor and pencil on laid paper, 14.1 x 11 cm (5 ⁵⁄₁₆ x 4 ⁷⁄₁₆ inches)

44
Pablo Picasso
THE TABLE (LE GUÉRIDON)

December 24, 1922
Watercolor and gouache on laid paper, 16.3 x 10.3 cm (6 ⁷⁄₁₆ x 4 ⁱ⁄₁₆ inches)

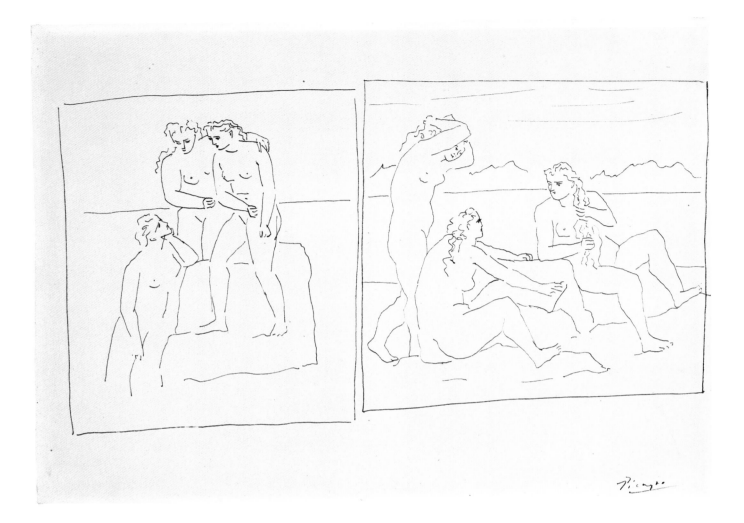

45

Pablo Picasso

TWO GROUPS OF BATHERS

(DEUX GROUPES DE BAIGNEUSES)

1923

Ink on wove paper, 25.9 x 35.2 cm (10 ³⁄₁₆ x 13 ⅞ inches)

46

Pablo Picasso

THREE DANCERS (TROIS DANSEURS)

April 1925

India ink on wove paper, 34 x 24.8 cm (13 ⅜ x 9 ¾ inches)

47

Pablo Picasso

BIRD ON A TREE (L'OISEAU)

August 1928

Oil on canvas, 34.9 x 24.1 cm (13 ¼ x 9 ½ inches)

Pablo Picasso

WOMAN WITH YELLOW HAIR
(FEMME AUX CHEVEUX JAUNES)

December 1931
Oil on canvas, 100 x 81 cm (39 ⅜ x 31 ⅞ inches)

Pablo Picasso

WOMAN WITH YELLOW HAIR

by Michael FitzGerald

IN DECEMBER 1931, PABLO PICASSO began a series of paintings depicting a voluptuous, blond woman that would become the finale of a major retrospective exhibition and a flamboyant exposition of how intimately he intertwined his public stature as the leading contemporary artist with his secretive private life. Although it is part of this series, *Woman with Yellow Hair* did not appear in the retrospective, which was held at the Galerie Georges Petit in Paris in June and July 1932.

The apparent simplicity of *Woman with Yellow Hair* might suggest that, within the series, it is a late, reductive work, but in fact it is only the second, made eleven days after the first, *The Red Armchair*, and several months before the symphonically complex *Girl Before a Mirror* (March 1932, The Museum of Modern Art, New York). Moreover, the subject of *Woman with Yellow Hair* is an abrupt departure from the self-conscious figure depicted in *The Red Armchair*, a woman whose staring eyes and ramrod posture (which is accentuated by the vertically striped upholstery of the chair) signal alert engagement. In the Thannhauser painting, Picasso introduced the theme of slumber, or abandonment to sleep, that would dominate the series as he plumbed further and further into imagined states of mind. Although he had explored the related theme of a sleeping woman watched by a man as early as his Blue Period (in *Meditation* [1904, The Museum of Modern Art, New York]), Picasso now focused exclusively on the female figure and her state of reverie (perhaps most prominently in *The Dream, Marie-Thérèse*, January 24, 1932).

Cradling her head in her arms, the seated woman in *Woman with Yellow Hair* drapes her upper body across a side table in a makeshift position that could support only a nap—and only one commanded by Morpheus. Yet the composition conveys no awkwardness. The woman's pristine head, centered in the top half

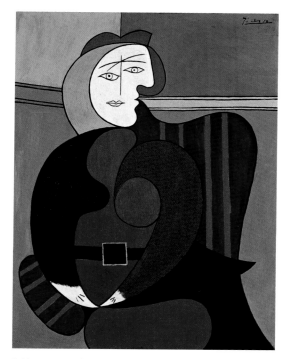

Pablo Picasso, *The Red Armchair*, 1931. Oil and enamel on plywood, 130.8 x 99 cm (51 ½ x 39 inches). The Art Institute of Chicago, Gift of Mr. and Mrs. Daniel Saidenberg 1957.72.

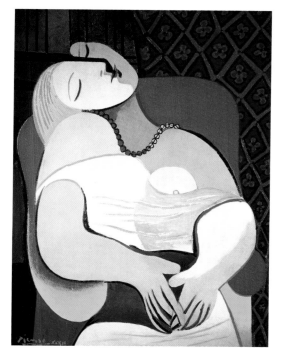

Pablo Picasso, *The Dream (Marie-Thérèse)*, January 24, 1932. Oil on canvas, 130 x 97 cm (51 ¼ x 38 ⅛ inches). Private collection.

of the canvas, is wrapped in plump, enveloping flesh and thick tresses. The edge of the circular table seems to join the unison of curves, although the tablecloth's bold stripes (which are inherited from *The Red Armchair*) provide thrusting counterpoints to highlight her roundness and to buttress her weight.

Despite a sensation of sensual abandon, the image is not explicitly erotic. The woman's clothing is demure, even dowdy. Unlike other figures depicted in the series, her ivory-hued blouse has not slipped off her shoulder, and her loose, brown skirt reveals nothing beneath. Although one full breast is outlined, her face is the center of attention. Her strict profile, however, betrays no solidity, no volume that an open mouth, nostril, or even a broad eye might suggest. With her eyelid closed, her face is uninflected, a nearly empty well sinking into the depths of its nocturnal lavender from the spirals of brighter pink, yellow, and whites that surround it, just as her entire upper body is detached from the busy alternation of black and white and red and green across the tablecloth.

This suggested union of mind and body in slumber, which is further implied by the loose outlines and open contours of the head, hand, and shoulder, reflects Picasso's fascination with the Surrealists' longstanding devotion to dreams as a portal to the unconscious and a profound human nature beyond reason. Yet in the series of paintings that began in December 1931, Picasso did far more than invent a personal interpretation of ideas at the forefront of contemporary art; he marshaled his full arsenal to overcome an old rival and to celebrate a new love.

In June and July 1931—a year before Picasso's retrospective was held—the Galerie Petit presented the first full-scale exhibition of Henri Matisse's art in twenty-one years. It was a revelation to those who had not kept abreast of Matisse's activities since he had departed for Nice in 1917. Apparently, Picasso was among

those startled by the paintings on view. He immediately canceled an exhibition of his work that Alfred H. Barr, Jr. had arduously negotiated for the Museum of Modern Art in New York that fall, and soon agreed to a retrospective at Petit for the following summer.[1]

In preparing to take over the rooms where Matisse's paintings had hung, Picasso claimed the subject that permeated Matisse's work— the odalisque. Picasso swept Matisse's bourgeois hothouses clean, stripping down the compositions until they resembled Matisse's bold simplifications of the early 1910s rather than his more conventional style of the 1920s. He also cultivated an introspective complexity more compelling than the blank looks of Matisse's models. (Matisse's *Harmony in Yellow* [1928, private collection], for example, which was in his exhibition at Petit, is strikingly similar to *Woman with Yellow Hair* in its portrayal of a half-length woman sleeping beside a circular table, but the figure is placed in the background as little more than another element of the still life.)

After all, Picasso's woman with yellow hair is his mistress, Marie-Thérèse Walter. The origin of their relationship remained so clandestine that only in the last decade have we realized that Picasso and Walter probably met in 1925, when she was a fifteen-year-old minor. By then, his six-year marriage to Olga Khokhlova, who had been a dancer with Sergei Diaghilev's Ballets Russes, was failing. When Khokhlova moved out of the family apartment on the rue La Boétie in June 1935 and Walter gave birth to a daughter, Maya, four months later, Picasso's new domestic life became apparent to many in the art world. In 1932, the affair was implied by the array of paintings at Petit.[2]

Nonetheless, *Woman with Yellow Hair* is not simply a portrait of Walter. Like the figure's liberating doze, the painting offers a passage through an array of experiences far beyond the limits of a particular relationship, however adventurous. In this picture and its successors, Picasso surpassed Matisse and the Surrealists by overcoming a seemingly impossible contradiction; he projected an impression of intense inwardness onto a public stage of professional ambition and intellectual ferment, without sacrificing the intimacy necessary for others to share the illusion.

NOTES

1. For a fuller account of this history, see Michael C. FitzGerald, *Making Modernism: Picasso and the Creation of the Market for Twentieth-Century Art* (Berkeley, 1996), pp. 213–14.

2. For the most comprehensive discussion of the paintings of Walter, see Robert Rosenblum, "Picasso's Blond Muse: The Reign of Marie-Thérèse Walter," in William Rubin, ed., *Picasso and Portraiture: Representation and Transformation*, exh. cat. (New York: The Museum of Modern Art, 1996), pp. 336–83.

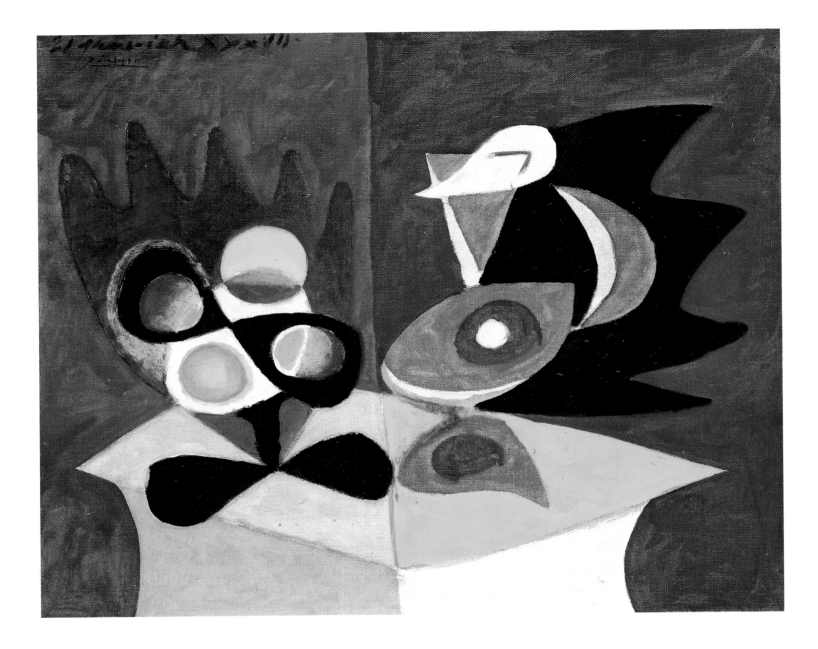

49

Pablo Picasso

STILL LIFE: FRUIT DISH AND PITCHER

(NATURE MORTE: COMPOTIER ET CRUCHE)

January 21–22, 1937

Enamel on canvas, 49.8 x 60.8 cm (19 ⅝ x 23 ¹⁵/₁₆ inches)

50

Pablo Picasso

STILL LIFE: FRUITS AND PITCHER

(NATURE MORTE: FRUITS ET POT)

January 22, 1939

Oil and enamel (?) on canvas, 27.2 x 41 cm (10 ¾ x 16 ⅛ inches)

51
Pablo Picasso

HEAD OF A WOMAN (DORA MAAR)
(TÊTE DE FEMME [DORA MAAR])

March 28, 1939
Oil on wood panel, 59.8 x 45.1 cm (23 ⁹⁄₁₆ x 17 ¾ inches)

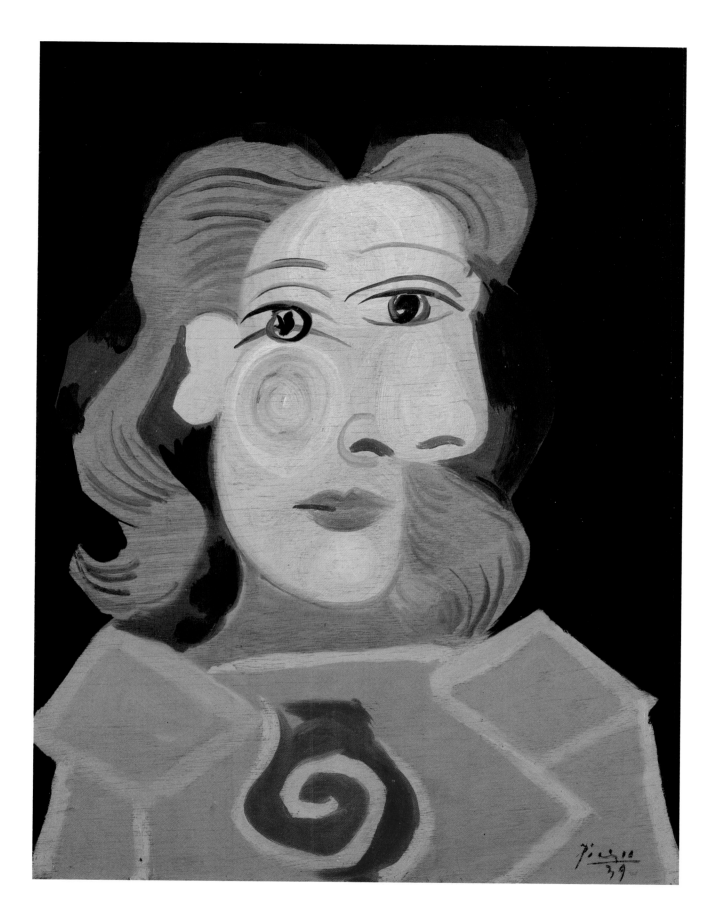

52

Pablo Picasso

FRANÇOISE GILOT

September 9, 1947

Sanguine on wove paper, 65.9 x 50.5 cm (25 ¹⁵⁄₁₆ x 19 ⅞ inches)

53
Pablo Picasso
GARDEN IN VALLAURIS (JARDIN À VALLAURIS)
June 10, 1953
Oil on canvas, 18.7 x 26.7 cm (7 ⅜ x 10 ½ inches)

54

Pablo Picasso

TWO DOVES WITH WINGS SPREAD

(DEUX PIGEONS AUX AILES DÉPLOYÉES)

March 16–19, 1960

Oil on linen, 59.7 x 73 cm (23 ⅝ x 28 ¾ inches)

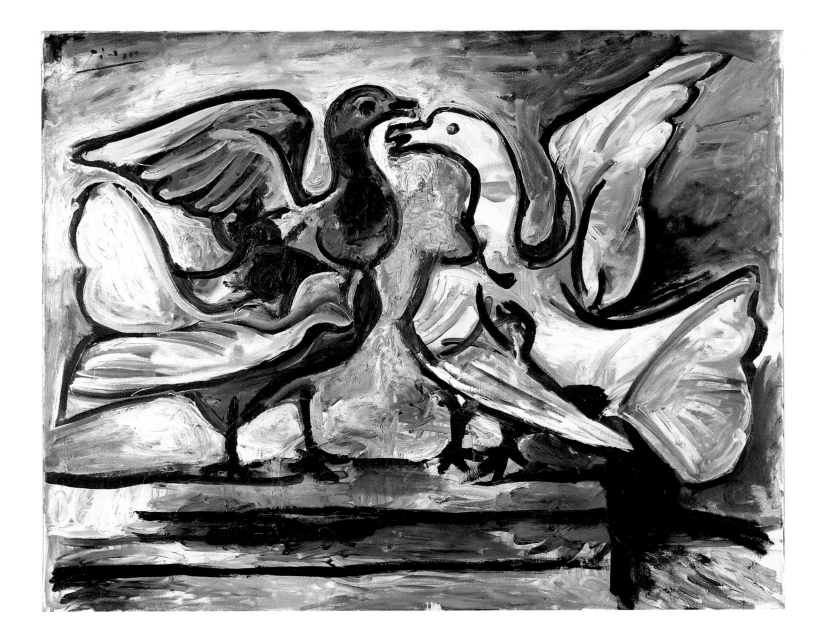

55

Pablo Picasso

LOBSTER AND CAT (LE HOMARD ET LE CHAT)

January 11, 1965

Oil on canvas, 73 x 92 cm (28 ¼ x 36 ¼ inches)

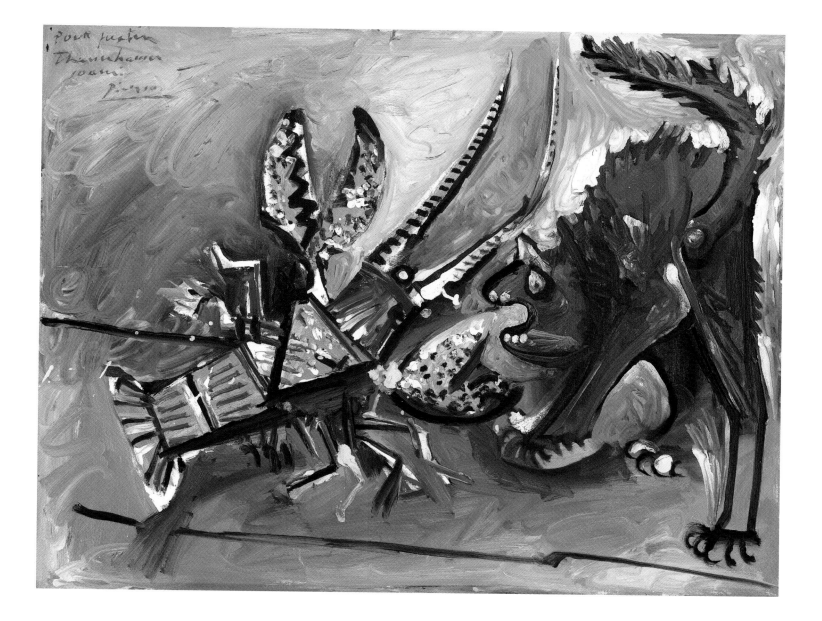

56

Camille Pissarro

THE HERMITAGE AT PONTOISE

(LES CÔTEAUX DE L'HERMITAGE, PONTOISE)

ca. 1867

Oil on canvas, 151.4 x 200.6 cm (59 ⅝ x 79 inches)

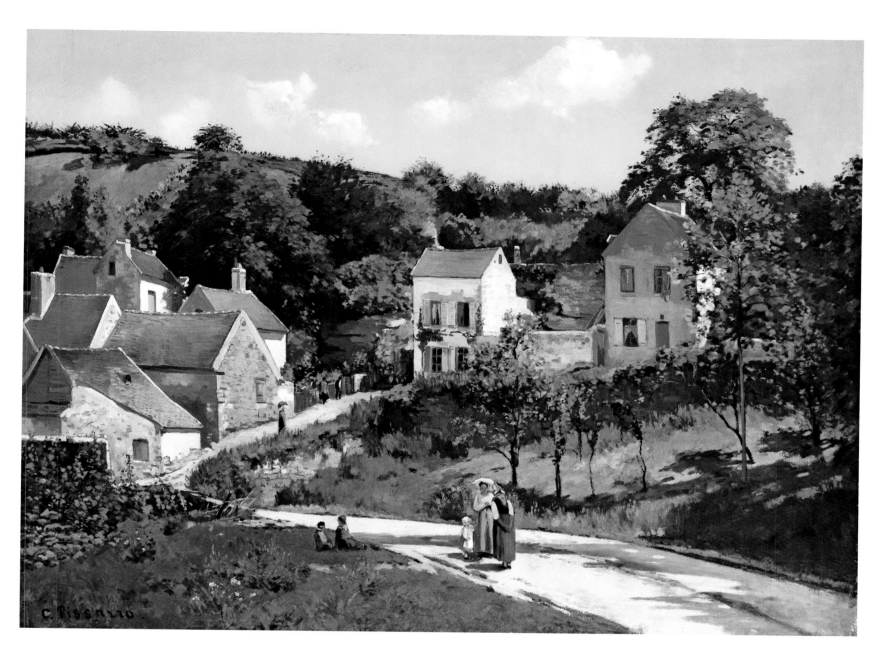

Camille Pissarro
THE HERMITAGE AT PONTOISE

by Anne F. Collins

CAMILLE PISSARRO'S *THE HERMITAGE at Pontoise* impresses the viewer not least for its remarkable size: at one-and-a-half by two meters, the canvas is Pissarro's largest.[1] The uncharacteristic dimensions of this work, which was painted relatively early in Pissarro's career, suggest an ambition on the artist's part to have his work accepted by the jury of the Paris Salon. Other details support this reading. The composition is arranged in a conservative, almost academic fashion. Pissarro balanced the elements of the picture, setting them within a consistent effect of outdoor illumination. He accentuated two primary objects of attention: a house expelling a puff of smoke and a group consisting of two women and a little girl chatting. The viewer's gaze is further drawn to these features because Pissarro arranged them on the same axis, perhaps deliberately implying narrative content to make the painting additionally attractive to a conservative audience.[2]

Whether or not—and when—Pissarro's efforts over this painting were rewarded by the jury is debated among scholars. A work by Pissarro entitled *L'Ermitage* was included in the Salon of 1868 and another of the same name appeared in the Salon of 1869, but which of these (if either of them) is *The Hermitage at Pontoise* is unknown.[3] Although the Thannhauser painting cannot be tied conclusively to the Salon of 1868, the reception of Pissarro's work there does shed light upon the painting's significance. Study of this image, in turn, helps one to understand the critical response.

Pissarro's Salon entries of 1868 were difficult to see because of the elevation at which they were hung. Critic Jules Antoine Castagnary observed, "They are placed too high . . . but not high enough to prevent art lovers from observing the solid qualities that distinguish him."[4] Indeed, Pissarro's paintings were singled out

for praise by two other noteworthy spectators, Emile Zola and Odilon Redon. Zola attributed the unfavorable hanging of Pissarro's work to the fact that it was "too strong, too simple, too honest for the crowd." As for himself, "After studying [*L'Ermitage*] for several minutes, I thought I saw the very countryside open up before me."[5] Redon agreed with Zola, explaining that Pissarro's "rudimentary" technique "denotes above all his sincerity.... M. Pissarro sees things simply, as a colorist he makes sacrifices which allow him to express more vividly *the general impression*, and this impression is strong because it is simple."[6]

Pissarro's bold and relatively unmodeled colors create a strange, destabilizing effect, to which both Zola and Redon responded. Examining *The Hermitage at Pontoise*, one notices that his pigments flatten the canvas, while at the same time asserting their own physicality. In his depiction of the buildings in the painting, Pissarro evidently benefited from his experimental use of the palette knife in two images that he had created only a few months earlier, *Still Life* (1867) and *A Square at the Roche-Guyon* (ca. 1867, Nationalgalerie, Berlin).

By challenging the established conventions of academic painting through his use of color and his expressive brushwork, Pissarro not only drew the support of Castagnary, Zola, and Redon, but also signaled the "honesty" of his representation. The painting is not the studied product of the studio but an immediate response to the natural world. In his depiction of his personal "sensation," Pissarro anticipated the Impressionist practice of the 1870s;[7] indeed, his achievement led Paul Cézanne to identify him as "the first Impressionist."[8]

The Hermitage at Pontoise suggests still other aspects of Pissarro's future work. Significantly, the painting is one of several images of the Hermitage executed by Pissarro during 1867–68. In each painting, he examined the settlement from a different angle, exploring various

Camille Pissarro, *Still Life*, 1867. Oil on canvas, 81 x 99.6 cm (31 ¾ x 39 ¼ inches). The Toledo Museum of Art, Toledo, Ohio, Purchased with funds from the Libbey Endowment, Gift of Edward Drummond Libbey.

pictorial effects—a multiplicity to which he was particularly sensitive as an inhabitant of the village. Between 1893 and 1903, he again painted in series, in order to investigate the changing aspect of four urban centers as they were affected by fluctuations in light, weather, and the presence of their inhabitants. In the final year of his life, Pissarro wrote to his son Rodolphe, "If I listened to myself, I'd stay in the same town or village for years, contrary to many other painters; I'd end up finding in the same place effects that I didn't know, and that I hadn't attempted or achieved."[9]

Pissarro's commitment to continually renewing his outlook and his painterly habits emerges in *The Hermitage at Pontoise*. The painting reflects his early ties to Jean-Baptiste-Camille Corot and Charles-François Daubigny, both of whom he consulted between the late 1850s and mid-1860s. In the following years, Pissarro continued to experiment with his technique through collaboration with fellow Impressionist painters, including Cézanne, Edgar Degas, Claude Monet, and Georges Seurat. Cézanne was perhaps most strongly affected by his partnership with Pissarro. In a letter of 1876, he made specific mention of *The Hermitage of*

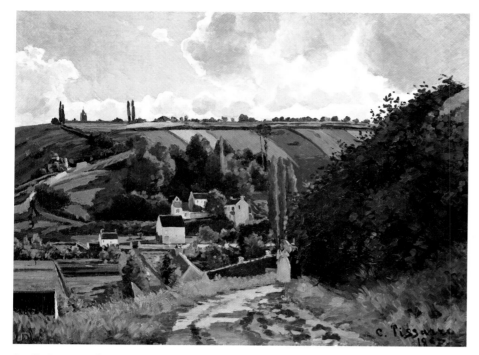

Camille Pissarro, *Jallais Hill, Pontoise*, 1867. Oil on canvas, 87 x 114.9 cm (34 ¼ x 45 ¼ inches). The Metropolitan Museum of Art, New York, Bequest of William Church Osborn, 1951 (51.30.2).

Pontoise, telling Pissarro that he aspired to do something like it at L'Estaque.[10]

In Pissarro's eyes, the authentic expression of an individual can only benefit from interaction with other artists, for such partnerships enable one to develop the skills to be true to one's own vision. He eloquently testified to his artistic philosophy in a letter of 1895 to his son Lucien: "People forget that Cézanne was first influenced by Delacroix, Courbet, Manet, and even Legros, like all of us; he was influenced by me at Pontoise, and I by him. You may remember the sallies of Zola and Béliard in this regard. They imagined that artists are the sole inventors of their styles and that to resemble someone else is to be unoriginal.... [I]n Cézanne's show at Vollard's there are certain landscapes of Auvers and Pontoise that are similar to mine.... But what cannot be denied is that each of us kept the only thing that counts, the unique "sensation!"[11]

NOTES

1. Gary Tinterow, *"The Hermitage,"* in *Origins of Impressionism*, exh. cat. (New York: The Metropolitan Museum of Art, 1994), p. 447.

2. Kermit Swiler Champa, *Studies in Early Impressionism* (New Haven, 1973; reprinted New York, 1985), p. 77.

3. The works titled *L'Ermitage* were no. 2016 in the Salon of 1868 and no. 1950 in the Salon of 1869. (A second work by Pissarro, entitled *La Côte du Jallais*, was also included in the Salon of 1868, as no. 2015; see *Jallais Hill, Pontoise*, 1867.) Ludovic Pissarro and Lionello Venturi state that *The Hermitage at Pontoise* "probably was" exhibited in the Salon of 1868. This point of view is supported by Kermit Champa and Joachim Pissarro. However, other scholars, including Vivian Endicott Barnett, Christopher Lloyd and Anne Distel, and Gary Tinterow have questioned this assumption, arguing that it could just have easily appeared in 1869, if at all. On this question, see L. R. Pissarro and Lionello Venturi, *Camille Pissarro: Son Art–Son Oeuvre* (Paris, 1939; reprinted San Francisco, 1989), vol. 1, p. 86, fig. 58; Champa, *Studies in Early Impressionism*, p. 76; Joachim Pissarro, *Camille Pissarro* (New York, 1993), p. 51; Vivian Endicott Barnett, *"The Hermitage at Pontoise,"* in *Guggenheim Museum: Thannhauser Collection* (New York, 1978; rev. ed. 1992), p. 163; Christopher Lloyd and Anne Distel, *"The Hillsides of L'Hermitage, Pontoise,"* in *Pissarro*, exh. cat. (London: Arts Council of Great Britain; Boston: Museum of Fine Arts, 1980), p. 77; and Tinterow, "The Hermitage," p. 447.

4. Jules Antoine Castagnary, *Salons, 1857–1879* (Paris, 1892), vol. 1, p. 278; quoted in Ralph E. Shikes and Paula Harper, *Pissarro: His Life and Work* (New York, 1980), p. 75.

5. Emile Zola, "Les Naturalistes," *L'Evénement illustré*, May 19, 1868; reprinted in Zola, *Salons*, collected and edited by F. W. J. Hemmings and Robert J. Niess (Paris, 1959), p. 128.

6. Odilon Redon, "Salon de 1868," *La Gironde*, May 19, 1868; reprinted in Redon, *Critiques d'art*, ed. Robert Couset (Bordeaux, 1987), p. 57; quoted in John Rewald, *History of Impressionism*, fourth ed. (New York, 1973), p. 188. Emphasis added.

7. For a comprehensive discussion of the theory of the "sensation" and the "impression" in Impressionist painting, see Richard Shiff, *Cézanne and the End of Impressionism* (Chicago, 1984).

8. *Conversations avec Cézanne*, ed. P. M. Doran (Paris, 1978), p. 121.

9. Camille Pissarro to Rodolphe Pissarro, Le Havre, July 6, 1903, in *Correspondance de Camille Pissarro*, ed. Janine Bailly-Herzberg (Saint-Ouen-l'Aumône, 1991), vol. 5, p. 352; quoted in English in Joachim Pissarro, "Pissarro's Series Conception, Realisation, and Interpretation," in *The Impressionist and the City*, exh. cat. (London: Royal Academy of Arts, 1992), p. xxxviii.

10. Paul Cézanne to Pissarro, L'Estaque, July 2, 1876, in *Paul Cézanne: Correspondance*, ed. John Rewald and Lucien Pissarro (Paris, 1937), p. 127.

11. Camille Pissarro to Lucien Pissarro, Paris, November 22, 1895, in *Correspondance de Camille Pissarro*, ed. Janine Bailly-Herzberg, 5 vols. (Paris, 1980–91), vol. 4, p. 121; published in English in *Camille Pissarro: Letters to His Son Lucien*, ed. John Rewald, trans. Lionel Abel (New York, 1943; reprinted New York, 1995), p. 276.

Pierre Auguste Renoir

WOMAN WITH PARROT (FEMME À LA PERRUCHE)

1871

Oil on canvas, 92.1 x 65.1 cm (36 ¼ x 25 ⅝ inches)

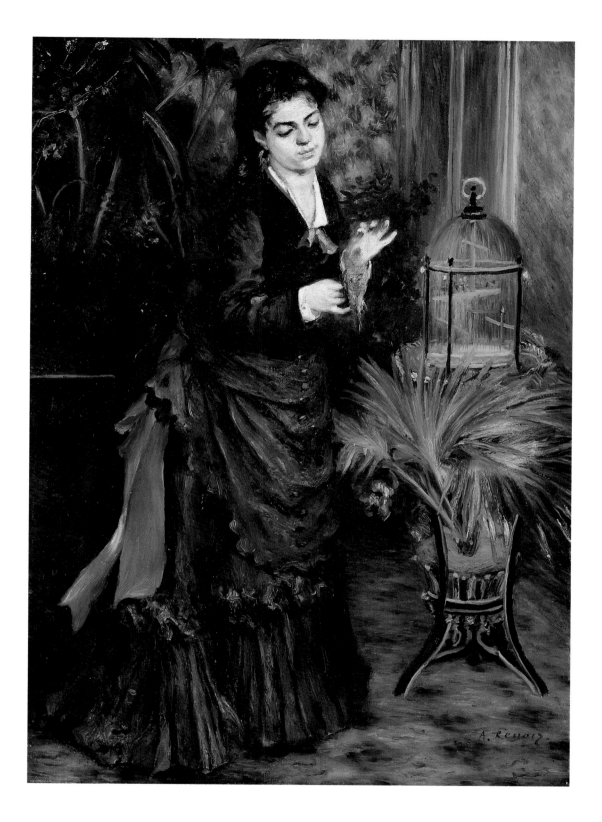

Pierre Auguste Renoir
WOMAN WITH PARROT

by Colin B. Bailey

In March 1912, Joseph Durand-Ruel wrote to Pierre Auguste Renoir, asking him to authenticate two paintings from the collection of Cornelis Hoogendijk that were to be auctioned in Amsterdam in May, and with which the family firm was evidently unfamiliar.[1] From Nice, Renoir replied immediately: "I'm returning the photographs of the two paintings along with this letter. The *Woman with Parrot* must have been done at roughly the same time as the *Nude*, or in 1871 at the latest, because after this time I lost sight of the woman who posed for this picture. In any event, they are paintings of no value, especially the *Woman with Bird* [sic]. Pray do not get too excited over such daubs."[2] At a distance of more than forty years, he might be forgiven for not remembering that the precise date of *Woman with Parrot* was 1871, but his reticence about the model, and, above all, his dismissal of these early works as "*croûtes*" (daubs) are unexpected and give pause for thought. (While Renoir's works of the Impressionist decade are favored today, it was his late, classic manner that was then considered his most desirable.) His outburst made its mark; Durand-Ruel was discouraged from acquiring either of these masterpieces at the sale.[3]

From the vantage point of the early 1870s, *Woman with Parrot* was the thirty-year-old Renoir's valediction to the type of genre painting that was much the rage in the Paris Salon during the 1860s and 1870s. Although nothing is known of its early history—Hoogendijk would not have acquired it until the 1890s, some twenty years after it was made—the painting was in all likelihood produced for the Parisian market (rather than for exhibition at the Salon) and is distinctly Second Empire in mood and setting. As with Renoir's other domestic genre paintings of the late 1860s and early 1870s— notably *The Engaged Couple* (ca. 1868, Wallraf-Richartz Museum, Cologne) and *La Promenade* (1870, The J. Paul Getty Museum, Los Angeles),

Alfred Stevens, *The Porcelain Collector*, 1868. Oil on canvas, 68.3 x 45.7 cm (26 ¾ x 18 inches). North Carolina Museum of Art, Raleigh, Gift of Dr. and Mrs. Henry C. Landon III.

for which the same model posed—*Woman with Parrot* suggests something of the fluctuating and uncertain allegiances of this young Actualiste, who was indebted to Gustave Courbet and Edouard Manet, certainly, but was drawn also to subjects favored by practitioners of an altogether more conventional (and respectable) bent.[4]

In a luxuriously appointed interior, a dark-haired Parisienne, dressed in the latest fashion, is feeding her pet parrot, while perhaps teaching it some new words.[5] Despite its wall-to-wall carpeting and patterned wall hangings, the room is transformed into a makeshift conservatory by the oversize indoor plants in the background at left and by the bright green ferns that burst forth from the lacquer stand at right. The young woman wears a black taffeta day dress (without bustle), buttoned down the bodice and skirt, whose extravagant red sash serves no purpose other than to provide a complementary accent to the burgeoning spray of ferns.

In genre painting of the 1860s and 1870s, such richly dressed young women were generally assumed to be kept women—the *lorette*, or high-class courtesan, was a social type created during the Second Empire—and the erotic symbolism of the parrot and the gilded bird cage would have been obvious even to those unfamiliar with the conventions of seventeenth-century Dutch cabinet painting.[6] Yet Renoir's presentation of this lascivious subject is actually rather well-mannered. He avoids anecdote and innuendo, refuses to pander to the prurient beholder, and in doing so acknowledges his debt to Manet (with whom he was publicly associated as early as 1868).[7] In handling and construction, however, *Woman with Parrot* has less in common with Manet's monumental *Woman with a Parrot* (1866; see p. 38)—which is detached and ironic in ways that Renoir's paintings never are—than with the more modestly scaled interior scenes by lesser Realists such as Alfred Stevens (for example, *The Porcelain Collector*, 1868).[8] It even bears an affinity with Rococo-revival genre painting, which was much in demand at the Salon, as practiced by several of Renoir's former fellow classmates in Charles Gleyre's atelier, such as Marie-François Firmin-Girard and Auguste Toulmouche, a distant cousin of Claude Monet.[9]

Where Renoir parted company with these chic, anecdotal painters—and where his work may, at times, appear even more audacious than Manet's—was in his technique, which overturned accepted notions of decorousness and transparency. *Woman with Parrot* is sensuous and erotic, not in its composition or deployment of accoutrements—both of which are relatively anodyne—but in its exuberant handling of paint, which communicates a plenitude and an excitement that are almost palpable. (Renoir later referred to this type of painting as *"en pleine pâte."*)[10]

Renoir's facture consciously draws attention to itself. Paint is laid on thickly and lusciously, with areas of impasto accenting the edges of the ferns, the tidbit fed to the bird, and the creamy white cuffs of the Parisienne's blouse. Renoir paints wet on wet: the twelve buttons that line the dress are highlighted in white, just as the brilliant carmine of the sash appears to cast shadows of red onto the folds of the skirt. Color is used idiosyncratically—the legs of the planter are outlined in yellow and red—and juxtapositions are willfully eccentric: the green branches and leaves of the looming tree at left are set against a patterned wall hanging, of floral motif, in softer greens and blues. Above all, *Woman with Parrot* is a celebration of the color black, which Renoir described to Ambroise Vollard many years later as "Queen of the colors."[11] Thick black paint outlines the bird cage and plant stand, and is at its most sumptuous in the layering of the Parisienne's velvet jacket and cuffs against the silken folds of her dress.

Brushwork, in Modernist paintings such as *Woman with Parrot*—as John House has recently pointed out—is made to carry the weight of academic drawing.[12] It serves as the agent of representation and in so doing consciously draws attention to itself, inviting the initiated viewer to take pleasure in experiencing the medium before attending to the message (as it were), and thereby undermining expectations of legibility that were then in place. That Renoir, at this early stage in his career, was not always in full command of his medium—spatial organization failed him in the definition of the planter and the bird cage, which seem to have collapsed into a single plane—is an indication of the struggle he experienced in transforming genre into authentic visual sensation.

In Renoir's genre painting of the late 1860s to early 1870s, the particularity of the female model was another important component of his modernity. Neither sanitized nor idealized, she is, as Emile Zola pointed out in 1868, "One of our women, or better yet, one of our mistresses—painted with great truth to life and a felicitous preference for the modern."[13] While *Woman with Parrot* is genre and not portraiture, the distinctions between these categories were constantly blurred in the figure painting of the future Impressionists.[14] The model for the painting—to whom Renoir referred so tersely in his letter of March 1912—was Lise Tréhot), the artist's companion between 1866 and 1872. In those years, she posed for no fewer than sixteen figure paintings and portraits by Renoir, including all of his Salon submissions. Daughter of a country postmaster from Equevilly, eight miles northwest of Saint-Germain-en-Laye, Tréhot had moved to Paris with her family at the age of seven, when her father lost his position and was granted the management of a *bureau de tabac* on avenue des Ternes. She and Renoir would have met around 1865–66, when her sister, Clémence, became involved with the widowed Jules Le Coeur, a former classmate of Renoir at Gleyre's atelier who, with his brother, the architect Charles Le Coeur, was among the artist's closest friends and most committed supporters in the decade before the first Impressionist exhibition.[15] Tréhot posed for Renoir naked, dressed, and in fancy dress until the spring of 1872, when she married, on April 24, Georges Brière de L'Isle, a young architect from a well-to-do family (his father, a general at the time of their wedding, later became governor of Senegal).

In his letter of March 1912, Renoir dated *Woman with Parrot* to "1871 at the latest"; when the painting was exhibited in a retrospective of Renoir's work at the gallery Bernheim-Jeune in Paris the following year, it was assigned to

1868;[16] Vollard, who may have sold it to Hoogendijk, and who was the first to publish the painting, dated it to 1865.[17] These inconsistencies, made while Renoir was still alive, serve to remind us that the exact dating of the work—which is signed but not dated—may not be quite as straightforward as has been implied by the recent literature.[18] In subject and composition, *Woman with Parrot* is certainly related to the larger and more ambitious *Rapha Maître*, which is signed and dated "April 1871" and was the first picture that Renoir painted following his demobilization and return to Paris from the Franco-Prussian War in the weeks leading to the Commune's *"semaine sanglante"* (bloody week).[19] Yet it does not follow that the two works are exactly contemporaneous: the handling in the Thannhauser painting is more fluid and spontaneous than the encrusted surface of *Rapha Maître*. In fact, it is more likely that *Woman with Parrot* was painted at the same time as *Lise in a White Shawl* (1872). As several authors have noted, Tréhot's costume and jewelry—black dress, red bow, gold cuff link and earrings—are identical in these works, the oversize golden hoop earrings having migrated from the earlier *Woman of Algiers* (1870, National Gallery of Art, Washington, D.C.).[20] A tender and engaging portrait, *Lise in a White Shawl* is one of only two paintings by Renoir that Tréhot is known to have owned, and its looser handling and more daring close-up are appropriate for an intimate work not intended for the commercial market.

Once a date of 1871–72 is assigned to *Woman with Parrot* and *Lise in a White Shawl*—both works having been painted between Renoir's return from the war and Tréhot's marriage—

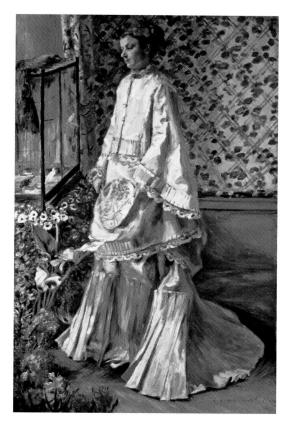

Pierre Auguste Renoir, *Rapha Maître*, 1871. Oil on canvas, 130 x 83 cm (51 x 32 ⅜ inches). Private collection.

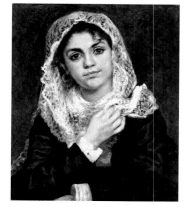

Pierre August Renoir, *Lise in a White Shawl*, 1872. Oil on canvas, 55.9 x 45.7 cm (22 x 18 inches). Dallas Museum of Art, The Wendy and Emery Reeves Collection.

two conclusions follow. First, affectionate as it is, *Lise in a White Shawl* cannot claim precedence as Renoir's last painting of Tréhot before her marriage; in all likelihood, that distinction belongs to the considerably more revealing *Parisian Women in Algerian Dress* (National Museum of Western Art, Tokyo), which was rejected by the Salon of 1872.[21] Second, by distancing *Woman with Parrot* from the turbulent weeks of the Paris Commune—even if only by a few months—Renoir's unexpected nostalgia for the pleasures and comforts of bourgeois domesticity may be said to have found expression in an appropriately boisterous, painterly language, freed of the introspection and fragility that pervade *Rapha Maître*.

NOTES

Lise Tréhot at the age of sixteen, 1864.

1. Joseph Durand-Ruel to Pierre Auguste Renoir, March 21, 1912, in *Correspondance de Renoir et Durand-Ruel*, ed. Caroline Durand-Ruel Godfroy, 2 vols. (Lausanne, 1995), vol. II, p. 97.

2. Ibid., vol. II, p. 99. (English translation by the author.) Renoir's letter, but not Durand-Ruel's, was first published in Lionello Venturi, *Les Archives de l'Impressionisme*, 2 vols. (Paris, 1939), vol. I, p. 202. The painting that Renoir refers to as *La Femme nue* is *Bather with a Griffon* (1870, Museu de Arte, São Paulo).

3. Hoogendijk was a wealthy Dutchman from Amsterdam, who acquired outstanding Impressionist paintings in Paris between 1894 and 1899, and whose inspired collecting was cut short by illness and an early death. Thirteen of the works by Paul Cézanne that he purchased from Ambroise Vollard were bought by Albert Barnes in July 1920; these have been described as "the most important single group of works by Cézanne that has ever come to America." John Rewald, *Cézanne and America: Dealers, Collectors, Artists and Critics, 1891–1921* (Princeton, 1989), p. 269.

4. On this topic, see, most recently, John House, *Pierre-Auguste Renoir, La Promenade*, Getty Museum Studies on Art (Los Angeles, 1997), to which my discussion is much indebted.

5. Noting the popularity of parrots as domestic pets, despite *"leur prix assez élevé"* (their rather high price), Larousse's *Grand Dictionnaire universel du XIXe siècle* explained that in order to instruct them how to speak, "You begin by giving them something to eat . . . then you repeat the word that you want to teach them several times," adding that parrots are especially partial to the voices of women and children. Pierre Larousse, *Grand Dictionnaire universel du XIXe siècle*, 17 vols. (Paris, 1875–1911), vol. XII, p. 686. (English translation by Ellen Sowchek.)

6. See Mona Hadler, "Manet's 'Woman with a Parrot' of 1866," *Metropolitan Museum Journal* 7 (1973), pp. 115–22. For a Victorian perspective, see Elaine Shefer, "The 'Bird in the Cage' in the History of Sexuality: Sir John Everett Millais and William Holman Hunt," *Journal of the History of Sexuality* 1, no. 3 (1991), pp. 446–80.

7. Discussing Renoir's *Lise* (1867, Museum Folkwang, Essen), Maurice Chaumelin wrote, "M. Manet is already apparently a master, since he has imitators, among them is M. Renoir." Chaumelin, "Salon de 1868," in *L'Art contemporain* (Paris, 1873); quoted in Gary Tinterow and Henri Loyrette, *The Origins of Impressionism*, exh. cat. (New York: The Metropolitan Museum of Art, 1994), p. 410.

8. Renoir would have met Stevens in the late 1860s, either at the café Guerbois or through his friend (and landlord) Frédéric Bazille. See Peter Mitchell, *Alfred Emile Léopold Stevens (1823–1906)* (London, 1973), p. 24.

9. See Paul Girard, *Firmin-Girard (1838–1921)* (Luchon, 1988), and the examples illustrated in House, *Pierre-Auguste Renoir, La Promenade*, pp. 6–9, 24–31, 50–57. Toulmouche's mawkish and immaculately finished domestic scenes inspired the Realist critic Edmond Duranty to christen an entire school in his name ("the greater and lesser Toulmoucherie"); House, *Pierre-Auguste Renoir, La Promenade*, p. 29.

10. According to Albert André, Renoir exclaimed during a discussion about his early manner, *"J'ai peint ensuite au pinceau en pleine pâte. J'y ai peut-être réussi quelques morceaux, mais je ne trouvais cela commode pour 'revenir.'"* ("I then painted with a fully loaded brush. I perhaps had some success with a few pieces, but I did not find it easy to 'return' to it.") André, *Renoir* (Paris, 1923), p. 35. (English translation by Ellen Sowchek.).

11. *Ambroise Vollard, Renoir: An Intimate Record*, trans. H. L. Van Doren and R. T. Weaver (New York, 1925), p. 112.

12. House, *Pierre-Auguste Renoir, La Promenade*, p. 61.

13. Emile Zola, "Mon Salon: Les Actualistes" (May 24, 1868), in Zola, *Ecrits sur l'Art*, ed. J-P. Leduc Adine (Paris, 1991), p. 211. (English translation by the author.)

14. See Colin B. Bailey, "Portrait of the Artist as a Portrait Painter," in *Renoir's Portraits: Impressions of an Age*, exh. cat. (Ottawa: National Gallery of Canada, 1997), pp. 13–15.

15. On Lise Tréhot, see the magisterial article by Douglas Cooper, "Renoir, Lise and the Le Coeur Family: A Study of Renoir's Early Development," *The Burlington Magazine* 101 (May 1959), pp. 163–71, 322–28. On the Le Coeurs, see Marc Le Coeur, *Charles Le Coeur (1830–1906), architecte et premier amateur de Renoir*, exh. cat. (Paris: Musée d'Orsay, 1996), and Bailey, "Portrait of the Artist," pp. 97–100, 132. Cooper

identified fourteen paintings for which Tréhot had modeled, but overlooked both *The Engaged Couple* (ca. 1868, Wallraf-Richartz Museum, Cologne) and *La Promenade* (1870, The J. Paul Getty Museum, Los Angeles).

16. *Exposition Renoir*, exh. cat. (Paris: Bernheim-Jeune, March 10–29, 1913), cat. no. 2 (*"La Femme à la Perruche, 1868"*).

17. Ambroise Vollard, "La Jeunesse de Renoir," *La Renaissance de l'Art Français et des Industries de Luxe* 3 (May 1918), p. 17 (*"La Femme au perroquet* [1865]").

18. For example, Cooper, "Renoir, Lise, and the Le Coeur Family," p. 168; and François Daulte, *Auguste Renoir: Catalogue raisonné de l'oeuvre peint* (Lausanne, 1971), p. 36. *Woman with Parrot* was first published with the date of 1871–72 in Julius Meier-Graefe, *Renoir* (Leipzig, 1929), p. 44.

19. Bailey, "Portrait of the Artist," pp. 114–16.

20. Cooper, "Renoir, Lise and the Le Coeur Family," p. 171; and Richard R. Brettell, *Impressionist Paintings, Drawings and Sculpture from the Wendy and Emery Reves Collection* (Dallas, 1995), p. 51.

21. Cooper, "Renoir, Lise and the Le Coeur Family," pp. 168–71. Anne Distel noted that *Parisian Women in Algerian Dress* was the last composition by Renoir for which Tréhot posed. See John House and Anne Distel, *Renoir*, exh. cat. (London: Hayward Gallery, 1985), p. 199.

Pierre Auguste Renoir

STILL LIFE: FLOWERS (NATURE MORTE: FLEURS)

1885

Oil on canvas, 81.9 x 65.8 cm (32 ¼ x 25 ⅞ inches)

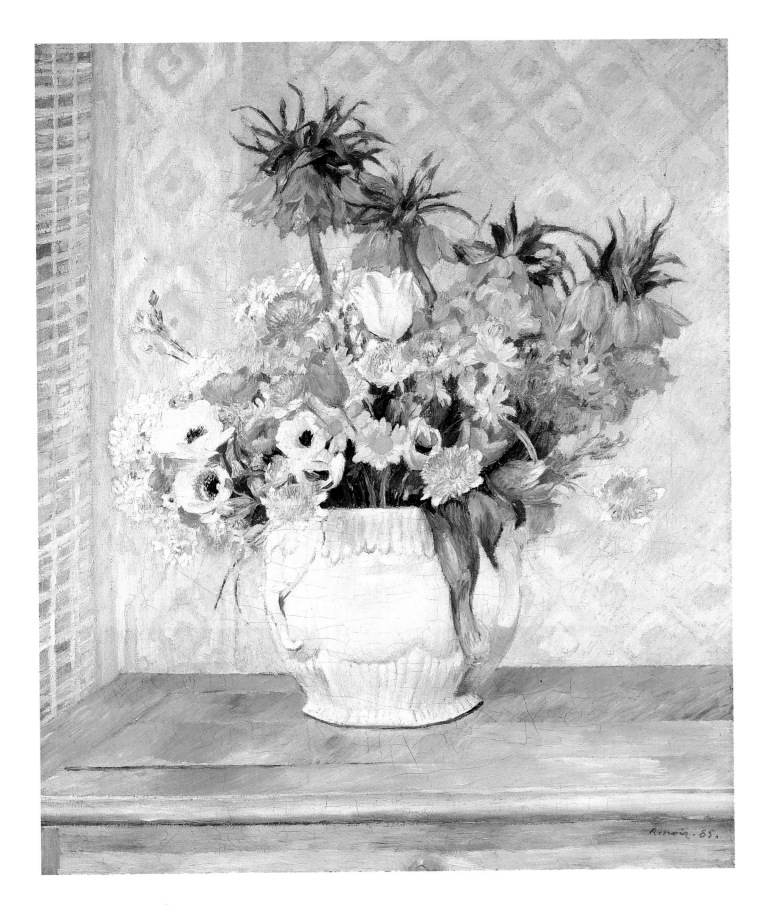

59
Henri de Toulouse-Lautrec
IN THE SALON (AU SALON)
1893
Pastel, gouache, and pencil on cardboard, 53 x 79.7 cm (20 ⅞ x 31 ⅜ inches)

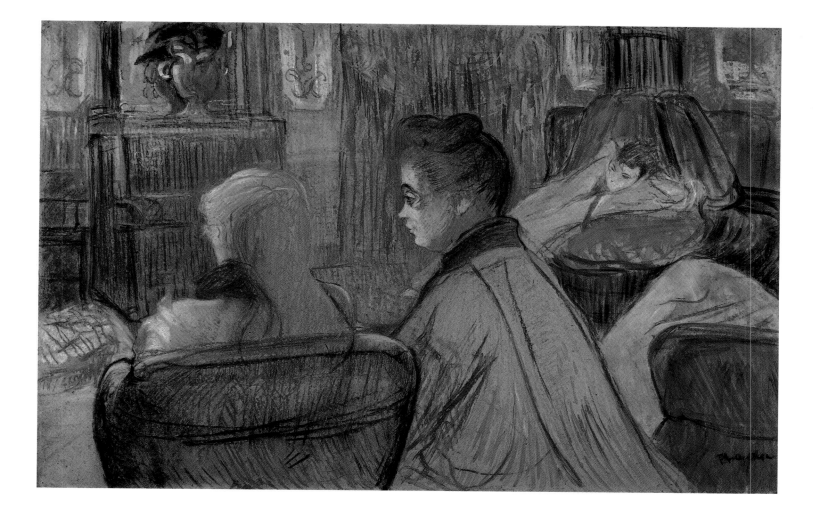

Henri de Toulouse-Lautrec

IN THE SALON

by Mary Weaver

"I SHALL SET UP MY TENT in a brothel," Henri de Toulouse-Lautrec declared, and indeed, in the early part of the 1890s, he turned his attention to the life of the brothel, or *maison close*, and its female inhabitants.' Typically, once a subject or a model caught Toulouse-Lautrec's attention, he worked on the theme from all angles, making rapid sketches from life as well as more finished compositions. Such was the case with the *maisons closes*; more than forty paintings and hundreds of preparatory drawings survive, most of which date from 1893 to 1895.

In the Salon, created in 1893 with pastel, gouache, and pencil, depicts prostitutes waiting for customers in the salon of a brothel at 24, rue des Moulins in central Paris. Although this *maison close* was decorated in outlandish, exotic motifs, Toulouse-Lautrec focused on a rather ordinary corner of the sitting room, replete with curtains, a vase, a bookcase, and an upright piano, which he hastily sketched in blue and dark red gouache. Only the lush red velvet upholstery on the furniture, the acid-green curtains, and the garish color combinations suggest that this is not a polite bourgeois sitting room.

Just as Toulouse-Lautrec paid little attention to the ornate setting of the salon, he likewise eschewed the erotic possibilities of the scene. The women are dressed in modest underclothes, and the two figures in the foreground have their backs to the viewer, thereby denying access to their bodies and to the room. The *fille* reclining on the circular sofa strikes a traditional pose of seduction, but the shapelessness of her form and the blankness of her expression erase any erotic charge. Toulouse-Lautrec did, however, include a sly reference to the occupation of these women by showing the crossed legs of a fourth *fille* on the right

of the painting; no proper lady at this time would have crossed her legs at the knee, as this was considered vulgar.

The dominant feeling of the scene is one of tedium. Although the women are in close proximity, they do not communicate with one another, nor do they play cards or exchange caresses, as Toulouse-Lautrec sometimes depicted in other brothel paintings. The women simply stare into space and wait with resignation or boredom for the next customer.

The prostitutes pictured here appear in other brothel paintings by Toulouse-Lautrec. The woman with the upswept hair in the center of *In the Salon* sits on a red circular divan in *In the Salon: The Divan* (1893, Museu de Arte, São Paulo) and is pictured on the far right in a painting of prostitutes at a dinner table, *Ces Dames au Réfectoire* (1893, The Museum of Fine Arts, Budapest). She may also have been a model for *The Friends* (1894, Musée Toulouse-Lautrec, Albi), one of several paintings that show two women embracing on a red settee. In addition, three drawings of this woman exist, including a sensitive portrait in blue crayon, *Head of a Woman in Profile* (ca. 1895). The woman with the golden hair pictured at the left of *In the Salon* appears in the same pose in a preparatory drawing in blue pencil (private collection).

Toulouse-Lautrec was not the first to explore the theme of the brothel. He kept a photograph of Vittore Carpaccio's painting *Two Courtesans* (ca. 1495, Museo Correr, Venice) in his studio his entire life. More recent artistic examples were also available to him. French illustrators such as Honoré Daumier and Paul Gavarni had focused on the art of modern life and the role of the prostitute as early as the mid-nineteenth century. Japanese *ukiyo-e* prints, which had caught the imagination of Parisian artists and society during the same period, depicted the daily lives of courtesans and were also precedents for French painters. Edgar Degas, whom Toulouse-Lautrec emulated in

Henri de Toulouse-Lautrec, *Head of a Woman in Profile*, ca. 1895. Chalk on buff paper, 14.6 x 22.9 cm (5 ¾ x 9 inches). The British Museum, London.

many ways, created monotypes of life in Parisian brothels in the 1870s, but it is unlikely that Toulouse-Lautrec would have seen these since Degas showed them only to a small coterie of friends.

By the 1890s, the prostitute was a common figure in art, literature, and the fabric of daily life. While many artists focused on the titillating aspects of hired sex, Toulouse-Lautrec seems to have valued the *maisons* primarily for social reasons. Beginning around 1893, he worked at several brothels in the center of Paris. He bragged that he had convinced a madam to lease him a room in one so that he could stay there for days at a time, yet as such an arrangement was illegal, this may have been one of his frequent exaggerations. Toulouse-Lautrec relished the time he spent working and socializing at the *maisons closes*, often arriving with friends and treating the *maisons* "as extensions of the café, where one could sit around with friends, drink or play cards and, when the time was ripe, choose a female companion with whom to go upstairs."[2]

Nonsexual aspects of brothel life piqued Toulouse-Lautrec's interest and kept him coming back to the *maison* on the rue des Moulins. His friend Thadée Natanson, editor of the fin-de-siècle journal *La Revue blanche*, noted, "What

[Toulouse-Lautrec] found touching about the brothels was the atmosphere of family life—the little cliques, jealousies, rows and reconciliations, and especially the shared meals."[3] Toulouse-Lautrec had grown up in a predominantly female household, and the society of women in a brothel may have been both an affirmation of the all-female environment of his childhood and a refutation of the devoutly religious upbringing he received from his mother.

Toulouse-Lautrec also appreciated the lack of hypocrisy of the *filles*. He resented the pity shown to him in polite society because of his congenital deformities and found the purely economic relationship with the prostitutes refreshing. As biographer Julia Frey notes, Toulouse-Lautrec was more comfortable in the *maisons closes* than at society gatherings: "The interactions were straightforward; everything was for sale. No one was being nice to him because they felt sorry for him. He, like any other client, paid for drinks, amusement, sex."[4]

Toulouse-Lautrec claimed that prostitutes made better models than "honest" women, since they were more natural even when undressed: "A model always looks stuffed whereas *they* are alive. . . . I would never give them the usual fee of a hundred *sous* for posing, although God knows they're worth it. . . . They stretch out on their couches like animals . . . you know what I mean? The brothel is the only place left where you can get your shoes shined without listening to a lot of nonsense. They're just so unpretentious."[5]

NOTES

1. Henri Perruchot, *Toulouse-Lautrec*, trans. Humphrey Hare (London, 1960), p. 169.

2. Julia Frey, *Toulouse-Lautrec: A Life* (New York, 1994), p. 341.

3. Thadée Natanson, "At the Brothel," in *Un Henri de Toulouse-Lautrec* (Geneva, 1951); quoted in Gale B. Murray, ed., *Toulouse-Lautrec: A Retrospective* (New York, 1992), p. 179.

4. Frey, *Toulouse-Lautrec: A Life*, p. 341.

5. Natanson, "At the Brothel"; quoted in Murray, ed., *Toulouse-Lautrec: A Retrospective*, p. 178.

60

Vincent van Gogh

ROADWAY WITH UNDERPASS (LE VIADUC)

1887

Oil on cardboard, mounted on panel, 32.7 x 41 cm (12 ⅞ x 16 ⅛ inches)

61

Vincent van Gogh

LANDSCAPE WITH SNOW (PAYSAGE ENNEIGÉ)

late February 1888

Oil on canvas, 38.2 x 46.2 cm (15 ⁷⁄₁₆ x 18 ⁷⁄₁₆ inches)

Surely Monticelli gives us not neither pretends to give us local colour or even local truth. But gives us something passionate and eternal - the rich colour and rich sun of the glorious South in a true colourists way parallel with Delacroix conception of the South. Viz that the South be represented now by contrast simultané of colours and their derivations and harmonies and not by forms or lines in themselves as the ancient artists did formerly by pure form greeks & michel Ange or by pure line or delineation Rafael Mantegna — Venetian primitifs (Botticelli Cimabue Giotto Bellini.) Contrariwise the thing undertaken by P. Veronese & Titian — Colour the thing undertaken by Velasquez and Goya to be continued and more fully or rather more universally done by the more universal knowledge we have or gather of the colours of the prism and their properties. Hoping to write to you again and to hear of you pretty soon

your very truly
Vincent

My dear ████, I ought to have answered your letter ever so long ago but working pretty hard every day at night I feel so often too weary to write. As it rains to day I avail myself of the opportunity. Last Sunday I have met Macknight and a Danish painter and I intend to go to see him at Fonvieille next monday. I feel sure I shall prefer him as an artist to what he is as an art critic. his views as such being so narrow that they make me smile. I heartily hope for you that you will be able to leave Paris for good soon and no doubt leaving Paris will do you a world of good in all respects. As for me I remain enraptured with the scenery here am working at a series of blooming orchards. And involuntarily thought often of you because you did the same in Sicily. I wished you would one day or another when I shall send over some work to Paris exchange a Sicilian study with me — in case you should have one to spare —

You know I thought and think such a deal of those of yours I don't gainsay that your portraits are more serious and higher art but I think it meritory in you and a rare quality that together with a perfection as appeared to me the Fabian and McKnight portraits you are at the same time able to give a Scherzo the adagio con expressione the gay note in one word together with more manly conceptions of a higher order. And I so heartily hope that you will continue to give us both the grave and elaborate works and those aforesaid scherzos. Then let them say if they like that you are not always serious or that you have done works of a lighter sort — So much the worse for the critics & the better for you. I have heard nothing of our friend McRead. I felt rather anxious on his account because I feel sure that he was on a false track. My brother has received a letter of him but pretty unsatisfactory.

I was very much taken in by him during the first 6 weeks or 2 months but after that period he was in pecuniary difficulties and in the same action in a way that made me the impression that he had lost his wits. Which I still think was the case and consequently he not responsible even if his doings then were pretty unfair. He is very nervous — as we all are — and can't help being so — He is prompted to act in his crises of nerves to make money — whilst painters would make pictures. So much to say that I consider the dealer stronger in him than the artist Though there be a battle in his conscience concerning this — of which battle I don't know how that so much — pour ou contre gouverné — as I had the pleasure of introducing him to you I feel bound to warn you with the same sympathy however for him because I found him artistic in pleading the monticelli cause In the which I took and take my part Witnessing the very scenery which inspired Monticelli I maintain his artistic rights to public though late appreciation

My dear Russell, I ought to have answered your letter ever so long ago but working pretty hard every day at night I feel so often too weary to write. As it rains to day I avail myself of the opportunity. Last Sunday I have met MacKnight and a Danish painter and I intend to go to see him at Fonvieille next Monday. I feel sure I shall prefer him as an artist to what he is as an art critic his vieuws as such being so narrow that they make me smile.

I heartily hope for you that you will be able to leave Paris for good soon and no doubt leaving Paris will do you a world of good in all respects. As for me I remain enraptured with the scenery here am working at a series of blooming orchards. And unvoluntarily I thought often of you because you did the same in Sicily. I wished you would one day or another when I shall send over some work to Paris exchange a Sicilian study with me—in case you should have one to spare—

You know I thought and think such a deal of those of yours I don't gainsay that your portraits are more serious and higher art but I think it meritory in you and a rare quality that together with a perfection as appeared to me the Fabian and McKnight portraits you are at the same time able to give a Scherzo the adagio con expressione the gay note in one word together with more manly conceptions of a higher order. And I so heartily hope that you will continue to give us simultanément both the grave and elaborate works and those aforesaid scherzos.—Then let them say if they like that you are not always serious or that you have done work of a lighter sort—So much the worse for the citics {critics} & the better for you.

I have heard nothing of our friend Mr. Reid. I felt rather anxious on his account because I feel sure that he was on a false track. My brother has received a letter of him but pretty unsatisfactory.

I was very much taken in by him during the first 6 weeks or 2 months but after that period he was in pecuniary difficulties and in the same acted in a way that made on me the impression that he had lost his wits.

Which I still think was the case and consequently he not responsable even if his doings then were pretty unfair. He is very nervous—as we all are—and can't help being so—He is prompted to act in his crisis of nerves to make money . . . whilst painters would make pictures . . .

So much to say that I consider the dealer stronger *in him than* the artist *though there be a battle in his conscience concerning this—of the which battle I do not yet know the result. So much—pour votre gouverne—as I had the pleasure of introducing him to you feel bound to warn you with the same sympathy however for him because I found him artistic in pleading the monticelli cause.*

In the which I took and take my part Witnessing the very scenery which inspired Monticelli I maintain this artists rights to public though too late appreciation.

Surely Monticelli gives us not neither pretends to give us local colour or even local truth. But gives as something passionate and eternal—the rich colour and rich sun of the glorious South in a true colourists way parallel with Delacroix conception of the South Viz that the South be represented now by contraste simultané of colours and their derivations and harmonies and not by forms or lines in themselves as the ancient artists did formerly by pure form *greeks & Michel Ange or by pure line or delineation Rafael Mantegna Venetian* primitifs *(Botticelli Cimabue Giotto Bellini.)*

Contrariwise the thing undertaken by P. Veronese & Titian—Colour. The thing undertaken by Velasquez and Goya to be continued and—more fully or rather more universally done by the more universal knowledge we have & possess of the colours of the prism and their properties.

Hoping to write to you again and to hear of you pretty soon!

Yours very truly,
Vincent

I heard Rodin had a beautiful head at the Salon.

I have been to the seaside for a week and very likely am going thither again soon. - Flat shore sands - fine figures there like Cimabue - straight stylish. I am working at a Sower.

The great field all violet the sky & sun very yellow. It is a hard subject to treat. Please remember me very kindly to Mrs Russell - and in thought I heartily shake hands.

yours very truly
Vincent

My dear ▓▓▓ for ever so long I have been wanting to write to you - but then the work has so taken me up. We have harvest time here at present and I am always in the fields.

And when I sit down to write I am so abstracted by recollections of what I have seen that I leave the letter. For instance at the present occasion I was writing to you and going to say something about Arles as it is _ and as it was in the old days of Boccaccio. -

Well instead of continuing the letter I began to draw on the very paper the head of a dirty little girl I saw this afternoon whilst I was painting a view of the river with a yellow sky.

This dirty "mudlark" I thought yet had a vague florentine sort of figure like the heads in the Monticelli pictures. and reasoning and drawing this wise I worked on the letter

I was writing to you - I enclose the slip of scribbling. That you may judge of my abstractions and forgive my not writing before as such.

Do not however imagine I am painting old florentine scenery - no I may dream of such - but I spend my time in painting and drawing landscapes or rather studies of colour.

The actual inhabitants of this country often remind me of the figures we see in Zola's work.

And Manet would like them as they are and the city as it is.

Bernard is still in Brittany and I believe he is working hard and doing well.

Gauguin is in Brittany too but has again suffered of an attack of his liver complaint. I wished I were in the same place with him or he here with me.

My brother has an exhibition of 10 new pictures by Claude Monet - his latest works. for instance a landscape with red sun set and a group of dark firtrees by the sea side

The red sun casts an orange or blood red reflection on the blue green trees and the ground. I wished I could see them.

How is your house in Brittany getting on - and have you been working in the country.

I believe my brother has also another picture by Gauguin which is as I heard say very fine. Two negro women talking. It is one of those he did at martinique.

McKnight told me he had seen at marseilles a picture by monticelli flowerpiece.

Very soon I intend sending over some studies to Paris and then you can, if you like, choose one for our exchange.

I must hurry off this letter for I feel some more abstractions coming on and if I did not quickly fill up my paper I would again set to drawing and you would not have your letter. _

Vincent

63
Vincent van Gogh
LETTER TO JOHN PETER RUSSELL
late June 1888
Ink on wove paper, 20.3 x 26.3 cm (8 x 10 ⅜ inches)

My dear Russell for ever so long I have been wanting to write to you—but then the work has so taken me up. We have harvest time here at present and I am always in the fields.

And when I sit down to write I am so abstracted by recollections of what I have seen that I leave the letter. For instance at the present occasion I was writing to you and going to say something about Arles as it is—and as it was in the old days of Boccaccio.—

Well instead of continuing the letter I began to draw on the very paper the head of a dirty little girl {cat. no. 64} I saw this afternoon whilst I was painting a view of the river with a greenish yellow sky.

This dirty "mudlark" I thought yet had a vague florentine sort of figure like the heads in the monticelli pictures, and reasoning and drawing this wise I worked on the letter I was writing to you. I enclose the slip of scribbling. that you may judge of my abstractions and forgive my not writing before as such.

Do not however imagine I am painting old florentine scenery—no I may dream of such—but I spend my time in painting and drawing landscapes or rather studies of colour.

The actual inhabitants of this country often remind me of the figures we see in Zola's work.

And Manet would like them as they are and the city as it is.

Bernard is still in Brittany and I believe he is working hard and doing well.

Gauguin is in Brittany too but has again suffered of an attack of his liver complaint. I wished I were in the same place with him or he here with me.

My brother has an exhibition of 10 new pictures by Claude Monet—his latest works. for instance a landscape with red sun set and a group of dark firtrees by the seaside. The red sun casts an orange or blood red reflection on the blue green trees and the ground. I wished I could see them.

How is your house in Brittany getting on— and have you been working in the country.

I believe my brother has also another picture by Gauguin which is as I heard say very fine two negro women talking. it is one of those he did at Martinique.

McKnight told me he had seen at Marseilles a picture by Monticelli, flowerpiece.

Very soon I intend sending over some studies to Paris and then you can, if you like, choose one for our exchange.

I must hurry off this letter for I feel some more abstractions coming on and if I did not quickly fill up my paper I would again set to drawing and you would not have your letter.

I hear Rodin had a beautiful head at the salon.

I have been to the seaside for a week and very likely am going thither again soon. Flat shore sands—fine figures there like Cimabue—straight stylish.

Am working at a Sower:

the great field all violet the sky & sun very yellow. it is a hard subject to treat.

Please remember me very kindly to Mrs. Russell—and in thougt I heartily shake hands.

Yours very truly

Vincent

The letter is transcribed as van Gogh wrote it and differs slightly from the transcription in *The Complete Letters of Van Gogh* (Greenwich, Conn., 1958), vol. II, pp. 592–94.

64

Vincent van Gogh

HEAD OF A GIRL

late June 1888

Ink on wove paper, 18 x 19.5 cm (7 ⅛ x 7 ¹¹⁄₁₆ inches)

Verso: handwritten letter in ink

This drawing is inscribed by van Gogh in
English on the reverse:

*Have you {John Peter Russell} been working in the
country lately and is the house you are building
getting on. It appears that Claude Monet has done
fine things my brother writes to say that he has at
present an exhibition of 10 new pictures. One
representing pine trees at the seaside with a red sunset
casting a red glow over some branches foliage and
the ground. It is a marvel I hear. Bernard is doing
good things I believe he is taking a lot of trouble.
Gauguin is still at Pont-Aven and suffering of his
liver complaint {bu}t working nevertheless.*

The drawing was included with the letter
van Gogh sent to Russell in late June 1888
(cat. no. 63).

65

Vincent van Gogh

BOATS AT SAINTES-MARIES

late July–early August 1888

Pencil and ink on wove paper, 24.3 x 31.9 cm (9 ⁹⁄₁₆ x 12 ⁹⁄₁₆ inches)

66

Vincent van Gogh

THE ROAD TO TARASCON

late July–early August 1888

Pencil and ink on wove paper, 23.2 x 31.9 cm (9 ⅛ x 12 ⁹⁄₁₆ inches)

67

Vincent van Gogh

THE ZOUAVE

end of July–early August 1888

Ink on wove paper, 31.9 x 24.3 cm (12 ⁵⁄₁₆ x 9 ⁹⁄₁₆ inches)

68

Vincent van Gogh

MOUNTAINS AT SAINT-RÉMY

(MONTAGNES À SAINT-RÉMY)

July 1889
Oil on canvas, 71.8 x 90.8 cm (28 ¼ x 35 ¾ inches)

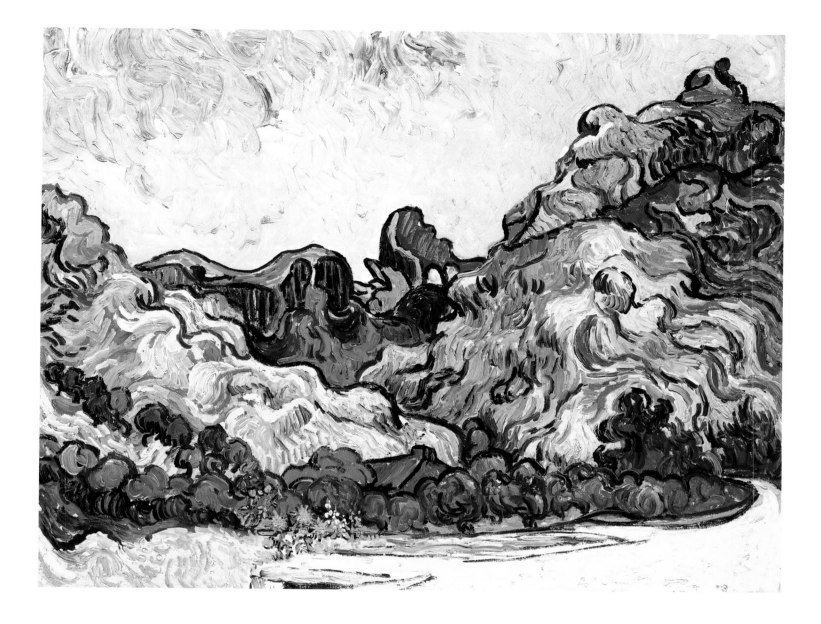

Vincent van Gogh
MOUNTAINS AT SAINT-RÉMY

by Albert Boime

VINCENT VAN GOGH PAINTED *Mountains at Saint-Rémy* during the second week of July 1889, exactly two months after his arrival at the asylum of Saint-Paul-de-Mausole and one week before his second major attack on July 16. Located just south of the small town of Saint-Rémy, the clinic was nestled in the rambling Provençal countryside. Despite the dashing of his high hopes of the previous year and his fear of an unexpected seizure like the one that had overcome him in Arles, he looked forward to recuperation in the salubrious rural environment. He wrote to his brother, Theo, shortly after arriving in May, "The change of surroundings does me good, I think," and expressed an ardent desire to get back to work.[1] The director of the asylum, Doctor Théophile Peyron, encouraged his patients to pick up their occupational routine in the clinic as part of the healing process. Under this regime, van Gogh gradually adjusted to his new environment and began to engage with the landscape as a kind of therapy. He wrote to Theo on May 22, "Since I have been here, the deserted garden, planted with large pines beneath which the grass grows tall and unkempt and mixed with various weeds, has sufficed for my work, and I have not yet gone outside. However, the country round Saint-Rémy is very beautiful and little by little I shall probably widen my field of endeavor."[2] He contemplated the possibility of a "fresh start" in the "lovely" scenery nearby. The local mountainside exalted him, and his painting of the jagged, saw-toothed Alpilles (Alpine foothills) in *Mountains at Saint-Rémy* suggests his voluntary submission to the influence of the countryside in his quest for rehabilitation.

Van Gogh first mentioned this picture around July 9 in a letter to Theo, in which he stated that the last canvas he had done "is a view of mountains with a dark hut at the bottom

View of the Alpilles from the north.

among some olive trees."[3] The painting metaphorically embodies the dialectical tension between shelter and confinement, personal liberty and security that the asylum represented for van Gogh. The frenzied brushwork—which is equally intense across the picture, distorting the scale and perspective of the view—together with the wild limestone formations and the winding road that abruptly disappears behind the rocks startle the viewer with their violent energy. The apparent jumble that meets the spectator's first glance gradually crystallizes into a coherent view as it coalesces around the desolate dwelling surrounded by olive trees and its tiny garden of sunflowers and gladioli. Although the looming mountainous mass dwarfs and even threatens the diminutive hut, it is a retreat amid the chaos; it appears simultaneously protected and precariously perched on the edge of existence. Like the lone white iris of van Gogh's *Irises* (1889, The J. Paul Getty Museum, Los Angeles)—which he also painted in the garden of the asylum—the tiny hut is the site of the artist's projection of his feelings of isolation and vulnerability.[4]

At the same time that van Gogh subjected himself to scientific treatment for his malady, he followed the naturalistic method of using observation to comprehend his environment. He carefully scrutinized the unique geological features of the terrain that surrounded the asylum, particularly the fissures and deep ravines that are characteristic of the local limestone formations and whose waterways were indispensable to fertilizing the plains of the Rhône river valley. On the left of *Mountains at Saint-Rémy*, he depicted the dense grove of olive trees that grew up the side of a hill where rich alluvial sediment had gathered in the gullies. The curving roadway opens up at the bottom of the picture, and here it borders a deep ravine or canal that runs in front of the row of olive trees. A pier or an observation platform, extending outward from the side of the road, drops down into the ravine. The peculiar jagged outlines of the mountains suggest that the artist was looking south across the ruins of the Glanum, the famous Roman ruins situated

235

Vincent van Gogh, *The Starry Night*, 1889. Oil on canvas, 73.7 x 92.1 cm (29 x 36 ¼ inches). The Museum of Modern Art, New York, Acquired through the Lillie P. Bliss Bequest.

the Western tradition, he associated trial and attainment with ascension; he wondered, in regard to the wrenching away of his energy after the mental and spiritual crisis that he had undergone in Arles, "if this is the way one thinks when, with the passions lessened, one descends the hill instead of climbing it." Later in the same letter, in a cheerier frame of mind, as he described his return to work in the clinic's garden, the mountain image recurred: "It may well be that I shall stay here long enough— I have never been so peaceful as here and in the hospital of Arles—to be able to paint a little at last. Quite near here there are some little mountains, gray and blue, and at their foot some very, very green cornfields and pines."[7]

The agitated character of the landscape in *Mountains at Saint-Rémy*, which is typical of van Gogh's work at this time (including *The Starry Night*, 1889), gives the limestone boulders an anthropomorphic quality. In the bizarre limestone formations, he seems to have seen animate creatures rendered in the stone by water and wind. The pinnacles and crags twist and tumble, as if rising from some abysmal depths of slumber. In September, preparing to send Theo the canvas, van Gogh anticipated the critics saying "that mountains are not like that and that there are black outlines of a finger's width."[8] Here he was referring to the coarse contours he used, particularly in the upper right of the mountainous mass, to mimic the eroded striations and what geologists call "bedding planes" in the limestone formations. Beneath the nodal outcroppings appears a horizontal break in the sequence of striations, which the artist accented by using differing paint textures and abruptly changing directions in his brushstrokes. He also used heavy lines in the left-hand section of the painting to indicate

within walking distance of the asylum.[5] On the right side of the painting is the western part of the Alpilles, including the craggy knobs of Mount Gaussier; on the left, or the eastern portion of the mountains, is the curious pierced rock formation known as "*les deux trous*" (the two holes). Here two windowlike apertures— which are easily visible in the painting—have been hollowed out of the rock by water and the violent action of the Mistral. It was the raw nature in this scene, rather than its antique human constructions, that excited van Gogh's admiration.[6]

In contrast to the positive tone of van Gogh's letter to his brother in late May, a more somber note infuses a letter he wrote to Theo's wife, Johanna (Jo), whom he calls his sister, earlier that month. In it, he wrote of his troubled mental state in the aftermath of his seizure in Arles and his ambivalent attitude about the asylum, expressing himself forcibly with mountain metaphors. Consistent with

the cavernous backdrop behind the foremost rock formation and to depict headward erosion in the mountains behind, trying to obtain the effect of the heavy contours of old woodcuts by packing the lines close together like hatchings.[9]

Van Gogh planned to create a sort of album of painted studies, titled *Impressions of Provence*, that would display the full range of the region's topography, including its vegetation and geology—"The olive trees, the fig trees, the vines, the cypresses, all the other characteristic things," including the Alpines, which he felt must be given special prominence within the landscape.[10] He emphasized that cypresses and mountains are central to conveying "an idea of Provence."[11] By undertaking this project, he emulated his idol Karl Bodmer, "who knew the whole forest of Fontainebleau, from the insect to the wild boar and from the stag to the lark, from the great oak and the rock mass to the fern and the blade of grass."[12]

It was not enough for van Gogh to convey the spiritual and mental excitation conventionally associated with lofty peaks; he had to establish the scientific and empirical foundations of this experience. Just as he had sought the inspiration for *The Starry Night* in astronomy when he had painted that work a month earlier, so now he tried to penetrate into the dynamics of rock structures in his exalted depiction of the mountains in *Mountains at Saint-Rémy*. Van Gogh's correspondence reveals that he was intensely aware of the elevations in his vicinity during this time. He sketched rock quarries, ravines, and the erosion caused by streams winding their way through the rock beds, and eventually felt up to doing "a whole series of these Alpines."[13] At one point, he wrote to his mother that he was "working on a picture of a path between the mountains and a little brook forcing its way between the stones."[14] He also expressed a "great desire to do for the mountains and the cypresses what I have just done for the olives, and have a good go at them."[15]

In all of these mountainous landscapes, van Gogh bounded the horizon, limiting the view just as his own movement was confined to a small part of his environment. The lofty walls of gray and creamy rock create an impenetrable visual barrier that closes in upon the viewer. The hut in *Mountains at Saint-Rémy* is locked into the landscape topography, enclosed on all sides by the rugged hills and dense cluster of olive groves, metonymically referencing this claustrophobic state. Yet beyond the asylum's walls lay the fearfulness and uncertainty of life that induced van Gogh to stay within his controlled environment.

Van Gogh's readings during this period informed his conceptual grasp of the mountains around the asylum. Near the end of June, just before he painted *Mountains at Saint-Rémy*, his sister, Wilhelmina (Wil), sent him the Swiss writer Edouard Rod's novel *Le Sens de la vie*, published that year and crowned by the Académie Française's Prix Jouy. The confessional character of the novel may have appealed to van Gogh, although his initial response to it was negative.[16] (For one thing, he considered it to be pretentious.) He wrote to Theo in August, "While I have no extravagant liking for Rod's book, all the same I have made a canvas of the passage where he speaks of the mountains and the dark huts."[17] He associated this passage with his own mountainous ideal, and told Theo in a letter in early September that he believed he would derive "great pleasure from going into the mountains to paint the whole day," and hoped that the authorities would permit him to do so. He added that he intended to send Theo "a canvas of a hovel in the mountains, which I did under the influence of that book of Rod's."[18] Again, a few weeks later, he noted that he had tried to capture the passage in Rod's book: "One of the rare passages of his in which I found

something good—about a desolate country of somber mountains, among which are some dark goatherds' huts and blooming sunflowers."[19]

The anonymous protagonist of *Le Sens de la vie* attempts to answer the riddle of the meaning of life. He has engaged all his life in futile self-analysis—at one point he is convinced that human beings are only "imperceptible atoms" lost in cosmic space—but marriage and fatherhood gradually dissipate his indifference and skepticism and he learns that love and affection are crucial components of the life process.[20] Contact with the wholesome and simple life of the mountains exercises a regenerative influence on his soul and helps bring about his conversion. Following the trauma of the near-death of his infant daughter and her restoration to health, he recalls pleasant scenes of his youth, including the sight of the "line of the Alps drawn on the horizon, where the beech trees of the forest shelter in their shadow the life of an invisible and teeming world; it was the symphony of nature singing in the light—the hidden and certain concord of all things whose voices are silent and whose forms are infinite."[21] He travels with his family to an Alpine resort, where he basks in the upland seclusion. In a chapter with the dedication "*A la montagne*," he describes climbing the heights alone, which relieves him of a great burden and allows him to breath freely. It is not the beauty of the landscape that moves him, but the "solitude . . . with the illusions of force and liberty that it rescues" from the flatlands. In the mountains, one rises above "human beings, their tumult, their petty troubles, and their tyranny!" Given the choice, he would move permanently to the mountains, renounce all ambition and worldly success, and sidestep "the hatred and injustice" of the plains.[22]

Just as van Gogh felt the tug between the uplifting experience of mountain heights and their delimiting role in the landscape, Rod similarly allegorized this dialectical tension. The novel's protagonist states that when a child "sees the mountains for the first time they seem to him as the limits of the world: he does not suspect that they represent just another threshold . . . behind which lies an unfolding immensity of unknown land."[23] The book suggests that many adults still cling to a one-sided view of life; it lauds the creative individual who breaks the mental barrier, braves the mountains, and risks the abyss on the opposite side. Rod's protagonist acknowledges that many people "admire the architecture of rock formations, the lines of mountains, the effect of glaciers against the sky, and the torrents and cascades," but doubts his own capacity to understand them and perceive their underlying structure; he feels that their subtleties entirely escape him, but that the mental exhilaration he gains from the experience of panoramic space more than compensates him for his ignorance.[24] Of course, this is a privileged experience; he sees the struggling *montagnards* who inhabit the area as incapable of an aesthetic response to their environment because they are too caught up in survival to recognize its intrinsic beauty. Similarly, van Gogh's understanding of his surroundings included an imaginary and idealized vision of the "dark" wooden hut.

Van Gogh's mountainous landscapes were influenced not only by *Le Sens de la vie* but also Alphonse Daudet's satirical novels *Tartarin de Tarascon* (1872) and, especially, *Tartarin sur les Alpes* (1885), which he evidently first read in 1888 and then picked up again while at the asylum.[25] He wrote to his brother from Saint-Rémy that after receiving the next shipment of his canvases Theo would "become better acquainted with good Tartarin's 'Alps' than you are now. Apart from the canvas of the 'Mountains,' you have not seen them yet except in the background of the

canvases."[26] Van Gogh's reference to Tartarin suggests a tongue-in-cheek attitude to his work that in turn attests to an improved mental state. Tartarin is an outsize buffoon with Quixote-like aspirations to feats beyond his competence, given over to tall tales and grandiose self-promotion, but for the simple townspeople of Tarascon (a Provençal town near Arles), he is a beloved hero and idol. *Tartarin sur les Alpes* finds him president of the Tarascon Alpine Club, whose greatest challenge is the Alpilles, "that chain of mountainettes . . . not very dangerous, nor yet very high . . . which make a horizon of blue waves along the Provençal roads and are embellished by the local imagination with fabulous and characteristic names: Mont-Terrible, Bout-du-Mond, Pic-des-Géants, etc."[27] Armed with pickaxes and ropes, with knapsacks and tents on their backs, the members of the Alpine Club advance on these awesome peaks every Sunday. The local journal, *Forum*, reports on these exploits, using a colorful inventory of epithets to describe the terrain—"abysses, gulfs, terrifying gorges"—as if the climb were taking place in the Himalayas. Van Gogh's allusion to the novel in his letter to Theo hints that in his depiction of the Alpilles he too was making mountains out of molehills.

The mountains in Daudet's novels are personalized, as when Tartarin travels to the Swiss Alps in the hopes of ascending to the summit of the Jungfrau and the mountain sternly asks the hesitant mountaineer, "Tartarin, where are we?"[28] This personalizing of mountains is typical in Provence, where the odd-shaped limestone crags and pinnacles often suggest enchanted figures of every species. Describing the water-eroded forms of a section of the Alpilles at Les Baux, just south of Saint-Rémy, one writer stated, "Huge heads, with profiles

half-human, half-bestial, monsters natural and supernatural, griffins, hippogriffs, sphinxes, unicorns, dragons, centaurs, chimeras, all these weird, fantastic shapes, ludicrous or terrible, rise up around, below, above us, a petrified nightmare of horrid forms."[29] On the right of *Mountains at Saint-Rémy*, among the riotous shapes of the rocky masses, is the profile, painted in blues and grays, of a seated male with his head facing to the right. The figure is unmistakably detached from the surrounding ochers as a kind of folklorish Old Man of the Mountain. Despite van Gogh's emphasis on a naturalistic method of painting, he also recognized its shortcomings and admitted into its structures imaginative and psychological insights. These insights must have become more tangible to him during his recuperation at Saint-Rémy.

Mountains at Saint-Rémy is linked dialectically with *The Starry Night*, which van Gogh painted the previous month. In the earlier work, he tried to capture the teeming forces of the cosmic universe, articulated in dynamic shapes and serpentine forms that assume a life of their own; in the later painting, he tried to grasp the eons of geological time recorded in the earth's stratifications, imaginatively conceiving the organic existences concealed in the earth's cavities.[30] Van Gogh's pictorial visions countered his sense of physical vulnerability by seeking the facts of vital growth and change in cosmic time; yet he did not flinch from depicting the convulsions of metamorphosis from infancy through maturity to decay. As in *The Starry Night*, where he posited a metaphorical rebirth on a distant star, he intimated in this landscape the cyclical renewal of geological action. At Saint-Rémy, his pictorial thoughts transported him from the known to the unknown, from the microcosm to the macrocosm, helping him during his crisis to negotiate the fearful prospects of the uncertain void.

NOTES

I am grateful to Frank Tepley of the Department of Geology, UCLA, and to Robert Leroy, Conseiller Municipal chargé du Patrimoine, Saint-Rémy-de-Provence, for their constructive advice and suggestions during the writing of this essay.

1. *The Complete Letters of Vincent van Gogh*, 3 vols. (Greenwich, Conn., 1958), vol. 3, no. 591 (ca. May 10–15, 1889), p. 169. I have used Jan Hulsker, *Vincent van Gogh: A Guide to His Work and Letters* (Amsterdam, 1993), as a corrective to *The Complete Letters of Vincent van Gogh* for dates and translations.

2. *The Complete Letters of Vincent van Gogh*, no. 592 (May 22, 1889), p. 173.

3. Ibid., no. 600 (ca. July 9, 1889), p. 193.

4. That van Gogh conceptualized the landscape in symbolic terms is seen in a letter he wrote to Theo and Jo from Auvers about his paintings of wheat fields: "There are vast fields of wheat under troubled skies, and I am not ashamed of trying to express sadness and extreme loneliness." Ibid., no. 649 (ca. July 10, 1890), p. 295.

5. See Ronald Pickvance, *Van Gogh in Saint-Rémy and Auvers*, exh. cat. (New York: The Metropolitan Museum of Art, 1986), cat. nos. 13, 20, pp. 101–02, 117–18.

6. Excavations at the Glanum began only in 1921, but the site known as the Plateau des Antiquités, where the Arch of Triumph and Mausoleum of Julii stood alone in the open, framed by the jagged outlines of the Alpilles, was conspicuous on the horizon in van Gogh's time.

7. *The Complete Letters of Vincent van Gogh*, no. 591 (May 9), p. 170. (Van Gogh's letter to Jo was apparently enclosed in the same envelope as his letter to Theo of ca. May 10–15 [see note 1].)

8. Ibid., no. 607 (September 19, 1889), pp. 216–17. I have used the translation given by Vojtech Jirat-Wasiutynski in "Van Gogh's Paintings of Olive Trees and Cypresses from St.-Rémy," *Art Bulletin* 75 (December 1993), p. 654.

9. This confirms my conclusion that van Gogh's painting gestures derived in large measure from his intense study and copying of wood engravings from popular illustrated newspapers. See Boime, "Van Gogh, Thomas Nast and the Social Role of the Artist," in J. D. Mascheck, ed., *Van Gogh 100* (Westport, Colo., 1996), pp. 71–111.

10. *The Complete Letters of Vincent van Gogh*, no. 609 (October 5, 1889), p. 221.

11. Ibid., no. 622 (January 4, 1890), p. 244.

12. Ibid., no. 602 (September 3 or 4, 1889), p. 198.

13. Ibid., no. 610 (ca. October 8, 1889), pp. 222–23; see also no. 622, p. 244.

14. Ibid., no. 619 (ca. December 20, 1889), p. 240.

15. Ibid., no. 615 (ca. November 21, 1889), p. 234; see also no. 617, p. 237.

16. Ibid., no. 596 (June 25, 1889), p. 184.

17. Ibid., no. 601 (August 22, 1889), p. 195.

18. Ibid., no. 602, p. 196.

19. Ibid., no. 607, p. 217.

20. Edouard Rod, *Le Sens de la vie* (Paris, 1918), p. 145. (English translation by the author.)

21. Ibid., pp. 161–62.

22. Ibid., pp. 214–15.

23. Ibid., pp. 262–63.

24. Ibid., pp. 216–17; see also no. 617, p. 237.

25. *The Complete Letters*, no. 530 (September 1, 1888), p. 24; no. 531 (September 3, 1888), p. 25; no. 571 (January 17, 1889), pp. 121–22; no. W6 (ca. August 21, 1888), p. 442.

26. Ibid., no. 610 (ca. October 8, 1889), p. 223.

27. Alphonse Daudet, *Tartarin de Tarascon suivi de Tartarin sur les Alpes* (Lausanne, 1944), p. 175. (English translation by the author.)

28. Ibid., p. 258.

29. Cecil Headlam, *Provence and Languedoc* (London, 1912), p. 100.

30. See Albert Boime, "Van Gogh's *Starry Night*: A History of Matter and a Matter of History," *Arts Magazine* 59 (December 1984), pp. 86–103.

69

Vincent van Gogh

LETTER TO JOHN PETER RUSSELL

late January 1890

Ink on laid paper, 17.8 x 22.5 cm (7 x 8 ⅞ inches)

My dear friend Russell,

Today I am sending you a little roll of photographs of pictures by Millet, which you may not know.

However this may be, the purpose is to remind you of myself and my brother.

Do you know that my brother has got married in the meantime, and that he is now expecting his first child? Let's hope all goes well—he has a very nice Dutch wife.

How much it pleases me to write you after such a long silence! Do you remember when we met our friend Gauguin almost at the same time—I think you were the first, and I the second?

He is still struggling on—alone, or nearly alone, like the brave fellow he is. I feel sure you have not forgotten him.

I assure you that he and I are still friends, but perhaps you are not unaware that I am ill, and that I have had serious nervous crises and delirium more than once. This was the cause of our parting company, he and I, for I had to go into a lunatic asylum. But, before that, how many times we spoke of you!

At the moment Gauguin is still with one of my fellow countrymen by the name of De Haan, and De Haan praises him highly, and does not think it at all bad to be with him.

You will find {an} article about some canvases I have at the exhibition of the Vingtistes. I assure you that I owe much to the things Gauguin told me on the subject of drawing, and I have the highest respect for the way he loves nature. For in my opinion he is worth even more as a man than as an artist.

And is everything going well with you? And are you still working hard?

Though it is not pleasant to be ill, yet I have no right to complain, for it seems to me that nature sees to it that disease is a means of putting us on our legs again and of healing us, rather than an absolute evil.

If you should go to Paris, please go and take a canvas of mine at my brother's, if you still stick to the idea of someday getting together a collection for you native country.

You will remember that I have already told you it is my great desire to give you one for this purpose. How is our friend MacKnight? If he is still with you, and if there are others with you whom I have had the pleasure of meeting, please remember me to them.

Above all give my kind regards to Mrs. Russell, and believe me, with a handshake in thought,

Sincerely yours, Vincent van Gogh

The translation by C. de Dood is from *The Complete Letters of Vincent van Gogh* (Greenwich, Conn., 1958), vol. III, pp. 249–50, courtesy of the New York Graphic Society.

70

Edouard Vuillard

PLACE VINTIMILLE

1908–10

Distemper on cardboard, mounted on canvas;

two panels: 200 x 69.5 cm (78 ¼ x 27 ⅜ inches) and

200 x 69.9 cm (78 ¼ x 27 ½ inches)

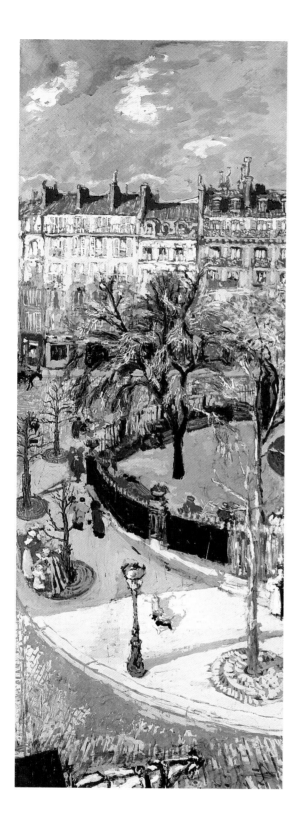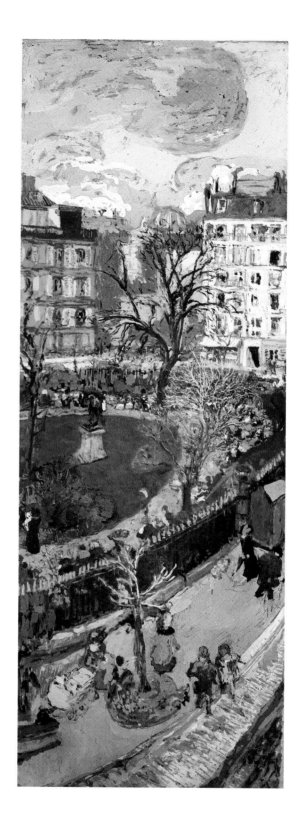

Edouard Vuillard
PLACE VINTIMILLE

by Elizabeth W. Easton

IN A JOURNAL ENTRY dated 1894, Edouard Vuillard distinguished between the two modes of pictorial construction that he pursued during his career: "There are two occupations in me: the study of exterior perception, filled with painful experiences, dangerous for my humor and my nerves. And the study of pictorial decoration . . . which ought to give me the tranquillity of a worker."[1]

Vuillard is mostly thought of as an Intimist, a painter of small pictures peopled by family and friends. Using complicated manipulations of pictorial space, his canvases depict these people engaged in dramas, often within airless interiors. Exaggeration of the foreground plane and a resulting diminution of the background, multiple perspectives, and dense patterning create feelings of unease and disquietude that speak of Vuillard's feelings about his favorite subjects: his mother, his sister, and his closest friends.

While these small canvases are Vuillard's better-known works, he spent much of the first two decades of his career on large-scale decorative projects.[2] Although most of these ensembles were commissioned by friends or members of Vuillard's most intimate circle, they did not record the turbulent relationships that figure so prominently in his small easel pictures; as commissioned works, they served a more public function and were intended for a broader audience. Often depicting the out-of-doors, they embraced the flatness that was a dominant aesthetic of the 1890s. Yet even in the decorations he produced in the last decade of the nineteenth century, Vuillard continued to push the definition of pictorial space, creating decorative environments that evoked the sensibility of an idea, or that sprang from his imagination, rather than conveying a more traditional depiction of observed reality.

By the time Vuillard painted the two views of the Place Vintimille in the Thannhauser Collection—part of a larger group of four he worked on from 1908 to 1910—he was in his forties and had departed from the complex compositions of densely woven patterns that marked his earlier work. This change in his pictorial vocabulary paralleled a move away from the avant-garde group of artists, writers, and patrons that had made up his social circle in the 1890s and early years of the twentieth century, including Pierre Bonnard, Maurice Denis, and Thadée and Misia Natanson. The Natansons' journal, *La Revue blanche*, which had been the central focus of this group of intellectuals, had ceased publication in 1903, and Thadée Natanson, the magazine's publisher and Vuillard's principle patron, had been forced to sell his art collection in 1908.[3]

With the closing of the magazine and the dissolution of the Natansons' marriage, Vuillard's social milieu had changed. His daily companion after this time was Lucie Hessel, whom he had met in 1900. Through her, he joined a social circle—and consequently acquired a group of patrons—that was less tightly knit and more aristocratic and conservative than that associated with *La Revue Blanche*. Lucie was the wife of Jos Hessel, who ran the gallery Bernheim-Jeune in Paris and who became Vuillard's dealer in 1905. At Bernheim-Jeune in 1908, Vuillard exhibited four panels entitled *Paris Streets*, the first decorative ensemble he had undertaken since 1901. The series was painted not on commission but under Vuillard's own auspices; this freed him from the constraints imposed by commissions, such as the portraits that constituted the main body of his work at this time. The works constituted a departure in format and style from the Symbolist-inspired evocations of Vuillard's earlier years; apart from their more naturalistic subject matter, the panels also demonstrate a greater stylistic freedom than that of his more detailed works of the previous few years.

In *Paris Streets*, Vuillard depicted the neighborhood of Passy, in the fashionable sixteenth arrondissement, where he lived from 1904 to 1908. The four views are painted on brown paper with rabbit-skin glue mixed with pigment (*à la colle*), a medium favored by the artist for its opaqueness and assertion of the flatness of the surface, in contrast to the luminosity of oil. The freely handled brush strokes in these panels, which were necessitated by the quickly drying paint, contrast with the dense layering of his earlier decorative compositions and give an impression of immediacy. In their subject, which was drawn from life (as opposed to the Symbolist inspirations of his earlier works, which were drawn from his imagination), the panels recall Edgar Degas's exhortation to depict "houses from below, from above, up close, as one sees them in strolling on the streets."[4]

The well-known playwright Henry Bernstein purchased the four panels of *Paris Streets* and commissioned four more, for which Vuillard chose as his subject the Place Vintimille, where he had just moved. In contrast to his previous home in Passy, which was the neighborhood of the Bernheims and many of their clients, Vuillard's new apartment returned him to the area where he had spent his youth and to the quarter of his friends and fellow artists.[5] From the window of the fifth-floor apartment he shared with his mother at 26, rue de Calais, Vuillard looked onto the park of the Place Vintimille, which would serve as the subject of his work for many years to come. The first work he undertook after moving to the new neighborhood was the series of four panels for Bernstein, which were intended to complement *Paris Streets*. Unlike the four scenes of Passy in that work, which are unrelated, not contiguous, and depict rather generic streets (despite the inclusion of the Eiffel Tower in the

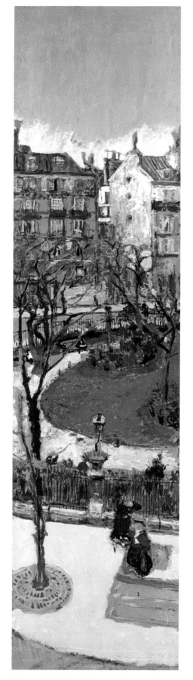

Edouard Vuillard, *Streets of Paris: Place Vintimille*, 1909–10. Distemper on cardboard, mounted on canvas, 200 x 49.8 cm (78 ¾ x 19 ⅝ inches). Private collection.

distance in one of the panels), three of the four panels of the Place Vintimille can be read as a triptych: the two panels from the Thannhauser Collection form the outer views of the place, with a third panel, *Streets of Paris: Place Vintimille* (1909–10), forming the center. The fourth panel depicts the rue de Calais; its plunging perspective recalls that of the earlier series, though here the street is seen from the vantage point of the fifth floor rather than from the ground, with the artist's balcony vertically bisecting the composition. While the earlier series contained large areas of unpainted surface, these four panels are complex and detailed; the paint was carefully applied, with highlights and details layered after earlier coats of paint had dried.[6] Although the three panels depicting the Place Vintimille itself read as a unit, there are a few repetitions between the central panel and the one on the left, and each panel appears to portray a different time of day.

Vuillard's journal entries indicate that the work on these compositions was carried out in the winter of 1909–10. In December 1909, Vuillard and Bonnard paid a visit to Claude Monet at Giverny. Vuillard had a "charming day," he later recorded in his journal, with the Impressionist "charming. his painting. his newness still for me."[7] Two days later, the visit to Monet was still clearly in his mind as he worked on the panels: "Project for the Bernstein paintings. Memories of Monet. General ideas. Difficulty to finish."[8]

Vuillard would paint several other compositions of the Place Vintimille, most notably a five-panel screen entitled *Place Vintimille* (private collection, United States), completed in 1911 for Marguerite Chapin. This work focuses on the park within the place, with the trees in full bloom and no view to the buildings on the other side of the square. A large, single-panel composition, *La Place*

Vintimille (1916, private collection, New York), combines a view of the bucolic square with work being done on the sidewalks in the foreground.

Vuillard painted the Place Vintimille panels when he was still stimulated by the view from the window of his new apartment as a subject for his art. The panels reconcile the artist's ties to the decorative, and thus to the goal of pictorial harmony, with the careful depiction of the time of day, weather conditions, and anecdotal particularities of specific moments during his observation of objective reality. In this way, the panels offer a resolution between the complexities of Vuillard's early work, which strove to depict an "idea,"[9] and the embrace of the real world that occupied the last three decades of his career.

It appears that Bernstein kept the eight panels he purchased from Vuillard at least until 1940, when he fled the German occupation of Paris and came to the United States. Justin Thannhauser purchased all eight panels in 1948, and gave two of the Place Vintimille panels to the Guggenheim Museum in 1973. The six other panels remain in a private collection, having been purchased from Thannhauser in 1958.

248

NOTES

1. Edouard Vuillard, journal, July 16, 1894, archives of the Bibliothèque, Institut de France, Paris. (English translation by the author.)

2. The most important early twentieth-century book devoted to painters of decorations was Achille Segard, *Les Peintres d'aujourd'hui: Les Décorateurs*, 2 vols. (Paris, 1914). Segard includes Vuillard in his list of the eight most prominent *peintres-décorateurs* of the late-nineteenth and early twentieth centuries; he also mentions that between Vuillard's first decorative commission, in 1892, and that for the Théâtre de Champs-Elysées, in 1912–13, he painted no fewer than twelve decorative ensembles comprising forty-six paintings (pp. 247–303, 320–22). The most thorough account of Vuillard's decorative work is Gloria Groom, *Edouard Vuillard: Painter-Decorator, Patrons and Projects, 1892–1912* (New Haven, 1993); most of the information about the panels in the Thannhauser Collection comes from the chapter entitled "Of Avenues, Streets, and Squares: The Commission for Henry Bernstein, 1908–1910," pp. 165–77.

3. Twenty-seven of the sixty-one works of art put up for sale were by Vuillard. Groom, *Edouard Vuillard: Painter-Decorator*, p. 234, n. 2.

4. Notebook 39, p. 196, in Theodore Reff, *The Notebooks of Edgar Degas* (Oxford, 1976), vol. 1, pp. 134–35; quoted in Groom, *Edouard Vuillard: Painter-Decorator*, p. 170.

5. This is explained in greater detail in Groom, *Edouard Vuillard: Painter-Decorator*, pp. 169–70.

6. In several entries in his journal, Vuillard noted reworking these panels. December 8, 1909: "Am working out Bernstein's panels." December 14, 1909: "beautiful weather. Moving along. Spend my time at the window. Small pastels for Bernstein's panels. Somewhat feverish intoxication and awkwardness. No rapid progress." January 11, 1910: "decided to make Bernstein's fourth panel. pastel cloud has just begun to take shape, a day shut in, excited." January 18, 1910: "return to the rue de Calais sketch. pastel effect of the rain. corner of the square." His work continued right up until he delivered the panels to Bernstein. March 14, 1910: "Raise my eyes to have another look. Touching up the fire[?] to finish. Beautiful weather. Idea of harmony." Quoted in Groom, *Edouard Vuillard: Painter-Decorator*, p. 240, n. 66. (English translation by Ellen Sowchek.)

7. Vuillard, journal, December 3, 1909; quoted in Groom, *Edouard Vuillard: Painter-Decorator*, p. 240, n. 67.

8. Vuillard, journal, December 5, 1909; quoted in Groom, *Edouard Vuillard: Painter-Decorator*, p. 175.

9. Vuillard wrote, "What I should really be concerned with: the consolidation of an idea as a work of art, of which the *existence* would be the *product* of an *idea*." Journal, October 24, 1890. (English translation by the author.)

Art Center College

CATALOGUE ENTRIES

Art Center College

NOTE TO THE READER

THE CATALOGUE ENTRIES have been substantially corrected and brought up to date from the Guggenheim's previous publications about the Thannhauser Collection. While every attempt has been made to be comprehensive, some gaps exist for provenance, exhibitions, and references prior to World War II. The abbreviations used for exhibitions and references are listed on pp. 254–55. Information in parentheses in exhibitions and references is given exactly as published in original sources.

PROVENANCE has been established by consulting Justin Thannhauser's personal records, when available, as well as through Moderne Galerie or Galerien Thannhauser sales records, which are at the Silva-Casa Foundation, Bern. Exhibition catalogues, books, articles, correspondence with previous owners, and myriad other archival records were also used to establish provenance.

THE PRIMARY TITLE of each work is given in English, followed by the original-language title in parentheses. The primary title is the way the work is commonly referred to in scholarly publications or catalogues raisonnés and may differ from the title originally given by the artist, if indeed it was ever known. In cases where the titles have never appeared in English before, they have been translated for this publication. In cases where an alternative title was used in an exhibition or publication, that title is given in parentheses in the exhibitions and references listings.

EXHIBITIONS are listed chronologically from earliest to latest. When an exhibition catalogue accompanied an exhibition, it is included. Also provided are the work's citations within such publications, such as its catalogue number and figure or plate number; repr. indicates a reproduction. When known, the name of the lender to the exhibition is given in parentheses.

REFERENCES are listed alphabetically by author or institution.

ABBREVIATIONS

EXHIBITIONS

1965. New York, Solomon R. Guggenheim Museum:
1965. New York, Solomon R. Guggenheim Museum. *Masterpieces of Modern Art, by Courtesy of the Thannhauser Foundation.* Apr. 30–Oct. 3.

1978. Kunstmuseum Bern:
1978. Kunstmuseum Bern. *Sammlung Justin Thannhauser.* June 8–Sept. 16, 1978.

1978. New York, Solomon R. Guggenheim Museum:
1978. New York, Solomon R. Guggenheim Museum. *The Thannhauser Collection* (permanent installation). Opened Dec. 14.

1986. New York, Solomon R. Guggenheim Museum:
1986. New York, Solomon R. Guggenheim Museum. *The Expressive Figure from Rousseau to Bacon: European Art in the Guggenheim Museum Collection.* July 18–Sept. 21.

1987–88a. New York, Solomon R. Guggenheim Museum:
1987–88. New York, Solomon R. Guggenheim Museum. *Fifty Years of Collecting: An Anniversary Selection, Painting by Modern Masters.* Nov. 13, 1987–Mar. 13, 1988.

1987–88b. New York, Solomon R. Guggenheim Museum:
1987–88. New York, Solomon R. Guggenheim Museum. *Fifty Years of Collecting: An Anniversary Selection, Sculpture of the Modern Era.* Nov. 13, 1987–Mar. 13, 1988.

1989. New York, Solomon R. Guggenheim Museum:
1989. New York, Solomon R. Guggenheim Museum. *Selections from the Permanent Collection.* May 26–Sept. 3.

1990. New York, Solomon R. Guggenheim Museum:
1990. New York, Solomon R. Guggenheim Museum. *Masterpieces from the Collection.* Feb. 21–Apr. 29.

1990. Venice, Palazzo Grassi:
1990. Venice, Palazzo Grassi. *From van Gogh to Picasso, From Kandinsky to Pollock: Masterpieces of Modern Art (Da van Gogh a Picasso, Da Kandinsky a Pollock: Il percorso dell'arte moderna).* Organized by the Solomon R. Guggenheim Museum. Sept. 9–Dec. 9.

1992. The Montreal Museum of Fine Arts:
1992. The Montreal Museum of Fine Arts. *Masterpieces from the Guggenheim (Chefs-d'oeuvre du Musée Guggenheim).* Organized by the Solomon R. Guggenheim Museum. Feb. 3–Apr. 26.

1992. New York, Solomon R. Guggenheim Museum:
1992. New York, Solomon R. Guggenheim Museum. *The Guggenheim Museum and the Art of this Century.* June 28–Sept. 7.

1997. Washington, D.C., National Gallery of Art:
1997. Washington, D.C., National Gallery of Art. *Young Picasso: The Early Years, 1892–1907.* Mar. 16–June 29. Traveled to Museum of Fine Arts, Boston, Sept. 10, 1997–Jan. 4, 1998.

1998. New York, Solomon R. Guggenheim Museum:
1998. New York, Solomon R. Guggenheim Museum. *The Modern Still-Life: Selections from the Collection.* Jan. 24–May 28.

1998. Deutsche Guggenheim Berlin:
1998. Berlin, Deutsche Guggenheim Berlin. *From Dürer to Rauschenberg: A Quintessence of Drawing, Masterworks from the Albertina and the Guggenheim.* June 30–Sept. 6. Traveled to Guggenheim Museum Bilbao, Mar. 9–May 16, 1999, and Graphische Sammlung Albertina, Vienna, Oct. 1–Nov. 21, 1999.

REFERENCES

Barnett. 1980:
Barnett, V. E. *Handbook: The Guggenheim Museum Collection (1900–1980)*. New York, 1980.

Blunt and Pool. 1962:
Blunt, A., and P. Pool. *Picasso: The Formative Years*. Greenwich, Conn., 1962.

Cassou. 1940:
Cassou, J. *Picasso* (Paris, 1940). Trans. Mary Chamot. New York, 1940.

Cirici Pellicer. 1946:
Cirici Pellicer, A. *Picasso antes de Picasso*. Barcelona, 1946.

Cirici Pellicer. 1950:
Cirici Pellicer, A. *Picasso avant Picasso*. Trans M. de Floris and V. Gasol. Geneva, 1950.

Cirlot. 1972:
Cirlot, J.-E. *Picasso: Birth of a Genius*. New York and Washington, D.C., 1972.

CLVG:
The Complete Letters of Vincent van Gogh. Greenwich, Conn., 1958, vols. I–III.

Daix. 1965:
Daix, P. *Picasso*. New York, 1965.

Daix. 1977:
Daix, P. *La Vie de peintre de Pablo Picasso*. Paris, 1977.

Daix and Boudaille. 1967:
Daix, P., and G. Boudaille. *Picasso: The Blue and Rose Periods*. Trans. P. Pool. Greenwich, Conn., 1967.

Daulte. 1971:
Daulte, F. *Auguste Renoir: catalogue raisonné de l'oeuvre peint*. Lausanne, 1971, vol. I.

de la Faille. 1928:
de la Faille, J.-B. *L'Oeuvre de Vincent van Gogh*. Paris and Brussels, 1928, vols. I–IV.

de la Faille. 1939:
de la Faille, J.-B. *Vincent van Gogh*. Paris, 1939.

de la Faille. 1970:
de la Faille, J.-B. *The Works of Vincent van Gogh: His Paintings and Drawings*. Rev. ed. Amsterdam, 1970.

Duncan. 1961:
Duncan, D. D. *Picasso's Picassos*. New York, 1961.

Gatto and Orienti. 1970:
Gatto, A., and S. Orienti. *L'opera completa di Cézanne*. Milan, 1970. English ed.: I. Dunlop and S. Orienti. *The Complete Paintings of Cézanne*. 1972. Reprint, Harmondsworth, England, 1985.

Gordon. 1974:
Gordon, D. E. *Modern Art Exhibitions 1900–1916*. Munich, 1974, vols. I–II.

Solomon R. Guggenheim Museum. 1972:
Solomon R. Guggenheim Museum. *Masterpieces of Modern Art: A Picture Book of Nineteenth and Twentieth Century Masterpieces from the Thannhauser Foundation*. New York, 1972.

Guggenheim Museum. 1992:
Guggenheim Museum. *Guggenheim Museum: A to Z*. New York, 1992.

Guggenheim Museum. 1993:
Guggenheim Museum. *Art of This Century: The Guggenheim Museum and Its Collection*. New York, 1993.

Hulsker. 1980:
Hulsker, J. *The Complete van Gogh: Paintings, Drawings, Sketches*. New York, 1980.

Lecaldano. 1968:
Lecaldano, P. *L'opera completa di Picasso blu e rosa*. Milan, 1968. English ed.: *The Complete Paintings of Picasso: Blue and Rose Periods*. New York, 1970.

Lemoisne. 1946:
Lemoisne, P. A. *Degas et son oeuvre*. Paris, 1946, vols. I–IV.

Palau i Fabre. 1981:
Palau i Fabre, J. *Picasso: The Early Years: 1881–1907*, trans. K. Lyons. New York, 1981. Catalan ed.: *Picasso Vivent 1881–1907. Infantesa i primera joventut d'un demiürg*, 1980.

Penrose. 1958:
Penrose, R. *Picasso: His Life and Work*. London, 1958.

Rewald. 1944:
Rewald, J. *Degas: Works in Sculpture, A Complete Catalogue*. New York, 1944.

Rewald. 1956:
Rewald, J. *Degas Sculpture: The Complete Works*. Rev. ed. New York, 1956.

Rewald. 1962:
Rewald, J. *Post-Impressionism: From van Gogh to Gauguin*. Second ed. New York, 1962.

Rewald. 1996:
Rewald, J. *The Paintings of Paul Cézanne: A Catalogue Raisonné*. New York, 1996, vols. I–II.

Venturi. 1936:
Venturi, L. *Cézanne: son art, son oeuvre*. Paris, 1936, vols. I–II.

Wildenstein. 1964:
Wildenstein, G., and R. Cogniat. *Gauguin*. Paris, 1964.

Zervos. 1932–77:
Zervos, C. *Pablo Picasso*. Paris and New York, 1932, vol. I. Paris, 1942–77, vols. II–XXXII.

Georges Braque, Paris, 1932,
photographed by Man Ray.

GEORGES BRAQUE

1882–1963

Georges Braque was born on May 13, 1882, in Argenteuil-sur-Seine, France. He grew up in Le Havre and studied evenings at the Ecole des Beaux-Arts there from about 1897 to 1899. He left for Paris to study under a master decorator to receive his craftsman certificate in 1901. From 1902 to 1904, he painted at the Académie Humbert in Paris, where he met Marie Laurencin and Francis Picabia. By 1906, Braque's work was no longer Impressionist but Fauve in style; after spending that summer in Antwerp with Othon Friesz, he showed his Fauve work the following year in the Salon des Indépendants in Paris. His first solo show was at Daniel-Henri Kahnweiler's gallery in 1908. From 1909, Pablo Picasso and Braque worked together in developing Cubism; by 1911, their styles were extremely similar. In 1912, they started to incorporate collage elements into their paintings and to experiment with the *papier collé* (pasted paper) technique. Their artistic collaboration lasted until 1914. Braque served in the French army during World War I and was wounded; upon his recovery in 1917, he began a close friendship with Juan Gris. After World War I, Braque's work became freer and less schematic. His fame grew in 1922 as a result of an exhibition at the Salon d'Automne in Paris. In the mid-1920s, Braque designed the decor for two Sergei Diaghilev ballets. By the end of the decade, he had returned to a more realistic interpretation of nature, although certain aspects of Cubism always remained present in his work. In 1931, Braque made his first engraved

plasters and began to portray mythological subjects. His first important retrospective took place in 1933 at the Kunsthalle Basel. He won First Prize at the *Carnegie International*, Pittsburgh, in 1937.

During World War II, Braque remained in Paris. His paintings at that time, primarily still lifes and interiors, became more somber. In addition to paintings, Braque also made lithographs, engravings, and sculpture. From the late 1940s, he treated various recurring themes, such as birds, ateliers, landscapes, and seascapes. In 1954, he designed stained-glass windows for the church of Varengeville. During the last few years of his life, Braque's ill health prevented him from undertaking further large-scale commissions, but he continued to paint, make lithographs, and design jewelry. He died on August 31, 1963, in Paris.

1.

LANDSCAPE NEAR ANTWERP (PAYSAGE PRÈS D'ANVERS)

1906

Oil on canvas, 60 x 81 cm (23 ⅝ x 31 ⅞ inches)
Thannhauser Collection, Gift, Justin K. Thannhauser
78.2514.1

Signed lower left: G Braque
Not dated.

PROVENANCE

Purchased from an unknown private collection in Paris by Robert Lebel, ca. 1935; purchased from Lebel by J. K. Thannhauser, 1950–51.

CONDITION

This work is painted on canvas and has an old glue-paste lining. There is an old repair in the top-right corner, where a

canvas insert has been fitted. The painting has a very lean ground, which is unevenly discolored (probably as a result of the penetration and subsequent discoloration of the glue-paste adhesive). There are numerous old paint losses, which were filled and inpainted in 1995 at the time the old varnish was removed (Aug. 1999).

EXHIBITIONS

1938. Paris, Galerie Pierre. *Georges Braque: Paysages de l'époque fauve.* Feb. 4–21.

1941. New York, Marie Harriman Gallery. *Les Fauves.* Oct. 20–Nov. 22. No. 27 (*La Rivière*).

1943. New York, Buchholz Gallery (Curt Valentin). *Early Work by Contemporary Artists.* Nov. 16–Dec. 4. No. 3 (*The River*, Collection Robert Lebel).

1944. New York, Mortimer Brandt Gallery. *Color and Space in Modern Art Since 1900.* Feb. 19–Mar. 18. No. 10.

1944. Boston, Institute of Modern Art. *Pioneers.* Mar. 28–Apr. 30. No. 1.

1946. The Toledo Museum of Art. *The Spirit of Modern France: An Essay on Painting in Society 1745–1946.* Nov.–Dec. No. 67. Traveled to the Art Gallery of Toronto, Jan.–Feb. 1947.

1950. Venice, XXV Esposizione Biennale Internazionale d'Arte. *Mostra dei Fauves.* No. 6 bis (*Riviera* [sic], Collection Robert Lebel, New York).

1950. New York, Sidney Janis Gallery. *Les Fauves.* Nov. 13–Dec. 23. No. 2 (*River*, Collection Robert Lebel).

1955. The Art Institute of Chicago, on loan from J. K. Thannhauser. May–Aug.

1960. Pasadena Art Museum. *Georges Braque.* Apr. 20–June 5. No. 2 (*Landscape*).

1965. New York, Solomon R. Guggenheim Museum. P. 49, no. 44, color repr.

1978. New York, Solomon R. Guggenheim Museum.

1987–88a. New York, Solomon R. Guggenheim Museum. No. 26, color repr.

1988. New York, Solomon R. Guggenheim Museum. *Georges Braque* (organized with Kunsthalle der Hypo-Kulturstiftung, Munich, the first venue). June 10–Sept. 11 (shown in New York only). Pp. 38–39, cat. no. 4, color repr.

1989. New York, Solomon R. Guggenheim Museum.

1990. New York, Solomon R. Guggenheim Museum.

1990. Los Angeles County Museum of Art. *The Fauve Landscape.* Oct. 7–Dec. 30 (first venue only). P. 271, no. 282, repr.

1998–99. New York, Solomon R. Guggenheim Museum. *Rendezvous: Masterpieces from the Centre Georges Pompidou and the Guggenheim Museums.* Oct. 16–Jan. 24. P. 119, no. 8, color repr.

REFERENCES
Arnason, H. H. *History of Modern Art.* New York, 1968, pp. 122–23, repr.

Barnett. 1980, pp. 44–45, no. 10, color repr.

de Romilly, N. W., and J. Laude. *Braque: Cubism: 1907–1914.* Paris, 1982, p. 17, repr., and p. 18 (*La Petite Baie d'Anvers*).

Solomon R. Guggenheim Museum. 1972, p. 78, repr.

Monod-Fontaine, I., and N. Pouillon. *Oeuvres de Georges Braque (1882–1963).* Exh. cat., Paris, 1982, p. 18.

————. *Les Fauves ou la couleur libéré.* Actualité des arts plastiques, no. 92. Paris, 1995, pp. 54–55.

Oppler, E. C. *Fauvism Reexamined.* New York, 1976, p. 52, fn. 2 (photo reprint of Ph.D. dissertation, Columbia University, New York, 1969).

Wilkin, K. "Georges Braque at the Guggenheim." *New Criterion,* vol. 7, no. 2, Oct. 1988, p. 53.

————. *Georges Braque.* New York, 1991, pp. 22, 24–25, fig. 11.

2.

GUITAR, GLASS, AND FRUIT DISH ON SIDEBOARD (GUITARE, VERRE ET COMPOTIER SUR UN BUFFET)
early 1919

Oil on canvas, 81 x 100.3 cm (31 ⅞ x 39 ½ inches)
Thannhauser Collection, Gift, Justin K. Thannhauser Foundation, by exchange
81.2821

Signed and dated on reverse: G. Braque / 19

PROVENANCE
Purchased from Galerie L'Effort Moderne (Léonce Rosenberg), Paris, by Raoul La Roche, Paris and Basel, 1919–20; La Roche Family Collection, 1965; acquired by Stephen Hahn, Inc., New York, 1980; purchased from Hahn, 1981, by Solomon R. Guggenheim Museum: Gift, Justin K. Thannhauser Foundation, by exchange.

CONDITION
The painting is unlined and in good condition. The ground and paint layers are very dry, and there is no varnish layer.

Besides the signature on the reverse, there is an area of paint in the top right of the reverse that shows as a "stain" at the top left of the front. In places on the reverse there appear to be areas of what is possibly mold or something similar (Mar. 1992).

EXHIBITIONS
1919. Paris, Galerie L'Effort Moderne (Léonce Rosenberg). *Braque.* Mar. 5–31.

1949. The Cleveland Museum of Art. *Georges Braque.* Jan. 25–Mar. 13. Traveled to New York, The Museum of Modern Art (organizer). Mar. 29–June 12. No. 41, p. 77, repr., and p. 83 (*The Buffet*).

1961. Paris, Musée du Louvre. *L'Atelier de Braque.* Nov. Cat. no. 24, repr. (*La Guitare*).

1962. Basel, Galerie Beyeler. *Le Cubisme: Braque, Gris, Léger, Picasso.* May–July. No. 28, repr. (*Nature morte à la guitare*).

1962. Paris, Galerie Knoedler. *Le Cubisme: Picasso, Braque, Gris, Léger.* Oct. 9–Nov. 10. No. 24, cover, color repr. (*Nature morte à la Guitare*).

1963. Munich, Haus der Kunst. *Georges Braque.* Oct. 18–Dec. 15. No. 60, color repr. (*Stilleben mit einer Gitarre* [*Nature morte avec une guitare*]).

1968. Basel, Galerie Beyeler. *G. Braque.* July–Sept. No. 25, color repr. (*Nature morte à la guitare*).

1988. New York, Solomon R. Guggenheim Museum. *Georges Braque.* June 10–Sept. 11. P. 26 and cat. no. 32, color repr.

1989. New York, Solomon R. Guggenheim Museum.

1992. New York, Solomon R. Guggenheim Museum.

1998. New York, Solomon R. Guggenheim Museum.

REFERENCES

Bissière, [R.]. *Georges Braque*. Paris, 1920, pl. 15 (*Nature morte*).

Bulletin de L'Effort Moderne, no. 3, Mar. 1924, repr. betw. pp. 8–9 (*La guitare*).

Cahiers d'Art. Special issue devoted to Braque in commemoration of his retrospective exhibition at the Kunsthalle Basel, 8ᵉ année, nos. 1–2, 1933, pp. 36–37, repr. (1917).

Carrà, M., and P. Descargues. *Tout l'oeuvre peint de Braque, 1908–1929*. Paris, 1973, p. 94, no. 172, repr. (*Le Buffet*).

Cogniat, R. *Georges Braque*. Paris, 1976, repr. as accompanying illustration to pl. 19 (*Le Buffet*).

————. *Braque*. Trans. Eileen B. Hennessy. New York, 1978, p. 28, color repr. (*Still Life with Guitar*; reproduced upside down).

Cooper, D. *Braque: The Great Years*. Exh. cat., The Art Institute of Chicago, 1972, pp. 37–38 (*The Sideboard*).

L'Esprit Nouveau, no. 25, July 1924.

Fumet, S. *Georges Braque*. Paris, 1965, p. 70, color repr., and p. 216 (*Le buffet*).

Isarlov, G. *Georges Braque*. Paris, 1932, p. 22, no. 256 (*Verre posé sur papier à musique*).

Judkins, W. *Fluctuant Representation in Synthetic Cubism: Picasso, Braque, Gris, 1910–1920*. New York and London, 1976, pp. 79–80 and 456, no. 77, repr. (*The Buffet*).

Mangin, N. *Catalogue de l'oeuvre de Georges Braque: Peintures 1916–1923*. Paris, 1973, pl. 46 (*Le Buffet*).

Monod-Fontaine, I. *Georges Braque: Les papiers collés*. Exh. cat., Centre Georges Pompidou, Musée Nationale d'Art Moderne, Paris, 1982, p. 62, fig. 6 (*Le Buffet*).

————, with E. A. Carmean, Jr. *Braque: The Papiers Collés*. Exh. cat., National Gallery of Art, Washington, D.C., 1982, p. 83, fig. 61, and pp. 84–85.

————, and N. Pouillon. *Oeuvres de Georges Braque (1882–1963)*. Exh. cat., Centre Georges Pompidou, Musée Nationale d'Art Moderne, Paris, 1982, pp. 62–63, fig. 2 (*Le Buffet*).

Ponge, F. *Braque le réconciliateur*. Geneva, 1947, no. 8, color repr. (*Verre et Guitare*).

Russell, J. *G. Braque*. London, 1959, pp. 22 and 122, pl. 27 (*The Sideboard* {*Le Buffet*}).

Sélection, no. 5, Dec. 15, 1920, p. 13, repr.

Tériade, E. "Documentaire sur la jeune peinture: II. L'avènement classique du Cubisme." *Cahiers d'Art*, 4ᵉ année, no. 10, 1929, p. 451, fig. 1 (*Nature-morte*).

Valsecchi, M., and M. Carra. *L'opera completa di Braque dalla scomposizione cubista al recupero dell'oggetto 1908–1929*. Milan, 1971, p. 94, no. 172, repr. (*Natura morta con chitarra* {*La credenza*}).

Verdet, A. *Georges Braque*. Geneva, 1956, p. 32 (*Le Buffet*).

Wilkin, K. *Georges Braque*. New York, 1991, p. 114, fig. 97.

Zervos, C. "Georges Braque." *Gaseta de les Arts*, añy II, no. 9, May 1929, p. 128, repr. (*Nature morte*).

3.
TEAPOT ON YELLOW GROUND (THÉÌÈRE SUR FOND JAUNE)

1955
Oil on canvas, 35 x 65 cm (13 ¼ x 25 ⅛ inches)
Thannhauser Collection, Gift, Justin K. Thannhauser, 1978
78.2514.2

Signed at bottom left of center: G Braque
Not dated.

PROVENANCE
Purchased from the artist by Galerie Maeght, Paris, 1955; purchased from Maeght by J. K. Thannhauser, Feb. 1956.

CONDITION
The support is sized but unprimed linen. The canvas has tack holes on the top and right sides, and it has been cut on the bottom and left sides. On the reverse is a fragment of a Cubist landscape painted on commercially primed canvas. Small losses above the handle and spout of the teapot (Jan. 1975).

EXHIBITIONS:
1965. New York, Solomon R. Guggenheim Museum. P. 72, no. 74, repr.

1978. New York, Solomon R. Guggenheim Museum.

1982. Washington, D.C., The Phillips Collection. *Georges Braque: The Late Paintings 1940–1963*. Oct. 9–Dec. 12. Pp. 28, 39, and 83, cat. no. 38, color repr. Traveled to The Fine Arts Museums of San Francisco, The California Palace of the Legion of Honor, Jan. 1–Mar. 15, 1983; Minneapolis, Walker Art Center, Apr. 14–June 14, 1983; and Houston, The Museum of Fine Arts, July 7–Sept. 14, 1983.

1987–88a. New York,
Solomon R. Guggenheim
Museum. No. 95, repr.

1989. New York, Solomon R.
Guggenheim Museum.

1998. New York, Solomon R.
Guggenheim Museum.

REFERENCES

Solomon R. Guggenheim
Museum. 1972, p. 79, repr.

Mangin, N., ed. *Catalogue
de l'oeuvre de Georges Braque:
Peintures 1948–1957.* Paris, 1959,
vol. I, pl. 98 (*Théière sur fond
jaune*).

PAUL CÉZANNE

1839–1906

Paul Cézanne was born on
January 19, 1839, in Aix-en-
Provence. While in school, he
enrolled in the free drawing
academy in Aix, which he
attended intermittently for
several years. In 1858, he
graduated from the Collège
Bourbon, where he had become
an intimate friend of his fellow
student Emile Zola. Cézanne
entered the law school of the
University of Aix in 1859 to
placate his father but
abandoned his studies to join
Zola in Paris in 1861. For the
next twenty years, Cézanne
divided his time between the
Midi and Paris. In the capital,
he briefly attended the Atelier
Suisse with Camille Pissarro,
whose art later came to
influence his own. In 1862,
Cézanne began long friendships
with Claude Monet and Pierre-
Auguste Renoir. His paintings
were included in the 1863 Salon
des Refusés, which displayed
works not accepted by the
jury of the official Paris Salon.
The Salon itself rejected
Cézanne's submissions each
year from 1864 to 1869.

In 1870, following the
declaration of the Franco-
Prussian War, Cézanne left
Paris for Aix-en-Provence and
then nearby L'Estaque, where
he continued to paint. He made
the first of several visits to
Pontoise in 1872; there, he
worked alongside Pissarro. He
participated in the first
Impressionist exhibition of
1874. From 1876 to 1879, his
works were again rejected for
the Salon. Cézanne showed
again with the Impressionists
in 1877 in their third
exhibition. At that time,
Georges Rivière was one of the
few critics to support his art.
In 1882, the Salon accepted his
work for the first and only
time. Beginning in 1883,
Cézanne resided in the South
of France, returning to Paris
occasionally.

In 1890, Cézanne exhibited
with the group Les XX in
Brussels and spent five months
in Switzerland. He traveled
to Giverny in 1894 to visit
Monet, who introduced him
to Auguste Rodin and the
critic Gustave Geffroy.
Cézanne's first solo show was
held at Ambroise Vollard's
gallery in Paris in 1895. From
this time, he received
increasing recognition. In 1899,
he participated in the Salon des
Indépendants in Paris for the
first time. The following year,
he took part in the *Centennial
Exhibition* in Paris. In 1903,
the Berlin and Vienna
Secessions included Cézanne's
work, and in 1904 he exhibited
at the Salon d'Automne,
Paris. That same year, he was
given a solo exhibition at the
Galerie Cassirer, Berlin.
Cézanne died on October 22,
1906, in Aix-en-Provence.

4.

STILL LIFE: FLASK, GLASS, AND JUG (FIASQUE, VERRE ET POTERIE)

ca. 1877
Oil on canvas, 45.7 x 55.3 cm
(18 x 21 ¾ inches)
Thannhauser Collection, Gift,
Justin K. Thannhauser, 1978
78.2514.3

Not signed or dated.

PROVENANCE

Eugène Murer, Auvers-sur-
Oise; purchased from Murer
family by Bernheim-Jeune
family collection, Paris,
ca. 1907; purchased from
Bernheim-Jeune by Joseph
Brochier, Lyons, probably
after 1934; acquired from
Brochier by J. K. Thannhauser,
ca. 1957.

CONDITION

This painting was glue lined at
an unknown date prior to 1965
and the edges were trimmed.
The surface texture in the area
above the glass suggests that
the rim of the glass has been
lowered by approximately one
half of an inch. This was
confirmed by X rays. There is
an indication of reworking in
the area of the jug and flask.
A discolored and yellowed
varnish was removed in 1998
(Aug. 2000).

EXHIBITIONS

1912. Paris, Galerie Manzi-
Joyant et Cie. *Exposition d'art
moderne.* Unknown date.
Nos. 1, 3, 12, 13, 20, 21, or 23.

1934. London, Alex Reid and
Lefevre, Ltd. *Renoir, Cézanne,
and Their Contemporaries.*
June. No. 3, repr. (*La Bouteille
paillée*, 1883).

1935. Paris, Bernheim-Jeune.
*Quelques Tableaux d'Ingres à
Gauguin.* June 11–July 13.
No. 3.

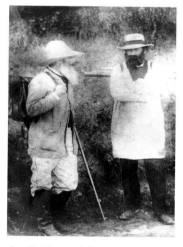

Camille Pissarro (left) and
Paul Cézanne.

1939. Paris, Paul Rosenberg. *Exposition Cézanne organisée à l'occasion de son centenaire.* Feb. 21–Apr. 1. No. 5, repr. (1877, Collection Joseph Brochier).

1939. London, Wildenstein and Co., Ltd. *Homage to Paul Cézanne (1839–1906).* July. No. 20 (*Flask, Glass, and Pot*).

1939. Musée de Lyon. *Centenaire de Paul Cézanne.* No. 19 and pl. viii.

1942. Musée de Lyon. *Exposition de peinture française de l'Impressionisme à nos jours.* May. No. 6.

1953. Aix-en-Provence, Musée Granet. *Cézanne: Peintures, Aquarelles, Dessins.* Traveled to Nice. No. 7 (*Fiasque, verre et poterie, 1875–77*).

1955. Saint-Etienne, Musée d'Art et d'Industrie. *Nature mortes de Géricault à nos jours.* No. 15, repr.

1956. Aix-en-Provence, Pavillon de Vendôme. *Exposition pour commemorer le cinquantenaire de la mort de Cézanne.* July 21–Aug. 15. No. 16, repr. (private collection, Lyons).

1962. The Cleveland Museum of Art. Loan exhibition. Summer. (Lent by J. K. Thannhauser).

1965. New York, Solomon R. Guggenheim Museum. P. 17, no. 5, color repr.

1978. New York, Solomon R. Guggenheim Museum.

1987–88a. New York, Solomon R. Guggenheim Museum. No. 8, color repr.

1989. New York, Solomon R. Guggenheim Museum.

1990. New York, Solomon R. Guggenheim Museum.

1990. Venice, Palazzo Grassi. Pp. 58–59, no. A2, color repr.

1992. New York, Solomon R. Guggenheim Museum.

REFERENCES

Arishima, I. *Cézanne.* Tokyo, 1926, pl. 34.

L'Art moderne et quelques aspects de l'art d'autrefois. Paris, 1919, vol. I, p. 90 and pl. 31 (*Le Pichet*).

Barnett. 1980. p. 14, fig. 2.

Baumann, Felix, et al., eds. *Cézanne. Vollendet-Unvollendet.* Exh. cat., Kunstforum Wien, Vienna, and Kunsthaus Zürich; Ostfildern-Ruit, 2000, p. 108, fig. 9, repr. (*Flasche, Glas, und Keramikgefäß*, ca. 1888). English ed.: *Cezanne: Finished-Unfinished.*

Bernard, E. *Sur Paul Cézanne.* Paris, 1925, p. 61, repr.

———. *Souvenirs sur Paul Cézanne, Une Conversation avec Cézanne.* Paris, 1926, opp. p. 30, repr.

Bernheim-Jeune, ed. *Cézanne.* Paris, 1914, pl. XXXV (*La Bouteille treillissée*).

Brion-Guerry, L. *Cézanne et l'expression de l'espace.* Paris, 1966, pp. 91 and 276, no. 21.

Bye, A. E. *Pots and Pans or Studies in Still Life Painting.* Princeton, 1921, pl. 136.

Dunlop, R. O. "Modern Still Life Painting in Oils." *The Artist,* vol. XIII, May 1937, p. 67, repr.

Eddy, A. J. *Cubists and Post-Impressionism.* Chicago, 1914, opp. p. 36, repr.

Faure, E. *Cézanne.* Paris, 1936, pl. 23.

Fry, R. "Cézannes Udvikling." *Samleren,* 1929, pp. 97–103, 113–19, 129–140, repr.

Gatto and Orienti. 1970, p. 96, no. 212, repr. (*Fiasco, Bicchiere, e Frutta*). English ed.:

pp. 94 and 96, repr. (*Flask, Glass and Fruit*).

Gaunt, W. "P. Cézanne: An Essay in Valuation." *The London Studio,* vol. 16, Sept. 1938, p. 148, repr. (*La Bouteille paillée,* 1883).

Gowing, L. "Notes on the Development of Cézanne." *The Burlington Magazine,* vol. XCIII, June 1956, p. 188 (1877).

Solomon R. Guggenheim Museum. 1972, p. 18, repr.

Guggenheim Museum. 1992, p. 61, color repr.

Meier-Graefe, J. *Cézanne und sein Kreis.* Second ed. Munich, 1920, p. 158, repr. (*Stilleben*).

———. *Cézanne.* Trans. J. Holroyd-Reece. London, 1927, pl. LIX (*Still Life*).

Paul Cézanne: Mappe. Munich, 1912, no. 2 (*Stilleben mit Weinflasche*).

Ratcliffe, R. W. *Cézanne's Working Methods and Their Theoretical Background.* Ph.D. dissertation, Courtauld Institute of Art, University of London, 1961, pp. 140, 158, 290, 383, fn. 35, and p. 430, fn. 151.

Raynal, M. *Cézanne.* Paris, 1936, pl. lxxxvi.

Rewald. 1996, vol. I, p. 221, no. 326, and vol. II, p. 105, fig. 326, repr. (*Fiasque, verre Augerie*).

Rivière, G. *Le Maître Paul Cézanne.* Paris, 1923, p. 211 (*La Bouteille treillissée,* 1883).

Schapiro, M. "Les Pommes de Cézanne." *Revue de l'Art,* nos. 1–2, 1968, p. 80, fn. 44.

Trublot [P. Alexis]. "La Collection Murer." *Le Cri du Peuple,* Oct. 21, 1887, no. 8 (*Desserts de table*). Reprinted in P. Gachet, *Deux Amis des impressionnistes: Le Dr. Gachet et Murer,* Paris, 1956, p. 171.

Venturi. 1936, vol. I, p. 113, no. 214, and vol. II, pl. 58, fig. 214 (*Fiasque, verre Augerie*).

Zeisho, A. *Paul Cézanne*. Tokyo, 1921, pl. 5.

Z[ervos], C. "Renoir, Cézanne, leurs contemporains et la jeune peintre anglaise." *Cahiers d'Art*, 9ᵉ année, nos. 5–8, 1934, p. 127, repr. (*La Bouteille paillée*, 1883).

5.
STILL LIFE: PLATE OF PEACHES (ASSIETTE DE PÊCHES)
1879–80

Oil on canvas, 59.7 x 73.3 cm (23 ¼ x 28 ⅞ inches)
Thannhauser Collection, Gift, Justin K. Thannhauser
78.2514.4

Not signed or dated.

PROVENANCE
Egisto Fabbri, Florence; purchased from Fabbri by Paul Rosenberg, Paris, 1928; acquired from Rosenberg by J. K. Thannhauser, 1929.

CONDITION
This painting was glue lined at an unknown date prior to 1965. The painting is in good condition. The paint is of medium thickness. There is evidence of overpainting in the background immediately above the table, but X rays revealed nothing of special interest in this area. A discolored varnish was removed in 1999 (Aug. 2000).

EXHIBITIONS
1910. Paris, Bernheim-Jeune. *Exposition Cézanne*. Jan. 10–22. No. 20 (listed erroneously as no. 19 in exh. cat.).

1920. Venice, XII Esposizione Internazionale d'Arte della città di Venezia, French Pavilion. *Mostra individuale di Paul Cézanne*. May–Oct. No. 4, 5, or 6.

1931. Basel, Kunsthalle. *Maîtres du XXᵉ siècle*. Sept. 27–Oct. 25. No. 2.

1952. The Art Institute of Chicago. *Cézanne: Paintings, Watercolors, and Drawings*. Feb. 7–Mar. 16. P. 30, no. 25, repr. (1879–82). Traveled to New York, The Metropolitan Museum of Art, Apr. 1–May 16.

1955. Kansas City, William Rockhill Nelson Gallery of Art. *Summer Exhibition*.

1963. New York, Solomon R. Guggenheim Museum. *Cézanne and Structure in Modern Painting*. June–Aug.

1965. New York, Solomon R. Guggenheim Museum. P. 19, no. 7, color repr.

1978. New York, Solomon R. Guggenheim Museum.

1987–88a. New York, Solomon R. Guggenheim Museum. No. 9, color repr.

1989. New York, Solomon R. Guggenheim Museum.

1990. New York, Solomon R. Guggenheim Museum.

1990. Venice, Palazzo Grassi. Pp. 60–61, no. A3, color repr.

1992. The Montreal Museum of Fine Arts. Pp. 62–63, no. 4, color repr.

1992. New York, Solomon R. Guggenheim Museum.

1996. Seoul, Ho-Am Art Gallery. *Masterpieces from the Guggenheim Museum*. July 15–Oct. 3. No. 1, color repr. Traveled to Singapore Art Museum, Oct. 16, 1996–Feb. 10, 1997; Dunedin, New Zealand, Dunedin Public Art Gallery, Mar. 1–May 15, 1997; and Shanghai Museum, June 27–Sept. 15, 1997.

REFERENCES
Gatto and Orienti. 1970, p. 107, no. 455, repr., and p. 108 (*Piatto con Pesche*, 1879–82). English ed.: (*Plate of Peaches*).

Solomon R. Guggenheim Museum. 1972, p. 19, repr. (1879–82).

Henraux, L. "I Cézanne della raccolta Fabbri." *Dedalo*, no. 1, 1920, p. 67, repr.

H[enraux], L. "Une Grande Collection de Cézanne en Italie, la Collection Egisto Fabbri." *L'Amour de l'art*, Vᵉ année, Nov. 1924, p. 340, repr.

Rewald. 1996, vol. I, p. 284, no. 423, and vol. II, p. 135, fig. 423 (*Assiette de Pêches*).

Venturi. 1936, vol. I, p. 113, no. 347, and vol. II, pl. 96, fig. 347 (*Assiette de pêches*, 1879–82).

6.
THE NEIGHBORHOOD OF JAS DE BOUFFAN (ENVIRONS DU JAS DE BOUFFAN)
1885–87

Oil on canvas, 65 x 81 cm (25 ⁹⁄₁₆ x 31 ⅞ inches)
Thannhauser Collection, Bequest, Hilde Thannhauser
91.3907

Not signed or dated.

PROVENANCE
Ambroise Vollard, Paris; Walther Halvorsen, Oslo; Galerie Thannhauser, Lucerne; private collection, France; J. K. Thannhauser, before 1976; Hilde Thannhauser, Bern, 1976–91.

CONDITION
This work is painted on canvas and is lined onto a very fine canvas with what appears to be a glue-paste adhesive. The reverse of the lining canvas is primed with an off-white

preparation. There is an off-white ground. The work is fairly thinly painted. The paint is in good condition and is well adhered to the support. The varnish was removed in 1991 (Aug. 1999).

EXHIBITIONS
1918. Oslo, Kristiania Kunstnerforbundet. *Den franske Utstilling.* Jan.–Feb. P. 23, no. 11 (*Paysage*).

1925. London, Leicester Galleries. *Paintings and Drawings by Paul Cézanne.* June–July. Exh. cat., *Catalogue of the Paul Cézanne Exhibition,* no. 13 (*Paysage d'Aix*).

1927. Berlin, Berliner Künstlerhaus (organized by Galerien Thannhauser, Berlin). *Erste Sonderausstellung in Berlin.* Jan. 9–mid-Feb. No. 25 (*Landschaft*).

1978. Kunstmuseum Bern. Cover, color repr., p. 33, cat. no. 3, color repr., and p. 107, no. 3 (*Environs du Jas de Bouffan*).

REFERENCES
"Exhibition of Cézanne Paintings." *The Burlington Magazine,* vol. XLVII, July 1925, pp. 56–57, repr. (*Meadow Landscape*).

Fry, R. *Cézanne: A Study of His Development.* New York, 1927, p. 74, pl. XXVIII, fig. 38 (*Landscape*).

Gatto and Orienti. 1970, p. 103, no. 365, repr. (*Dintorni del Jas de Bouffan*). English ed.: (*Jas de Bouffan Neighbourhood*).

Jamot, P. "L'Art français en Norvège." *La Renaissance,* vol. 1, Feb. 1929, p. 98, repr. (*Paysage: Au Jas de Bouffan*).

Rewald. 1996, vol. I, p. 355, no. 524, and vol. II, p. 170, fig. 524, repr.

Rivière, G. *Le Maître Paul Cézanne.* Paris, 1923, p. 217.

Venturi. 1936, vol. I, p. 167, no. 473, and vol. II, pl. 142, fig. 473.

7.
MADAME CÉZANNE
1885–87

Oil on canvas, 55.6 x 45.7 cm (21 7/8 x 18 inches)
Thannhauser Collection, Gift, Justin K. Thannhauser
78.2514.5

Not signed or dated.

PROVENANCE
Ambroise Vollard, Paris; probably purchased from Vollard by Marie Harriman, New York, by 1933; purchased from Marie Harriman by J. K. Thannhauser, Jan. 1946; purchased from Thannhauser by Vladimir Horowitz, New York, 1946–47; purchased from Horowitz by the Cincinnati Art Museum, 1947; acquired by J. K. Thannhauser through exchange, 1955.

CONDITION
This painting was glue lined at an unknown date prior to 1965. The edges are trimmed. The painting has an off-white ground, which is visible as part of the design of the background. The portrait is very thinly painted. A rather heavy, glossy, and very yellowed varnish was removed in 1993 (Aug. 2000).

EXHIBITIONS
1933. New York, Marie Harriman Gallery. *French Paintings.* Opened Feb. 21. No. 2 (*Tête de Femme*).

1934. Philadelphia, Pennsylvania Museum of Art. *Cézanne.* Nov. 10–Dec. 10. No. 34 (*Head of a Woman,* ca. 1890–91, 22 x 18 1/2 inches, lent by Marie Harriman Gallery).

1935. San Francisco Museum of Art. *Opening Exhibition (Modern French Painting).* From Jan. 18. No. 1 (*Head of a Woman,* 1890–91, lent by Marie Harriman Galleries).

1936. New York, Marie Harriman Gallery. *Paul Cézanne, André Derain, Walt Kuhn, Henri Matisse, Pablo Picasso, Auguste Renoir, Vincent van Gogh.* Feb. 17–Mar. 14. No. 5 (*Study: Madame Cézanne*).

1937. San Francisco Museum of Art. *Paul Cézanne.* Sept. 1–Oct. 4. Cat. no. 22, repr. (*Portrait of Madame Cézanne* [*Portrait de Madame Cézanne*]).

1939. New York, Marie Harriman Gallery. *Cézanne Centennial Exhibition.* Nov. 7–Dec. 2. No. 12.

1940. Lynchburg, Va., Randolph-Macon Woman's College. *Modern French Paintings.* May 6–June 5. No. 1 (*Portrait de Mme Cézanne*).

1940. Oberlin, Ohio, Allen Memorial Art Museum. *Modern Paintings.* Nov. 1–27.

1941. New York, The Museum of Modern Art. *Advisory Committee Exhibition: Techniques of Painting.* Aug. 4–Oct. 15 (no cat.).

1947. New York, Wildenstein and Co. *Cézanne.* Mar. 27–Apr. 26. No. 38 (*Portrait de Madame Cézanne;* lent by Mr. and Mrs. Vladimir Horowitz).

1956. Raleigh, The North Carolina Museum of Art. *French Painting of the Last Half of the Nineteenth Century.* June 15–July 29. Repr. (lent by J. K. Thannhauser).

1963. New York, Solomon R. Guggenheim Museum. *Cézanne and Structure in Modern Painting.* June–Aug.

1965. New York, Solomon R. Guggenheim Museum. P. 23, no. 11, color repr.

1978. New York, Solomon R. Guggenheim Museum.

1987–88a. New York, Solomon R. Guggenheim Museum. No. 10, repr.

1989. New York, Solomon R. Guggenheim Museum.

1990. New York, Solomon R. Guggenheim Museum.

1990. Venice, Palazzo Grassi. Pp. 62–63, no. A4, color repr.

1992. New York, Solomon R. Guggenheim Museum.

2000. Vienna, Kunstforum Wien. *Cézanne. Vollendet-Unvollendet.* Jan. 20–Apr. 25. Pp. 160, 163, cat. no. 18, color repr., and p. 164 (*Portrait Madame Cézanne,* ca. 1888). Traveled to Kunsthaus Zürich, May 5–July 30.

REFERENCES
Chappuis, A. *The Drawings of Paul Cézanne: A Catalogue Raisonné.* Greenwich, 1973, vol. I, p. 246 (discussed in context of related work, no. 1068).

Cincinnati Art Museum News, vol. 40, no. 7, Nov. 1947, p. i, repr.

Gatto and Orienti. 1970, p. 110, no. 532, repr. (*La Signora Cézanne*).

Solomon R. Guggenheim Museum. 1972, p. 20, repr.

Hoog, M., with H. Guicharnaud and C. Giraudon. *Catalogue de la collection Jean Walter et Paul Guillaume.* Paris, Musée de l'Orangerie, 1984, p. 32.

Musée Granet, Aix-en-Provence. *Cézanne au Musée d'Aix.* Aix-en-Provence, 1984, p. 221.

Musée de l'Orangerie, Paris. *Collection Jean Walter-Paul Guillaume.* Exh. cat., 1966, no. 11 (suggests Venturi 524 and 525 are studies for 523).

———. *Cézanne dans les musées nationaux.* Exh. cat., 1974, p. 92, no. 35 (Venturi 525 is "esquisse" or "reprise" for 523).

Museo Español de Arte Contemporáneo, Madrid. *Paul Cézanne.* Exh. cat., 1984, p. 134.

Parnassus, vol. VIII, no. 3, Mar. 1936, p. 4, repr. (*Head of a Woman*).

Reff, T. Review of "Album de Paul Cézanne." *The Burlington Magazine,* vol. CIX, Nov. 1967, p. 653 (relates Venturi 525 to p. 7 of *Album*).

Rewald. 1996, vol. I, p. 390, no. 582, and vol. II, p. 194, fig. 582 (*Portrait de Madame Cézanne,* ca. 1888).

Venturi. 1936, vol. I, p. 177, no. 525, and vol. II, pl. 163, fig. 525.

8.
BIBÉMUS
ca. 1894–95

Oil on canvas, 71.5 x 89.8 cm (28 ⅛ x 35 ⅜ inches)
Thannhauser Collection, Gift, Justin K. Thannhauser
78.2514.6

Not signed or dated.

PROVENANCE
Ambroise Vollard, Paris; purchased from Vollard by J. K. Thannhauser, Nov. 1929.

CONDITION
This painting was glue lined at an unknown date prior to 1965. The tacking edges have been trimmed. The work has an off-white ground, which is visible as part of the design. The work is smoothly and very thinly painted. Some underdrawing is

visible in places, and can be more clearly seen with the infrared videcon. A glossy and very yellowed varnish was removed in 1992 (Aug. 2000).

EXHIBITIONS
1931. Frankfurt, Städelsches Kunstinstitut. *Von Abbild zum Sinnbild.* June 3–July 3. No. 25 (*Die roten Felsen bei Gardanne,* lent by Galerien Thannhauser, Berlin).

1939. Musée de Lyon. *Centenaire de Paul Cézanne.* No. 37 (*Rochers rouges à Bibémus*).

1939. Paris, Grand Palais. Société des Artistes Indépendants, *Centenaire du peintre indépendant Paul Cézanne.* Mar. 17–Apr. 10. No. 47 (*Bibémus: rochers rouges*).

1939. Adelaide, The National Art Gallery. *Exhibition of French and British Contemporary Art.* Opened Aug. 21. No. 24 (*Rochers rouges à Bibémus,* ca. 1900). Traveled to Melbourne, Town Hall, opened Oct. 16, and Sydney, David Jones, opened Nov. 20.

1952. The Art Institute of Chicago. *Cézanne: Paintings, Watercolors, and Drawings.* Feb. 7–Mar. 16. P. 87, no. 105, repr., and p. 90 (ca. 1900). Traveled to New York, The Metropolitan Museum of Art, Apr. 1–May 16.

1955. San Francisco Museum of Art. *Art in the 20th Century: Commemorating the Tenth Anniversary of the Signing of the United Nations Charter.* June 17–July 10. P. 5, repr.

1963. New York, Solomon R. Guggenheim Museum. *Cézanne and Structure in Modern Painting.* June–Aug.

1965. New York, Solomon R. Guggenheim Museum. P. 37, no. 28, color repr.

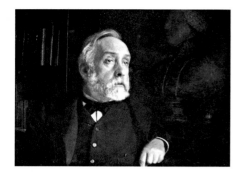

Edgar Degas, probably autumn 1895, photographed by Degas.

1977–78. New York, Solomon R. Guggenheim Museum. *Forty Modern Masters: An Anniversary Show*. Dec. 16–Feb. 1.

1978. New York, Solomon R. Guggenheim Museum.

1987–88a. New York, Solomon R. Guggenheim Museum. No. 11, color repr.

1989. New York, Solomon R. Guggenheim Museum.

1990. New York, Solomon R. Guggenheim Museum.

1990. Venice, Palazzo Grassi. Pp. 64–65, no. A5, color repr.

1992. New York, Solomon R. Guggenheim Museum.

REFERENCES

Barnett. 1980, p. 15, fig. 3.

Gatto and Orienti. 1970, pp. 118–19, no. 709, repr. (1900).

Solomon R. Guggenheim Museum. 1972, p. 21, repr. (1900).

Guggenheim Museum. 1992, p. 61, color repr.

Reff, T. "Painting and Theory in the Final Decade." In *Cézanne: The Late Work*. Exh. cat., The Museum of Modern Art, New York, 1977, p. 24.

Rewald. 1996, vol. I, p. 478, no. 794, and vol. II, p. 274, fig. 794 (1894–95).

Venturi. 1936, vol. I, p. 232, no. 781, and vol. II, pl. 258, fig. 781 (ca. 1900).

EDGAR DEGAS

1834–1917

Hilaire-Germain-Edgar Degas was born on July 19, 1834, in Paris. Following his family's wishes, he began to study law but abandoned that pursuit in 1855 to become an artist. Starting in 1853, he copied often at the Musée du Louvre. As preparation for entrance into the Ecole des Beaux-Arts, he studied under Louis Lamothe, a former pupil of J.-A.-D. Ingres. In 1855 he was admitted to the Ecole but remained there only briefly. He spent 1856–57 in Florence, Rome, and Naples copying works by Italian masters, especially the Primitives. Throughout his life he continued to travel extensively, most frequently to Italy, but also to England, Spain, and the United States.

In the early 1860s Degas began to depict contemporary subjects: at first horses and racing scenes, later musicians, the opera, dancers, and circuses. From 1865 to 1870 he exhibited regularly at the Paris Salon, showing portraits for the most part. With the outbreak of the Franco-Prussian War in 1870, Degas enlisted in the infantry and was found to be almost blind in his right eye. His close friendship with Henri Rouart dates from 1870. Two years later he was introduced to Paul Durand-Ruel. In 1874 Degas's work was included in the first exhibition of the Impressionists; he showed in all but one of the seven subsequent Impressionist exhibitions and helped organize several of them. Degas met Mary Cassatt about 1877, the year he invited her to join the Impressionist group. In the late 1870s he began to work seriously in sculpture, choosing

as his subjects women bathing, horses, and dancers. His work was exhibited in London and New York in 1883, and Durand-Ruel showed his work in New York in 1886. Degas met Paul Gauguin in 1885. About 1890 his eyesight began to fail. That same year he started to collect art intensively and eventually formed an impressive collection that included works by Eugène Delacroix, Gauguin, El Greco, and Edouard Manet, as well as Japanese art. Degas's last solo exhibition during his lifetime, comprising landscape pastels, was organized by Durand-Ruel in 1892. The artist died on or about September 26, 1917, in Paris.

9.
DANCER MOVING FORWARD, ARMS RAISED
(DANSEUSE S'AVANÇANT, LES BRAS LEVÉS)
1882–95

Bronze, 35.3 x 15.3 x 16.5 cm (13 ⅞ x 6 x 6 ½ inches)
Thannhauser Collection, Gift, Justin K. Thannhauser
78.2514.8

Signature incised at left side of base: Degas
Stamp of founder in relief in base near model's right foot: CIRE PERDUE / A.A. HEBRARD
Incised identifying mark near model's right foot: 19 / D
Not dated.

PROVENANCE

Galerie Hébrard, Paris; Walther Halvorsen; J. K. Thannhauser, probably 1926.

CONDITION

This is the fourth cast from a bronze master cast; therefore details are fairly defined on this posthumous bronze cast. In 1978 the soiled sculpture was cleaned, then sprayed with a

polyurethane coating. By 1992 the polyurethane coating had discolored and had caused the shiny, dark patinated surface to appear matte and dull. A few spots of corrosion in the crevices indicated that the coating was no longer protecting the bronze. Removal of the polyurethane coat was accomplished using acetone-saturated cotton poultice. Loss of patina at the right ankle and base of foot was inpainted with dry earth pigments and five-percent polyvinyl acetate medium to match the color of the patinated bronze. Continuous display necessitated the application of a light microcrystalline wax coat (Aug. 1999).

EXHIBITIONS

1926. Berlin, Galerie Flechtheim. *Das Plastische Werk von Edgar Degas*. May. No. 18 (*Tänzerin vorschreitend, Arme erhoben* [Erster Zustand]). Traveled to Munich, Moderne Galerie/Thannhauser, July–Aug., and Dresden, Galerie Arnold, Sept.

1965. New York, Solomon R. Guggenheim Museum. P. 20, no. 8, repr.

1978. New York, Solomon R. Guggenheim Museum.

1984. New York, Solomon R. Guggenheim Museum. *From Degas to Calder: Major Sculpture and Works on Paper from the Guggenheim Museum Collection*. July 20–Sept. 9. P. 6, repr.

1987–88b. New York, Solomon R. Guggenheim Museum. No. 1, color repr.

1989. New York, Solomon R. Guggenheim Museum.

1990. New York, Solomon R. Guggenheim Museum.

1990. Venice, Palazzo Grassi. Pp. 66–67, no. A6, color repr.

1992. New York, Solomon R. Guggenheim Museum.

REFERENCES

Barnett. 1980. p. 18, fig. 7.

Beaulieu, M. *Degas: Oeuvres du Musée du Louvre*. Exh. cat., Musée de l'Orangerie, Paris, 1969, no. 268 (ca. 1898–1900; another cast).

————. "Les Sculptures de Degas: Essai de chronologie." *Revue du Louvre*, 19ᵉ année, no. 6, 1969, p. 377, fn. 69.

Boggs, J. S., D. W. Druick, H. Loyrette, M. Pantazzi, and G. Tinterow. *Degas*. Exh. cat., The Metropolitan Museum of Art, New York, and National Gallery of Canada, Ottawa, 1988, p. 473.

Glaser, C., and W. Hausenstein. *Das Plastische Werk von Edgar Degas*. Berlin, 1926, p. 13, no. 18 (*Danseuse s'avançant, les bras levés* [Premier état]).

Solomon R. Guggenheim Museum. 1972, p. 13, repr.

M. Knoedler and Co., New York. *Edgar Degas: Original Wax Sculptures*. Exh. cat., 1955, no. 24 (wax original).

The Lefevre Gallery, London. *The Complete Sculptures of Degas*. Exh. cat., 1976, p. 37, no. 18, repr. (*modèle* cast).

Millard, C. W. *The Sculpture of Edgar Degas*. Ph.D. dissertation, Harvard University, Cambridge, Mass., 1971, p. 126, fig. 100, and Appendix I (1889).

————. *The Sculpture of Edgar Degas*. Princeton, 1976, p. 69 and fig. 97.

Rewald. 1944, pp. 22 and 76, no. xxiv, repr.

————. 1956, p. 146, no. xxiv, and fig. 8 (original: greenish-black wax).

10.
SPANISH DANCE
(DANSE ESPAGNOLE)
1896–1911

Bronze, 40.4 x 16.5 x 17.8 cm (15 ⅞ x 6 ½ x 7 inches)
Thannhauser Collection, Gift, Justin K. Thannhauser
78.2514.9

Signature incised at left side of base: Degas
Stamp of the founder in relief on base near model's left foot:
CIRE PERDUE / A.A. HEBRARD;
Incised identifying mark near model's left foot: 20 / D
Not dated.

PROVENANCE

Galerie Hébrard, Paris; Walther Halvorsen; J. K. Thannhauser, probably 1926.

CONDITION

This is the fourth cast from a bronze master cast; therefore details are fairly sharp and defined on this posthumous bronze cast. In 1978 the sculpture was cleaned, then sprayed with a polyurethane coating. By 1992 the polyurethane coating had discolored and had caused the shiny, dark patinated surface to appear matte and dull. A few spots of light-green corrosion indicated that the coating was no longer protecting the bronze. Removal of the polyurethane coat was accomplished using acetone-saturated cotton poultice. Continuous display necessitated the application of a light microcrystalline wax coat (Aug. 1999).

EXHIBITIONS

1926. Berlin, Galerie
Flechtheim. *Das Plastische
Werk von Edgar Degas.* May.
No. 16 (*Spanischer Tanz*
[Erster Zustand]). Traveled
to Munich, Moderne
Galerie/Thannhauser,
July–Aug., and Dresden,
Galerie Arnold, Sept.

1954. Houston, Museum of Fine
Arts. *House of Art.* Oct. 17–
Nov. 28. No. 65, repr.
(*Danse espagnole*, lent by J. K.
Thannhauser).

1965. New York, Solomon R.
Guggenheim Museum. P. 33,
no. 24, repr.

1978. New York, Solomon R.
Guggenheim Museum.

1987–88b. New York,
Solomon R. Guggenheim
Museum. No. 2, repr.

1989. New York, Solomon R.
Guggenheim Museum.

1990. New York, Solomon R.
Guggenheim Museum.

1990. Venice, Palazzo Grassi.
Pp. 66 and 68–69, no. A7,
color repr.

1992. New York, Solomon R.
Guggenheim Museum.

2000. New York, Solomon R.
Guggenheim Museum. *1900:
Art at the Crossroads.* May 18–
Sept. 11. Pp. 220–21, cat. no. 151,
color repr., and p. 436 (shown
at New York venue only).

REFERENCES

Beaulieu, M. *Degas: Oeuvres du
Musée du Louvre.* Exh. cat.,
Musée de l'Orangerie, Paris,
1969, no. 254 (1882; another
cast).

————. "Les Sculptures de
Degas: Essai de chronologie."
Revue du Louvre, 19ᵉ année,
no. 6, 1969, p. 375.

Boggs, J. S., D. W. Druick,
H. Loyrette, M. Pantazzi, and
G. Tinterow. *Degas.* Exh. cat.,
The Metropolitan Museum of
Art, New York, and National
Gallery of Canada, Ottawa,
1988, p. 473.

Glaser, C., and W.
Hausenstein. *Das Plastische
Werk von Edgar Degas.* Berlin,
1926, p. 13, no. 16 (*Danse
espagnole* [Premier état]).

Solomon R. Guggenheim
Museum. 1972, p. 16, repr.

M. Knoedler and Co., New
York. *Edgar Degas: Original
Wax Sculptures.* Exh. cat., 1955,
no. 62, repr. (wax original).

The Lefevre Gallery, London.
The Complete Sculptures of Degas.
Exh. cat., 1976, p. 35, no. 16,
repr. (*modèle* cast).

Millard, C. W. *The Sculpture of
Edgar Degas.* Ph.D. dissertation,
Harvard University, 1971,
Appendix I (1892).

Rewald. 1944, pp. 27 and 130,
no. lxvi, repr.

————. 1956, p. 156, no. lxvi,
and pl. 51 (original: greenish
wax, pieces of wire appear in
left hand).

11.

SEATED WOMAN, WIPING HER LEFT SIDE
(FEMME ASSISE, S'ESSUYANT LE CÔTÉ GAUCHE)
1896–1911

Bronze, 35.6 x 35.9 x 23.5 cm
(14 x 14 ⅛ x 9 ¼ inches)
Thannhauser Collection, Gift,
Justin K. Thannhauser
78.2514.10

Signature incised on base near
model's left foot: Degas
Stamp of the founder in relief
on base in back of chair:
CIRE PERDUE / A.A. HEBRARD
Incised identifying mark also
on base in back of chair: 46 / D
Not dated.

PROVENANCE

Galerie Hébrard, Paris;
Walther Halvorsen; J. K.
Thannhauser, probably 1926.

CONDITION

This is the fourth cast from a
bronze master cast, therefore
details are fairly sharp and
defined on this posthumous
bronze cast. In 1978 the
sculpture was sprayed with a
polyurethane coating. By 1992
the polyurethane coating
had discolored and had caused
the rich, reddish-brown
surface to appear matte and
dull. Spots of green corrosion
in the recesses indicated that
the coating was no longer
protecting the bronze.
Removal of the polyurethane
coat was accomplished using
acetone-saturated cotton
poultice. Minor abrasions and
patina loss at the edges and
base were inpainted with
dry earth pigments and five-
percent polyvinyl acetate
medium to match the color
of the patinated bronze.
Continuous display necessitated
the application of a light
microcrystalline wax coat
(Aug. 1999).

EXHIBITIONS

1926. Berlin, Galerie
Flechtheim. *Das Plastische
Werk von Edgar Degas.* May.
No. 67 (*Frau im Sessel
Sitzend, sich die linke Seite
trocknend*). Traveled to Munich,
Moderne Galerie/Thannhauser,
July–Aug., and Dresden,
Galerie Arnold, Sept.

1945. New York, Buchholz
Gallery (Curt Valentin). *Degas:
Bronzes, Drawings, Pastels.*
Jan. 3–27. No. 48 (*Seated
Woman*, Rewald no. lxix).

1965. New York, Solomon R.
Guggenheim Museum. P. 34,
no. 25, repr.

1978. New York, Solomon R.
Guggenheim Museum.

1987–88b. New York,
Solomon R. Guggenheim
Museum. No. 3, repr.

1989. New York, Solomon R.
Guggenheim Museum.

1990. New York, Solomon R.
Guggenheim Museum.

1990. Venice, Palazzo Grassi.
Pp. 66 and 70–71, no. A8,
color repr.

1992. New York, Solomon R.
Guggenheim Museum.

2000. New York, Solomon R.
Guggenheim Museum. *1900:
Art at the Crossroads*. May 18–
Sept. 11. P. 117, cat. no. 145,
color repr., and p. 436 (shown
at New York venue only).

REFERENCES

Beaulieu, M. *Degas: Oeuvres du
Musée du Louvre*. Exh. cat.,
Musée de l'Orangerie, Paris,
1969, no. 287 (*Femme assise
s'essuyant la hanche gauche*,
ca. 1884; another cast).

Cooper, D. *Pastels d'Edgar
Degas*. Basel, 1952, p. 25 (after
1895).

Glaser, C., and W.
Hausenstein. *Das Plastische
Werk von Edgar Degas*. Berlin,
1926, p. 15, no. 67 (*Femme
assise dans un fauteuil s'essuyant
le côté gauche*).

Solomon R. Guggenheim
Museum. 1972, p. 17, repr.

M. Knoedler and Co., New
York. *Edgar Degas: Original
Wax Sculptures*. Exh. cat., 1955,
no. 65, repr. (wax original).

The Lefevre Gallery, London.
The Complete Sculptures of Degas.
Exh. cat., 1976, p. 84, no. 67,
repr. (*modèle* cast).

Millard, C. W. *The Sculpture of
Edgar Degas*. Princeton, 1976,
p. 109 and pl. 133 (another cast).

Rewald. 1944, pp. 28 and 135,
no. lxix, repr.

———. 1956, p. 157, no. lxix,
and pls. 85–88 (original: red wax
with large pieces of cork and
wood visible from behind).

Zweig, A. "Degas als
Plastiker." *Der Querschnitt*,
jg. VI, 1926, opp. p. 177, repr.

12.
DANCERS IN GREEN AND YELLOW (DANSEUSES VERTES ET JAUNES)
ca. 1903

Pastel on several pieces of
paper, mounted on board,
98.8 x 71.5 cm (38 ⅞ x
28 ⅛ inches)
Thannhauser Collection, Gift,
Justin K. Thannhauser
78.2514.12

Red signature stamp lower left:
degas
Not dated.

PROVENANCE

Purchased at the first sale of
Degas's studio, Galerie Georges
Petit, Paris, May 6–8, 1918, by
Paul Rosenberg, Paris; acquired
by J. K. Thannhauser, probably
by 1926.

CONDITION

A large piece of paper (82 x
68 cm [32 ¼ x 26 ¾ inches]) was
cut by hand at the left edge.
Strips of the same kind of
paper were added: four inches
at the top and one and one-
quarter inches at the bottom.
The pastel has not been
fixed, and it appears to have
been done in a wet technique
(Jan. 1975).

EXHIBITIONS

1926. Munich, Moderne
Galerie/Thannhauser. *Edgar
Degas: Pastelle, Zeichnungen,
Das Plastische Werk*. July–Aug.
No. 20 (*Vier Tänzerinnen*).

1927. Lucerne, Galerie
Thannhauser. *Maîtres français
du XIXᵉ siècle*. No. 72.

1965. New York, Solomon R.
Guggenheim Museum. P. 42,
no. 35, color repr.

1978. New York, Solomon R.
Guggenheim Museum.

1987–88a. New York,
Solomon R. Guggenheim
Museum. No. 6, color repr.

1989. New York, Solomon R.
Guggenheim Museum.

1990. New York, Solomon R.
Guggenheim Museum.

1992. New York, Solomon R.
Guggenheim Museum.

1996. London, National Gallery.
Degas: Beyond Impressionism.
May 22–Aug. 26. P. 206, no. 27,
color repr. Traveled to the Art
Institute of Chicago, Sept. 28,
1996–Jan. 12, 1997.

REFERENCES

Galerie Georges Petit, Paris.
*Catalogue des tableaux, pastels et
dessins par Edgar Degas et
provenant de son atelier*. Sale cat.,
May 6–8, 1918, no. 167 (*Danseuses
{Jupes vertes et jaunes}*).

Solomon R. Guggenheim
Museum. 1972, p. 15, repr.

Guggenheim Museum. 1993,
p. 87, pl. 10.

Kendall, R., ed. *Degas by
Himself: Drawings, Prints,
Paintings, Writings*. Boston,
1987, p. 292, repr., and p. 326.

Lemoisne. 1946, vol. III,
pp. 818–19, no. 1431, repr.
(*Danseuses vertes et jaunes {Quatre
danseuses}*).

Russoli, F., and F. Minervino.
L'opera completa di Degas.
Milan, 1970, p. 137, no. 1149,
repr.

Varnedoe, K. "The Ideology
of Time: Degas and
Photography." *Art in America*,
vol. 68, no. 6, summer 1980,
pp. 99, 102, fig. 7, and p. 105.

PAUL GAUGUIN
1848–1903

Paul Gauguin, 1894.

Paul Gauguin was born on June 7, 1848, in Paris and lived in Lima, Peru, from 1851 to 1855. He served in the merchant marine from 1865 to 1871 and traveled in the tropics. Gauguin later worked as a stockbroker's clerk in Paris but painted in his free time. He began working with Camille Pissarro in 1874 and showed in every Impressionist exhibition between 1879 and 1886. By 1884 Gauguin had moved with his family to Copenhagen, where he unsuccessfully pursued a business career. He returned to Paris in 1885 to paint full-time, leaving his family in Denmark.

In 1885 Gauguin met Edgar Degas; the next year he met Charles Laval and Emile Bernard in Pont-Aven and Vincent van Gogh in Paris. With Laval he traveled to Panama and Martinique in 1887 in search of more exotic subject matter. Increasingly, Gauguin turned to primitive cultures for inspiration. In Brittany again in 1888 he met Paul Sérusier and renewed his acquaintance with Bernard. As self-designated Synthetists, they were welcomed in Paris by the Symbolist literary and artistic circle. Gauguin organized a group exhibition of their work at the Café Volpini, Paris, in 1889, in conjunction with the World's Fair in that city.

In 1891 Gauguin auctioned his paintings to raise money for a voyage to Tahiti, which he undertook that same year. Two years later illness forced him to return to Paris, where, with the critic Charles Morice, he began *Noa Noa*, a book

about Tahiti. Gauguin was able to return to Tahiti in 1895. He unsuccessfully attempted suicide in January 1898, not long after completing his mural-sized painting *Where Do We Come From? What Are We? Where Are We Going?* In 1899 he championed the cause of French settlers in Tahiti in a political journal, *Les Guêpes*, and founded his own periodical, *Le Sourire*. Gauguin's other writings include *Cahier pour Aline* (1892), *L'Espirit moderne et e catholicisme* (1897 and 1902) and *Avant et après* (1902), all of which are autobiographical. In 1901 the artist moved to the Marquesas, where he died on May 8, 1903. A major retrospective of his work was held at the Salon d'Automne in Paris in 1906.

13.
IN THE VANILLA GROVE, MAN AND HORSE
(DANS LA VANILLÈRE, HOMME ET CHEVAL)
1891

Oil on burlap, 73 x 92 cm (28 ¼ x 36 ¼ inches)
Thannhauser Collection, Gift, Justin K. Thannhauser
78.2514.15

Signed and dated lower left: P Gauguin. 91

PROVENANCE
Galerie Barbazanges, Paris, by 1923; Vignier, Paris, by 1928; Wildenstein and Co., New York; purchased from Wildenstein by Baron Eduard von der Heydt, Zandvoort, the Netherlands, and Ascona, Switzerland, ca. 1935; S. Wright Ludington, Santa Barbara, by Jan. 1941 and until Dec. 1942; purchased from Ludington by J. K. Thannhauser, 1942.

CONDITION
This painting was glue lined at an unknown date prior to 1965. The support is a very coarse jute-type fabric, similar to that of *Haere Mai* (cat. no. 14). A glossy varnish and the overpaint at the edges were removed in 1988. The painting was revarnished with a thin matt varnish and local cleavage was set down at that time (Mar. 1992).

EXHIBITIONS
1928. Basel, Kunsthalle. *Paul Gauguin*. July–Aug. No. 65 or 76 (depending on cat. ed.), repr. (*Mann mit Pferd im Walde*, Collection Vignier, Paris).

1928. Berlin, Galerien Thannhauser. *Paul Gauguin*. Oct. P. 17, no. 51, repr. (*Mann mit Pferd im Walde*).

1935. The Art Gallery of Toronto. *Loan Exhibition of Paintings*. Nov. P. 40, no. 177 (Wildenstein).

1935. London, Wildenstein and Co., Ltd. *Nineteenth Century Masterpieces*. May 9–June 15. No. 12, repr. (*The White Horse*, Collection Baron von der Heydt).

1936. New York, Wildenstein and Co. *Paul Gauguin 1848–1903*. Mar. 20–Apr. 18. P. 30, no. 18 (*The White Horse*, von der Heydt).

1936. Cambridge, Mass., The Fogg Art Museum. *Paul Gauguin 1848–1903: A Retrospective Exhibition of His Paintings*. May 1–21. P. 28, no. 16 (*The White Horse*).

1936. The Baltimore Museum of Art. *Paul Gauguin*. May 24–June 5. No. 11.

1936. San Francisco Museum of Art. *Paul Gauguin*. Sept. 5–Oct. 4. Cat. no. 15, repr., and p. 17 (*The White Horse*).

1941. Los Angeles County Museum. *Aspects of French Painting from Cézanne to Picasso.* Jan. 15–Mar. 2. No. 22 (*The White Horse*, Collection S. Wright Ludington).

1946. New York, Wildenstein and Co. *Paul Gauguin.* Apr. 3–May 4. P. 36, cat. no. 21, repr., and p. 64 (*Landscape, Tahiti,* J. K. Thannhauser).

1965. New York, Solomon R. Guggenheim Museum. P. 30, no. 21, color repr.

1978. New York, Solomon R. Guggenheim Museum.

1987–88a. New York, Solomon R. Guggenheim Museum. No. 22, color repr.

1989. New York, Solomon R. Guggenheim Museum.

1990. New York, Solomon R. Guggenheim Museum.

1990. Venice, Palazzo Grassi. Pp. 72–73, no. A9, color repr.

1992. The Montreal Museum of Fine Arts. Pp. 66–67, no. 6, color repr.

1992. New York, Solomon R. Guggenheim Museum.

1998. Stuttgart, Staatsgalerie Stuttgart. *Paul Gauguin— Tahiti.* Feb. 7–June 2. Pp. 26, 35, cat. no. 26, color repr., and p. 167.

1998. Martigny, Switzerland, Foundation Gianadda. *Paul Gauguin.* June 10–Nov. 22.

1998–99. Berlin, Nationalgalerie. *Paul Gauguin: Das verlorene Paradies.* Nov. 23–Jan. 10. Cat. no. 17, color repr., and p. 320 (*Das weiße Pferd {das Treffen}*).

2000. Bilbao, Guggenheim Museum Bilbao. *Degas to Picasso: Painters, Sculptors and the Camera.* June 6–Sept. 10. Exh. cat., *The Artist and the Camera: Degas to Picasso* (1999), p. 120, no. 121, color repr.

REFERENCES

Barnett. 1980, p. 16, fig. 5.

Blunt, A., and P. Pool. *Picasso: The Formative Years.* Greenwich, 1962, p. 32 and pl. 166 (detail) (*Le Rendezvous*).

Daulte, F. "Une Donation sans précédent: la collection Thannhauser." *Connaissance des Arts,* no. 171, May 1966, p. 65, color repr. (*Le Rendez-vous*).

de Gravelaine, F. *Paul Gauguin: la vie, la technique, l'oeuvre peint.* Lausanne, 1988, pp. 116–17, color repr. (*Le Rendez-vous {Dans le champs de vanille}*).

Dietrich, L. S. *A Study of Symbolism in the Tahitian Painting of Paul Gauguin: 1891–1893.* Ph.D. dissertation, University of Delaware, Newark, 1973, pp. 234, 274.

Dorival, B. *Carnet de Tahiti.* Facsimile ed. Paris, 1954, pp. 2R, 18–19, and 37.

Fezzi, E. *Gauguin: Every Painting,* vol. II. Trans. Jane Carroll. New York, 1980, pp. 24–25, no. 423, color repr. (detail), and p. 30, repr. (*Landscape with a Man and a Horse {The Rendezvous}*).

Field, R. S. *Paul Gauguin: The Paintings of the First Voyage to Tahiti.* Ph.D. dissertation, Harvard University, Cambridge, Mass., 1963, pp. 21, 38–41, 305, no. 20, p. 312, no. 8, and pl. 20 (*The White Horse {Le Rendez-vous},* Oct.–Nov. 1891).

Galerie Marcel Guiot, Paris. *Gauguin: Documents Tahiti.* Exh. cat., 1942, p. 38 (incorrectly lists Basel exhibition as Bremen).

Solomon R. Guggenheim Museum. 1972, p. 25, repr. (*In the Vanilla Field, Man and Horse*).

Guggenheim Museum. 1992, p. 93, color repr.

Guggenheim Museum. 1993, p. 96, pl. 17.

Kane, W. M. "Gauguin's *Le Cheval Blanc*: Sources and Syncretic Meanings." *The Burlington Magazine,* vol. CVIII, July 1966, pp. 357 and 359, fig. 27.

Kantor-Gukovskaya, A., A. Barskaya, and M. Bessonova. *Paul Gauguin in Soviet Museums.* Trans. A. Mikoyan. Leningrad, 1988, p. 82, repr. (*The Rendezvous*). French ed.: *Paul Gauguin: Musée de l'Ermitage, Musée des Beaux-Arts Pouchkine,* Paris, 1988 (*Le Rendez-vous*). German ed.: *Paul Gauguin in den Museen der Sowjetunion,* Düsseldorf and Leningrad, 1989 (*Das Rendezvous*).

Langer, A. *Paul Gauguin.* Leipzig, 1963, pp. 53–54, repr. (detail) and p. 87.

le Pichon, Y. *Sur les traces de Gauguin.* Paris, 1986, p. 159, no. 298, color repr., and p. 261 (*Le Rendez-vous*). English ed.: *Gauguin: Life, Art, Inspiration,* trans. I. Mark Paris, New York, 1987, p. 159, no. 298, color repr., and p. 262.

Malingue, M. *Gauguin.* Paris, 1948, pl. 166 (*Le Rendez-Vous*).

Sugana, G. M. *Tout l'oeuvre peint de Gauguin.* Paris, 1981, p. 102, no. 258, repr. (*Le Rendez-vous*). Italian ed.: *L'opera completa di Gauguin,* Milan, 1972.

Taralon, J. *Gauguin.* Paris, 1953, p. 6, no. 32, repr.

van Dovski, L. *Paul Gauguin.* Basel, 1947, pl. 19 (*Homme avec un cheval dans la fôret,* Collection Vignier).

——. *Paul Gauguin oder die Flucht vor der Zivilisation.* Bern, 1950, p. 348, no. 253 (J. K. Thannhauser).

Wiese, E. *Paul Gauguin.* Leipzig, 1923, p. 29, repr. (*Pferdeführer*, Galerie Barbazanges, Paris).

Wildenstein. 1964, p. 175, no. 443, repr. (*Le Rendez-Vous*).

14.
HAERE MAI
1891

Oil on burlap, 72.4 x 91.4 cm (28 ½ x 36 inches)
Thannhauser Collection, Gift, Justin K. Thannhauser
78.2514.16

Signed and dated lower left:
P Gauguin 91
Inscribed lower right:
HAERE MAI

PROVENANCE
Ambroise Vollard, Paris; purchased from Vollard by J. K. Thannhauser, June 1934.

CONDITION
In 1968 the painting was lined with wax resin, and a small hole in the head of the pig at bottom right of center was repaired. In 1988 the painting was cleaned, and a thick glossy varnish was removed (Sept. 1987).

EXHIBITIONS
1910. Munich, Moderne Galerie.

1910–11. London, Grafton Galleries. *Manet and the Post-Impressionists.* Nov. 8–Jan. 15. No. 44A (*Les Cochons noirs dans la prairie*, lent by Vollard).

1923. Prague, Spolku Vytvarnych Umelcu Mánes. *Vystava francouzského umení XIX a XX století* [*French Art of the 19th and 20th centuries*]. May–June. No. 183 (Vollard).

1938. Amsterdam, Stedelijk Museum. *Honderd Jaar Fransche Kunst.* July 2–Sept 25. No. 125, repr. (J. K. Thannhauser).

1939. Buenos Aires, Museo Nacional de Bellas Artes. *La pintura francesa de David a nuestros días.* July–Aug. No. 57. Traveled to Montevideo, Ministerio de Instrucción Pública, Apr.–May 1940; Rio de Janeiro, Museu Nacional de Belas Artes, June 29–Aug. 15, 1940; and San Francisco, M. H. De Young Memorial Museum (*The Painting of France Since the French Revolution*), Dec. 1940–Jan. 1941 (no. 41, repr.).

1941. Los Angeles County Museum. *Aspects of French Painting from Cézanne to Picasso.* Jan. 15–Mar. 2. No. 19.

1941. The Art Institute of Chicago. *Masterpieces of French Art.* Apr. 10–May 20. No. 64.

1941. The Portland Art Museum. *Masterpieces of French Painting from the French Revolution to the Present Day.* Sept. 3–Oct. 5. No. 42.

1942–46. Washington, D.C., The National Gallery of Art. On loan. Feb. 1942–July 1946.

1946. Pittsfield, Mass., The Berkshire Museum. *French Impressionist Painting.* Aug. 2–31. No. 10.

1956. New York, Wildenstein and Co. *Gauguin.* Apr. 5–May 5. P. 16, no. 20, and p. 38, fig. 20 (*Tahitian Landscape with Black Pigs*).

1965. New York, Solomon R. Guggenheim Museum. P. 31, no. 22, color repr.

1978. New York, Solomon R. Guggenheim Museum.

1987–88a. New York, Solomon R. Guggenheim Museum. No. 21, color repr.

1989. New York, Solomon R. Guggenheim Museum.

1990. New York, Solomon R. Guggenheim Museum.

1990. Venice, Palazzo Grassi. Pp. 74–75, no. A10, color repr.

1992. The Montreal Museum of Fine Arts. Pp. 68–69, no. 7, color repr.

1992. New York, Solomon R. Guggenheim Museum.

1998. Stuttgart, Staatsgalerie Stuttgart. *Paul Gauguin—Tahiti.* Feb. 7–June 2. Pp. 26, 35, cat. no. 25, color repr., and p. 167 (*Haere mai venez!* [*Komm her!*]).

1998. Martigny, Switzerland, Fondation Pierre Gianadda. *Paul Gauguin.* June 10–Nov. 22.

1998–99. Berlin, Nationalgalerie. *Paul Gauguin: Das verlorene Paradies.* Nov. 23–Jan. 10. Cat. no. 18, color repr., and p. 320 (*Haere mai* [*Komm her!*]).

REFERENCES
Bodelsen, M. "The Wildenstein-Cogniat Gauguin Catalogue." *The Burlington Magazine*, vol. CVIII, Jan. 1966, p. 38 (correcting error of ex. coll. Fayet).

Bouge, L.-J. "Traduction et interprétation de titres en langue tahitienne . . . " In *Gauguin: sa vie, son oeuvre.* Paris, 1958, p. 162, no. 14.

Danielsson, B. "Gauguin's Tahitian Titles." *The Burlington Magazine*, vol. CIX, Apr. 1967, p. 230, no. 16.

Dorival, B. *Carnet de Tahiti.* Facsimile ed. Paris, 1954, pp. 2R, 18, 23, 28, 37, and 40.

Fezzi, E. *Gauguin: Every Painting*. Vol. II. Trans. Jane Carroll. New York, 1980, p. 26, fig. 419 (*Haere Mai* [*Come Here*]).

Field, R. S. *Paul Gauguin: The Paintings of the First Voyage to Tahiti*. Ph.D. dissertation, Harvard University, Cambridge, Mass., 1963, pp. 21, 38, 39, 304, and 311, no. 7 (Oct.–Nov. 1891).

Solomon R. Guggenheim Museum. 1972, p. 24, repr.

Guggenheim Museum. 1992, p. 93, color repr.

Guggenheim Museum. 1993, p. 96, pl. 18.

Malingue, M. *Gauguin*. Paris, 1948, no. 170, repr.

Metken, G. *Gauguin in Tahiti: The First Journey, Paintings 1891–1893*. Trans. Michael Hulse. New York and London, 1992, pl. 6.

Rewald, J. *Gauguin*. Paris, 1938, p. 105, color repr., and p. 167 (*"Haere Temai" Landscape with Black Hogs*).

Sterling, C., and M. M. Salinger. *French Paintings: A Catalogue of the Collection of the Metropolitan Museum of Art*. New York, 1967, vol. III, p. 174.

Sugana, G. M. *Tout l'oeuvre peint de Gauguin*. Paris, 1981, p. 102, no. 259, repr. Italian ed.: *L'opera completa di Gauguin*, Milan, 1972.

van Dovski, L. *Paul Gauguin oder die Flucht vor der Zivilisation*. Bern, 1950, p. 347, no. 244 (*Haere Temai*).

Wildenstein. 1964, p. 177, no. 447, repr. (*Haere Mai Venez!*).

PAUL KLEE
1879–1940

Paul Klee was born on December 18, 1879, in Münchenbuchsee, Switzerland, into a family of musicians. His childhood love of music was always to remain profoundly important in his life and work. From 1898 to 1901, Klee studied in Munich, first with Heinrich Knirr, then at the Kunstakademie under Franz von Stuck. Upon completing his schooling, he traveled to Italy in the first in a series of trips abroad that nourished his visual sensibilities. He settled in Bern in 1902. A series of his satirical etchings was exhibited at the Munich Secession in 1906. That same year, Klee married Lily Stumpf, a pianist, and moved to Munich. Here he gained exposure to Modern art. Klee's work was shown at the Kunstmuseum Bern in 1910 and at Moderne Galerie, Munich, in 1911.

Klee met Alexej Jawlensky, Vasily Kandinsky, August Macke, Franz Marc, and other avant-garde figures in 1911; he participated in important shows of advanced art, including the second Blaue Reiter exhibition at Galerie Hans Goltz, Munich, in 1912, and the *Erste deutsche Herbstsalon* at the Der Sturm Gallery, Berlin, in 1913. In 1912, he visited Paris for the second time, where he saw the work of Georges Braque and Pablo Picasso and met Robert Delaunay. Klee helped found the Neue Münchner Secession in 1914. Color became central to his art only after a revelatory trip to Tunisia in 1914.

In 1920, a major Klee retrospective was held at the Galerie Hans Goltz, Munich; his *Schöpferische Konfession* was published; he was also appointed to the faculty of the Bauhaus. Klee taught at the Bauhaus in Weimar from 1921 to 1926 and in Dessau from 1926 to 1931. During his tenure, he was in close contact with other Bauhaus masters, such as Kandinsky and Lyonel Feininger. In 1924, the Blaue Vier, consisting of Lyonel Feininger, Jawlensky, Kandinsky, and Klee, was founded. Among his notable exhibitions of this period were his first in the United States at the Société Anonyme, New York, in 1924; his first major show in Paris the following year at the Galerie Vavin-Raspail; and an exhibition at the Museum of Modern Art, New York, in 1930. Klee went to Düsseldorf to teach at the Akademie in 1931, shortly before the Nazis closed the Bauhaus. Forced by the Nazis to leave his position in Düsseldorf in 1933, Klee settled in Bern the following year. Seventeen of his works were included in the Nazi exhibition of "degenerate art," *Entartete Kunst*, in 1937. Major Klee exhibitions took place in Bern and Basel in 1935 and in Zurich in 1940. Klee died on June 29, 1940, in Muralto-Locarno, Switzerland.

Paul Klee, ca. 1929, photographed by Josef Albers.

15.
JUMPING JACK
(HAMPELMANN)
1919

Pencil, oil transfer drawing, and watercolor on paper, mounted on cardboard, 28.4 x 22 cm (11 ¾₆ x 8 ¹¹⁄₁₆ inches) Thannhauser Collection, Bequest, Hilde Thannhauser 91.3908

Signed lower right: Klee Dated and numbered lower left: 1919. 214.

PROVENANCE

Purchased from the artist by Hans Goltz, Munich, May–June 1920; J. K. Thannhauser, before 1976; Hilde Thannhauser, Bern, 1976–91.

CONDITION

The overall condition is stable. However, the thin primary support is pasted directly onto acidic cardboard along the edges. This is original and has caused the paper to yellow. The central part of the sheet is cockled and there is some surface dirt. In the upper right area, there are three superficial paint losses (scrapes). Along the bottom area there is a water stain coming from the reverse, which has caused distortion and delamination of the cardboard. A drawing on the reverse side shows through the center of the sheet (Aug. 1999).

EXHIBITIONS

1920. Munich, Galerie Neue Kunst Hans Goltz. *Paul Klee.* May–June. Exh. cat., *Paul Klee, Katalog der 60. Austellung der Galerie Neue Kunst Hans Goltz* (special issue of *Der Ararat*, no. 2), p. 15, no. 214, repr.

1927. Berlin, Galerien Thannhauser. *Eröffnungs-Ausstellung unseres neuen Berliner Hauses.* June. No. 105.

1978. Kunstmuseum Bern. P. 55, cat. no. 18, repr., and p. 109, no. 18.

1993. New York, Guggenheim Museum SoHo. *Paul Klee at the Guggenheim Museum.* May 7–Sept. 19. Pp. 15 and 77, color repr.

REFERENCES

Geist, F. "Kinder über Paul Klee." *Das Kunstblatt,* vol. 14, no. 1, Jan. 1930, pp. 21–22, repr.

Giedion-Welcker, C. *Paul Klee.* New York, 1952, p. 139.

———. *Paul Klee in Selbstzeugnissen und Bilddokumenten.* Reinbek bei Hamburg, 1961, p. 154.

Goldwater, R. *Primitivism in Modern Painting.* New York and London, 1938, p. 157.

Hausenstein, W. *Kairuan oder eine Geschichte vom Maler Klee und von der Kunst dieses Zeitalters.* Munich, 1921, p. 88, no. 30, color repr.

Helfenstein, J., and C. Rümelin. *Paul Klee, Catalogue Raisonné.* Vol. 3 (1919–22), Bern, 1999, p. 131, fig. 2278, repr., and p. 82, color repr. (*Hampelmann*).

Hopfengart, C. *Klee. Vom Sonderfall zum Publikumsliebling. Stationen seiner öffentlichen Resonanz in Deutschland 1905–1960.* Mainz, 1989, p. 41.

Osterwold, T. *Paul Klee. Ein Kind traumt sich.* Stuttgart, 1979, p. 185, repr.

Pierce, James. *Paul Klee and Primitive Art.* New York, 1976, p. 26.

Zahn, L. *Paul Klee. Leben, Werk, Geist.* Potsdam, 1920, p. 74, repr.

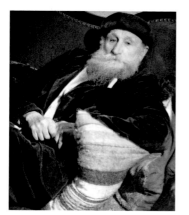

Aristide Maillol.

ARISTIDE MAILLOL

1861–1944

Aristide-Jean-Bonaventure Maillol was born on December 9, 1861, in Banyuls-sur-Mer, France. He went to Paris in 1882 to study painting and in 1885 was admitted to the Ecole des Beaux-Arts, where he studied with Alexandre Cabanel and Jean Léon Gérôme. He became dissatisfied with his academic training in 1889, partly due to his discovery of Paul Gauguin's paintings, pottery, and wood carvings. During the 1890s he concentrated on making tapestries, ceramics, and decorative wood carvings, in response to the arts and crafts movement popular in France at the time. In 1896 he showed small carved figures for the first time, at the Salon of the Société Nationale des Beaux-Arts. Maillol became friends with Pierre Bonnard, Maurice Denis, Edouard Vuillard, and the rest of the Nabis during the mid-1990s. In 1895 he married Clotilde Narcisse, who became the model for many of his sculptures.

By 1900 deteriorating eyesight forced Maillol to give up tapestry and concentrate on sculpture. His first solo exhibition was held at the Galerie Vollard in Paris in 1902. In 1905 his first monumental sculpture, *The Mediterranean,* was shown at the Salon d'Automne, Paris, prompting the German Count Harry Kessler to commission a version in stone. That same year Maillol was commissioned to execute *Action in Chains,* a memorial to Louis-Auguste Blanqui for the town of Puget-Théniers. In 1907 he completed the relief *Desire* and a statue, *Young Cyclist,* for his patron Kessler. The following year Kessler invited Maillol to Greece and asked him to make woodcut illustrations for Virgil's *Eclogues.*

In 1910 Maillol began a monument to Paul Cézanne that was finally installed in the Jardin des Tuileries in Paris in 1929. From 1919 to 1923 he worked on two war memorials for the towns of Céret and Port-Vendres. His first solo exhibition in the United States took place at the Albright Art Gallery in Buffalo, New York, in 1925. In 1930 he received a commission for a war memorial from the town of

Banyuls-sur-Mer and another for a monument to Claude Debussy in Saint-Germain-en-Laye. Major Maillol retrospectives were held at the Galerie Flechtheim, Berlin, in 1928, and the Kunsthalle Basel in 1933. In 1938 he began his last monument commissions, a memorial to aviators entitled *Air* for the city of Toulouse, and *River*, in memory of Henri Barbusse. Maillol died on September 27, 1944, in Banyuls-sur-Mer.

16.
WOMAN WITH CRAB
(LA FEMME AU CRABE)
ca. 1902(?)–05

Bronze, 15.2 x 14.6 x 12.1 cm
(6 x 5 ¼ x 4 ¼ inches)
Thannhauser Collection, Gift,
Justin K. Thannhauser
78.2514.26

Signed with the artist's monogram AM in a circle on the base between the crab and the figure's left foot
Not dated.

PROVENANCE
Acquired from the artist by Alfred Wolff, Munich, by 1917; acquired from Wolff by J. K. Thannhauser in 1917.

CONDITION
In 1978 the golden-brown patinated bronze cast was cleaned with solvents to remove accumulated soil. Following this treatment it was sprayed with a polyurethane coating. By 1992 the polyurethane coating had discolored and had caused the surface to appear matte and dull. Minor spots of light-green corrosion on the surface also indicated that the coating was no longer protecting the bronze. Removal of the polyurethane coat was accomplished using acetone-saturated cotton poultice. Continuous display necessitated the application of a light microcrystalline wax coat (Aug. 1999).

EXHIBITIONS
1965. New York, Solomon R. Guggenheim Museum. P. 38, no. 31, repr.

1978. New York, Solomon R. Guggenheim Museum.

1987–88b. New York, Solomon R. Guggenheim Museum. No. 4, repr.

1989. New York, Solomon R. Guggenheim Museum.

1990. New York, Solomon R. Guggenheim Museum.

1990. Venice, Palazzo Grassi. Pp. 90–91, no. A18, color repr.

1992. New York, Solomon R. Guggenheim Museum.

REFERENCES
Bouvier, M. *Aristide Maillol*. Lausanne, 1945, pp. 118–19, repr.

Solomon R. Guggenheim Museum. 1972, p. 36, repr. (ca. 1900–05).

Johnson, U. E. *Ambroise Vollard Editeur*. New York, 1944, pp. 40, 102, and 195, no. 97.

Musée Départemental des Beaux-Arts, Yamanashi, Japan. *Exposition Maillol au Japon*. Exh. cat., 1984, p. 194, repr., no. S-51 (Alexis Rudier no. 1/6, 1930, Fondation Dina Vierny, Musée Maillol, Paris).

EDOUARD MANET
1832–1883

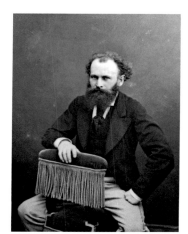

Edouard Manet, ca. 1866, photographed by Félix Nadar.

Edouard Manet was born on January 23, 1832, in Paris. While studying with Thomas Couture from 1850 to 1856, he drew at the Académie Suisse and copied the Old Masters at the Musée du Louvre. After he left Couture's studio, Manet traveled extensively in Europe, visiting Belgium, the Netherlands, Germany, Austria, and Italy. In 1859 he was rejected by the official Paris Salon, although Eugène Delacroix intervened on his behalf. In 1861 Manet's paintings were accepted by the Salon and received favorable press, and he began exhibiting at the Galerie Martinet in Paris. During the early 1860s his friendships with Charles Baudelaire and Edgar Degas began. The three paintings Manet sent to the Salon of 1863, including *Le Déjeuner sur l'herbe* (see p. 37), were relegated to the Salon des Refusés, where they attracted the attention of the critic Théophile Thoré.

In 1865 Manet's *Olympia* and *Christ Mocked* were greeted with great hostility when shown at the Salon. That year the painter traveled to Spain, where he met Théodore Duret. He became a friend of Emile Zola in 1866, when the writer defended him in a controversial article for the periodical *L'Evènement*. In 1867 Zola published a longer article on Manet, who that year exhibited his work in an independent pavilion at the Paris World's Fair. The artist spent the first of several summers in Boulogne at this time. In 1868 two of his works were accepted by the Salon but were not shown to advantage.

The dealer Paul Durand-Ruel began buying his work in

1872. That same year *The Battle of the Kearsarge and the Alabama* was shown at the Salon, and Manet traveled to the Netherlands for the second time. The poet Stéphane Mallarmé, who met the artist in 1873, wrote articles about him in 1874 and 1876 and remained a close lifelong friend. Manet declined to show with the Impressionists in their first exhibition in 1874. That summer he worked at Gennevilliers and Argenteuil with Claude Monet and the following year he visited Venice. In 1876 he exhibited *Olympia* and two paintings rejected that year by the Salon at his own studio. From 1879 to 1882 Manet participated annually at the Salon. In 1880 he was given a solo exhibition at Georges Charpentier's new gallery, La Vie Moderne, Paris. In 1881 Manet, then ailing, was decorated with the Légion d'Honneur. He died on April 30, 1883, in Paris. A memorial exhibition of his work took place at the Ecole des Beaux-Arts the following year.

17.

BEFORE THE MIRROR
(DEVANT LA GLACE)
1876

Oil on canvas, 92.1 x 71.4 cm (36 ¼ x 28 ⅛ inches)
Thannhauser Collection, Gift, Justin K. Thannhauser
78.2514.27

Signed lower right: Manet
Not dated.

PROVENANCE

Inventory of the contents of Manet's studio on Dec. 28, 1883, no. 20; acquired at Hôtel Drouot sale, Paris, Feb. 4–5, 1884, by Dr. Albert Robin; purchased from Robin, Feb. 1901, by Bernheim-Jeune; sold jointly to Durand-Ruel and

Cassirer, Mar. 1901; purchased from Cassirer by Durand-Ruel, Paris, Dec. 1902; sold to Durand-Ruel, New York, Jan. 1903; bought back by Durand-Ruel, Paris, Jan. 1910; acquired again by Durand-Ruel, New York, Aug. 1916; sold to Joseph F. Flanagan, Apr. 1917; purchased by American Art Association, New York, Feb. 1920; sent to Carl O. Nielsen, Feb. 1923; belonged to J. K. Thannhauser by 1927.

CONDITION

This painting was lined with an aqueous adhesive at an unknown date prior to 1965. In 1990 the painting was cleaned and revarnished. X-radiographs and photographs of an infrared videcon image taken at this time suggest that Manet moved the position of the model's proper right hand and arm from below her corset across to the right, its present position (Mar. 1992).

EXHIBITIONS

1880. Paris, Galerie de la Vie Moderne. *Exposition des oeuvres nouvelles d'Edouard Manet.* Apr. 10–30. No. 8 (*Devant la glace*).

1884. Paris, Hôtel Drouot. *Succession Edouard Manet.* Feb. 2–3. No. 43 (*Devant la glace*).

1910. Vienna, Galerie Miethke. *Manet-Monet.* May. No. 6, repr. (*Vor dem Spiegel*).

1916. New York, Durand-Ruel. *Exhibition of Paintings and Pastels by Edouard Manet and Edgar Degas.* Apr. 5–29. No. 2.

1920. New York, Durand-Ruel. *Exhibition of Paintings by Modern French Masters.* Apr. 18–24. No. 7 (*Devant la psyché*).

1927. Berlin, Künstlerhaus (organized by Galerien Thannhauser, Berlin). *Erste*

Sonderausstellung in Berlin. Jan. 9–Feb. 15. No. 146, repr. (*Vor dem Spiegel*).

1961. San Antonio, The Marion Koogler McNay Art Institute. *Paintings from the Justin K. Thannhauser Foundation.* June 15–Sept. 11. No. iii, repr.

1965. New York, Solomon R. Guggenheim Museum. P. 16, no. 4, color repr.

1978. New York, Solomon R. Guggenheim Museum.

1983. Paris, Galeries Nationales du Grand Palais, *Manet: 1832–1883,* Apr. 22–Aug. 8, Traveled to New York, The Metropolitan Museum of Art, Sept. 10–Nov. 27. Exh. cats. (French and English), pp. 390–92, cat. no. 156, color repr. (1876–77).

1987–88a. New York, Solomon R. Guggenheim Museum. No. 2, color repr.

1990. New York, Solomon R. Guggenheim Museum.

1990. Venice, Palazzo Grassi. Pp. 92–93, no. A19, color repr.

1992. The Montreal Museum of Fine Arts. Pp. 58–59, no. 2, color repr.

1992. New York, Solomon R. Guggenheim Museum.

REFERENCES

Adler, K. *Manet.* Oxford, 1986, pp. 220–21, no. 215, repr., and p. 235.

American Art Association, New York. *Catalogue of Highly Important Old and Modern Paintings belonging to . . . Mr. Joseph F. Flanagan, Boston.* Sale cat., Jan. 14–15 1920, no. 65, repr. (*Devant la psyché*).

Bodelsen, M. "Early Impressionist Sales 1874–94." *The Burlington Magazine,* vol. CX, June 1968, p. 342.

Burger, F. *Einführung in die Moderne Kunst*. Berlin, 1917, vol. I, p. 96, repr.

Cachin, F. *Manet*. Chêne, 1990, pp. 122–23, no. 5, color repr., and p. 158 (*Devant la glace*).

Daix, P. *La vie de peintre d'Edouard Manet*. Paris, 1983, pp. 274 and 303, fig. 43 (1877).

Darragon, E. *Manet*. Paris, 1989, p. 281.

Daulte, F. "Une Donation sans précédent: la collection Thannhauser." *Connaissance des Arts*, no. 171, May 1966, pp. 62–63, color repr. (*Devant la glace*).

Düchting, H. *Edouard Manet: Images of Parisian Life*. Trans. Michael Robertson. Munich and New York, 1995, pp. 56–57, color repr., pp. 58, 60, and 126.

Duret, T. *Edouard Manet et son oeuvre*. Paris, 1902, p. 246, no. 213 (*La Toilette devant la glace*).

———. *Manet and the French Impressionists*. Trans. J. E. C. Flitch. London, 1912, p. 238, no. 213.

———. *Histoire de Manet et de son oeuvre avec un catalogue des peintures et des pastels*. Fourth ed. Paris, 1926, p. 266, no. 213 (*La Toilette devant la glace*).

Fleischer, V. "Ausstellungen." *Der Cicerone*, jg. II, 1910, p. 369 (*Vor dem Spiegel*).

Gottlieb, C. "Picasso's *Girl Before a Mirror*." *Journal of Aesthetics and Art Criticism*, vol. XXIV, summer 1966, p. 517, fn. 15.

Solomon R. Guggenheim Museum. 1972, p. 11, repr.

Guggenheim Museum. 1992, p. 163, color repr.

Guggenheim Museum. 1993, p. 84, pl. 9.

Hanson, A. C. *Manet and the Modern Tradition*. New Haven and London, 1977, p. 101, fn. 213.

Hofmann, W. *Nana: Mythos und Wirklichkeit*. Cologne, 1973, pp. 18, 89, 177, and 194, and pl. 25 (*Frau vor dem Spiegel*).

Isaacson, J. "Impressionism and Journalistic Illustration." *Arts*, vol. 56, no. 10, June 1982, p. 115, fn. 86.

Jamot, P., G. Wildenstein, and M. Bataille. *Manet*. Paris, 1932, vol. I, pp. 107 and 154, no. 278, and vol. II, fig. 85 (*Devant la glace*, ca. 1877).

Körner, H. *Edouard Manet: Dandy, Flaneur, Maler*. Munich, 1996, p. 189, pl. 160 (*Vor dem Spiegel*, 1876–77).

Lallemand, H. *Manet: A Visionary Impressionist*. New York, 1994, p. 50, color repr.

Meier-Graefe, J. *Entwicklungsgeschichte der Modernen Kunst*. Stuttgart, 1904, vol. III, p. 56, repr. (*Devant la psyché*).

———. *Edouard Manet*. Munich, 1912, p. 321 and pl. 187.

———. "Die Franzosen in Berlin." *Der Cicerone*, jg. XIX, Jan. 1927, p. 50, repr.

Micha, R. "Manet." *Art International*, vol. XXVI, no. 3, July–Aug. 1983, p. 6 (*Devant la glace*, 1876–77).

Monneret, S. "L'Immédiate fraîcheur de la rencontre." *Connaissance des arts*, no. 374, Apr. 1983, pp. 50–51, color repr. (*Devant la glace*, 1877).

Moreau-Nélaton, E. "Catalogue général: peintures et pastels." Manuscript on deposit in the Cabinet des Estampes, Bibliothèque Nationale, Paris, [1906], no. 216 (*Devant la glace*, D. 213).

———. *Manet raconté par lui-même*. Paris, 1926, vol. II, pp. 43, 66–67, 141, fig. 222 (*Devant la glace*, ca. 1877).

Osborn, M. "Klassiker der Französischen Moderne." *Deutsche Kunst und Dekoration*, vol. 59, Mar. 1927, p. 343, repr. (*Vor dem Spiegel*).

Pool, P., and S. Orienti. *The Complete Paintings of Manet*. New York, 1967, p. 105, no. 216, repr. (*Devant la glace* [*In Front of the Mirror*]). French ed.: D. Rouart and S. Orienti, *Tout l'oeuvre peint d'Edouard Manet*, Paris, 1970, p. 105, no. 217, repr. (*Devant la glace*). Italian ed.: M. Venturi and S. Orienti, *L'opera pittorica di Edouard Manet*, Milan, 1967, p. 105, no. 216, repr.

Rey, R. *Manet*. Trans. E. Lucie-Smith. New York, n.d., p. 66, color repr. (1876–77).

Rosenblum, R. "Picasso's *Girl before a Mirror*: Some Recent Reflections." *Source*, vol. I, no. 3, Spring 1982, p. 2, repr., and p. 4.

Ross, N. *Manet's Bar at the Folies-Bergère and the Myths of Popular Illustration*. Ann Arbor, 1982, pp. ix, 49, and pl. 32.

Rouart, D., and D. Wildenstein. *Edouard Manet*. Lausanne and Paris, 1975, vol. I, pp. 212–13, repr., no. 264 (*Devant la glace*, 1877).

Rubin, W., ed. *Picasso and Portraiture: Representation and Transformation*. Exh. cat., The Museum of Modern Art, New York, 1996, pp. 354, 358, repr.

Schneider, P. *The World of Manet 1832–1883*. New York, 1968, pp. 7–11, color repr., and p. 142.

Stuckey, C. F. "Manet." Checklist published in conjunction with exhibition

at the Metropolitan Museum of Art, 1983.

Sutton, D. "Edouard Manet: The Artist as Dandy." *Apollo*, vol. CXVIII, no. 260, Oct. 1983, p. 339 (*Woman and the Mirror*).

Tabarant, A. *Manet: Histoire catalographique*. Paris, 1931, pp. 298–99 and 582, no. 246 (*Devant la glace*).

———. *Manet et ses oeuvres*. Paris, 1947, pp. 290–91, 376, 540, and 611, fig. 255 (*Devant la glace*).

Werner, B. E. "Französische Malerei in Berlin." *Die Kunst für Alle*, jg. 42, Apr. 1927, p. 224, repr.

Wilson-Bareau, Juliet, ed. *Manet by Himself: Correspondence and Conversation, Paintings, Pastels, Prints and Drawings*. London and Boston, 1991, p. 222, pl. 172, and p. 312. (ca. 1876–79).

Zervos, C. "Manet et la femme." *Cahiers d'Art*, 7ᵉ année, nos. 8–10, 1932, p. 331, repr. (*Femme devant le miroir*).

18.

WOMAN IN EVENING DRESS (FEMME EN ROBE DE SOIRÉE)
1877–80

Oil on canvas, 174.3 x 83.5 cm (68 ⅛ x 32 ⅞ inches)
Thannhauser Collection, Gift, Justin K. Thannhauser
78.2514.28

Signed at center left edge, possibly posthumously: Ed Manet
Not dated.

PROVENANCE
Probably retained by Mme. Manet following the artist's death in 1883; Cognacq, Paris, by 1902; purchased from Monteux by Bernheim-Jeune,

Paris, Jan. 6, 1903; Carl Reininghaus, Vienna; J. K. Thannhauser by 1931.

CONDITION
This work is painted on a fine-weave canvas, which was glue lined at an unknown date. The paint was applied very vigorously, and it is in general of a fairly thin to medium thickness. There is a glossy, slightly uneven, and discolored varnish (Aug. 2000).

EXHIBITIONS
1904. Brussels, La Libre Esthétique. *Exposition des peintres Impressionistes*. Feb. 25–Mar. 29. No. 84 (*Portrait de Mlle S. Reichenberg*).

1955. Kansas City, William Rockhill Nelson Gallery of Art. *Summer Exhibition* (*Lady in a Striped Dress*, lent by J. K. Thannhauser).

1965. New York, Solomon R. Guggenheim Museum. P. 18, no. 6, color repr.

1978. New York, Solomon R. Guggenheim Museum.

1987–88a. New York, Solomon R. Guggenheim Museum. No. 3, color repr.

1989. New York, Solomon R. Guggenheim Museum.

1990. New York, Solomon R. Guggenheim Museum.

1990. Venice, Palazzo Grassi. Pp. 94–95, no. A20, color repr.

1992. The Montreal Museum of Fine Arts. Pp. 60–61, no. 3, color repr.

REFERENCES
Adler, K. *Manet*. Oxford, 1986, pp. 195, 197, repr., and p. 235, no. 188 (*Woman in an Evening Gown*, 1880).

Cachin, F. *Manet*. Chêne, 1990, p. 154, no. 12, repr. (*Femme en robe de soirée*, 1878).

Colin, P. *Edouard Manet*. Paris, 1932, pp. 42, 180, and pl. LXV (*Femme en robe de soirée*, 1878).

Duret, T. *Edouard Manet et son oeuvre*. Paris, 1902, p. 250, no. 231 (*Femme en robe de soirée*, Collection Cognacq, Paris).

———. *Manet and the French Impressionists* (Paris, 1902). Trans. J. E. Crawford Flitch. London, 1910, p. 239, no. 231 (1875–77, Collection Cognacq, Paris).

———. *Histoire de Manet et de son oeuvre avec un catalogue des peintures et des pastels*. Fourth ed. Paris, 1926, p. 269, no. 231 (*Femme en robe de soirée*).

Florisoone, M. *Manet*. Monaco, 1947, p. 79, repr., and p. 101 (*Femme en robe de soirée {Suzanne Reichenberg}*, 1879).

Solomon R. Guggenheim Museum. 1972, p. 12, repr. (1878).

Guggenheim Museum. 1992, p. 163, color repr.

Guggenheim Museum. 1993, p. 89, pl. 12.

Jamot, P., G. Wildenstein, and M. Bataille. *Manet*. Paris, 1932, vol. I, p. 161, no. 331, and vol. II, fig. 138 (*Femme en robe de soirée*, 1879, Galerie Thannhauser).

Moreau-Nélaton, E. "Catalogue général: peintures et pastels." Manuscript on deposit in the Cabinet des Estampes, Bibliothèque Nationale, Paris [1906], no. 257 (*Jeune femme à l'écran*, 180 x 85 cm, D. 231).

Pool, P., and S. Orienti. *The Complete Paintings of Manet*. New York, 1967, p. 108, no. 246A, repr. (*Femme en Robe de Soirée* [*Woman in Evening Dress*], 1878). French ed.: D. Rouart and S. Orienti, *Tout l'oeuvre peint d'Edouard Manet*, Paris, 1970, pp. 108–09,

no. 247A, repr. (*Femme en robe de soirée*, 1878). Italian ed.: M. Venturi and S. Orienti, *L'opera pittorica di Edouard Manet*. Milan, 1967, p. 108, no. 246, repr. (1878).

Rouart, D., and D. Wildenstein. *Edouard Manet*. Lausanne and Paris, 1975, vol. I, pp. 262–63, no. 341, repr. (*Femme en robe de soirée {Suzanne Reichenberg?}*, 1880).

Stuckey, C. F. "Manet Revised: Whodunit?" *Art in America*, vol. 71, no. 10, Nov. 1983, pp. 163 and 165, repr. (photograph of painting before cropping).

Tabarant, A. *Manet: Histoire catalographique*. Paris, 1931, pp. 322–23 and 583, no. 272 (*Femme en Robe de soirée*, 1878, Galerie Thannhauser, Berlin-Lucerne).

————. *Manet et ses oeuvres*. Paris, 1947, pp. 322–23, 541, and 612, fig. 288 (*Femme en robe de soirée*, 1878).

Zervos, C. "Manet et la femme." *Cahiers d'Art*, 7e année, nos. 8–10, 1932, p. 331, repr. (*Femme en robe de soirée*).

19.
PORTRAIT OF COUNTESS ALBAZZI (PORTRAIT DE LA COMTESSE ALBAZZI)
1880

Pastel on primed canvas, 56.5 x 46.5 cm (22 ¼ x 18 ⅛ inches)
Thannhauser Collection, Bequest, Hilde Thannhauser
91.3909

Signed bottom center: M
Inscribed on reverse, not by the artist: fait à Trouville en Bretagne / Comtesse Iza Albazzi / née de Kwiatowska
Not dated.

PROVENANCE
Given by the artist to George Moore, London/Paris; purchased by Countess Albazzi for her friend Lord Grimpthorpe at Moore's auction sale, May 12, 1906; Ernest Béchet, London, 1910; Mrs. M. Oppenheim, Wannsee, Berlin, until 1936; J. K. Thannhauser, 1936; Hilde Thannhauser, Bern, 1976–91.

CONDITION
This work is executed on very fine canvas, which is stretched over a five-member wooden wedged stretcher with keys. The priming is an off-white, yellowish preparation estimated to be oil. There is a cooler-toned ground over the priming. The pastel is applied both thinly and quite thickly, and it is very friable. There are a number of tiny losses scattered throughout the face, neck, collar, and background (Aug. 1999).

EXHIBITIONS
1884. Paris, Ecole des Beaux-Arts. *Exposition posthume Manet*. Jan. No. 133 (*Bes. Ctsse. Albizzi* [sic]).

1978. Kunstmuseum Bern. P. 59, cat. no. 21, color repr., and p. 109, no. 21 (*Portrait de la Comtesse Iza Albazzi, née de Kwiatowska*).

1996. Martigny, Switzerland, Fondation Pierre Gianadda. *Manet*. June 5–Nov. 11. Cat. no. 59, pp. 122–23, color repr., and p. 198 (*Portrait de la comtesse Albazzi*).

REFERENCES
Duret, T. *Edouard Manet et son oeuvre*. Paris, 1902, p. 254, no. 19 (*La Comtesse D'Albazzi*).

————. *Manet and the French Impressionists* (Paris, 1902). Trans. J. E. Crawford Flitch. London, 1910, p. 266, no. 19 (*La Comtesse D'Albazzi*).

————. *Histoire de Edouard Manet et de son oeuvre avec un catalogue des peintures et des Pastels*. Fourth ed. Paris, 1926, p. 288, no. 19 (*La Comtesse Albazzi*).

Jamot, P., G. Wildenstein, and M. Bataille. *Manet*. Paris, 1932, vol. I, p. 172, no. 441, and vol. II, p. 130, fig. 240 (*La Comtesse Albazzi*).

Moore, G. *Memoirs of My Dead Life*. London, 1906, pp. 60–61.

Moreau-Nélaton, E. *Manet raconté par lui-même*. Paris, 1926, vol. II, pp. 64, 141, and figs. 252 and 351 (*La Comtesse Albazzi*, ca. 1880).

Pool, P., and S. Orienti. *The Complete Paintings of Manet*. New York, 1967, p. 116, no. 361, repr. (*Portrait de la Comtesse 'Iza' Kwiatowska Albazzi* [*Portrait of the Comtesse 'Iza' Kwiatowska Albazzi*], 1881). French ed.: D. Rouart and S. Orienti, *Tout l'oeuvre peint d'Edouard Manet*, Paris, 1970, pp. 116–17, no. 365, repr. (*Portrait de la Comtesse "Iza" Kwiatowska Albazzi*, 1881). Italian ed.: M. Venturi and S. Orienti, *L'opera pittorica di Edouard Manet*. Milan, 1967.

Rouart, D., and D. Wildenstein. *Edouard Manet*. Lausanne and Paris, 1975, vol. II, no. 35, repr.

Severini, G. *Edouard Manet*. Rome, 1924, fig. 28 (*Woman with Chinese Head-Dress*). French ed.: (*Femme coiffé à la chine*).

Tabarant, A. *Histoire catalographique*. Paris, 1931, pp. 479–80 and 589, no. 44 (*Portrait de la Comtesse Albazzi*, 1881, coll. anglaise [Lord G.]).

————. *Manet et ses oeuvres*. Paris, 1947, pp. 427–28, 547, 618, fig. 507 (*Portrait de la comtesse Albazzi*, 1881).

Henri Matisse drawing a model at no. 1, place Charles-Félix, Nice, ca. 1927–28.

HENRI MATISSE

1869–1954

Henri-Emile-Benoît Matisse was born on December 31, 1869, in Le Cateau–Cambrésis, France. He grew up at Bohain-en-Vermandois and studied law in Paris from 1887 to 1888. By 1891, he had abandoned law and started to paint. In Paris, Matisse studied art briefly at the Académie Julian and then at the Ecole des Beaux-Arts with Gustave Moreau.

In 1901, Matisse exhibited at the Salon des Indépendants in Paris and met another future leader of the Fauve movement, Maurice de Vlaminck. His first solo show took place at the Galerie Vollard in 1904. Both Leo and Gertrude Stein, as well as Etta and Claribel Cone, began to collect Matisse's work at that time. Like many avant-garde artists in Paris, Matisse was receptive to a broad range of influences. He was one of the first painters to take an interest in "primitive" art. Matisse abandoned the palette of the Impressionists and established his characteristic style, with its flat, brilliant color and fluid line. His subjects were primarily women, interiors, and still lifes. In 1913, his work was included in the Armory Show in New York. By 1923, two Russians, Sergei Shchukin and Ivan Morosov, had purchased nearly 50 of his paintings.

From the early 1920s until 1939, Matisse divided his time primarily between the South of France and Paris. During this period, he worked on paintings, sculptures, lithographs, and etchings, as well as on murals for the Barnes Foundation, Merion, Pennsylvania, designs for tapestries, and set and costume designs for Léonide Massine's ballet *Rouge et noir*. While recuperating from two major operations in 1941 and 1942, Matisse concentrated on a technique he had devised earlier: *papiers découpés* (paper cutouts). *Jazz*, written and illustrated by Matisse, was published in 1947; the plates are stencil reproductions of paper cutouts. In 1948, he began the design for the decoration of Chapelle du Rosaire at Vence, which was completed and consecrated in 1951. The same year, a major retrospective of his work was presented at the Museum of Modern Art, New York, and then traveled to Cleveland, Chicago, and San Francisco. In 1952, the Musée Matisse was inaugurated at the artist's birthplace of Le Cateau–Cambrésis. Matisse continued to make large paper cutouts, the last of which was a design for the rose window at Union Church of Pocantico Hills, New York. He died on November 3, 1954, in Nice.

20.

MALE MODEL

(HOMME NU DEBOUT)

ca. 1900

India ink on wove paper, 31.3 x 26.5 cm (12 ⁷⁄₁₆ x 10 ⁷⁄₁₆ inches) Thannhauser Collection, Gift, Justin K. Thannhauser 78.2514.29

Watermark upside down at bottom edge: ADALON-LES-ANNONAY / B CRAYON

Signed lower right: Henri-Matisse
Not dated.

PROVENANCE

Presumably acquired from the artist by Heinz Braune; acquired from Braune by J. K. Thannhauser, Oct. 1929.

CONDITION

The primary support is pasted directly onto a thin paper that is then pasted onto an acidic board. The borders of the primary support (originally white) have darkened unevenly. Despite the poor condition of the paper, the condition of the ink is stable (Aug. 1999).

EXHIBITIONS

1930. Berlin, Galerien Thannhauser. *Henri Matisse.* Feb.–Mar. Probably no. 113 (*Das Modell*).

1965. New York, Solomon R. Guggenheim Museum. P. 38, no. 29, repr.

1978. New York, Solomon R. Guggenheim Museum.

1987–88a. New York, Solomon R. Guggenheim Museum.

1989. New York, Solomon R. Guggenheim Museum.

REFERENCES

The Baltimore Museum of Art. *Matisse as a Draughtsman.* Exh. cat., 1971, pp. 14 and 26.

Barr, A. H., Jr. *Matisse: His Art and His Public.* New York, 1951, p. 44, repr., pp. 48–49 and 531.

Elsen, A. E. *The Sculpture of Henri Matisse.* New York, 1972, p. 27, fig. 30.

Geldzahler, H. "Two Early Matisse Drawings." *Gazette des Beaux-Arts*, vol. LX, Nov. 1962, pp. 497–502, repr. (*Male Nude*, 1900–01).

Solomon R. Guggenheim Museum. 1972, p. 40, repr.

Hadley, R. vN., ed. *Drawings.* Isabella Stewart Gardner Museum, Boston, 1968, p. 59.

Jacobus, J. *Henri Matisse.* New York, 1972, p. 64, fig. 80.

Musée National d'Art Moderne, Paris. *Henri Matisse: Dessins et sculpture.* Exh. cat., 1975, p. 64 (*Homme nu debout*).

Schacht, R. *Henri Matisse*. Dresden, 1922, p. 64, repr. (*Aktstudie*, private collection, Breslau).

Schneider, P., M. Carrà, and X. Deryng. *Tout l'oeuvre peint de Matisse: 1904–1928*. Trans. S. Darses. Paris, 1982, p. 85, repr., and p. 86, no. 13A.

Selz, J. *Matisse*. Trans. A. P. H. Hamilton. New York, 1964, p. 8, repr. (*Model*).

21.
WOMAN BEFORE MIRROR
(JEUNE FEMME DEVANT UN MIROIR)
November 1939

India ink on wove paper, 38.1 x 28.3 cm (15 x 11 ⅛ inches)
Thannhauser Collection, Gift, Justin K. Thannhauser
78.2514.30

No watermark.

Signed and dated lower left: Henri Matisse nov. 39

PROVENANCE
Purchased from Mrs. Cramer, Paris, by H. C. Goldsmith, 1951; purchased from Goldsmith by J. K. Thannhauser, 1952.

CONDITION
This work is in good condition. The support is cockling slightly, and the left edge is slightly yellowed. The conditions of both the paper and the ink are otherwise stable (Aug. 1999).

EXHIBITIONS
1955. Kansas City, William Rockhill Nelson Gallery of Art. *Summer Exhibition* (label on reverse reads: *Woman Before a Mirror*; incorrectly dated 1954, lent by J. K. Thannhauser).

1965. New York, Solomon R. Guggenheim Museum. P. 65, no. 60, repr.

1978. New York, Solomon R. Guggenheim Museum.

1989. New York, Solomon R. Guggenheim Museum.

REFERENCES
Solomon R. Guggenheim Museum. 1972, p. 41, repr.

Malingue, M. *Matisse: Dessins*. Paris, 1949, pp. 14 and 18, repr. (*Dessin à l'encre de chine*).

CLAUDE MONET
1840–1926

Oscar-Claude Monet was born on November 14, 1840, in Paris. He spent his childhood in the Normandy coast town of Le Havre, where his father prospered as a grocer and ship chandler. Monet was an indifferent student, making a career out of beach explorations and ornamenting his school ledgers with caricatures of his teachers. These caricatures brought him local renown, and by the age of fifteen he was exhibiting and selling satirical drawings in the town. Two years later the landscape artist Eugène Boudin introduced him to plein-air painting, which allowed him to merge his penchant for the outdoors with his drafting acumen. He began to produce increasingly ambitious and naturalistic work.

In 1859 Monet moved to Paris, where he attended the Académie Suisse beginning in 1860. The following year, when it appeared likely that he would be called up for military service, he chose (possibly under the romantic influence of Eugène Delacroix's Orientalist idylls) to enlist in a cavalry regiment destined for Algeria. Within a year he was ill with typhoid, and an aunt paid his way out of his contractual

obligation. While convalescing in Le Havre, he worked in the plein-air mode alongside Boudin and Dutch painter Johan Barthold Jongkind. In 1862 he returned to Paris to enroll in the studio of Charles Gleyre, where his fellow students included Frédéric Bazille, Pierre Auguste Renoir, and Alfred Sisley. Despite some success in 1865, when two of his works were exhibited at the Salon, by 1867 financial difficulties forced Monet to return to his family in Le Havre, leaving his pregnant companion, Camille-Léonie Doncieux, in Paris, where she gave birth to their son Jean on August 8. Over the following years, the couple lived together in Gloton and Saint-Michel—where Monet painted in tandem with Renoir—and were married in 1870. Soon after, in response to the Franco-Prussian War, they left for London, where Monet met the dealer Paul Durand-Ruel, who would later become his dealer and a champion of Impressionism. On their return to France, Monet and his family settled in Argenteuil at the end of 1871.

In 1874, having banded together with other artists to form the Société Anonyme des Artistes, Monet submitted his painting *Impression, Sunrise* (1872, Musée Marmottan, Paris) to the group's first exhibition. The work, grounded in sensation and causing one as well, gave a name to the burgeoning movement, when the critic Louis Leroy lampooned the group as "impressionists," a term the artists themselves soon adopted without satirical inflection. Eighteen of Monet's paintings were included in the second Impressionist exhibition in

Claude Monet, 1899, photographed by Paul Nadar.

1876, and thirty in the third exhibition the following year.

In 1878, with financial troubles looming and his wife gravely ill after the birth of their second son, Michel, the Monets embarked on an unorthodox joint household arrangement in Vétheuil with the family of former patron Ernest Hoschedé, who soon moved to Paris after declaring bankruptcy. The following year Camille succumbed to her illness. Monet and Alice Hoschedé continued to live together, waiting until Ernest Hoschedé died before marrying in 1892. Monet continued to exhibit with the Impressionists on an irregular basis, choosing also to show his work at the Salon in 1880, in a solo exhibition at Galerie Durand-Ruel in Paris in 1883, and at several of Georges Petit's Expositions Internationales de Peinture. He continued his peripatetic existence, moving to Giverny in 1883, then traveling to Brittany and later to Antibes. In 1889 Galerie Georges Petit staged a major retrospective of his work, showing 145 of his paintings. Two years later Durand-Ruel mounted an exhibition of Monet's first series paintings, his *Grainstacks*, which met with great critical acclaim. The artist continued his exploration of series with his paintings of poplars and of Rouen Cathedral, documenting in a succession of canvases subtle shifts in light or focus.

By 1890 Monet was financially secure enough to purchase the house at Giverny, later adding adjacent land and installing both the water-lily garden and Japanese bridge he would famously paint in series. Between 1899 and 1901 he made three trips to London to paint

views of the Thames. Over the next decade he completed more series studies of the lily garden at Giverny, which he continued to enlarge, and traveled with Alice to Madrid and Venice. Alice's death in 1911 was succeeded by that of his elder son in 1914. The following year Monet began work on an expansive new garden studio, in which he would fabricate his *Grandes-Décorations*, the large-scale water-lily series that would occupy him until his death. He made plans to turn a large number of these works over to the State, to be housed in specially built galleries in the Paris Orangerie. The installation of twenty-two paintings opened to the public in May 1927, five months after his death, at the age of eighty-six, on December 5, 1926, in Giverny.

22.
THE PALAZZO DUCALE, SEEN FROM SAN GIORGIO MAGGIORE
(LE PALAIS DUCAL VU DE SAINT-GEORGES MAJEUR)
1908

Oil on canvas, 65 x 100.5 cm (25 9/16 x 39 9/16 inches)
Thannhauser Collection, Bequest, Hilde Thannhauser
91.3910

Signed and dated lower right: Claude Monet 1908

PROVENANCE
Wildenstein and Co., New York, by 1928; Galerien Thannhauser, Berlin, 1928; J. K. Thannhauser; Hilde Thannhauser, Bern, 1976–91.

CONDITION
This work is oil painted on a delicate, tightly woven linen canvas. The commercial ground has a gray tone, and there is a greenish-gray preparation layer

in the foreground. The image is built up with numerous layers of color. It is in good condition overall, except for fragile tacking margins. An inappropriate, yellowed varnish was removed in 1994. In order to give the fragile canvas additional support and to reinforce the tacking edges, it was taken off the stretcher and the edges were mended. A strip lining was applied to the edges and a loose lining stretched on the original stretcher before the painting was restretched (Aug. 1999).

EXHIBITIONS
1928. Berlin, Galerien Thannhauser. *Claude Monet, 1840–1926: Gedächtnis-Ausstellung*. Feb.–mid-Mar. P. 61, cat. no. 68, repr. (*Venedig, Canale Grande*).

1939. Buenos Aires, Museo Nacional de Bellas Artes. *La pintura francesa de David a nuestros días*. July–Aug. Traveled to Montevideo, Ministerio de Instrucción Pública, Apr.–May 1940; Rio de Janeiro, Museu Nacional de Belas Artes, June 29–Aug. 15, 1940; San Francisco, M. H. De Young Memorial Museum (*The Painting of France Since the French Revolution*), Dec. 1940–Jan. 1941 and Nov. 1941–Jan. 1942 (no. 80 [*View of Venice*]); and Los Angeles County Museum (*The Painting of France Since the French Revolution*), June–July 1941 (no. 101 [*View of Venice*]).

1941. The Art Institute of Chicago. *Masterpieces of French Art*. Apr. 10–May 20. No. 117 (*View of Venice*).

1942–46. Washington, D.C., The National Gallery of Art. On loan. Feb. 1942–July 1946.

1953. San Francisco Museum of Art. *Art in the Twentieth Century: Commemorating the Tenth Anniversary of the Signing of the United Nations Charter.* June 17–July 10. P. 15 (*Venice*).

1960. New York, The Museum of Modern Art. *Claude Monet: Seasons and Moments.* Mar. 9–May 15. No. 93. Traveled to the Los Angeles County Museum, June 14–Aug. 7.

1961. San Antonio, The Marion Koogler McNay Art Institute. *Paintings from the Justin K. Thannhauser Foundation.* June 15–Sept. 11. No. VI, repr.

1978. Kunstmuseum Bern. P. 63, cat. no. 24, color repr., and p. 109, no. 24 (*Venise*).

1997. Fort Worth, Kimbell Art Museum. *Monet and the Mediterranean.* June 8–Sept. 7. Pp. 152 and 155, no. 82, color repr. Traveled to Brooklyn Museum of Art, Oct. 10, 1997–Jan. 4, 1998.

REFERENCES

Jullian, R. *Les impressionnistes français et l'Italie.* Florence and Paris, 1968, 1st series, section II, no. 11, p. 19.

Mirbeau, O. "Les Venise de Claude Monet." *L'Art moderne,* June 2, 1912, pp. 167–68.

Piguet, P. *Monet et Venise.* Paris, 1986, p. 80, fig. 13 (*Le Palais Ducal vu de Saint-Georges Majeur*).

Seiberling, G. *Monet's Series.* New York and London, 1981, pp. 210 and 380, no. 14.

Wildenstein, D. *Claude Monet.* Lausanne and Paris, 1985, vol. IV, pp. 240–41, no. 1756, repr. Rev. ed.: Cologne and Paris, 1996, vol. IV, pp. 822–23, no. 1756, repr. (*Le Palais ducal vu de Saint-Georges Majeur*).

JULES PASCIN

1885–1930

Jules Pascin was born Julius Mordecai Pincas on March 31, 1885, in Vidin, Bulgaria. He left Bulgaria in 1902 for Vienna, and by 1904 was studying at the Heymann Art School in Munich. He made a monthly sum by contributing cartoons to the German periodicals *Jugend* and *Simplicissimus*, the latter of which was known for its satirical drawings. His submissions honed his approach to figure drawing, which would become his forté. The artist started signing his name Pascin in 1905, apparently to save his family the embarrassment associated with his unconventional lifestyle. In December 1905 he moved to Paris and began frequenting the Café du Dôme with artists such as George Grosz and Rudolf Lévy. The focus of his output was the bohemian life of cafés and brothels.

The year 1907 marked a turning point for Pascin: he met Hermine David, an art student (whom he would marry in 1918), and he had his first solo exhibition, at the Berlin gallery of Paul Cassirer, who helped establish the reputation of the Impressionists and early Expressionists. In 1911 (the year he drew Lévy and Justin Thannhauser at the Café du Dôme), he participated in the Berlin Secession exhibition at the Austellungshaus am Kurfürstendamm. Two years later he was represented by twelve works in the Armory Show in New York. In 1914 Pascin traveled to London to avoid the draft and from there to New York, where he associated with artists such as Walt Kuhn, Alfred Stieglitz, and Max Weber. He traveled in the southern United States and

to Cuba. Pascin's first solo exhibition in the United States was held in 1915 at the Berlin Photographic Company in New York. Shortly after becoming an American citizen in 1920, he moved back to Paris, where he showed with Berthe Weill and Georges Bernheim.

Depressed by the unfavorable reviews of an exhibition of his work at Knoedler Galleries in New York (including one by his close friend Henry McBride), Pascin committed suicide in Paris on June 2, 1930. On the day of his funeral, all galleries in Paris closed in his honor.

Jules Pascin.

23.
JUSTIN K. THANNHAUSER AND RUDOLF LÉVY PLAYING CARDS
(JUSTIN K. THANNHAUSER ET RUDOLF LÉVY JOUANT AUX CARTES)
December 24, 1911

India ink and colored pencil on paper, 23 x 29 cm (9 ⅟₁₆ x 11 ⅞₁₆ inches)
Thannhauser Collection, Bequest, Hilde Thannhauser 91.3911

Verso: sketch with figures

Signed, dated, and inscribed upper right, possibly by the artist: Justin Thanhauser [sic] vor Ankunft / des Christkindls 1911 / Pascin / Café du Dôme

PROVENANCE
Christmas present from the artist to J. K. Thannhauser, 1911; Hilde Thannhauser, Bern, 1976–91.

CONDITION
The acidic paper support is considerably darkened, and the original ink has probably changed in tone somewhat. There is some cockling near the top left corner and small stains all along the left edge. The

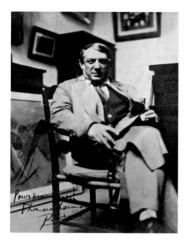

Pablo Picasso, May 1933. Inscribed:
Pour mon ami / Thannhauser / Picasso.

paper appears brighter than in the rest of the sheet in a small area next to the bottom right corner. In the upper center, an inscription in ink on the reverse side shows through the front of the work (Aug. 1999).

EXHIBITIONS

1965. Duisburg, Wilhelm-Lehmbruck-Museum der Stadt Duisburg. *Pariser Begegnungen, 1901–1914: Café du Dôme, Académie Matisse, Lehmbrucks Freundeskreis.* Oct. 16–Nov. 28. No. 326, repr. (*Justin K. Thannhauser und Levy im Café du Dôme*).

1966. Berkeley, University Art Museum, University of California. *Pascin.* Nov. 15–Dec. 18. No. 79, repr. Traveled to Art Galleries, University of California, Los Angeles, Jan. 4–Feb. 5, 1967; Ackland Art Center, University of North Carolina at Chapel Hill, Feb. 19–Mar. 19, 1967; Rose Art Museum, Brandeis University, Waltham, Mass., Apr. 3–30, 1967; and Whitney Museum of American Art, New York, May 17–June 25, 1967.

1978. Kunstmuseum Bern. P. 64, cat. no. 26, repr., and p. 110, no. 26 (*Justin K. Thannhauser et Rudolf Lévy jouant aux cartes*).

REFERENCES

"Ausstellung der Sammlung Justin Thannhauser im Kunstmuseum Bern (Ansprache von Herrn Botschafter Paul R. Jolles bei der Eröffnung der Ausstellung am 7. Juni 1978)." *Berner Kunstmitteilungen*, no. 184, Aug.–Sept. 1978, p. 2.

Werner, A. *Pascin*. New York, 1959, no. 29, repr. (*Justin K. Thannhauser and Rudolf Levy Playing Poker*).

———. *Pascin, 110 Drawings.* New York, 1972, p. xii.

PABLO PICASSO
1881–1973

Pablo Ruiz Picasso was born on October 25, 1881, in Málaga, Spain. The son of an academic painter, José Ruiz Blanco, he began to draw at an early age. In 1895, the family moved to Barcelona, and Picasso studied there at La Lonja, the academy of fine arts. His visit to Horta de Ebro from 1898 to 1899 and his association with the group at the café Els Quatre Gats about 1899 were crucial to his early artistic development. In 1900, Picasso's first exhibition took place in Barcelona, and that fall he went to Paris for the first of several stays during the early years of the century. Picasso settled in Paris in April 1904, and soon his circle of friends included Guillaume Apollinaire, Max Jacob, Gertrude and Leo Stein, as well as two dealers, Ambroise Vollard and Berthe Weill.

His style developed from the Blue Period (1901–04) to the Rose Period (1905) to the pivotal work *Les Demoiselles d'Avignon* (1907), and the subsequent evolution of Cubism from an Analytic phase (ca. 1908–11), through its Synthetic phase (beginning in 1912–13). Picasso's collaboration on ballet and theatrical productions began in 1916. Soon thereafter, his work was characterized by neoclassicism and a renewed interest in drawing and figural representation. In the 1920s, the artist and his wife, Olga (whom he had married in 1918), continued to live in Paris, to travel frequently, and to spend their summers at the beach. From 1925 into the 1930s, Picasso was involved to a certain degree with the Surrealists, and from the fall of 1931 he was especially interested

in making sculpture. In 1932, with large exhibitions at the Galeries Georges Petit, Paris, and the Kunsthaus Zürich, and the publication of the first volume of Christian Zervos's catalogue raisonné, Picasso's fame increased markedly.

By 1936, the Spanish Civil War had profoundly affected Picasso, the expression of which culminated in his painting *Guernica* (1937). Picasso's association with the Communist Party began in 1944. From the late 1940s, he lived in the South of France. Among the enormous number of Picasso exhibitions that were held during the artist's lifetime, those at the Museum of Modern Art, New York, in 1939 and the Musée des Arts Décoratifs, Paris, in 1955 were most significant. In 1961, the artist married Jacqueline Roque, and they moved to Mougins. There Picasso continued his prolific work in painting, drawing, prints, ceramics, and sculpture until his death April 8, 1973.

24.
THE END OF THE ROAD
(AU BOUT DE LA ROUTE)
1898–99

Oil washes and conté crayon on laid paper, 47.1 x 30.8 cm (18 9⁄16 x 12 1⁄8 inches)
Thannhauser Collection, Gift, Justin K. Thannhauser
78.2514.33

Watermark of a crown above a shield upon which appears diagonally: JOHANNOT

Signed lower right: P. Ruiz Picasso
Not dated.

PROVENANCE

Unidentified private collection, Barcelona; J. K. Thannhauser by 1957.

EXHIBITIONS

1957. New York, The Museum of Modern Art. *Picasso: 75th Anniversary Exhibition.* May 22–Sept. 8. P. 14, repr. (*Redemption*, 1898 [?]). Traveled to the Art Institute of Chicago, Oct. 29–Dec. 8.

1958. Philadelphia Museum of Art. *Picasso.* Jan. 8–Feb. 23. No. 1, repr. (*Redemption*, ca. 1898).

1960. New York, The Museum of Modern Art. *Art Nouveau: Art and Design at the Turn of the Century.* June 6–Sept. 6. No. 222, repr. Traveled to Pittsburgh, Carnegie Institute Museum of Art, Oct. 13–Dec. 12; Los Angeles County Museum, Jan. 17–Mar. 5, 1961; and the Baltimore Museum of Art, Apr. 1–May 15, 1961.

1965. New York, Solomon R. Guggenheim Museum. P. 36, no. 27, color repr.

1978. New York, Solomon R. Guggenheim Museum.

1981. Cambridge, Mass., Fogg Art Museum. *One Hundred Master Drawings by Picasso.* Feb. 20–Apr. 15. Pp. 34–35, no. 3, repr. (1898). Traveled to the Art Institute of Chicago, Apr. 29–June 14, and Philadelphia Museum of Art, July 11–Aug. 23.

1986. New York, Solomon R. Guggenheim Museum, p. 4.

1987–88a. New York, Solomon R. Guggenheim Museum.

1989. New York, Solomon R. Guggenheim Museum.

1990. New York, Solomon R. Guggenheim Museum.

1990. Venice, Palazzo Grassi. Pp. 96–97, no. A21, color repr.

1992. New York, Solomon R. Guggenheim Museum.

1997. Washington, D.C., National Gallery of Art. P. 111, cat. no. 23, color repr. (1899–1900). Shown at Washington venue only.

1998. Deutsche Guggenheim Berlin. Pp. 164–65, no. 61, color repr. (*Am Ende der Strasse*). English ed.: pp. 164–65, no. 61, color repr. Spanish ed.: pp. 190–91, no. 71, color repr. (*El final del camino*).

REFERENCES

Arnason, H. H. *History of Modern Art.* New York, 1968, pp. 117–18, fig. 187.

Barnett. 1980, pp. 50–51, no. 13, repr.

Blunt and Pool. 1962, p. 30, pl. 64, and back cover, repr. (1898).

Daix. 1977, pp. 29 and 33, fn. 6.

Daix and Boudaille. 1967, no. I. 2, pp. 22 and 107, repr.

Solomon R. Guggenheim Museum. 1972, p. 44, repr. (ca. 1898).

Kunsthalle Bielefeld. *Picasso: Todesthemen.* Exh. cat., 1984, p. 12, fig. 2, repr. (*Das Ende der Straße*, ca. 1900), p. 283, fig. 29a (*Die letze Wegstrecke*, 1898), repr., and p. 284.

McCully, M. *Els Quatre Gats: Art in Barcelona around 1900.* Princeton, 1978, pp. 37–38, 54–55, fig. 15 (ca. 1899).

Palau i Fabre. 1981, p. 178, no. 370, repr., and pp. 179 and 528 (*The Angel of Death*, 1900).

Richardson, J. *Pablo Picasso: Watercolours and Gouaches.* London, 1964, pp. 16–17, pl. 1 (1898).

————, with M. McCully. *A Life of Picasso: Volume I: 1881–1906.* New York, 1991, pp. 50 and 151, repr. (1900).

Rojas, C. *El mundo mítico y mágico de Picasso.* Barcelona, 1984, pp. 111 and 113, repr. (*El final del camino, El ángel de la muerte*).

Seling, H., ed. *Jugendstil: Der Weg ins 20. Jahrhundert.* Munich, 1959, pp. 29 and 113, and pl. 24 (ca. 1898).

Setford, D. F. *Pablo Picasso: A Vision.* Exh. cat., Norton Gallery of Art, West Palm Beach, Fla., 1994, p. 11, fig. 1.

Zervos. 1969, vol. XXI, no. 79 and pl. 35 (*Le Double Cortège*, 1898).

25.
LE MOULIN DE LA GALETTE
autumn 1900

Oil on canvas, 88.2 x 115.5 cm (34 ¼ x 45 ½ inches) Thannhauser Collection, Gift, Justin K. Thannhauser 78.2514.34

Signed lower right: P. R. Picasso
Not dated.

PROVENANCE

Purchased from Galerie Berthe Weill, Paris, by M. Huc, ca. 1900; Moderne Galerie, Munich, ca. 1909; purchased from Moderne Galerie by Paul von Mendelssohn Bartholdy, Berlin, ca. 1910; purchased from Bartholdy by J. K. Thannhauser, ca. 1935.

CONDITION

This work is painted on a medium-weight canvas, which was glue lined at an unknown date. The paint is thin to fairly thick in application, with one or two areas of quite thick impasto. There is some wrinkling of the white paint in the tablecloth in the foreground, probably due to an excess of medium in the paint in this area. There are some areas of impasto that do not appear to relate to the design on the surface; however, infrared examination revealed no remarkable changes. There is a varnish layer (Aug. 2000).

EXHIBITIONS

1939–40. New York, The Museum of Modern Art. *Picasso: Forty Years of His Art.* Nov. 15–Jan. 7. P. 24, no. 5, repr. Traveled to the Art Institute of Chicago, Feb. 1–Mar. 3, 1940; Boston, Institute of Modern Art, Apr. 27–May 26, 1940.

1941. New York, The Museum of Modern Art. *Masterpieces of Picasso.* July 15–Sept. 7. No. 5.

1947. New York, M. Knoedler and Co. *Picasso Before 1907.* Oct. 15–Nov. 8. No. 3.

1957. New York, The Museum of Modern Art. *Picasso: 75th Anniversary Exhibition.* May 22–Sept. 8. P. 15, repr. Traveled to the Art Institute of Chicago, Oct. 29–Dec. 8.

1958. Philadelphia Museum of Art. *Picasso.* Jan. 8–Feb. 23. No. 4, repr.

1960. London, Tate Gallery (organized by the Arts Council of Great Britain). *Picasso.* July 6–Sept. 18. No. 4, pp. 13–14, and pl. 1b.

1965. New York, Solomon R. Guggenheim Museum. P. 39, no. 30, color repr.

1966–67. Paris, Grand Palais. *Hommage à Pablo Picasso.* Nov.–Feb. No. 3, repr.

1978. New York, Solomon R. Guggenheim Museum.

1980. New York, The Museum of Modern Art. *Pablo Picasso: A Retrospective.* May 14–Sept. 16. P. 32, repr.

1986. New York, Solomon R. Guggenheim Museum. P. 3, repr., and p. 4.

1987–88a. New York, Solomon R. Guggenheim Museum. No. 27, color repr.

1989. New York, Solomon R. Guggenheim Museum.

1990. New York, Solomon R. Guggenheim Museum.

1990. Venice, Palazzo Grassi. Pp. 98–99, no. A22, color repr.

1992. The Montreal Museum of Fine Arts. Pp. 70–71, no. 8, color repr.

1992. New York, Solomon R. Guggenheim Museum.

1997. Washington, D.C., National Gallery of Art. P. 16, repr. (detail), and p. 123, cat. no. 40.

2000. London, Royal Academy. *1900: Art at the Crossroads.* Jan. 16–Apr. 3. P. 210, cat. no. 141, color repr., and p. 438. Traveled to New York, Solomon R. Guggenheim Museum, May 18–Sept. 11.

REFERENCES

Arnason, H. H. *History of Modern Art.* New York, 1968, pp. 117–18, repr.

Auckland City Art Gallery. *Pablo Picasso: The Artist Before Nature.* Exh. cat., 1989, p. 40.

Aznar, J. C. *Picasso y el cubismo.* Madrid, 1956, p. 319, fig. 214.

Barnett. 1980, pp. 52–53, no. 14, repr.

Barr, A. H., Jr. *Picasso: Fifty Years of His Art.* New York, 1946, p. 18, repr., and pp. 19 and 253.

Baumann, F. A. *Pablo Picasso: Leben und Werk.* Stuttgart, 1976, pp. 12–13, fig. 12, and p. 204, no. 12.

Boeck, W., and J. Sabartés. *Picasso.* New York, 1955, p. 117.

Boone, D. *Picasso.* Trans. J. Greaves. London, 1989, p. 10. French ed.: Paris, 1989.

Broude, N. F. "Picasso's Drawing, *Woman with a Fan*: The Role of Degas in Picasso's Transition to his 'First Classical Period.'" *Oberlin College Bulletin,* vol. 29, winter 1972, p. 87, fn. 9.

Cassou. 1940, p. 36, repr., and p. 165.

Cirici Pellicer. 1946, p. 64 and no. 20, repr.

———. 1950, no. 18, repr.

Cooper, D. *Picasso Theatre.* New York, 1968, p. 341 and pl. 25.

Daix. 1965, p. 28.

———. 1977, p. 37.

Daix and Boudaille. 1967, no. II. 10, pp. 28, 29, color repr., pp. 30, 33, 34, and 122, repr.

Daulte, F. "Une Donation sans précédent: la collection Thannhauser." *Connaissance des Arts,* no. 171, May 1966, p. 68, color repr. (*Le Bal du moulin de la Galette*).

Daval, J.-L. "Guidelines." In J. Leymarie, *Picasso: The Artist of the Century.* New York, 1972, p. 203, repr., and p. 291.

de Champris, P. *Picasso: ombre et soleil.* Paris, 1960, pl. 3.

Elgar, F., and R. Maillard. *Picasso.* Rev. ed. New York, 1972, p. 182.

Fermigier, A., ed. *Picasso.* Paris, 1967, p. 41, repr.

Finkelstein, S. *Der junge Picasso*. Dresden, 1970, pp. 44–45, 162, and pl. 54.

Frankfurter, A. M. "Picasso in Retrospect: 1939–1900. The Comprehensive Exhibition in New York and Chicago." *Art News*, vol. 38, no. 7, Nov. 18, 1939, p. 11, repr.

Galleria d'Arte Moderna e Contemporanea Palazzo Forti, Verona. *Picasso in Italia*. Exh. cat., Milan, 1990, p. 200.

Glimcher, A., and M. Glimcher, eds. *Je Suis Le Cahier: The Sketchbooks of Picasso*. Boston and New York, 1986, p. 308.

Solomon R. Guggenheim Museum. 1972, p. 45, repr.

Guggenheim Museum. 1992, pp. 206–07, color repr.

Guggenheim Museum. 1993, pp. 98–99, pl. 19.

Jaffé, H. L. C. *Picasso*. New York, 1964, p. 15.

Kramer, H. "Picasso's Very First Painting in Paris." *The New York Times*, July 28, 1974, Section D, p. 17, repr.

Kunstmuseum Bern. *Der Junge Picasso: Frühwerk und Blaue Periode*. Exh. cat., Zurich, 1984, p. 55, fig. a, repr., and p. 174.

Lieberman, W. S. *Pablo Picasso: Blue and Rose Periods*. New York, 1954, pl. 12.

Mackenzie, H. F. *Understanding Picasso*. Chicago, 1940, pl. 1.

Merli, J. *Picasso, el artista y la obra de nuestro tiempo*. Rev. ed. Buenos Aires, 1948, pl. 24.

The Metropolitan Museum of Art, New York. *Impressionism*. Exh. cat., 1974, p. 186.

Musée des Arts Décoratifs, Paris. *Picasso*. Definitive ed. Exh. cat., 1955, p. 20.

Museo Español de Arte Contemporáneo, Madrid, and Museu Picasso, Barcelona. Barcelona. *Picasso: 1881–1973: Exposició Antològica*. Exh. cat., 1981, p. 16, repr.

Palais des Beaux-Arts, Charleroi, Belgium. *Picasso/Miró/Dalí: Evocations d'Espagne*. Exh. cat., 1985, p. 20 (1901).

Palau i Fabre. 1981, pp. 208–09, no. 509, color repr., and p. 531.

Penrose. 1958, no. 8, pl. 1.

Porzio, D., and M. Valsecchi. *Understanding Picasso*. New York, 1974, pl. 2, pp. 34, 57.

Quinn, E., and P. Descargues. *Picasso*. Paris, 1974, p. 206, repr.

Reff, T. Review of A. Blunt and P. Pool, *Picasso: The Formative Years*. *The Art Bulletin*, vol. XLVIII, June 1966, p. 267.

Richardson, J., with M. McCully. *A Life of Picasso: Volume I: 1881–1906*. New York, 1991, p. 166, repr., pp. 167–68, 182, and 195.

Setford, D. F. *Pablo Picasso: A Vision*. Exh. cat., Norton Gallery of Art, West Palm Beach, Fla., 1994, p. 12, fig. 2.

Stuckey, C. *Toulouse-Lautrec: Paintings*. Exh. cat., The Art Institute of Chicago, 1979, p. 147, fig. 8.

Thomas, D. *Picasso and His Art*. London and New York, 1975, p. 16.

Toyama, K., K. Nakayama, and S. Takashina. *Picasso*. Tokyo, 1973, p. 114, fig. 17, and pl. 17.

Vallentin, A. *Pablo Picasso*. Paris, 1957, p. 48.

Warnod, J. *Washboat Days*. Trans. C. Green. New York, 1972, pp. 61 and 65.

Weill, B. *Pan! dans l'Oeil!* Paris, 1933, p. 67.

Wertenbaker, L. *The World of Picasso*. New York, 1967, p. 21, repr., and p. 31.

Zervos. 1932, vol. I, no. 41 and pl. 20.

26.
THE PICADOR
(LE PICADOR)
1900

Pastel on paper, 19 x 27 cm (7 ⁷⁄₁₆ x 10 ⅝ inches)
Thannhauser Collection, Bequest, Hilde Thannhauser
91.3912

Signed lower left: P Ruiz Picasso
Not dated.

PROVENANCE
Mrs. J. Barbey, Barcelona; J. K. Thannhauser, after 1955; Hilde Thannhauser, 1976–91.

CONDITION
Until recently this drawing was mounted on a wooden panel and frame that did not allow one to view the sheet in its entirety. In 1998 the drawing was removed from this support, and it is now mounted with two hinges on a mat. Little holes along the top edge are remaining traces of another older mounting, possibly with thumbtacks. The paper support is of medium thickness, and the pastel is oil pastel. The work is signed in pastel in the lower left. On the reverse, there are areas of residual pink color (pastel) and two old hinges, which are attached with animal glue. The number "4" is written in pencil in the upper center on the reverse. This drawing is in fragile condition. The prolonged contact with the wooden frame has damaged the paper: acidity, darkening, and stains transferred from the

wood to the paper can clearly be seen on the reverse. The pastel medium is also fragile. There are a few losses of painting, such as along the left edge near the bottom (Aug. 1999).

EXHIBITIONS

1965. New York, Solomon R. Guggenheim Museum (*Bullfight*, 1901).

1978. Kunstmuseum Bern. P. 67, cat. no. 28, color repr., and p. 110, no. 28 (*Course de taureaux*, 1901).

REFERENCES

Cirici Pellicer. 1946, no. 83, repr. (*Picador*, 1901).

————. 1950, no. 78, repr. (*Picador*, 1901).

Daix and Boudaille. 1967, no. II. 1, p. 119, repr.

Palau i Fabre. 1981, p. 194, no. 449, repr., and p. 530 (*Picador Sticking a Bull with His Lance*).

Zervos. 1954, vol. VI, p. 47, no. 379 (*Pastel*, 1901).

27.
IN THE CAFÉ (AU CAFÉ)
1901

Charcoal on paper, 21.4 x 25.6 cm (8 ⁷⁄₁₆ x 10 ¹⁄₁₆ inches)
Thannhauser Collection, Gift, Justin K. Thannhauser
78.2514.35

Signed lower left: P. R. Picasso
Not dated.

PROVENANCE

Santiago Laporta, Barcelona; J. K. Thannhauser by 1932.

CONDITION

Flattened and creases at top and bottom retouched by C. Gaehde (June 1973).

EXHIBITIONS

1932. Kunsthaus Zürich. *Picasso*. Sept. 11–Oct. 30. No. 252 (label

on reverse of frame reads: *Café*, 1900).

1934. Buenos Aires, Galería Müller. *Picasso*. Oct. No. 28 (label on reverse of frame reads: *Café*, Madrid 1900).

1965. New York, Solomon R. Guggenheim Museum. P. 40, no. 32, repr.

1978. New York, Solomon R. Guggenheim Museum.

1987–88a. New York, Solomon R. Guggenheim Museum.

1989. New York, Solomon R. Guggenheim Museum.

1990. New York, Solomon R. Guggenheim Museum.

1992. New York, Solomon R. Guggenheim Museum.

REFERENCES

Cirici Pellicer. 1946, no. 37, repr. (*El Mostrador*, 1900).

————. 1950, no. 33, repr. (*Le Comptoir*).

Solomon R. Guggenheim Museum. 1972, p. 46, repr.

Zervos. 1932, vol. I, no. 37 and pl. 18 (*The Counter*, Madrid, 1900).

28.
THE FOURTEENTH OF JULY
(LE QUATORZE JUILLET)
1901

Oil on cardboard, mounted on canvas, 48 x 62.8 cm (18 ⅞ x 24 ¾ inches)
Thannhauser Collection, Gift, Justin K. Thannhauser
78.2514.36

Signed upper right: Picasso
Not dated.

PROVENANCE

Purchased by J. K. Thannhauser, Paris, 1936–39; promised gift of J. K. Thannhauser to Solomon R.

Guggenheim Museum, 1964 (formerly 64.1707).

CONDITION

The cardboard support was adhered to fabric with an aqueous-type adhesive and mounted onto a stretcher at an unknown date prior to 1975. The brown color of the support is visible in many places as part of the design. A varnish was removed in 1992 (Mar. 1992).

EXHIBITIONS

1902. Paris, Galerie Berthe Weill. *Tableaux et pastels de Louis Bernard-Lemaire et de Picasso*. Apr. 1–15. No. 5.

1944. Mexico City, Sociedad de Arte Moderno (organized by The Museum of Modern Art, New York). *Picasso*. June. P. 41 and Added Corrections List.

1953. Santa Barbara Museum of Art. *Fiesta Exhibition 1953: Picasso, Gris, Miró, and Dalí*. Aug. 4–30. No. 2.

1965. New York, Solomon R. Guggenheim Museum. P. 41, no. 33, color repr.

1978. New York, Solomon R. Guggenheim Museum.

1984–85. Kunstmuseum Bern. *Der Junge Picasso: Frühwerk und Blaue Periode*. Dec. 9–Mar. 3. Pp. 57, 226, cat. no. 127, color repr., and p. 323 (*Der 14. Juli*).

1987–88a. New York, Solomon R. Guggenheim Museum. No. 28, repr.

1989. New York, Solomon R. Guggenheim Museum.

1990. New York, Solomon R. Guggenheim Museum.

1990. Venice, Palazzo Grassi. Pp. 100–01, no. A23, color repr.

1992. New York, Solomon R. Guggenheim Museum.

1997. Washington, D.C., National Gallery of Art. P. 161, cat. no. 62.

REFERENCES

Arnason, H. H. *History of Modern Art*. New York, 1968, p. 90, repr.

Cirici Pellicer. 1946, pp. 95, 168, and 170.

————. 1950, pp. 100, 172, and 174.

Daix. 1977, pp. 44 and 49, fn. 19.

Daix and Boudaille. 1967, no. V. 70, pp. 42, 43, 45, and 187, repr.

Solomon R. Guggenheim Museum. 1972, p. 47, repr.

Leymarie, J. *Picasso: The Artist of the Century*. New York, 1972, p. 207.

Nochlin, L. "Picasso's Color: Schemes and Gambits." *Art in America*, vol. 68, no. 10, Dec. 1980, p. 109, fig. 5, and pp. 113–14.

Palau i Fabre. 1981, p. 258, no. 649, repr., and p. 535.

Vallentin, A. *Picasso*. Ed. K. Woods. Garden City, N.Y., 1963, p. 46.

Zervos. 1932, vol. I, pp. xxvi–xxvii.

————. "Oeuvres et images inédites de la jeunesse de Picasso." *Cahiers d'Art*, 25ᵉ année, no. 2, 1950, p. 314, repr. (*Le 14 Juillet*).

————. 1954, vol. VI, no. 334 and pl. 41.

29.
WOMAN AND CHILD
(FEMME ET ENFANT)
1903

Conté crayon on wove paper, 33.7 x 23.2 cm (13 ¼ x 9 ⅛ inches)
Thannhauser Collection, Gift, Justin K. Thannhauser
78.2514.37

Watermark: VILASECA

Signed lower right: Picasso
Inscribed lower right, not by the artist: D'Eugène Carrière
Inscribed, not by the artist, on reverse: 10 centimetro
Not dated.

PROVENANCE

Santiago Laporta, Barcelona; J. K. Thannhauser by 1932.

CONDITION

The condition of the drawing is stable. It is mounted with an overmat. The paper support is yellowed and probably acidic. There are some strong undulations of the paper support, particularly along the bottom area. The condition of the medium appears stable (Oct. 2000).

EXHIBITIONS

1932. Kunsthaus Zürich. *Picasso*. No. 258 (*Frau mit Kind nach Carrière*, 1902). Sept. 11–Oct. 30.

1965. New York, Solomon R. Guggenheim Museum. P. 40, no. 34, repr.

1978. New York, Solomon R. Guggenheim Museum.

1987–88a. New York, Solomon R. Guggenheim Museum.

1989. New York, Solomon R. Guggenheim Museum.

1990. New York, Solomon R. Guggenheim Museum.

1992. New York, Solomon R. Guggenheim Museum.

REFERENCES

Bantens, R. J. *Eugène Carrière— His Work and His Influence*. Ph.D. dissertation, Pennsylvania State University, Philadelphia, 1975, pp. 260–63 and 745, repr.

Blunt and Pool. 1962, pp. 10, 31, and pl. 93 (*Two Children*).

Cirici Pellicer. 1946, pl. 143 (*Dos Niños*, 1902).

————. 1950, pl. 136 (*Deux Enfants*, 1902).

Solomon R. Guggenheim Museum. 1972, p. 48, repr. (ca. 1902).

Palau i Fabre. 1981, p. 351, no. 910, repr., and p. 542 (*In the Manner of Eugène Carrière*).

Reff, T. Review of A. Blunt and P. Pool, *Picasso: The Formative Years. The Art Bulletin*, vol. XLVIII, June 1966, p. 267 (first identifies source).

Zervos. 1932, vol. I, no. 134 and pl. 66 (*Two Children*, 1902).

30.
THE MADMAN (EL LOCO)
1903–04

Watercolor on wove paper, 32.6 x 23.2 cm (12 ¹³⁄₁₆ x 9 ⅛ inches)
Thannhauser Collection, Gift, Justin K. Thannhauser
78.2514.40

Inscribed upper right: El loco
Not signed or dated.

PROVENANCE

Ricardo Viñes, Paris; Alphonse Bellier, Paris, until 1935; acquired from Bellier by Alex Reid and Lefevre, Ltd., London; purchased from Reid and Lefevre, 1935, by R. J. L. Griffin; Mr. and Mrs. Jonathan Griffin, London, by 1938–42; purchased from Griffin by Theodore Schempp, New York, 1942; acquired from Schempp by J. K. Thannhauser, New York, ca. 1943.

CONDITION

The drawing appears to be in good condition. The colors are brilliant though the paper support is a little bit yellowed. There are some cockled areas along the top-right edge and along the left edge (Oct. 2000).

EXHIBITIONS

1939–42. Boston, The Museum of Fine Arts. On loan from Mr. and Mrs. Jonathan Griffin.

1940. Boston, The Museum of Fine Arts. *Drawings and Prints by Picasso.* Apr. 26–June 12.

1965. New York, Solomon R. Guggenheim Museum. P. 43, no. 36, color repr.

1978. New York, Solomon R. Guggenheim Museum.

1984–85. Kunstmuseum Bern. *Der Junge Picasso: Frühwerk und Blaue Periode.* Dec. 9, 1984–Mar. 3. P. 306, cat. no. 201, repr., and p. 326 (*Der Wahnsinnige, mit Hund—«El Loco»*, 1904).

1987–88a. New York, Solomon R. Guggenheim Museum.

1989. New York, Solomon R. Guggenheim Museum.

1990. New York, Solomon R. Guggenheim Museum.

1990. Venice, Palazzo Grassi. Pp. 102–03, no. A24, color repr.

1992. New York, Solomon R. Guggenheim Museum.

REFERENCES

Daix and Boudaille. 1967, no. X. 5, pp. 62, 233, 235, repr., and p. 238 (*El Loco {Madman with a Dog}*).

Solomon R. Guggenheim Museum. 1972, p. 49, repr. (1903).

Lecaldano. 1968, p. 95, fig. 103, and pl. XX. (*Mendicante con cane*). English ed.: (*Beggar Man with Dog*).

Palau i Fabre. 1981, pp. 362, 363, no. 947, repr., and p. 543 (1904).

Zervos. 1932, vol. I, no. 184 and pl. 86 (*Fool with a Dog*, 1903, Collection Viñes, Paris).

31.
PROFILE OF WOMAN WITH A CHIGNON (PROFIL DE FEMME AU CHIGNON)
1904

Pencil, india ink, charcoal, and blue wash on paper, 37 x 26.7 cm (14 ⁹⁄₁₆ x 10 ½ inches)
Thannhauser Collection, Bequest, Hilde Thannhauser 91.3913

Signed lower left: Picasso
Not dated.

PROVENANCE

Collection Medens, London; Collection René Gaffé, Brussels; J. K. Thannhauser, by 1960; Hilde Thannhauser, 1976–91.

CONDITION

The blue color of the background corresponds to a prepared paper made by the artist using watercolor and washed black and blue charcoal. The drawing, which is mounted on a mat with four hinges, is quite fragile. The black ink is visibly altered: bright yellow halos around the lines reveal a strong and active acidity. The sheet is very fragile with cockling and several support losses along the edges. Signs of old retouchings are visible, such as along the top edge (Aug. 1999).

EXHIBITIONS

1938. London Gallery. *Picasso Drawings and Collages.* May 5–31 (*Profile and Chignon*).

1960. Berkeley, Krocker Hall, University of California. *Art from Ingres to Pollock.* Mar. 5–Apr. 3 (*Blue Head*).

1960. San Francisco, Palace of Legion of Honor. On loan. Apr. 4–Oct. 19 (*Blue Head*).

1978. Kunstmuseum Bern. P. 69, cat. no. 30, repr., and p. 110, no. 30 (*Femme de profil au chignon*).

REFERENCES

Daix and Boudaille. 1967, no. XI. 12, p. 249, repr.

Lecaldano. 1968, p. 99, fig. 145 (*Profilo femminile*). English ed.: (*Profile Feminile, Profile of a Woman*).

Zervos. 1932, vol. I, p. 98, no. 221, repr. (*Profile with Chignon*). Third ed., 1957 (*Profil au chignon*).

32.
WOMAN IRONING (LA REPASSEUSE)
1904

Oil on canvas, 116.2 x 73 cm (45 ¼ x 28 ¼ inches)
Thannhauser Collection, Gift, Justin K. Thannhauser 78.2514.41

Signed lower right: Picasso
Not dated.

PROVENANCE

Ambroise Vollard, Paris; Der Neuer Kunstsalon, Munich; Moderne Galerie Heinrich Thannhauser, Munich, ca. 1913; Karl Adler, Berlin and Amsterdam, 1916; purchased from Adler by J. K. Thannhauser, 1937.

CONDITION

This work is painted on canvas, which was glue lined at an unknown date. There are two old, long cuts in the canvas at the extreme edges, which are secured by the lining. The work is fairly thinly painted. X-radiographs and infrared examination reveal a painting of a male figure in the opposite orientation beneath the woman ironing. The paint is in good condition. A thin glossy varnish was removed in 1989 (Aug. 1999).

EXHIBITIONS

1913. Munich, Moderne Galerie Heinrich Thannhauser. *Pablo Picasso.* Feb. No. 28 (1906).

1913. Stuttgart, Kgl. Kunstgebäude. *Grosse Kunstausstellung*. May–Oct. No. 420.

1913. Berlin, Ausstellungshaus am Kurfürstendamm. *Herbstausstellung*. Autumn. No. 171.

1927. Hamburg, Kunstverein. *Europäische Kunst der Gegenwart*. P. 64, no. 374 (*Die Büglerin*, 1905).

1939. Amsterdam, Stedelijk Museum. *Parijsche Schilders*. Feb. 25–Apr. 10. No. 85.

1939–40. New York, The Museum of Modern Art. *Picasso: Forty Years of His Art*. Nov. 15–Jan. 7. Pp. 37, 38, no. 27, repr. Traveled to the Art Institute of Chicago, Feb. 1– Mar. 3, 1940, and Boston, Institute of Modern Art, Apr. 27–May 26, 1940.

1941. New York, The Museum of Modern Art. *Masterpieces of Picasso*. July 15–Sept. 7. No. 27.

1944. New York, The Museum of Modern Art. *Art in Progress*. May 24–Oct 15. P. 99, repr.

1947. The Minneapolis Institute of Arts. *20th Century French Painters*. May 3–June 1.

1947. New York, M. Knoedler and Co. *Picasso Before 1907*. Oct. 15–Nov. 8. No. 18.

1949. The Art Gallery of Toronto. *Picasso*. Apr. No. 2.

1952. Paris, Musée National d'Art Moderne. *L'Oeuvre du XXᵉ siècle*. May–June. No. 85, repr.

1957. New York, The Museum of Modern Art. *Picasso: 75th Anniversary Exhibition*. May 22– Sept. 8. P. 20, repr.

1965. New York, Solomon R. Guggenheim Museum. P. 45, no. 39, color repr.

1978. New York, Solomon R. Guggenheim Museum.

1980. New York, The Museum of Modern Art. *Pablo Picasso: A Retrospective*. May 14–Sept. 16. P. 60, color repr. (spring 1904).

1986. New York, Solomon R. Guggenheim Museum.

1987–88a. New York, Solomon R. Guggenheim Museum. No. 29, color repr.

1989. New York, Solomon R. Guggenheim Museum.

1990. New York, Solomon R. Guggenheim Museum.

1990. Venice, Palazzo Grassi. Pp. 104–05, no. A25, color repr.

1992. The Montreal Museum of Fine Arts. Pp. 72–73, no. 9, color repr.

1992. New York, Solomon R. Guggenheim Museum.

1997. Washington, D.C., National Gallery of Art. P. 230, cat. no. 106, and p. 288, repr. (detail).

1998–99. New York, Solomon R. Guggenheim Museum. *Rendezvous: Masterpieces from the Centre Georges Pompidou and the Guggenheim Museums*. Oct. 16– Jan. 24. P. 132, no. 16, color repr.

REFERENCES

Arnason, H. H. *History of Modern Art*. New York, 1968, pp. 95 and 117, pl. 40.

Auckland City Art Gallery. *Pablo Picasso: The Artist Before Nature*. Exh. cat., 1989, p. 42.

Barnett. 1980, pp. 54–55, no. 15, color repr.

Barr, A. H., Jr. *Picasso: Fifty Years of His Art*. New York, 1946, p. 32, repr.

Blunt and Pool. 1962, p. 21.

Boeck, W., and J. Sabartés. *Picasso*. New York, 1955, pp. 38–39, 123.

Broude, N. F. "Picasso's Drawing, *Woman with a Fan*: The Role of Degas in Picasso's Transition to his 'First Classical Period.'" *Oberlin College Bulletin*, vol. 29, winter 1972, pp. 83 and 85, repr.

Cabanne, P. *Degas*. Paris, 1993, p. 140, fig. 1 (*Femme repassant*).

Cassou. 1940, p. 49, color repr., and p. 165 (*The Ironer*).

Cirici Pellicer. 1946, pp. 175 and 179, pl. 188.

————. 1950, pp. 179 and 183, pl. 180.

Cirlot. 1972, p. 157 (1905).

Crespelle, J-P. *Picasso and His Women*. New York, 1969, p. 49.

Daix. 1965, p. 39, repr., pp. 40– 41 and 262.

Daix and Boudaille. 1967, no. XI. 6, pp. 56, 64–65, 76, 78, and 240, repr.

Daulte, F. "Une Donation sans précédent: la collection Thannhauser." *Connaissance des Arts*, no. 171, May 1966, p. 66, color repr., and p. 67.

de Champris, P. *Picasso: Ombre et soleil*. Paris, 1960, pp. 17 and 287, pl. 7.

Einstein, C. *Die Kunst des 20. Jahrhunderts*. Berlin, 1926, vol. I, pl. vii (1903).

Elgar, F. *Picasso*. New York, 1956, p. 22 and n.p., repr.

————, and R. Maillard. *Picasso*. Rev. ed. New York, 1972, p. 186, repr.

"Exposition d'*Art européen d'aujourd'hui* à Hambourg." *Cahiers d'Art*, 2ᵉ année, no. 6, 1927, supp. p. 7, repr. (installation view, Hamburg exhibition).

Fermigier, A., ed. *Picasso*. Paris, 1967, pp. 178–79, color repr.

Finkelstein, S. *Der junge Picasso*. Dresden, 1970, pp. 35, 161, and pl. 25 (*Büglerin*).

Friedeberger, H. "Die Berliner Herbstausstellung." *Der Cicerone*, jg. V, Nov. 1913, p. 800.

Gaya Nuño, J. A. *Picasso*. Barcelona, 1950, p. 12, pl. 13 (*La planchadora*).

Solomon R. Guggenheim Museum. 1972, p. 52, repr.

Guggenheim Museum. 1992, p. 209, color repr.

Guggenheim Museum. 1993, p. 101, pl. 21.

Hildebrandt, H. "Die Frühbilder Picassos." *Kunst und Künstler*, jg. 11, Apr. 1913, p. 378, repr.

Hochschule Bremen. *Was glauben Sie denn ist Picasso?* Fischerhude, Germany, 1985, p. 165.

Jaffé, H. L. C. *Picasso*. New York, 1964, pp. 19 and 70–71, repr.

———. *Pablo Picasso*. Garden City, N.Y., 1980, pp. 70–71, color repr.

Lecaldano. 1968, p. 96, fig. 125, and pl. XXIII (*La stiratrice*).

Level, A. *Picasso*. Paris, 1928, p. 55 and pl. 9.

Lieberman, W. S. *Pablo Picasso: Blue and Rose Periods*. New York, 1954, pl. 20.

Lindahl, G. "Konstnären och Samhället." *Paletten*, vol. 12, no. 4, 1951, p. 98, repr.

Merli, J. *Picasso, el artista y la obra de nuestro tiempo*. Rev. ed. Buenos Aires, 1948, pl. 106.

National Gallery of Art, Washington, D.C. *Picasso: The Saltimbanques*. Exh. cat., 1980, p. 32, fig. 23.

O'Brian, J. *Degas to Matisse: The Maurice Wertheim Collection*. New York and Cambridge, Mass., 1988, p. 112, fig. 1.

Palau i Fabre. 1981, pp. 377–78, 379, no. 982, color repr., and p. 544 (*The Ironing-woman*).

Penrose. 1958, p. 106.

Porzio, D., and M. Valsecchi. *Understanding Picasso*. New York, 1974, p. 58, repr.

Richardson, J., with M. McCully. *A Life of Picasso: Volume I: 1881–1906*. New York, 1991, pp. 222, 303, repr., and p. 304.

Richet, M. *The Picasso Museum, Paris: Drawings, Watercolors, Gouaches, and Pastels*. Trans. A. Audubert. New York, 1989, p. 18. French ed.: Paris, 1985.

Rohe, M. K. "Pablo Picasso." *Die Kunst für Alle*, jg. 28, May 15, 1913, p. 383, repr. (1906, lent by Neuer Kunstsalon, Munich).

Schiff, G. *Picasso at Work at Home: Selections from the Marina Picasso Collection*. Exh. cat., Center for the Fine Arts, Miami, 1985, p. 25.

Steingräber, E. "La Repasseuse: zur frühesten Version des Themas von Edgar Degas." *Pantheon*, vol. XXXII, Jan.–Feb.–Mar. 1974, pp. 52–53, repr.

Thomas, D. *Picasso and His Art*. London and New York, 1975, pp. 18–19, pl. 10, and p. 20.

Toyama, K., K. Nakayama, and S. Takashina. *Picasso*. Tokyo, 1973, p. 116, fig. 25, and pl. 25.

Vallentin, A. *Pablo Picasso*. Paris, 1957, p. 90.

Wertenbaker, L. *The World of Picasso*. New York, 1967, pp. 44–45, repr.

Zervos. 1932, vol. I, no. 247 and pl. 111 (ex. coll. A. Vollard).

33.
FERNANDE WITH A BLACK MANTILLA (FERNANDE À LA MANTILLE NOIR)

1905–06

Oil on canvas, 100 x 81 cm (39 ⅜ x 31 ⅞ inches)
Thannhauser Collection, Bequest, Hilde Thannhauser
91.3914

Signed on reverse at upper left: Picasso
Not dated.

PROVENANCE

Collection Paul von Mendelssohn Bartholdy, Berlin; Elsa Grafin Kesselstatt (formerly Mrs. Mendelssohn Bartholdy); Walter Feilchenfeldt, Zurich, after 1945; Marianne Feilchenfeldt, Zurich, 1953; J. K. Thannhauser, 1956; Hilde Thannhauser, 1976–91.

CONDITION

This work is in excellent condition. The canvas is unlined. The thinly painted surface appears slightly polished. There are several superficial scratches in the paint layer (Aug. 1999).

EXHIBITIONS

1998–99. New York, Solomon R. Guggenheim Museum. *Rendezvous: Masterpieces from the Centre Georges Pompidou and the Guggenheim Museums*. Oct. 16– Jan. 24. P. 135, no. 18, color repr.

REFERENCES

Daix and Boudaille. 1967, p. 304, repr. (summer 1906).

Guggenheim Museum. 1992, p. 209, color repr. (1905/06?).

Lecaldano. 1968, p. 107, fig. 250, repr. (*Ritratto di Fernande*

Olivier con mantiglia nera, 1906).
English ed.: (*Portrait of Fernande Olivier with Black Headdress*, 1906).

Palau i Fabre. 1981, pp. 424, 425, no. 1154, repr., and p. 548 (*Fernande in a Mantilla*, 1905).

Zervos. 1932, vol. I, no. 253, repr. (*Woman with Scarf*, 1905). Third ed., 1957 (*Fernande Olivier*, 1906).

34.
YOUNG ACROBAT AND CHILD (JEUNE ACROBATE ET ENFANT)
Mar. 26, 1905

Ink and gouache on gray cardboard, 31.3 x 25.1 cm (12 ⁵⁄₁₆ x 9 ⅞ inches)
Thannhauser Collection, Gift, Justin K. Thannhauser
78.2514.42

Signed and dated lower right: Picasso / Paris 26 Mars 05
Inscribed above signature: A Mlle / A. Nachmann

PROVENANCE
Acquired through an unknown source from A. Nachmann, Cannes, by J. K. Thannhauser, Aug. 1939.

CONDITION
White pigment at bottom has oxidized (May 1973).

EXHIBITIONS
1965. New York, Solomon R. Guggenheim Museum. P. 46, no. 41, color repr.

1978. New York, Solomon R. Guggenheim Museum.

1980–81. Washington, D.C., National Gallery of Art. *Picasso: The Saltimbanques*. Dec. 14– Mar. 15. P. 36, fig. 33, and p. 87, cat. no. 35.

1987–88a. New York, Solomon R. Guggenheim Museum.

1989. New York, Solomon R. Guggenheim Museum.

1990. New York, Solomon R. Guggenheim Museum.

1990. Venice, Palazzo Grassi. Pp. 106–07, no. A26, color repr.

1992. New York, Solomon R. Guggenheim Museum.

1998. Deutsche Guggenheim Berlin. Pp. 166–67, no. 62, color repr. (*Junger Akrobat und Kind*). English ed.: pp. 166–67, no. 62, color repr. Spanish ed.: pp. 192–93, no. 72, color repr. (*Joven acróbata y niño*).

REFERENCES
Arnason, H. H. *History of Modern Art*. New York, 1968, p. 119.

Barnett. 1980, pp. 56–57, no. 16, repr.

Cirlot. 1972, p. 157.

Daix and Boudaille. 1967, no. XII. 15, p. 261, repr.

Solomon R. Guggenheim Museum. 1972, p. 53, repr. (*Two Harlequins*).

Guggenheim Museum. 1993, p. 100, pl. 20.

Kay, H. *Picasso's World of Children*. Garden City, 1965, p. 64, repr.

Lecaldano. 1968, p. 99, fig. 158, and pl. XXX (*Giovane acrobata e bambino*).

Palau i Fabre. 1981, p. 403, no. 1046, repr., and p. 545.

Picasso: Fifteen Drawings. New York, 1946, pl. 3.

Rubin, W. *Picasso in the Collection of The Museum of Modern Art*. New York, 1972, pp. 33 and 191.

Zervos, C. "Oeuvres et images inédites de la jeunesse de Picasso." *Cahiers d'Art*, 25ᵉ année, no. 2, 1950, p. 328, repr. (*Saltimbanques et enfants*).

———. 1954, vol. VI, no. 718 and pl. 87.

35.
VASE OF FLOWERS (VASE DE FLEURS)
1905–06

India ink on wove paper, 26.7 x 19.7 cm (10 ½ x 7 ¾ inches)
Thannhauser Collection, Gift, Justin K. Thannhauser
78.2514.43

Signed upper left: Picasso
Not dated.

PROVENANCE
J. K. Thannhauser before 1940.

CONDITION
This drawing was deacidified, flattened, and rehinged in 1973 and now appears to be in stable condition. The paper is yellowed, although the edges— which have been protected from light by an overmat—are lighter than the rest of the sheet. The paper support is distorted and there is one tear along the left edge. The ink is stable (Aug. 2000).

EXHIBITIONS
1965. New York, Solomon R. Guggenheim Museum.

1978. New York, Solomon R. Guggenheim Museum.

1987–88a. New York, Solomon R. Guggenheim Museum.

1989. New York, Solomon R. Guggenheim Museum.

1990. Venice, Palazzo Grassi. Pp. 108–09, no. A27, color repr.

REFERENCES
Cassou. 1940, p. 149, repr., and p. 167 (*Bunch of Flowers*, Collection Thannhauser).

Daix and Boudaille. 1967, no. XV. 41, repr. (summer 1906).

de Champris, P. *Picasso: Ombre et soleil*. Paris, 1960, pp. 211, 293, and pl. 251.

Solomon R. Guggenheim Museum. 1972, p. 54, repr. (ca. 1905).

Zervos. 1970, vol. XXII, no. 339 and pl. 122 (*Vase de fleurs*, 1906).

36.
STILL LIFE: FLOWERS IN A VASE (NATURE MORTE: FLEURS DANS UN VASE)
1906

Gouache on cardboard, 72.1 x 55.9 cm (28 ⅜ x 22 inches)
Thannhauser Collection, Gift, Justin K. Thannhauser
78.2514.44

Signed lower left: Picasso
Not dated.

PROVENANCE
Acquired from the artist by J. K. Thannhauser, Paris, 1937–39.

CONDITION
The work was scratched by the artist with a sharp, pointed instrument and with a blunt one. There are small nail punctures from the reverse at the upper corners and near the two pieces of pottery (May 1975).

EXHIBITIONS
1932. Paris, Galeries Georges Petit. *Picasso*. June 16–July 30. No. 29 (*Nature morte au vase de fleurs*, 1905, 71 x 54 cm).

1965. New York, Solomon R. Guggenheim Museum. P. 47, no. 43, color repr.

1978. New York, Solomon R. Guggenheim Museum.

1987–88a. New York, Solomon R. Guggenheim Museum. No. 30, repr.

1990. Venice, Palazzo Grassi. Pp. 108 and 110–11, no. A28, color repr.

1992. Barcelona, Museu Picasso. *Pablo Picasso 1905–1906*. Feb. 5–Apr. 19. Pp. 310 and 313, fig. 146. Traveled to Musée des Beaux-Arts, Bern, May 8–July 26.

1997. Washington, D.C., National Gallery of Art. P. 330, cat. no. 162 (*Still Life*, summer 1906). Shown at Boston venue only.

REFERENCES
Daix and Boudaille. 1967, no. XV. 16, pp. 99, 296, repr. (Gosol, summer 1906).

Solomon R. Guggenheim Museum. 1972, p. 56, repr. (1905–06).

Lecaldano. 1968, p. 111, fig. 285, repr. (*Ceramiche e vaso con fiori*). English ed.: (*Pottery and Vase with Flowers*).

Palau i Fabre. 1981, p. 450, no. 1249, repr., and p. 550 (*Vase with Bouquet of Flowers*).

Zervos, C. "Oeuvres et images inédites de la jeunesse de Picasso." *Cahiers d'Art*, 25ᵉ année, no. 2, 1950, p. 324, repr. (*Fleurs*, 1905).

———. 1954, vol. VI, no. 889 and pl. 107 (1905).

37.
WOMAN WITH OPEN FAN (FEMME À L'ÉVENTAIL)
1906

Ink on wove paper, 17.1 x 11 cm (6 ¾ x 4 ⁵⁄₁₆ inches)
Thannhauser Collection, Gift, Justin K. Thannhauser
78.2514.45

No watermark.

Not signed or dated.

PROVENANCE
Probably acquired from the artist by Arthur B. Davies, Nov. 1912; purchased from Davies collection sale at American Art Association, New York, Apr. 16–17, 1929, by J. B.

Neumann, New York; purchased from Neumann by Mr. and Mrs. Charles J. Liebman, New York, 1929; purchased from Liebman collection sale at Parke Bernet, New York, Dec. 7, 1955, by J. K. Thannhauser, New York.

CONDITION
Horizontal tears repaired and loss at lower right replaced in 1971 by C. Gaehde (May 1973).

EXHIBITIONS
1965. New York, Solomon R. Guggenheim Museum. P. 48, no. 45, repr.

1978. New York, Solomon R. Guggenheim Museum.

1987–88a. New York, Solomon R. Guggenheim Museum.

1990. Venice, Palazzo Grassi. Pp. 112–13, no. A29, color repr.

1992. Barcelona, Museu Picasso. *Pablo Picasso 1905–1906*. Feb. 5–Apr. 19. Pp. 326–29, fig. 159. Traveled to Musée des Beaux-Arts, Bern, May 8–July 26.

REFERENCES
American Art Association, New York. *The Arthur B. Davies Art Collection*. Sale cat., Apr. 16–17, 1929, no. 15, repr. (*Portrait of a Lady*).

Daix and Boudaille. 1967, no. XV. 38 (mentioned as related version).

Parke Bernet, New York. *The Liebman Collection of Valuable Modern Paintings, Drawings and Sculptures*. Sale cat., Dec. 7, 1955, no. 27 (*Portrait of a Lady*).

Solomon R. Guggenheim Museum. 1972, p. 57, repr.

Tinterow, G. *Master Drawings by Picasso*. Exh. cat., Fogg Art Museum. Cambridge, Mass., 1981, p. 70.

Zervos. 1954, vol. VI, no. 786 and pl. 95 (*Dessin à la plume*,

incorrect dimensions listed, Collection Mrs. Charles J. Liebman, New York).

38.
WOMAN AND DEVIL
(FEMME ET DIABLE)
1906

India ink on laid paper, 30.8 x 23.2 cm (12 ⅛ x 9 ⅛ inches)
Thannhauser Collection, Gift, Justin K. Thannhauser
78.2514.46

Not signed or dated.

PROVENANCE
Curt Valentin, New York, by 1940; acquired from Valentin by J. K. Thannhauser.

CONDITION
Removed from cardboard mount, cleaned, deacidified, and mat burn minimized by C. Gaehde (May 1973).

EXHIBITIONS
1940. New York, Buchholz Gallery (Curt Valentin). *Pablo Picasso: Drawings and Watercolors*. Mar. 5–30. No. 9.

1941. New York, Buchholz Gallery. *Beaudin, Braque, Gris . . . and Picasso*. Apr. 7–26. no. 39.

1965. New York, Solomon R. Guggenheim Museum. P. 48, no. 42, repr.

1978. New York, Solomon R. Guggenheim Museum.

1987–88a. New York, Solomon R. Guggenheim Museum.

1989. New York, Solomon R. Guggenheim Museum.

1990. Venice, Palazzo Grassi. Pp. 112 and 114–15, no. A30, color repr.

REFERENCES
Solomon R. Guggenheim Museum. 1972, p. 55, repr. (*Courtship*, 1905–06).

Palau i Fabre. 1981, pp. 466,

467, no. 1331, repr., and p. 552 (*Satyr and Maiden*).

Curt Valentin Gallery, New York. *Picasso*. N.d., vol. II of unpublished "Black Albums" of photographs on deposit at the Museum of Modern Art, New York, [pp. 29–30], repr.

Zervos. 1954, vol. VI, no. 804 and pl. 97 (1905 or 1906).

39.
GLASS, PIPE, AND PACKET OF TOBACCO (VERRE, PIPE ET PAQUET DE TABAC)
1914

Gouache and pencil on wove brown paper, 19.8 x 29.7 cm (7 ¹⁵⁄₁₆ x 11 ¹³⁄₁₆ inches)
Thannhauser Collection, Gift, Justin K. Thannhauser
78.2514.47

Signed on reverse: Picasso
Not dated.

PROVENANCE
Acquired from M. Perel, Paris, by Galerie Jeanne Bucher, Paris, 1947; purchased from Bucher by Paul Martin a few years later; Robert Lebel, New York and Paris, until ca. 1950; purchased from Lebel by J. K. Thannhauser, New York.

CONDITION
The condition of this work is fair. In 1973 it was removed from its old mount and rehinged, but, already at that time, the paper support was distorted and it remains so now. The colors remain bright, although the white gouache is flaking slightly, which makes this work fragile. There are numerous accretions on the surface. There are some old support losses around the left and top edges (Aug. 2000).

EXHIBITIONS
1965. New York, Solomon R. Guggenheim Museum. P. 54, no. 49, color repr.

1978. New York, Solomon R. Guggenheim Museum.

1989. New York, Solomon R. Guggenheim Museum.

1992. New York, Solomon R. Guggenheim Museum.

1998. New York, Solomon R. Guggenheim Museum.

REFERENCES
Daix, P., and J. Rosselet. *Picasso—The Cubist Years 1907–1916. A Catalogue Raisonné of the Paintings and Related Works*. Boston, 1979, p. 328, no. 733, repr. (*Wineglass, Pipe and Packet of Tobacco*).

Solomon R. Guggenheim Museum. 1972, p. 58, repr. (*Composition*, 1914–15).

Zervos. 1975, vol. XXIX, no. 69 and pl. 28 (*Nature morte au paquet de tabac*, spring 1914).

40.
THREE BATHERS
(TROIS BAIGNEUSES)
August 1920

Pastel with oil and pencil on laid paper, 47.8 x 61.4 cm (18 ¹⁵⁄₁₆ x 24 ³⁄₁₆ inches)
Thannhauser Collection, Gift, Justin K. Thannhauser
78.2514.49

Watermark: CANSON & MONTGOLFIER FRANCE

Signed lower right: Picasso
Dated upper right: 19.8.20

PROVENANCE
Acquired from the artist by Galerie Simon (D.-H. Kahnweiler), Paris; purchased from Galerie Simon by G. F. Reber, Lugano, June 1924; probably purchased from Valentine Gallery, New York, by Lee Ault soon after World War II; acquired from Ault shortly thereafter by J. K. Thannhauser.

CONDITION

In 1976 the original paper support was removed from the double cardboard mount, deacidified, and rehinged. The condition appears stable, but the paper support has some distortions and is yellowed and probably acidic. There are some unexplained, slightly paler areas of discoloration in the upper right, which could be caused by light. There are also some foxing stains. There are several watermarks easily visible on the paper support even within the design areas (Oct. 2000).

EXHIBITIONS

1937. New York, Valentine Gallery. *Drawings, Gouaches and Pastels by Picasso.* Apr. 12–May 1. Probably one of five bathers listed: nos. 43–46 and 48.

1953. Santa Barbara Museum of Art. *Fiesta Exhibition 1953: Picasso, Gris, Miró, and Dalí.* Aug. 4–30. No. 15 (*Bathers*, incorrect dimensions listed).

1962. New York, Duveen Brothers, Inc. *Picasso, An American Tribute: The Classic Phase.* Apr. 25–May 12. No. 12, repr.

1965. New York, Solomon R. Guggenheim Museum. P. 55, no. 52, color repr.

1978. New York, Solomon R. Guggenheim Museum.

1989. New York, Solomon R. Guggenheim Museum.

1992. New York, Solomon R. Guggenheim Museum.

1998. Deutsche Guggenheim Berlin. Pp. 170–71, no. 64, color repr. (*Drei badende Frauen*). English ed.: pp. 170–71, no. 64, color repr. Spanish ed.: pp. 196–97, no. 74, color repr. (*Las tres bañistas*).

REFERENCES

Boeck, W., and J. Sabartés. *Picasso.* New York, 1955, p. 467, no. 101, repr.

Daix. 1965, p. 120, repr., and p. 265 (*Women by the Sea*, pastel, 64 x 49 cm, Collection Reber, Lausanne).

Solomon R. Guggenheim Museum. 1972, p. 60, repr.

Vallentin, A. *Pablo Picasso.* Paris, 1957, n.p., repr. under "Catalogue des oeuvres."

Zervos. 1951, vol. IV, no. 165 and pl. 52 (*Trois baigneuses*, pastel, 49 x 64 cm).

41.

DINARD

summer 1922

Pencil on wove gray-blue paper, 42.2 x 29.4 cm (16 ⅛ x 11 %₆ inches)
Thannhauser Collection, Gift, Justin K. Thannhauser
78.2514.50

Signed lower left: Picasso
Not dated.

PROVENANCE

Acquired from the artist by Paul Rosenberg, Paris, in 1926; purchased from Rosenberg by J. K. Thannhauser by 1932.

CONDITION

This drawing was removed from its old mount and deacidified in 1973. There are some distortions and the paper support is yellowed, particularly in the center. The left edge is serrated. There is some slight foxing, but the general condition appears to be stable (Aug. 2000).

EXHIBITIONS

1927. Paris, Paul Rosenberg. *Exposition de cent dessins par Picasso.* June–July. Probably no. 73 (*Vue de Saint-Servan*, 1921).

1932. Kunsthaus Zürich. *Picasso.* Sept. 11–Oct. 30. No. 319 (*Blick auf Saint-Servan*, ca. 1921).

1934. Buenos Aires, Galería Müller. *Picasso.* Oct. No. 43 (label on reverse reads: *Vista de Servan*, 1921).

1957. New York, The Museum of Modern Art. *Picasso: 75th Anniversary Exhibition.* May 22–Sept. 8. P. 54, repr. (*St. Servan, near Dinard*, 1922). Traveled to the Art Institute of Chicago, Oct. 29–Dec. 8.

1958. Philadelphia Museum of Art. *Picasso.* Jan. 8–Feb. 23. No. 105, repr. (*St. Servan, near Dinard*).

1965. New York, Solomon R. Guggenheim Museum. P. 59, no. 54, repr.

1978. New York, Solomon R. Guggenheim Museum.

1989. New York, Solomon R. Guggenheim Museum.

1999. Paris, Palais des Arts. *Picasso à Dinard.* June 19–Sept. 19.

REFERENCES

Cassou. 1940, p. 28, repr. (*View of St. Servan*).

Solomon R. Guggenheim Museum. 1972, p. 61, repr. (*Saint-Servan, near Dinard*).

Solmi, S. *Disegni di Picasso.* Milan, 1945, pl. xxii (*Veduta di St. Servan*).

Zervos. 1951, vol. IV, no. 375 and pl. 153 (*Vue de Dinard*, incorrect medium listed).

42.

WOMAN IN AN ARMCHAIR (FEMME DANS UN FAUTEUIL)
1922

Oil on canvas, 91.5 x 62.5 cm (36 x 24 ⅛ inches)
Thannhauser Collection, Bequest, Hilde Thannhauser
91.3915

Signed upper right: Picasso
Not dated.

PROVENANCE
Acquired from the artist by J. K. Thannhauser, May 10, 1938; Hilde Thannhauser, 1976–91.

CONDITION
The work is a thinly painted monochromatic oil on canvas with an open weave. It has an unusually taut quality and some weave enhancement, although the painting is not lined. The painting is in good condition overall. There is an old strip lining on the work, and a few small old tears. A glossy yellow varnish was removed in 1998. This cleaning revealed the overall rose tonality of the painting (Aug. 1999).

EXHIBITIONS
1978. Kunstmuseum Bern. P. 82, cat. no. 41, repr., and p. 111, no. 41.

REFERENCES
Zervos. 1951, vol. IV, p. 162, no. 391, repr.

43.

TABLE BEFORE THE WINDOW (TABLE DEVANT LA FENÊTRE)
1922

Watercolor and pencil on laid paper, 14.1 x 11 cm (5 ⁹⁄₁₆ x 4 ⁵⁄₁₆ inches)
Thannhauser Collection, Gift, Justin K. Thannhauser
78.2514.51

Signed and dated upper right: Picasso / 22

PROVENANCE
Purchased from Galerie Simon (D.-H. Kahnweiler), Paris, by J. K. Thannhauser, June 1929.

CONDITION
Some areas of this drawing, particularly the top and left edges, are strongly discolored. In 1973 the drawing was removed from its old mount, deacidified, and remounted to a rag board. All edges are lifting and the paper support is distorted. The top edge is serrated. The condition is stable (Aug. 2000).

EXHIBITIONS
1932. Kunsthaus Zürich. *Picasso.* Sept. 11–Oct. 30. No. 323.

1934. Buenos Aires, Galería Müller. *Picasso.* Oct. No. 25.

1939. Adelaide, The National Art Gallery. *Exhibition of French and British Contemporary Art.* Opened Aug. 21. No. 90. Traveled to Melbourne, Town Hall, opened Oct. 16, and Sydney, David Jones, opened Nov. 20.

1965. New York, Solomon R. Guggenheim Museum. P. 57, no. 55, color repr.

1978. New York, Solomon R. Guggenheim Museum.

1989. New York, Solomon R. Guggenheim Museum.

1992. New York, Solomon R. Guggenheim Museum.

1998. New York, Solomon R. Guggenheim Museum.

1998. Deutsche Guggenheim Berlin. Pp. 172–73, no. 65, color repr. (*Tisch vor dem Fenster*). English ed.: pp. 172–73, no. 65, color repr. Spanish ed.: pp. 198–99, no. 75, color repr. (*Mesa frente a la ventana*).

REFERENCES
Cassou. 1940, p. 116, repr., and p. 166.

Solomon R. Guggenheim Museum. 1972, p. 63, repr.

Picasso: Fifteen Drawings. New York, 1946, pl. 11.

Zervos. 1951, vol. IV, no. 432 and pl. 179 (*Table devant la fenêtre*, incorrect medium listed).

44.

THE TABLE (LE GUÉRIDON)
December 24, 1922

Watercolor and gouache on laid paper, 16.3 x 10.3 cm (6 ⁷⁄₁₆ x 4 ¹⁄₁₆ inches)
Thannhauser Collection, Gift, Justin K. Thannhauser
78.2514.52

Signed lower right: Picasso
Dated on reverse:
24 Decembre / 1922

PROVENANCE
Purchased from the artist by Galerie Louise Leiris, Paris, 1952; purchased from Galerie Leiris by Mrs. Jaray, London, Oct. 1953; Curt Valentin Gallery, New York; acquired from Valentin by J. K. Thannhauser.

CONDITION
There is a fairly severe warping of the support. The overall condition of the primary support, which is a good-quality, heavy paper, and of the medium, which is watercolor and gouache, are otherwise stable (Aug. 1999).

EXHIBITIONS
1965. New York, Solomon R. Guggenheim Museum. P. 57, no. 56, color repr.

1978. New York, Solomon R. Guggenheim Museum.

1992. New York, Solomon R. Guggenheim Museum.

REFERENCES

Solomon R. Guggenheim
Museum. 1972, p. 62, repr.

Zervos. 1975, vol. XXX, no. 425
and pl. 135 (*Nature morte sur une
table ronde*).

45.
TWO GROUPS OF BATHERS (DEUX GROUPES DE BAIGNEUSES)

1923

Ink on wove paper, 25.9 x
35.2 cm (10 3/16 x 13 7/8 inches)
Thannhauser Collection, Gift,
Justin K. Thannhauser
78.2514.54

Signed lower right: Picasso
Not dated.

PROVENANCE

Purchased from the artist
by Paul Rosenberg, Paris,
1924 or 1925; probably
acquired from Rosenberg by
J. K. Thannhauser by 1932.

CONDITION

The primary support has been
mounted directly onto an acidic
board, which is causing the
original support to darken
severely. The borders of the
primary support are brighter
and show the support's original
color. There are several brown
foxing areas, and the support is
cockling slightly. The ink is
acidic (Aug. 1999).

EXHIBITIONS

1927. Paris, Paul Rosenberg.
*Exposition de cent dessins par
Picasso.* June–July. Probably
no. 61 (*Deux groupes de
baigneuses*).

1932. Kunsthaus Zürich. *Picasso.*
Sept. 11–Oct. 30. No. 343 (label
on reverse reads: *Zwei
Frauengruppen*).

1965. New York, Solomon R.
Guggenheim Museum. P. 59,
no. 58, repr.

1978. New York, Solomon R.
Guggenheim Museum.

1989. New York, Solomon R.
Guggenheim Museum.

1992. New York, Solomon R.
Guggenheim Museum.

REFERENCES

Solomon R. Guggenheim
Museum. 1972, p. 65, repr.

Zervos. 1952, vol. V, no. 18 and
pl. 12.

46.
THREE DANCERS (TROIS DANSEURS)

April 1925

India ink on wove paper, 34 x
24.8 cm (13 3/8 x 9 3/4 inches)
Thannhauser Collection, Gift,
Justin K. Thannhauser
78.2514.55

Signed and dated upper right:
Picasso / 25

PROVENANCE

Purchased from the artist by
Paul Rosenberg, Paris; acquired
from Rosenberg by G. F.
Reber; acquired from Reber by
Paul Adamidi Frascheri; J. K.
Thannhauser, New York.

CONDITION

This drawing was removed
from its old mount, deacidified,
and flattened in 1973. In 1978
some distortions of the support
were noted. The paper has been
yellowed by light exposure, and
there is some slight cockling
and some foxing stains. The
condition is fragile but stable
(Aug. 2000).

EXHIBITIONS

1965. New York, Solomon R.
Guggenheim Museum. P. 60,
no. 59, repr.

1978. New York, Solomon R.
Guggenheim Museum.

1989. New York, Solomon R.
Guggenheim Museum.

1992. New York, Solomon R.
Guggenheim Museum.

REFERENCES

Blunt, A. "Picasso's Classical
Period (1917–25)." *The Burlington
Magazine*, vol. CX, Apr. 1968,
p. 188.

Cooper, D. *Picasso Theatre*. New
York, 1968, p. 353 and pl. 358
(*Three Dancers Resting*, not
signed or dated).

George, W. *Picasso Dessins.*
Paris, 1926, pl. 27 (not signed or
dated; pls. 23–64 of "Album
inédit de l'artiste [1925]").

Solomon R. Guggenheim
Museum. 1972, p. 66, repr.

Zervos. 1952, vol. V, no. 431 and
pl. 173 (*Trois danseurs*, signed
and dated 1925).

47.
BIRD ON A TREE (L'OISEAU)

August 1928

Oil on canvas, 34.9 x 24.1 cm
(13 3/4 x 9 1/2 inches)
Thannhauser Collection, Gift,
Justin K. Thannhauser
78.2514.57

Signed and dated upper right:
Picasso / 28

PROVENANCE

Acquired from the artist by
J. K. Thannhauser by 1930.

CONDITION

The painting is not lined or
varnished. Minor repairs were
made at the lower left and
lower right prior to 1965.
Local consolidation and minor
filling and inpainting of small
losses were carried out in 1986
(Mar. 1992).

EXHIBITIONS

1932. Kunsthaus Zürich. *Picasso.*
Sept. 11–Oct. 30. No. 177.

1934. Buenos Aires, Galería
Müller. *Picasso.* Oct. No. 15.

1965. New York, Solomon R. Guggenheim Museum. P. 62, no. 62, repr.

1978. New York, Solomon R. Guggenheim Museum.

1987–88a. New York, Solomon R. Guggenheim Museum. No. 86, repr.

1989. New York, Solomon R. Guggenheim Museum.

1990. Venice, Palazzo Grassi. Pp. 112 and 114–15, no. A30, color repr.

REFERENCES

Bernier, G. "Humorage à Picasso." *L'Oeil*, nos. 217–18, Aug.–Sept. 1973, p. 44, repr.

Cahiers d'Art, 7ᵉ année, nos. 3–5, 1932, p. 177, repr. (*L'Oiseau sur la branche*; not signed or dated).

Cassou. 1940. p. 134, repr., and p. 167 (*Bird on a Branch*).

Daix. 1965, pp. 138, 139, repr., and p. 266.

Documents. Vol. 2, no. 3, 1930, p. 126, repr.

Elgar, F., and R. Maillard. *Picasso*. Trans. F. Scarfe. Rev. ed. New York, 1972, p. 212, repr.

Eluard, P. *A Pablo Picasso*. Geneva and Paris, 1944, p. 112, repr.

———. *Pablo Picasso*. New York, 1947, p. 112, repr.

Solomon R. Guggenheim Museum. 1972, p. 68, repr.

Runnqvist, J. *Minotauros*. Stockholm, 1959, pp. 90–91, pl. 99.

Zervos, C. "Picasso à Dinard été 1928." *Cahiers d'Art*, 4ᵉ année, no. 1, 1929, p. 7, repr. upside down (not signed or dated; caption reads: "Dinard, 13 août 1928").

———. *Pablo Picasso*. Milan, 1932, pl. xxiv.

———. *Pablo Picasso*. Milan, 1937, pl. xxii.

———. 1955, vol. VII, no. 217 and pl. 85 (*L'Oiseau*, Dinard, Aug. 13, 1928).

48.
WOMAN WITH YELLOW HAIR (FEMME AUX CHEVEUX JAUNES)
December 1931

Oil on canvas, 100 x 81 cm (39 ⅜ x 31 ⅞ inches)
Thannhauser Collection, Gift, Justin K. Thannhauser
78.2514.59

Signed lower left: Picasso
Dated on reverse of stretcher:
27 Decembre / M.CM.XXXI

PROVENANCE
Acquired from the artist by J. K. Thannhauser, Paris, 1937.

CONDITION
This work is in excellent condition. The canvas is unlined and is worn in all four corners. There is a small repair in the top left and a crack and very superficial scuff toward the center of the left edge along the stretcher bar. The ground has fine cracks in some areas along the foldover. There is some minor superficial abrasion at the bottom left and right. The painting has a glossy varnish (Aug. 1999).

EXHIBITIONS
1939–40. New York, The Museum of Modern Art. *Picasso: Forty Years of His Art*. Nov. 15, 1939–Jan. 7, 1940. P. 158, no. 250 (*Woman Sleeping*, 1932). Traveled to the Art Institute of Chicago, Feb. 1– Mar. 3, and San Francisco Museum of Art, June 25– July 22.

1944. Buffalo, Albright Art Gallery. *French Paintings of the Twentieth Century, 1900–1939*. Dec. 6–31. No. 50 (*Woman Sleeping*). Traveled to the Cincinnati Art Museum, Jan. 18–Feb. 18, 1945, and City Art Museum of St. Louis, Mar. 8–Apr. 16, 1945.

1953. Santa Barbara Museum of Art. *Fiesta Exhibition, 1953: Picasso, Gris, Miró, Dalí*. Aug. 4–30. No. 29 (*Woman Sleeping*, 1932).

1965. New York, Solomon R. Guggenheim Museum. P. 64, no. 65, color repr.

1978. New York, Solomon R. Guggenheim Museum.

1986. New York, Solomon R. Guggenheim Museum.

1987–88a. New York, Solomon R. Guggenheim Museum. No. 89, color repr.

1989. New York, Solomon R. Guggenheim Museum.

1990. Venice, Palazzo Grassi. Pp. 56–57, no. A1, color repr.

1992. The Montreal Museum of Fine Arts. Pp. 74–75, no. 10, color repr.

1992. New York, Solomon R. Guggenheim Museum.

1998–99. New York, Solomon R. Guggenheim Museum. *Rendezvous: Masterpieces from the Centre Georges Pompidou and the Guggenheim Museums*. Oct. 16– Jan. 24. P. 235, no. 95, color repr.

1999. Fort Worth, Kimbell Art Museum. *Matisse and Picasso: A Gentle Rivalry*. Jan. 31–May 9. Exh. cat., *Matisse & Picasso*, by Yve-Alain Bois, p. 138, fig. 127.

REFERENCES
Barnett. 1980. pp. 68–69, no. 22, repr.

Cassou. 1940, p. 137, color repr. (*Woman Asleep*).

Daix. 1977, p. 237, fn. 10, and pl. 32 (*Femme endormie*).

de Champris, P. *Picasso: Ombre et soleil*. Paris, 1960, pp. 128, 290, and pl. 132 (*Femme endormie*).

Solomon R. Guggenheim Museum. 1972, p. 70, repr.

Guggenheim Museum. 1992, p. 213, color repr.

Guggenheim Museum. 1993, p. 21, pl. 6.

Nochlin, L. "Picasso's Color: Schemes and Gambits." *Art in America*, vol. 68, no. 10, Dec. 1980, p. 119, fig. 17, cover, and p. 178.

Porzio, D., and M. Valsecchi. *Understanding Picasso*. New York, 1974, p. 10, repr. (1931–32).

Rubin, W. *Picasso in the Collection of The Museum of Modern Art*. New York, 1972, p. 226, fig. 108 (*Woman with Blond Hair*).

Schiff, G. *Picasso at Work at Home: Selections from the Marina Picasso Collection*. Exh. cat., Center for the Fine Arts, Miami, 1985, pp. 68 and 83.

Zervos. 1955, vol. VII, no. 333 and pl. 138 (*La Femme aux cheveux jaunes*).

49.
STILL LIFE: FRUIT DISH AND PITCHER (NATURE MORTE: COMPOTIER ET CRUCHE)
January 21–22, 1937

Enamel on canvas, 49.8 x 60.8 cm (19 ⅝ x 23 ¹⁵⁄₁₆ inches)
Thannhauser Collection, Gift, Justin K. Thannhauser
78.2514.61

Signed and dated upper left: 21 janvier XXXVII / Picasso
Dated on stretcher upper right: 22 janvier XXXVII

PROVENANCE
Purchased from the artist by Paul Rosenberg, Paris, 1938; on consignment to Bignou Gallery, New York, ca. 1939; purchased from Paul Rosenberg, New York, by Vladimir Golschmann between Feb. 1944 and Oct. 1947; Mary Callery, probably late 1947 or 1948–56; Perls Galleries, New York, Apr. 1956–57; purchased from Perls Galleries by J. K. Thannhauser, Feb. 1957.

CONDITION
This work is painted on a medium-weight, somewhat open-weave unlined canvas. The paint is fairly thinly applied. There is a repair in the upper left in the area of the fruit dish (Aug. 2000).

EXHIBITIONS
1939–40. New York, The Museum of Modern Art. *Picasso: Forty Years of His Art*. Nov. 15–Jan. 7. P. 172, no. 277 (*Still Life*, dated Jan. 21, 1937, lent by the Bignou Gallery, on consignment from Paul Rosenberg). Traveled to the Art Institute of Chicago, Feb. 1–Mar. 3, 1940.

1947. Cincinnati Modern Art Society. *Golschmann Collection*. Apr. 30–June 1 (probably *Still Life*, 1937, oil).

1947. New York, Rosenberg Galleries. *Vladimir Golschmann Collection*. Oct. 6–25. No. 14 (*Table bleue, orange, jaune et blanche*, 1937, 19 ½ x 23 ¼ inches).

1957. New York, The Museum of Modern Art. *Picasso: 75th Anniversary Exhibition*. May 22–Sept. 8. Addenda p. 115, repr. (*Fruit Dish and Pitcher*). Traveled to the Art Institute of Chicago, Oct. 29–Dec. 8.

1958. Philadelphia Museum of Art. *Picasso*. Jan. 8–Feb. 23. No. 192, repr. (*Fruit Dish and Pitcher*).

1965. New York, Solomon R. Guggenheim Museum. P. 66, no. 67, color repr.

1978. New York, Solomon R. Guggenheim Museum.

1989. New York, Solomon R. Guggenheim Museum.

1998. New York, Solomon R. Guggenheim Museum.

REFERENCES
Daix. 1977, p. 273, fn. 9.

Solomon R. Guggenheim Museum. 1972, p. 72, repr.

Merli, J. *Picasso, el artista y la obra de nuestro tiempo*. Rev. ed. Buenos Aires, 1948, pl. 447.

Zervos. 1957, vol. VIII, no. 329 and pl. 154 (*Nature morte*).

50.
STILL LIFE: FRUITS AND PITCHER (NATURE MORTE: FRUITS AUG)
January 22, 1939

Oil and enamel (?) on canvas, 27.2 x 41 cm (10 ¾ x 16 ⅛ inches)
Thannhauser Collection, Gift, Hilde Thannhauser
84.3231

Signed and dated upper left: 22.1.39 / Picasso
Dated on reverse of stretcher 22.1.39

PROVENANCE
Probably acquired from the artist by Paul Rosenberg, New York; J. K. Thannhauser, New York, probably 1940s; Hilde Thannhauser, Bern, 1976–84.

CONDITION
This work is in very good condition. It is painted on fine, unlined canvas. There are slight distortions in the support. The paint is thinly applied, with some low impasto around the forms. The outlines of the

forms were incised into the paint when it was wet. There is no varnish layer (Aug. 2000).

EXHIBITIONS

1978. Kunstmuseum Bern. P. 89, cat. no. 48, repr., and p. 112 (*Nature morte, fruits Aug*).

1998. New York, Solomon R. Guggenheim Museum.

REFERENCES

Zervos. 1958, vol. IX, no. 260, p. 124, repr. (*Nature Morte. Fruits et Pot*).

51.
HEAD OF A WOMAN (DORA MAAR) (TÊTE DE FEMME [DORA MAAR])
March 28, 1939

Oil on wood panel, 59.8 x 45.1 cm (23 ⁹⁄₁₆ x 17 ¾ inches)
Thannhauser Collection, Gift, Justin K. Thannhauser, 1978
78.2514.62

Signed and dated lower right:
Picasso / 39
Dated on reverse: 28.3.39

PROVENANCE

Purchased from the artist by Paul Rosenberg, Paris, 1939; purchased from Paul Rosenberg, New York, by Keith Warner, Oct. 1943; G. David Thompson, Pittsburgh; J. K. Thannhauser.

CONDITION

The panel, which is warped, has veneer on each side of the plywood core; its total thickness is approximately one-quarter inch. The pattern of cracks follows the grain of the veneer. The panel's unpainted surface is visible in places in the woman's hair (May 1975).

EXHIBITIONS

1939–40. New York, The Museum of Modern Art. *Picasso: Forty Years of His Art.* Nov. 15–Jan. 7. P. 190, no. 360 (*Girl with Blond Hair*, Paris,

dated Mar. 28, 1939, lent by Rosenberg and Helft, Ltd.). Traveled to the Art Institute of Chicago, Feb. 1–Mar. 3, 1940, and San Francisco Museum of Art, June 25–July 22, 1940.

1965. New York, Solomon R. Guggenheim Museum. P. 67, no. 69, color repr.

1978. New York, Solomon R. Guggenheim Museum.

1986. New York, Solomon R. Guggenheim Museum.

1987–88a. New York, Solomon R. Guggenheim Museum. No. 92, repr.

1989. New York, Solomon R. Guggenheim Museum.

1992. New York, Solomon R. Guggenheim Museum.

1998–99. San Francisco, Fine Arts Museums of San Francisco, California Palace of the Legion of Honor. *Picasso and the War Years: 1937–1945.* Oct. 10–Jan. 3. P. 149, cat. no. 28. Traveled to Solomon R. Guggenheim Museum, New York, Feb. 5–May 9, 1999.

REFERENCES

Solomon R. Guggenheim Museum. 1972, p. 75, repr.

52.
FRANÇOISE GILOT
September 9, 1947

Sanguine on wove paper, 65.9 x 50.5 cm (25 ¹¹⁄₁₆ x 19 ⅞ inches)
Thannhauser Collection, Gift, Justin K. Thannhauser
78.2514.63

Signed and dated lower left:
Golfe-Juan 9 septembre 47
Picasso

PROVENANCE

Purchased from the artist by J. K. Thannhauser, Sept. 1947.

CONDITION

The primary support is a thick sheet with irregular borders. This work has been matted onto a very acidic board, probably for a long time. For this reason, the primary support is unevenly darkened and has become more acidic and fragile. The medium is in good condition (Aug. 1999).

EXHIBITIONS

1965. New York, Solomon R. Guggenheim Museum. P. 69, no. 71, color repr.

1978. New York, Solomon R. Guggenheim Museum.

1989. New York, Solomon R. Guggenheim Museum.

REFERENCES

Solomon R. Guggenheim Museum. 1972, p. 74, repr.

Zervos. 1965, vol. XV, no. 73 and pl. 43 (*Tête de femme*).

53.
GARDEN IN VALLAURIS (JARDIN À VALLAURIS)
June 10, 1953

Oil on canvas, 18.7 x 26.7 cm (7 ⅜ x 10 ½ inches)
Thannhauser Collection, Gift, Justin K. Thannhauser
78.2514.64

Signed lower right: Picasso
Dated upper right: 10 / juin / 53
Inscribed on reverse: 1

PROVENANCE

Acquired from the artist by Galerie Louise Leiris, Paris, 1953; purchased from Galerie Leiris by Curt Valentin, New York, Jan. 1954; purchased from Valentin by J. K. Thannhauser shortly thereafter.

CONDITION

This painting is in good condition. The work was surface-cleaned in 1978. There are several tiny losses and abrasions along the edges and in the corners. It is not varnished (Mar. 1999).

EXHIBITIONS

1953. New York, Curt Valentin Gallery. *Pablo Picasso 1950–1953*. Nov. 24–Dec. 19. No. 24 (*Pinetree and Palmtree*, 1953, 7 ½ x 11 inches).

1965. New York, Solomon R. Guggenheim Museum. P. 70, no. 72, color repr.

1978. New York, Solomon R. Guggenheim Museum.

1987–88a. New York, Solomon R. Guggenheim Museum. No. 93, repr.

1989. New York, Solomon R. Guggenheim Museum.

REFERENCES

Gallwitz, K. *Picasso at 90: The Late Work*. New York, 1971, p. 66 and pl. 67 (*Pine and Palm*).

Solomon R. Guggenheim Museum. 1972, p. 75, repr.

Curt Valentin Gallery, New York. *Picasso*. N.d., vol. IV of unpublished "Black Albums" of photographs on deposit at the Museum of Modern Art, New York, [p. 61], repr. (no. 15722, *Pine Tree and Palm Tree*).

Zervos. 1965, vol. XV, no. 272 and pl. 150 (*Paysage de Vallauris*).

54.
TWO DOVES WITH WINGS SPREAD (DEUX PIGEONS AUX AILES DÉPLOYÉES)
March 16–19, 1960

Oil on linen, 59.7 x 73 cm (23 ⁹⁄₁₆ x 28 ¾ inches)
Thannhauser Collection, Gift, Justin K. Thannhauser
78.2514.66

Signed upper left: Picasso
Dated on reverse: 16.3.60 / 19. / I

PROVENANCE

Acquired from the artist by J. K. Thannhauser, Sept. 1960.

CONDITION

This painting is not varnished. The unpainted support is visible in places. There is considerable impasto in other areas, especially in the center, between the doves (May 1975).

EXHIBITIONS

1965. New York, Solomon R. Guggenheim Museum. P. 73, no. 75, color repr.

1978. New York, Solomon R. Guggenheim Museum.

1987–88a. New York, Solomon R. Guggenheim Museum. No. 94, repr.

1989. New York, Solomon R. Guggenheim Museum.

REFERENCES

Barnett, V. E. "The Thannhauser Collection." In *From Van Gogh to Picasso, From Kandinsky to Pollock, Masterpieces of Modern Art*. Exh. cat., Solomon R. Guggenheim Museum, New York, 1990, p. 53.

Solomon R. Guggenheim Museum. 1972, p. 77, repr.

Zervos. 1968, vol. XIX, no. 220 and pl. 65 (*Deux pigeons aux ailes déployées*).

55.
LOBSTER AND CAT (LE HOMARD ET LE CHAT)
January 11, 1965

Oil on canvas, 73 x 92 cm (28 ¼ x 36 ¼ inches)
Thannhauser Collection, Bequest, Hilde Thannhauser
91.3916

Signed and inscribed upper left: Pour Justin / Thannhauser / so [sic] ami / Picasso
Dated on reverse: 11.1.65 / III

PROVENANCE

Gift of the artist to J. K. and Hilde Thannhauser, Sept. 1, 1965; Hilde Thannhauser, 1976–91.

CONDITION

This work is in excellent condition. It is unlined and stretched on its original stretcher. There is a small paint loss down to the canvas on the right claw of the lobster. The inscription and signature have a precisely applied glossy surface coating, but the rest of the picture is unvarnished (Aug. 1999).

EXHIBITION

1978. Kunstmuseum Bern. P. 95, cat. no. 55, color repr., and p. 112, no. 55 (*Le Homard et le Chat*).

REFERENCES

"Ausstellung der Sammlung Justin Thannhauser im Kunstmuseum Bern (Ansprache von Herrn Botschafter Paul R. Jolles bei der Eröffnung der Ausstellung am 7. Juni 1978," *Berner Kunstmitteilungen*, no. 184, Aug.–Sept. 1978, p. 3 (*Le Homard et le Chat*).

Zervos. 1972, vol. XXV, p. 6, no. 10, repr. (*Le Homard et le Chat*).

CAMILLE PISSARRO

1830–1903

Jacob Camille Pissarro was born on July 10, 1830, to French Jewish parents on the West Indies island of St. Thomas. Sent to boarding school in France, he returned after six years to work in his parents' store. Pissarro abandoned this comfortable bourgeois existence at the age of twenty-two, when he left for Caracas with Danish painter Fritz Melbye, who became his first serious artistic influence.

After returning briefly to St. Thomas, Pissarro left in 1855 for Paris, where he studied at various academic institutions (including the Ecole des Beaux-Arts and Académie Suisse) and under a succession of masters (including Jean-Baptiste-Camille Corot, Gustave Courbet, and Charles-François Daubigny). Corot is often considered Pissarro's most important early influence; Pissarro listed himself as Corot's pupil in the catalogues to the 1864 and 1865 Paris Salons. While Pissarro was accepted to show at the official Salon throughout the 1860s, in 1863 he participated with Edouard Manet, James Abbott McNeill Whistler, and others in the historic Salon des Refusés. At the close of the decade, he moved to Louveciennes (near the Seine, twenty miles from Paris). Working in close proximity with Claude Monet, Pierre Auguste Renoir, and Alfred Sisley, he began to revise his method of landscape painting, privileging the role of color in his expression of natural phenomena and employing smaller patches of paint. This artistic circle was dispersed by the Franco-Prussian War, which Pissarro

fled by moving to London in 1870-71. There he met Paul Durand-Ruel, the Parisian dealer who would become an ardent supporter of Pissarro and his fellow Impressionists. Pissarro participated in his last official Salon in 1870.

The years after Pissarro's return to France were seminal ones. He settled in Pontoise, where he received young artists seeking advice, including Paul Cézanne and Paul Gauguin. He took part in the first Impressionist exhibition in 1874. Pissarro—along with Edgar Degas, one of the Salon's most passionate critics—was the only artist to show at all eight of the Impressionist exhibitions, the last of which took place in 1886.

Pissarro experienced somewhat of an artistic crisis in 1885. As he had done consistently throughout his career, he opened himself up to fresh influences by meeting with the younger generation, this time with Paul Signac and Georges Seurat, who were experimenting with a divisionist technique rooted in the scientific study of optics.

Pissarro lived long enough to witness the start of the Impressionists' fame and influence. He was revered by the Post-Impressionists, including Cézanne and Gauguin, who both referred to him toward the end of their own careers as their "master." In the last years of his life, Pissarro experienced eye trouble, which forced him to abandon outdoor painting. He continued to work in his studio until his death in Paris on November 13, 1903.

Camille Pissarro in his studio at Eragny, ca. 1900.

56.
THE HERMITAGE AT PONTOISE (LES CÔTEAUX DE L'HERMITAGE, PONTOISE)
ca. 1867

Oil on canvas, 151.4 x 200.6 cm (59 ⅝ x 79 inches)
Thannhauser Collection, Gift, Justin K. Thannhauser
78.2514.67

Signed at lower left: C. Pissarro
Not dated.

PROVENANCE
Acquired probably from Durand-Ruel or from the artist by J.-B. Faure by 1876; purchased from Faure by Durand-Ruel, Paris, June 1901; sold to Cassirer, June 1901; acquired by Moderne Galerie Heinrich Thannhauser by 1918; J. K. Thannhauser.

CONDITION
The painting is unlined and is on the original stretcher. There is a horizontal seam across the entire width, thirteen and one-half inches up from the bottom, where two pieces of canvas were joined. The painting was cleaned and revarnished in 1990. Very minor filling and inpainting were done along the top edge (Mar. 1992).

EXHIBITIONS
1868. Paris, Salon of 1868. No. 2016 (?).

1927. Berlin, Künstlerhaus (organized by Galerien Thannhauser, Berlin). *Erste Sonderausstellung in Berlin.* Jan. 9–Feb. 15. No. 189, repr. (*Pontoise*).

1930. Paris, Musée de l'Orangerie. *Centenaire de la naissance de Camille Pissarro.* Feb.–Mar. No. 10 (*Pontoise*).

1939–40. Buenos Aires, Museo Nacional de Bellas Artes. *La pintura francesa de David a*

nuestros días. July–Aug. No. 106 (*Vista de Pontoise*). Traveled to Montevideo, Ministerio de Instrucción Pública, Apr.–May 1940 (label on reverse); Rio de Janeiro, Museu Nacional de Belas Artes, June 29–Aug. 15 (label on reverse of frame); San Francisco, M. H. De Young Memorial Museum (*The Painting of France Since the French Revolution*), Dec. 1940–Jan. 1941 (no. 82, repr. [*View of Pontoise*]); and Los Angeles County Museum (*The Painting of France Since the French Revolution*), June–July 1941 (no. 104, repr. [*View of Pontoise*]).

1941. Worcester, Mass., Worcester Art Museum. *The Art of the Third Republic; French Painting 1870-1940*. Feb. 22–Mar. 16. No. 1, repr. (*View of Pontoise*, ca. 1870).

1941. The Art Institute of Chicago. *Masterpieces of French Art*. Apr. 10–May 20. Pl. XXVII, no. 123 (*View of Pontoise*).

1941. The Portland Art Museum. *Masterpieces of French Painting*. Sept. 3–Oct. 5. No. 86 (*View of Pontoise*).

1942–45. Washington, D.C., The National Gallery of Art. On loan. Feb. 1942–June 1945.

1945–46. New York, The Museum of Modern Art. On loan from Aug. 1945–July 1946.

1946. Pittsfield, Mass., The Berkshire Museum. *French Impressionist Painting*. Aug. 2–31. No. 13.

1965. New York, Solomon R. Guggenheim Museum. P. 14, no. 2, color repr.

1978. New York, Solomon R. Guggenheim Museum.

1981. Boston, Museum of Fine Arts. *Camille Pissarro:*

The Unexplored Impressionist. May 19–Aug. 9. Exh cat., *Pissarro: Camille Pissarro: 1830–1903*, p. 77, no. 11, repr. (*The Hillsides of L'Hermitage, Pontoise*, ca. 1867–68).

1987–88a. New York, Solomon R. Guggenheim Museum. No. 1, color repr.

1989. New York, Solomon R. Guggenheim Museum.

1992. New York, Solomon R. Guggenheim Museum.

1994–95. New York, The Metropolitan Museum of Art. *The Origins of Impressionism*. Sept. 27–Jan. 8. P. 447, no. 161, repr. (*L'Hermitage*, ca. 1868).

REFERENCES

Barnett. 1980, p. 13, fig. 1.

Champa, K. S. *Studies in Early Impressionism*. New Haven and London, 1973, pp. 75–77 and fig. 109.

Daulte, F. "Une Donation sans précédent: la collection Thannhauser." *Connaissance des Arts*, no. 171, May 1966, pp. 60–61, color repr. (*Les Côteaux de L'Hermitage à Pontoise*).

de Roux, P. *Pissarro: Villes et Campagnes*. Paris, 1995, cover, pp. 18–19, color repr. (*Les Côteaux de l'Hermitage, Pontoise*, ca. 1868).

Duret, T. *Die Impressionisten*. Berlin, 1923, p. 91, repr. (*Landschaft*).

Fontainas, A., and Louis Vauxcelles. *Histoire générale de l'art français de la Révolution à nos jours*. Paris, 1922, vol. I, p. 162, repr. (*Les Coteaux de l'Hermitage*).

Solomon R. Guggenheim Museum. 1972, p. 10, repr.

Guggenheim Museum. 1992, pp. 214–15, color repr.

Holl, J.-C. *Camille Pissarro.*

Paris, [1911], p. 41, repr. (*Les Côteaux de L'Ermitage, Pontoise*).

Kirchbach, W. "Pissarro und Raffaëli." *Die Kunst unserer Zeit*, jg. 15, 1904, p. 124, repr. (*Die Ermitage in Pontoise*).

Kunstler, C. *Pissarro Cities and Landscapes*. Trans. E. Kramer. Lausanne, 1967, pl. 1 (*Slopes at the Hermitage, Pontoise*).

Lloyd, C. *Camille Pissarro*. Geneva and New York, 1981, p. 30, repr., and pp. 31–32, 145 (*The Hillsides of L'Hermitage, Pontoise*).

Meier-Graefe, J. "Camille Pissarro." *Kunst und Künstler*, jg. 2, 1904, p. 483, repr. (*Hügellandschaft*).

Moderne Galerie Heinrich Thannhauser, Munich. *Nachtragswerk III*. 1918, p. 19, repr., and p. 119 (*Landschaft*, 150 x 200 cm).

Moffett, C. S. *Impressionist and Post-Impressionist Paintings in the Metropolitan Museum of Art*. New York, 1985, p. 85 (*Hillsides of l'Hermitage, Pontoise*).

Neumeyer, Alfred. "One Step Before Impressionism." *The Pacific Art Review*, vol. 1, no. 1, 1941, pp. 17–24, fig. 2 (*View of Pontoise*, 1872).

Osborn, H. "Klassiker der Französischen Moderne." *Deutsche Kunst und Dekoration*, vol. 59, Mar. 1927, p. 341, repr.

Palazzo dei Diamanti, Ferrara, Italy. *Camille Pissarro*. Exh. cat., 1998, pp. 24–25, fig. 13 (*L'Hermitage à Pontoise*, ca. 1867–68).

Paulsson, T. "From Rousseau to Pissarro: A Historical Link." In *Idea and Form: Studies in the History of Art*. Stockholm, 1959, p. 213, repr., and p. 214 (1867).

Pissarro, J. *Camille Pissarro*. New York, 1992, p. 6, repr., and pl. 2.

———. *Camille Pissarro.* New York, 1993, p. 51, pl. 45, and p. 52.

Pissarro, L. R., and L. Venturi. *Camille Pissarro: son art—son oeuvre.* Paris, 1939, vol. I, pp. 20, 86, no. 58, and vol. II, pl. 11, no. 58 (*Les Côteaux de l'Hermitage, Pontoise*). Reprint, San Francisco, 1989.

Reid, M. *Pissarro.* London, 1993, pp. 56–57, color repr., and p. 143.

Reidemeister, L. *Auf den Spuren der Maler der Ile de France.* Berlin, 1963, p. 39, repr.

Rewald, J. *The History of Impressionism.* Fourth rev. ed. New York, 1973, p. 159, repr.

———. "The Impressionist Brush." *The Metropolitan Museum of Art Bulletin*, vol. 32, no. 3, 1973–74, pp. 12–13, repr. and color repr. (detail).

Shikes, R. E., and P. Harper. *Pissarro: His Life and Work.* New York, 1980, pp. 73–74, repr., and p. 75 (*Hills of the Hermitage*).

PIERRE AUGUSTE RENOIR
1841–1919

Pierre Auguste Renoir was born on February 25, 1841, in Limoges and grew up in Paris. He worked as a commercial artist for several years and copied at the Musée du Louvre before entering the Ecole des Beaux-Arts in 1862 to study for one year with Emile Signol and Charles Gleyre. At Gleyre's private studio he met Frédéric Bazille, Claude Monet, and Alfred Sisley, who joined him in plein-air painting. In 1864 Renoir's first submission to the official Salon was accepted, and he began executing portrait commissions. The

following year he visited the village of Marlotte near the forest of Fontainebleau for the first of many summers; he also met Gustave Courbet. His work was accepted intermittently at the Salon until the early 1870s. In 1869 Renoir met Paul Alexis, Paul Cézanne, Edmond Duranty, the photographer Nadar (Félix Tournachon), and Emile Zola, and often painted with Monet. In 1871, after army service during the Franco-Prussian War, he returned to Paris. In 1872 Renoir met the dealer Paul Durand-Ruel and visited Gustave Caillebotte with Monet. He participated in the Salon des Refusés in 1873 and in the first Impressionist exhibition in 1874. He took part in the second, third, and seventh Impressionist shows of 1876, 1877, and 1882, but declined to show in the other four. Financial difficulties forced Renoir and other Impressionists to organize an auction of their work at the Hôtel Drouot in 1875.

During the late 1870s Renoir associated with Cézanne, Jules Champfleury, Paul Guillaumin, and the paint dealer Père Tanguy. From 1878 to 1883 he showed annually at the Salon. He visited Algeria and Italy in 1881–82. In 1883 Durand-Ruel gave him a solo exhibition. That same year Renoir traveled to the islands of Jersey and Guernsey and to L'Estaque to see Cézanne. He exhibited with the group Les XX in Brussels in 1885, 1886, and 1889. He began a lifelong association with Stéphane Mallarmé in 1887. In 1890 he participated in the Salon for the last time and was awarded the medal of the Légion d'Honneur. Despite failing health Renoir continued

to work until his death on December 3, 1919, in Cagnes.

57.
WOMAN WITH PARROT
(FEMME À LA PERRUCHE)
1871

Oil on canvas, 92.1 x 65.1 cm (36 ¼ x 25 ⅝ inches)
Thannhauser Collection, Gift, Justin K. Thannhauser
78.2514.68

Signed lower right: A. Renoir
Not dated.

PROVENANCE
C. Hoogendijk, The Hague, until 1912; purchased at Frederik Muller & Cie sale, Amsterdam, May 21–22, 1912, by Cassirer and Bernheim-Jeune; Modern Galerie Heinrich Thannhauser, Munich, by 1916; acquired by C. Tetzen Lund, Copenhagen, before 1921; Galerie Barbazanges, Paris, 1922; J. K. Thannhauser by 1927.

CONDITION
This painting was glue lined at an unknown date prior to 1965. There is moderate impasto in some areas, for example, in the sitter's head and hands and in the parrot. The skirt of the woman's dress is thinly painted. All edges show signs of considerable wear. There is an old repair in the lower right and some scattered areas of cleavage in the background. There is a heavy layer or layers of varnish (Jan. 1975).

EXHIBITIONS
1912. Berlin, Paul Cassirer. *XV. Jahrgang I. Ausstellung.* Oct.–Nov. No. 39.

1913. Paris, Bernheim-Jeune. *Renoir.* Mar. 10–29. No. 2.

1914. Dresden, Galerie Arnold. *Ausstellung Französischer Malerei des XIX Jahrhunderts.* Apr.–May. No. 99.

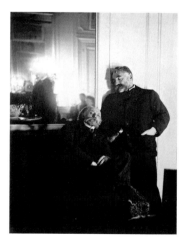

Pierre Auguste Renoir (left) and Stéphane Mallarmé, 1895, photographed by Edgar Degas.

1921. Oslo, Nasjonalgalleriet (arranged by Foreningen Fransk Kunst). *Renoir*. Feb. 12–Mar. 6. No. 4 (lent by Chr. Tetzen-Lund and ex. coll. H. Cassirer). Traveled to Copenhagen, Ny Carlsberg Glyptotek, Mar. 17–Apr. 10, and Stockholm, Nationalmuseum, Apr. 31–June 1.

1922. Paris, Palais du Louvre, Pavillon de Marsan. *Le Décor de la vie sous le Second Empire*. May 27–July 10. No. 149 (*Femme au Perroquet*, 1869, Galerie Barbazanges).

1927. Berlin, Künstlerhaus (organized by Galerien Thannhauser, Berlin). *Erste Sonderausstellung in Berlin*. Jan. 9–Feb. 15. No. 196, repr.

1938. Amsterdam, Stedelijk Museum. *Honderd Jaar Fransche Kunst*. July 2–Sept. 25. No. 200.

1939. Buenos Aires, Museo Nacional de Bellas Artes. *La pintura francesa de David a nuestros días*. July–Aug. No. 113. Traveled to Montevideo, Ministerio de Instrucción Pública, Apr.–May 1940; Rio de Janeiro, Museu Nacional de Belas Artes, June 29–Aug. 15; San Francisco, M. H. de Young Memorial Museum (*The Painting of France Since the French Revolution*), Dec. 1940–Jan. 1941 (no. 88, repr.); and Los Angeles County Museum (*The Painting of France Since the French Revolution*), June–July 1941 (no. 110).

1941. The Art Institute of Chicago. *Masterpieces of French Art*. Apr. 10–May 20. No. 130, repr.

1941. The Portland Art Museum. *Masterpieces of French Painting*. Sept. 3–Oct. 5. No. 91.

1942–46. Washington, D.C., The National Gallery of Art. On loan. Feb. 1942–July 1946.

1946. Pittsfield, Mass., The Berkshire Museum. *French Impressionist Painting*. Aug. 2–31. No. 20.

1955. Los Angeles County Museum. *Pierre Auguste Renoir*. July 14–Aug. 21. Cat. no. 9, repr., and p. 41 (ca. 1872). Traveled to San Francisco Museum of Art, Sept. 1–Oct. 2.

1965. New York, Solomon R. Guggenheim Museum. P. 15, no. 3, color repr.

1978. New York, Solomon R. Guggenheim Museum.

1987–88a. New York, Solomon R. Guggenheim Museum. No. 4, color repr.

1989. New York, Solomon R. Guggenheim Museum.

1990. New York, Solomon R. Guggenheim Museum.

1990. Venice, Palazzo Grassi. Pp. 116–17, no. A31, color repr.

1992. The Montreal Museum of Fine Arts. Pp. 56–57, no. 1, color repr.

1992. New York, Solomon R. Guggenheim Museum.

1998. Fort Worth, Kimbell Art Museum. *Renoir's Portraits*. Feb. 8–Apr. 26.

REFERENCES

Adler, K. *Manet*. Oxford, 1986, p. 89, fig. 80 (*Girl with a Parrot*).

Alazard, J. *Auguste Renoir*. Milan and Florence, 1953, no. 7, repr. (*La Femme au perroquet*, incorrectly states Hamburg Museum).

Basler, A. *Pierre-Auguste Renoir*. Paris, 1928, p. 15, repr.

Cooper, D. "Renoir, Lise and the Le Coeur Family: A Study of Renoir's Early Development—I. Lise." *The Burlington Magazine*, vol. CI,

May 1959, pp. 168–69 and 171, and fig. 12 (*Girl Feeding a Bird {Lise}*).

Daulte, F. "Une Donation sans précédent: la collection Thannhauser." *Connaissance des Arts*, no. 171, May 1966, p. 62, color repr. (*La Femme au perroquet*).

————. 1971, p. 36 and fig. 65 (*La Femme à la perruche*).

————. *Renoir*. Milan, 1971, p. 20, color repr., and p. 22 (*Donna con il pappagallo*). English ed.: Garden City, N.Y., 1973 (*Lady with a Parakeet*).

Frederik Muller & Cie, Amsterdam. *Catalogue des tableaux modernes*. Sale cat., May 21–22, 1912, no. 57.

Solomon R. Guggenheim Museum. 1972, p. 22, repr. (ca. 1872).

Guggenheim Museum. 1993, p. 88, pl. 11.

Hausenstein, W. *Katalog der Modernen Galerie, Heinrich Thannhauser München*. Munich, 1916, repr. betw. pp. 20–21 (*Dame mit Papagei*).

"La Jeunesse de Renoir." *Connaissance des Arts*, no. 34, Dec. 15, 1954, p. 70, repr.

Meier-Graefe, J. *Renoir*. Leipzig, 1929, p. 44, repr., and p. 437, no. 28 (*Die Dame mit dem Vogelbauer*, 1871–72).

Mirbeau, O. *Renoir*. Paris, Bernheim-Jeune, 1913, p. 55 and opp. p. ii, repr. (*La Femme à la perruche*, 1868).

Monneret, S. *Renoir*. Paris, 1989, p. 149, fig. 4 (*La Femme à la perruche*).

Osborn, M. "Klassiker der Französischen Moderne." *Deutsche Kunst und Dekoration*, vol. 59, Mar. 1927, p. 347, repr.

Roger-Marx, C. *Renoir*. Paris,

1933 and 1937, p. 31, repr. (*La femme à la perruche*, incorrectly states Musée de Hambourg).

Thiis, J. *Renoir.* Stockholm, 1944, p. 197, repr. (photo of 1921 exhibition of French art in Oslo).

Thomsen, O. *Chr. Tetzen-Lunds Samling af moderne fransk Malerkunst.* Copenhagen, 1934, no. 97 (*Dame avec un papegai*).

Vollard, A. "La Jeunesse de Renoir." *La Renaissance de l'art français et des industries de luxe.* Vol. I, May 1918, p. 17, repr. (*La Femme au Perroquet*, 1865).

58.
STILL LIFE: FLOWERS
(NATURE MORTE: FLEURS)
1885

Oil on canvas, 81.9 x 65.8 cm (32 ¼ x 25 ⅞ inches)
Thannhauser Collection, Gift, Justin K. Thannhauser
78.2514.70

Signed and dated lower right: Renoir. 85

PROVENANCE
Acquired by J. E. Blanche, probably from the artist; Walther Halvorsen, Oslo; Leicester Galleries, London, by 1926 (?); J. K. Thannhauser by 1927.

CONDITION
There is a thick, glossy, natural resin varnish on the surface that may be original. Scattered areas of lifting paint have been consolidated in the past. In 1986 the painting was cleaned of grime and the discolored varnish thinned very slightly in the area of the vase. In 1990 a linen loose-lining or dry backing was placed on the stretcher to provide support for the heavy paint layer and fine original linen (Mar. 1992).

EXHIBITIONS
1926. London, Leicester Galleries. *Catalogue of the Renoir Exhibition.* July–Aug. No. 3, repr. (*Fleurs*).

1927. Berlin, Künstlerhaus (organized by Galerien Thannhauser, Berlin). *Erste Sonderausstellung in Berlin.* Jan. 9–Feb. 25. No. 198, repr. (*Blumenstilleben*).

1955. Los Angeles County Museum. *Pierre Auguste Renoir.* July 14–Aug. 21. Cat. no. 33. Traveled to San Francisco Museum of Art, Sept. 1– Oct. 2 (*Still Life with Flowers and Pot*).

1958. Santa Barbara Museum of Art. *Fruits and Flowers in Painting.* Aug. 12–Sept. 14. No. 50, repr.

1965. New York, Solomon R. Guggenheim Museum. P. 22, no. 10, color repr.

1978. New York, Solomon R. Guggenheim Museum.

1987–88a. New York, Solomon R. Guggenheim Museum. No. 5, color repr.

1989. New York, Solomon R. Guggenheim Museum.

1990. New York, Solomon R. Guggenheim Museum.

1990. Venice, Palazzo Grassi. Pp. 118–19, no. A32, color repr.

REFERENCES
Solomon R. Guggenheim Museum. 1972, p. 26, repr.

Meier-Graefe, J. *Renoir.* Leipzig, 1929, p. 177, repr., and p. 441, no. 171 (*Blumen*).

White, B. E. "Renoir's Trip to Italy." *The Art Bulletin,* vol. LI, Dec. 1969, pp. 344–45, fn. 99 (*Still Life*).

————. "The *Bathers* of 1887 and Renoir's Anti-Impressionism." *The Art Bulletin,* vol. LV, Mar. 1973, p. 107, fn. 8 (*Still Life*).

————. *Renoir: His Life, Art, and Letters.* New York, 1984, p. 155, repr.

HENRI DE TOULOUSE-LAUTREC
1864–1901

Henri-Marie-Raymond de Toulouse-Lautrec-Montfa was born on November 24, 1864, in Albi, France, to Comte Alphonse-Charles de Toulouse-Lautrec-Montfa and Comtesse Adèle-Margarette-Zoë Tapié de Céleyran de Toulouse-Lautrec. As the confluence of names suggests, the two were first cousins, passing along to their son the rewards of an aristocratic lineage as well as the disabling effects of a rare genetic disorder. From early youth Toulouse-Lautrec suffered the consequences of an extreme skeletal fragility; by the age of fifteen both his thighbones had irremediably fractured. Despite periods of extended medical attention, he remained permanently crippled, walking with the assistance of a cane and with a wavering, ducklike gait.

The young Toulouse-Lautrec spent much of his childhood drawing, turning to art to pass the long hours of his frequent convalescences. Largely because of his disability, he was allowed by his family to pursue art as an occupation. (His grandfather, father, and uncles were all talented draftsmen, but approached drawing as a gentlemanly pastime.) In 1882 Toulouse-Lautrec moved with his mother to Paris, where he studied first with Léon Bonnat and later with Fernand Cormon. He grew close to

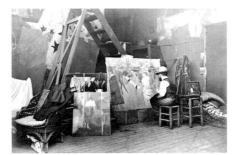

Henri de Toulouse-Lautrec.

Vincent van Gogh, who also studied with Cormon. Other influences included the prints of Honoré Daumier and Japonisme; Toulouse-Lautrec adapted Japanese print techniques, such as the incorporation of gold dust, in his own color lithography. He met with almost immediate critical and popular success, selling drawings to newspapers and magazines and illustrating books, programs, menus, and song sheets. Through *La Revue Blanche*, a periodical that published his illustrations, he came to know fellow contributors Pierre Bonnard and Edouard Vuillard. Their work compelled Toulouse-Lautrec toward greater abstraction and more simplified forms and colors.

By 1886 Toulouse-Lautrec had established a studio in Montmartre. Entering avidly into a life far removed from his own aristocratic beginnings, he became a raucous, alcohol-fueled habitué of local night spots such as the Moulin Rouge, and he began to document the louche world of nightclub performers, prostitutes, and dancers he found there. Despite his apparent descent into alcoholism and debauchery, Toulouse-Lautrec was in fact phenomenally productive, in ten years bringing forth more than five thousand drawings and seven hundred oils, as well as 275 watercolors and nearly four hundred posters. He participated in group shows, ranging from the formal, such as exhibiting with the Société des Peintres-Graveurs Français, to the subversive, such as the Salon des Arts Incohérents of 1886 and 1889 and the van Gogh–initiated Exposition du Petit Boulevard of 1887.

Toulouse-Lautrec also exhibited at the Salon des Indépendants, as well as with Les XX in Brussels, and with the dealers Louis Le Barc de Boutteville and Ambroise Vollard.

While Toulouse-Lautrec had first used alcohol in part to diminish his physical pain (at least one of his canes incorporated a flask), he soon came to suffer the effects of alcohol abuse. He grew increasingly erratic in his behavior and was institutionalized briefly toward the end of his life. He died on September 9, 1901, at the Château of Malromé of a cerebral hemorrhage attributed to alcoholism and syphilis.

59.
IN THE SALON (AU SALON)
1893

Pastel, gouache, and pencil on cardboard, 53 x 79.7 cm (20 ⅞ x 31 ⅛ inches)
Thannhauser Collection, Gift, Justin K. Thannhauser
78.2514.73

Signed lower right: H. T. Lautrec
Not dated.

PROVENANCE
Heim, Munich, until 1913; acquired at Hôtel Drouot sale, Paris, Apr. 30, 1913, by Georges Bernheim, Paris; S. Sévadjian until 1920; Baron Lafaurie by 1926; Mlle Lucie Callot; J. K. Thannhauser.

CONDITION
The primary support of this work has become darkened and is fragile. The mixed mediums (gouache, colored pencil, and especially pastel) are very delicate. The overall condition of this work is considered to be very fragile, though stable (Aug. 1999).

EXHIBITIONS
1943. Kunsthaus Zürich. *Ausländische Kunst in Zürich*. July 25–Sept. 26. No. 694 (80 x 52.7 cm).

1956. New York, The Museum of Modern Art. *Toulouse-Lautrec*. Mar. 20–May 6. No. 27 (*The Salon*).

1965. New York, Solomon R. Guggenheim Museum. P. 23, no. 23, color repr.

1978. New York, Solomon R. Guggenheim Museum.

1987–88a. New York, Solomon R. Guggenheim Museum. No. 20, color repr.

1989. New York, Solomon R. Guggenheim Museum.

1990. New York, Solomon R. Guggenheim Museum.

1992. New York, Solomon R. Guggenheim Museum.

REFERENCES
Barnett. 1980, p. 20, fig. 9.

Camesasca, E. *Trésors du Musée d'Art de São Paulo: De Manet à Picasso*. Exh. cat., Fondation Pierre Gianadda, Martigny, 1988, pp. 226 and 228, repr. (ca. 1893, 78 x 51 cm). Italian ed.: Milan, 1988.

Daulte, F. "Une Donation sans précédent: la collection Thannhauser." *Connaissance des Arts*, no. 171, May 1966, p. 67, color repr.

Dortu, M. G. *Toulouse-Lautrec et son oeuvre*. New York, 1971, vol. II, P. 500, pp. 306–07, repr. (*Au Salon*).

Fougerat, E. *Toulouse-Lautrec*. Paris, [1955], pl. vii.

Solomon R. Guggenheim Museum. 1972, p. 37, repr.

Guggenheim Museum. 1993, p. 91, pl. 13, and pp. 82–83, color repr. (detail).

Hôtel Drouot, Paris. *Catalogue des tableaux . . . par H. de Toulouse-Lautrec.* Sale cat., Apr. 30, 1913, no. 3, repr. (*Au Salon*).

————. *Catalogue des tableaux modernes . . . formant la collection de M.S. . . . S. . . .* Sale cat., Mar. 22, 1920, no. 22, repr. (*Intérieur*, 52 x 80 cm).

Jedlicka, G. *Henri de Toulouse-Lautrec.* Zurich, 1943, opp. p. 207, repr. (*Im Salon*).

Joyant, T. *Henri de Toulouse-Lautrec.* Paris, 1926, p. 283.

Sugana, G. M. *The Complete Paintings of Toulouse-Lautrec.* London, 1973, p. 108, no. 351.

VINCENT VAN GOGH

1853–1890

Vincent van Gogh was born on March 30, 1853, in Groot-Zundert, the Netherlands. Starting in 1869, he worked for a firm of art dealers and at various short-lived jobs. By 1877, van Gogh had begun religious studies, and from 1878 to 1880 he was an evangelist in the Borinage, a poor mining district in Belgium. While working as an evangelist, he decided to become an artist. Van Gogh admired the work of Jean François Millet and Honoré Daumier, and his early subjects were primarily peasants depicted in dark colors. He lived in Brussels and in various parts of the Netherlands before moving to Paris in February 1886.

In Paris, he lived with his brother, Theo, and encountered Impressionist and Post-Impressionist painting. Van Gogh worked briefly at Fernand Cormon's atelier, where he met Henri de Toulouse-Lautrec. The artist also met Emile Bernard, Edgar Degas, Paul

Gauguin, Camille Pissarro, and Paul Signac at that time. Flowers, portraits, and scenes of Montmartre, as well as a brighter palette, replaced his earlier subject matter and tonalities. Van Gogh often worked in Asnières with Bernard and Signac in 1887.

In February of the following year, van Gogh moved to Arles, where he painted in isolation, depicting the Provençal landscape and people. Gauguin joined him in the fall, and the two artists worked together. Van Gogh suffered his first mental breakdown in December 1888; numerous seizures and intermittent confinements in mental hospitals in Arles, Saint-Rémy, and Auvers-sur-Oise followed from that time until 1890. Nevertheless, he continued to paint. In 1890, van Gogh was invited to show with Les XX in Brussels, where he sold his first painting. That same year, he was represented at the Salon des Indépendants in Paris. Van Gogh shot himself on July 27, 1890, and died on July 29 in Auvers-sur-Oise.

60.

ROADWAY WITH UNDERPASS (LE VIADUC)

1887

Oil on cardboard, mounted on panel, 32.7 x 41 cm (12 ⅞ x 16 ⅛ inches)
Thannhauser Collection, Gift, Justin K. Thannhauser
78.2514.17

Not signed or dated.

PROVENANCE
Unknown Russian collector acting for Galerie Charpentier, Paris; Galerie Hans Bamman, Düsseldorf, by 1927; J. K. Thannhauser, Berlin, by 1937.

CONDITION
The painting is oil on thin cardboard, which was subsequently mounted on a paper-veneered compressed board. Small, thick strokes of paint define the forms, alternating with thinner washes of paint. There is a dark-brown layer in the interstices of the surface, which is somewhat enigmatic and appears to be a tinted varnish layer applied long ago. This layer was partially removed in the past, and another glossy natural varnish was applied prior to 1965. The surface is somewhat abraded overall, and the varnish is discolored, obscuring the bright colors below. Extensive analytical work has been done on the painting to identify materials and technique (Aug. 1999).

EXHIBITIONS
1955. New York, Wildenstein and Co. *Van Gogh.* Mar. 24–Apr. 30. No. 21, repr.

1956. The Art Center in La Jolla, Calif. *Great French Paintings 1870–1910.* June 15–July 26. No. 24, repr.

1961. San Antonio, The Marion Koogler McNay Art Institute. *Paintings from the Justin K. Thannhauser Foundation.* June 15–Sept. 11. No. iv, repr.

1964. New York, Solomon R. Guggenheim Museum. *Van Gogh and Expressionism.* July 1–Sept. 13. [P. 3.]

1965. New York, Solomon R. Guggenheim Museum. P. 24, no. 12, color repr.

1978. New York, Solomon R. Guggenheim Museum.

1987–88a. New York, Solomon R. Guggenheim Museum. No. 17, repr.

1989. New York, Solomon R. Guggenheim Museum.

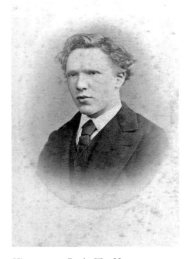

Vincent van Gogh, The Hague, January 1873, photographed by J. M. W. de Louw.

1990. New York, Solomon R. Guggenheim Museum.

1990. New York, The Metropolitan Museum of Art. Loan exhibition. May 4–Aug. 13.

1990. Venice, Palazzo Grassi. Pp. 76–77, no. A11, color repr.

1992. New York, Solomon R. Guggenheim Museum.

REFERENCES

de la Faille, J.-B. "Unbekannte Bilder von Vincent van Gogh." *Der Cicerone*, jg. XIX, Feb. 1927, pp. 102 and 104, repr. (*Tunnel*, ca. 1887, Collection Hans Bamman, Düsseldorf).

———. 1928, vol. I, p. 71, no. 239, and vol. II, pl. lxiv (*Le viaduc*, Collection Hans Bamman, Düsseldorf).

———. 1939, p. 280, no. 385, repr. (Galerien Thannhauser, Berlin).

———. 1970, pp. 122–23, repr., and p. 620, no. 239 (*The Viaduct*).

Solomon R. Guggenheim Museum. 1972, p. 27 (*The Viaduct*).

Hulsker. 1980, pp. 278 and 283, no. 1267, repr. (*Viaduct*, assigned to spring 1887).

Lecaldano, P. *L'opera pittorica completa di Van Gogh*. Milan, 1971, vol. I, pp. 114–15, fig. 385 (*Viadotto a Parigi*).

Testori, G., and L. Arrigoni. *Van Gogh: Catalogo completo dei dipinti*. Florence, 1990, p. 186, no. 427, repr. (*Viadotto*).

Walther, I. F., and R. Metzger. *Vincent van Gogh: Sämtliche Gemälde*. Cologne, 1989, vol. I, p. 249, color repr. (*Viadukt in Paris*).

Welsh-Ovcharov, B. *Vincent van Gogh: His Paris Period 1886–1888*. Utrecht and The Hague, 1976, p. 234 (*The Viaduct*; suggests an autumn date based on the colors of the painting).

61.
LANDSCAPE WITH SNOW
(PAYSAGE ENNEIGÉ)
late February 1888

Oil on canvas, 38.2 x 46.2 cm (15 1/16 x 18 3/16 inches)
Thannhauser Collection, Gift, Hilde Thannhauser
84.3239

Not signed or dated.

PROVENANCE
Unknown Russian collector acting for Galerie Charpentier, Paris; Galerie Hans Bamman, Düsseldorf, by 1927; J. K. Thannhauser, Berlin, probably by 1937; Hilde Thannhauser, Bern, 1976–84.

CONDITION
The painting was lined with an aqueous-type adhesive onto a primed linen canvas at an unknown date. There are a number of damages in the sky, notably a diagonal one in the sky above the trees at the top left. The painting was cleaned in 1985 (Mar. 1992).

EXHIBITIONS
1927. Düsseldorf, Galerie Hans Bamman. *Alte Meister: Deutsche und französische Kunst des 19. Jahrhunderts*. Autumn. N.p., repr. (*Helle Landschaft*).

1956. Raleigh, The North Carolina Museum of Art. *French Painting of the Last Half of the Nineteenth Century*. June 15–July 29. N.p. (*Paysage près d'Arles*).

1978. Kunstmuseum Bern. P. 51, cat. no. 14, color repr., and p. 108 (*Paysage enneigé*).

1987–88a. New York, Solomon R. Guggenheim Museum. No. 18, color repr.

1989. New York, Solomon R. Guggenheim Museum.

1990. New York, Solomon R. Guggenheim Museum.

1990. New York, The Metropolitan Museum of Art. Loan exhibition. May 4–Aug. 13.

1990. Venice, Palazzo Grassi. Pp. 78–79, no. A12, color repr.

1992. New York, Solomon R. Guggenheim Museum.

1996. Seoul, Ho-Am Art Gallery. *Masterpieces from the Guggenheim Museum*. July 15–Oct. 3. No. 3, color repr. Traveled to Singapore Art Museum, Oct. 16, 1996–Feb. 10, 1997; Dunedin Public Art Gallery, Dunedin, New Zealand, Mar. 1–May 15, 1997; and Shanghai Museum, June 27–Sept. 15, 1997.

REFERENCES
Aletrino, P. *Tout Van Gogh*. Paris, 1981, p. 12, no. 377, repr.

de la Faille, J.-B. "Unbekannte Bilder von Vincent van Gogh." *Der Cicerone*, jg. XIX, no. 3, Feb. 1927, pp. 102 and 105, repr. (*Landschaft*, ca. 1888).

———. 1928, vol. I, p. 84, no. 290, and vol. II, pl. lxxix (Paris: *Paysage de banlieue*).

———. 1939, p. 272, no. 371, repr. (Paris: *Paysage de Banlieue*).

———. 1970, p. 245, no. 290, repr., and p. 622.

Elgar, F. *Van Gogh*. Paris, 1958, p. 77, color repr., pp. 100 and 306 (*Le pays d'Arles sous la neige*).

Hulsker. 1980, pp. 306–07, no. 1360, repr.

———. *Vincent and Theo Van Gogh: A Dual Biography*. Ed. J. M. Miller. Ann Arbor, 1990, p. 263.

Lecaldano, P. *L'opera pittorica completa di Van Gogh*. Milan, 1971, vol. II, pp. 204–05, fig. 465 (*Paesaggio*).

Pickvance, R. *Van Gogh in Arles*. Exh. cat., The Metropolitan Museum of Art, New York, 1984, pp. 41 and 43.

Walther, I. F., and R. Metzger. *Vincent Van Gogh: Sämtliche Gemälde*. Cologne, 1989, vol. II, pp. 310–11, color repr. (*Landschaft mit Schnee*).

62.
LETTER TO JOHN PETER RUSSELL
April 1888

Ink on laid paper, 20.3 x 26 cm (8 x 10 ¼ inches)
Thannhauser Collection, Gift, Justin K. Thannhauser
78.2514.18

No watermark.

Signed at end of letter: Vincent
Not dated.

PROVENANCE
Received from the artist by John Peter Russell (d. 1931), 1888; inherited from Russell by his daughter, Jeanne Jouve, Paris, probably 1931–32; acquired from Jouve by J. K. Thannhauser, Paris, probably 1938–39.

CONDITION
At the moment the three letters by van Gogh in the Thannhauser Collection are encapsulated and framed together onto the same mat. Previous exposure to light, the kind of ink (probably iron gall ink), and the kind of paper make these sheets extremely fragile. The three letters had been mounted on silk. Splits along the folds (horizontal and vertical) were reinforced in 1984 (Aug. 1999).

EXHIBITIONS
1955. New York, Wildenstein and Co. *Van Gogh*. Mar. 24– Apr. 30. No. 110.

1965. New York, Solomon R. Guggenheim Museum. P. 26, no. 13, repr.

1978. New York, Solomon R. Guggenheim Museum.

1984. New York, The Metropolitan Museum of Art. *Van Gogh in Arles*. Oct. 18– Dec. 30. Exh. cat. by R. Pickvance, p. 252, no. 150, color repr.

1987–88a. New York, Solomon R. Guggenheim Museum.

REFERENCES
CLVG. Vol. II, Letter 477a, pp. 546–48.

Galbally, A. "Amitié: Russell and Van Gogh." *Art Bulletin of Victoria*, 1976, p. 32.

Graber, H., ed. *Vincent Van Gogh: Briefe an Emile Bernard, Paul Gauguin, John Russell, Paul Signac und Andere*. Basel, 1941, pp. 119–22.

Solomon R. Guggenheim Museum. 1972, p. 28, repr.

Hulsker, J. "Van Gogh's Extatische Maanden in Arles." *Maatstaf*, jg. 8, Aug.–Sept. 1960, pp. 332 and 334 (ca. Apr. 24–28, 1888).

Lubin, A. J. *Stranger on the Earth: A Psychological Biography of Vincent van Gogh*. 1972. Reprint, New York, 1987, p. 150.

Sayre, H. *A World of Art*. Second ed. Upper Saddle River, N.J., 1997, p. 70, fig. 89 (*Letter to John Russell*).

Thannhauser, H. "Documents inédits: Vincent van Gogh et John Russell." *L'Amour de l'Art*,

XIXe année, no. 7, Sept. 1938, pp. 285–86 (early Apr.).

————. "Van Gogh and John Russell: Some Unknown Letters and Drawings." *The Burlington Magazine*, vol. LXXIII, Sept. 1938, pp. 96–97 (early Apr.).

Wheldon, K. *Van Gogh*. London, 1989, p. 90.

63.
LETTER TO JOHN PETER RUSSELL
late June 1888

Ink on wove paper, 20.3 x 26.3 cm (8 x 10 ⅜ inches)
Thannhauser Collection, Gift, Justin K. Thannhauser
78.2514.19

Watermark: L-J D L&Co

Signed at end of letter: Vincent
Not dated.

PROVENANCE
Received from the artist by John Peter Russell (d. 1931), 1888; inherited from Russell by his daughter, Jeanne Jouve, Paris, probably 1931–32; acquired from Jouve by J. K. Thannhauser, Paris, probably 1938–39.

CONDITION
At the moment the three letters by van Gogh in the Thannhauser Collection are encapsulated and framed together onto the same mat. Previous exposure to light, the kind of ink (probably iron gall ink), and the kind of paper make these sheets extremely fragile. The three letters had been mounted on silk. Splits along the folds (horizontal and vertical) were reinforced in 1984 (Aug. 1999).

EXHIBITIONS
1955. New York, Wildenstein and Co. *Van Gogh*. Mar. 24– Apr. 30. No. 110.

1965. New York, Solomon R. Guggenheim Museum. P. 27, no. 16, repr.

1978. New York, Solomon R. Guggenheim Museum.

1984. New York, The Metropolitan Museum of Art. *Van Gogh in Arles*. Oct. 18– Dec. 30. Exh. cat. by R. Pickvance, p. 254, no. 151, color repr., and p. 255.

1987–88a. New York, Solomon R. Guggenheim Museum.

REFERENCES

Bremer, J., and T. van Kooten, eds. *Vincent van Gogh: Catalogus van 278 werken in de verzameling van het Rijksmuseum Kröller-Müller, Otterlo.* Otterlo, 1983, p. 85.

CLVG. Vol. II, Letter 501a, pp. 592–94 (*Sower*, repr.).

Elgar, F. *Van Gogh.* Trans. J. Cleugh. New York, 1958, p. 191.

Formaggio, D. *Van Gogh in cammino.* Milan, 1986, p. 71, repr. (*Lettera a John Russel* [sic]).

Graber, H., ed. *Vincent Van Gogh: Briefe an Emile Bernard, Paul Gauguin, John Russell, Paul Signac und Andere.* Basel, 1941, pp. 122–24.

Graetz, H. R. *The Symbolic Language of Vincent Van Gogh.* New York, 1963, pp. 96–97, repr.

Solomon R. Guggenheim Museum. 1972, p. 29, repr.

Guggenheim Museum. 1993, p. 94, pl. 15.

Hulsker, J. "Van Gogh's Extatische Maanden in Arles." *Maatstaf,* jg. 8, Aug.–Sept. 1960, pp. 332 and 334 (ca. June 27 and before Letter 501).

———. 1980, pp. 331–32.

———. *Lotgenoten: Het leven van Vincent en Theo van Gogh.* Weesp, 1985, pp. 413 and 419.

———. *Vincent and Theo van Gogh: A Dual Biography.* Ed. J. M. Miller. Ann Arbor, 1990, p. 282.

Lubin, A. J. *Stranger on the Earth: A Psychological Biography of Vincent van Gogh.* 1972. Reprint, New York, 1987, pp. 215 and 219.

The National Museum of Art, Osaka. *Vincent van Gogh from Dutch Collections.* Exh. cat., 1986, p. 142.

Pickvance, R. "Synthesis." In *Vincent van Gogh Exhibition.* Exh. cat., The National Museum of Western Art, Tokyo, 1985, p. 201.

Testori, G., and L. Arrigoni. *Van Gogh: Catalogo completo dei dipinti.* Florence, 1990, pp. 226–27.

Thannhauser, H. "Documents inédits: Vincent van Gogh et John Russell." *L'Amour de l'Art,* XIX^e année, Sept. 1938, p. 286.

———. "Van Gogh and John Russell: Some Unknown Letters and Drawings." *The Burlington Magazine,* vol. LXXIII, Sept. 1938, pp. 97–98 and 102, pl. IIIc, and p. 103 (end of June or early July).

van Uitert, E. "Van Gogh's Concept of his Oeuvre." *Simiolus,* vol. 12, no. 4, 1981–82, p. 238, fns. 66 and 67. Reprinted in van Uitert's *Vincent van Gogh in Creative Competition: Four Essays from Simiolus,* Amsterdam, 1983.

Zurcher, B. *Vincent van Gogh: Art, Life and Letters.* Trans. H. Harrison. New York, 1985, p. 161.

64.
HEAD OF A GIRL
late June 1888

Ink on wove paper, 18 x 19.5 cm (7 ⅛ x 7 ¹¹⁄₁₆ inches)
Thannhauser Collection, Gift, Justin K. Thannhauser 78.2514.20

Verso: handwritten letter in ink

Watermark: L-JD

Not dated.

PROVENANCE

Received from the artist by John Peter Russell (d. 1931), 1888 (included with letter of late June 1888, cat. no. 63); inherited from Russell by his daughter, Jeanne Jouve, Paris, probably 1931–32; acquired from Jouve by J. K. Thannhauser, Paris, probably 1938–39.

CONDITION

This drawing used to be mounted on silk. In 1973 the silk was removed and a letter on the verso was discovered. The drawing was deacidified at that time, and an original vertical cut on the right, from top to bottom, was repaired; this was re-repaired in 1999. The work is in a fragile but stable condition (Aug. 2000).

EXHIBITIONS

1965. New York, Solomon R. Guggenheim Museum. P. 25, no. 15, repr.

1978. New York, Solomon R. Guggenheim Museum.

1984. New York, The Metropolitan Museum of Art. *Van Gogh in Arles.* Oct. 18– Dec. 30. Exh. cat. by R. Pickvance, p. 105, no. 51, color repr. recto, repr. verso (*Head of a Girl: The Mudlark*).

1987–88a. New York, Solomon R. Guggenheim Museum.

1989. New York, Solomon R. Guggenheim Museum.

1990. New York, Solomon R. Guggenheim Museum.

1990. Venice, Palazzo Grassi. Pp. 80–81, no. A13, color repr.

1992. New York, Solomon R. Guggenheim Museum.

2000. Detroit, The Detroit Institute of Arts. *Van Gogh: Face to Face.* Mar. 12–June 4. P. 128, fig. 111, and p. 267 (*The Mudlark*, ca. June 17, 1888). Traveled to Boston, Museum of Fine Arts, July 2–Sept. 24, and Philadelphia Museum of Art, Oct. 22, 2000–Jan. 14, 2001.

REFERENCES
CLVG. Vol. II, p. 593, repr., and p. 665 (June 1888).

de la Faille. 1970, p. 523, no. 1507a, repr.

Erpel, F. *Vincent van Gogh: Lebensbilder, Lebenszeichen.* Berlin, 1989, p. 184, fig. 362, p. 185, and p. 300, no. 362 (*Kleiner "Schmutzfink" aus Arles*).

Solomon R. Guggenheim Museum. 1972, p. 32, repr.

Guggenheim Museum. 1993, p. 95, pl. 16.

Hulsker. 1980, pp. 328 and 335, no. 1466, repr. (*Girl's Head*).

Johnson, R. "Vincent van Gogh and the Vernacular: The Poet's Garden." *Arts*, vol. 53, no. 6, Feb. 1979, p. 101, repr., and p. 102, fig. 10 (*Head of a Girl* [*The Mudlark*], 1888).

Lecaldano, P. *L'opera pittorica completa di Van Gogh.* Milan, 1971, vol. II, pp. 206–07, fig. 506A, repr. (*Busto di ragazza {con capelli arruffati, di fronte}*).

Pickvance, R. "The new De La Faille." *The Burlington Magazine*, vol. CXV, Mar. 1973, p. 178.

Roskill, M. "Van Gogh's Exchanges of Work with Emile Bernard in 1888: Appendix A."

Oud Holland, jg. LXXXVI, no. 2–3, 1971, p. 169.

Thannhauser, H. "Documents inédits: Vincent van Gogh et John Russell." *L'Amour de l'Art*, XIXᵉ année, no. 7, Sept. 1938, p. 284, repr.

———. "Van Gogh and John Russell: Some Unknown Letters and Drawings." *The Burlington Magazine*, vol. LXXIII, Sept. 1938, pp. 97, 98, and 102, pl. IIIA.

65.
BOATS AT SAINTES-MARIES
late July–early August 1888
Pencil and ink on wove paper, 24.3 x 31.9 cm (9 ⁹⁄₁₆ x 12 ⁹⁄₁₆ inches)
Thannhauser Collection, Gift, Justin K. Thannhauser
78.2514.21

No watermark.

Not signed or dated.

PROVENANCE
Received from the artist by John Peter Russell (d. 1931), 1888; inherited from Russell by his daughter, Jeanne Jouve, Paris, probably 1931–32; acquired from Jouve by J. K. Thannhauser, Paris, probably 1938–39.

CONDITION
Deacidified, flattened, and rehinged by C. Gaehde (June 1973).

EXHIBITIONS
1939. Adelaide, The National Art Gallery. *Exhibition of French and British Contemporary Art.* Opened Aug. 21. No. 138. Traveled to Melbourne, Town Hall, opened Oct. 16, and Sydney, David Jones, opened Nov. 20.

1965. New York, Solomon R. Guggenheim Museum. P. 25, no. 14, repr.

1978. New York, Solomon R. Guggenheim Museum.

1984. New York, The Metropolitan Museum of Art. *Van Gogh in Arles.* Oct. 18–Dec. 30. Exh. cat. by R. Pickvance, no. 73, pp. 138 and 139, color repr. (*Fishing Boats at Saintes-Maries-de-la-Mer*).

1987–88a. New York, Solomon R. Guggenheim Museum.

1989. New York, Solomon R. Guggenheim Museum.

1990. New York, Solomon R. Guggenheim Museum.

1990. Venice, Palazzo Grassi. Pp. 84–85, no. A15, color repr.

1992. New York, Solomon R. Guggenheim Museum.

REFERENCES
Bernard, B., ed. *Vincent by Himself: A selection of his paintings and drawings together with extracts from his letters.* London, 1985, p. 226, color repr., and 324 (*Fishing Boats at Sea*). U.S. ed.: New York, 1985.

de la Faille. 1970, p. 503, repr., and p. 662, no. 1430a (*Sailing Boats Coming Ashore*, June 1888).

Dorn, Roland. "'Refiler à Saintes-Maries'? Pickvance and Hulsker Revisited." *Van Gogh Museum Journal*, 1997–98, p. 24, repr. (*Seascape, croquis*, end of July 1888).

Erpel, F. *Vincent van Gogh: Die Rohrfederzeichnungen.* Munich, 1990, pp. 168–69, cat. no. 70, repr. (*Fischerboote vor Les Saintes-Maries-de-la-Mer*).

Solomon R. Guggenheim Museum. 1972, p. 31, repr.

Hulsker. 1980, pp. 344, 346, and 350, no. 1526, repr. (*Fishing Boats at Sea*).

Keller, H. *Vincent van Gogh: The Final Years.* New York, 1969, p. 26, repr.

Lecaldano, P. *L'opera pittorica completa di Van Gogh*. Milan, 1971, vol. II, p. 207, fig. 508B (*Marina {barche a vela}*, June 1888).

Leymarie, J. *Who Was van Gogh?* Trans. J. Emmons. Geneva, 1968, p. 95, repr.

Rewald. 1962, p. 227, repr. (June 1888).

Thannhauser, H. "Documents inédits: Vincent van Gogh et John Russell." *L'Amour de l'Art*, XIX^e année, no. 7, Sept. 1938, p. 283, repr., and p. 284 (*Barques aux Saintes-Maries*).

————. "Van Gogh and John Russell: Some Unknown Letters and Drawings." *The Burlington Magazine*, vol. LXXIII, Sept. 1938, p. 99, pl. IIA, and p. 104 (private collection, France).

van Uitert, E. *Van Gogh Drawings*. Trans. E. Williams-Truman. Woodstock, N.Y., 1978, p. 27 and pl. 66 (*Sail-boats Coming Ashore*, Saintes-Maries, June 1888).

Welsh-Ovcharov, B. *Vincent van Gogh and the Birth of Cloisonism*. Exh. cat., Art Gallery of Ontario, Toronto, 1981, p. 124.

66.
THE ROAD TO TARASCON
late July–early August 1888

Pencil and ink on wove paper, 23.2 x 31.9 cm (9 ⅛ x 12 ⁹⁄₁₆ inches) Thannhauser Collection, Gift, Justin K. Thannhauser 78.2514.22

No watermark.

Signed lower right: Vincent Not dated.

PROVENANCE
Received from the artist by John Peter Russell (d. 1931), 1888; inherited from Russell by his daughter, Jeanne Jouve, Paris, probably 1931–32;

acquired from Jouve by J. K. Thannhauser, Paris, probably 1938–39.

CONDITION
There are small tears at the bottom and top center margins. The work was deacidified and rehinged by C. Gaehde (June 1973).

EXHIBITIONS
1939. Adelaide, The National Art Gallery. *Exhibition of French and British Contemporary Art*. Opened Aug. 21. No. 139. Traveled to Melbourne, Town Hall, opened Oct. 16, and Sydney, David Jones, opened Nov. 20.

1965. New York, Solomon R. Guggenheim Museum. P. 28, no. 18, repr.

1978. New York, Solomon R. Guggenheim Museum.

1984. New York, The Metropolitan Museum of Art. *Van Gogh in Arles*. Oct. 18–Dec. 30. Exh. cat. by R. Pickvance, pp. 2–3, repr., pp. 142–43, no. 78, color repr.

1987–88a. New York, Solomon R. Guggenheim Museum.

1989. New York, Solomon R. Guggenheim Museum.

1990. New York, Solomon R. Guggenheim Museum.

1990. Venice, Palazzo Grassi. Pp. 86–87, no. A16, color repr.

1992. New York, Solomon R. Guggenheim Museum.

REFERENCES
Bernard, B., ed. *Vincent by Himself: A selection of his paintings and drawings together with extracts from his letters*. London, 1985, p. 232, color repr., and p. 324.

de la Faille. 1970, pp. 522–23, repr., and p. 665, no. 1502a (*The Road to Tarascon: Sky with Sun*, Arles, Aug. 1888).

Elgar, F. *Van Gogh*. Trans. J. Cleugh. New York, 1958, p. 167, repr.

Erpel, F. *Vincent van Gogh: Lebensbilder, Lebenszeichen*. Berlin, 1989, pp. 179, 180–81, fig. 355, and p. 300, no. 355 (*Straße nach Tarascon*).

————. *Vincent van Gogh: Die Rohrfederzeichnungen*. Munich, 1990, pl. 36, pp. 15, 21, 23, and 168–69, cat. no. 76, repr. (*Straße nach Tarascon*; also reproduced in color on dust jacket).

Graber, H., ed. *Vincent Van Gogh: Briefe an Emile Bernard, Paul Gauguin, John Russell, Paul Signac und Andere*. Basel, 1941, opp. p. 68, repr. (*Landschaft bei Arles*).

Solomon R. Guggenheim Museum. 1972, p. 33, repr. (*The Road from Tarascon*).

Hammacher, A. M., and R. Hammacher. *Van Gogh: A Documentary Biography*. New York, 1982, p. 180, repr., pp. 181 and 237, no. 146 (*The Road to Tarascon: Sky with Sun*).

Hulsker. 1980, pp. 344, 346, and 351, repr., no. 1531.

————. *Lotgenoten: Het leven van Vincent en Theo van Gogh*. Weesp, 1985, p. 423.

————. *Vincent and Theo van Gogh: A Dual Biography*. Ed. J. M. Miller. Ann Arbor, 1990, p. 284.

Petrie, B. *Van Gogh*. London, 1974, pl. 77.

Pickvance, R. "The new De La Faille." *The Burlington Magazine*, vol. CXV, Mar. 1973, p. 179 (corrects omission of signature).

Thannhauser, H. "Documents inédits: Vincent van Gogh et John Russell." *L'Amour de l'Art*, XIX^e année, no. 7, Sept. 1938,

pp. 284–85, repr. (*Paysage d'Arles*).

————. "Van Gogh and John Russell: Some Unknown Letters and Drawings." *The Burlington Magazine*, vol. LXXIII, Sept. 1938, p. 99, pl. IIc, and p. 104 (private collection, France).

van der Wolk, J., R. Pickvance, and E. B. F. Pey. *Vincent van Gogh: Drawings*. Exh. cat., Rijksmuseum Kröller-Müller, Otterlo, 1990, p. 232.

67.
THE ZOUAVE
end of July–early August 1888

Ink on wove paper, 31.9 x 24.3 cm (12 ⁹⁄₁₆ x 9 ⁹⁄₁₆ inches)
Thannhauser Collection, Gift, Justin K. Thannhauser 78.2514.23

No watermark.

Signed lower left: Vincent
Not dated.

PROVENANCE
Received from the artist by John Peter Russell (d. 1931), 1888; inherited from Russell by his daughter, Jeanne Jouve, Paris, probably 1931–32; acquired from Jouve by J. K. Thannhauser, Paris, probably 1938–39.

CONDITION
Before 1973, this drawing was attached to an acid support and there were old pieces of tape on the back. Some foxing stains were noted on the right side. The work was treated in 1973, deacidified, and rehinged, but the stains were not removed. At present, the work is in good condition. The paper support has slight overall cockling and the edges are a bit worn. There are several areas with a brownish staining at the right edge. The ink is stable (Aug. 2000).

EXHIBITIONS
1939. Adelaide, The National Art Gallery. *Exhibition of French and British Contemporary Art*. Opened Aug 21. No. 137. Traveled to Melbourne, Town Hall, opened Oct. 16, and Sydney, David Jones, opened Nov. 20.

1962. Minneapolis, University Gallery, University of Minnesota. *The Nineteenth Century: One Hundred Twenty-five Master Drawings*. Mar. 26– Apr. 23. No. 119. Traveled to the Solomon R. Guggenheim Museum, May 15–June 28.

1965. New York, Solomon R. Guggenheim Museum. P. 28, no. 17, repr.

1978. New York, Solomon R. Guggenheim Museum.

1984. New York, The Metropolitan Museum of Art. *Van Gogh in Arles*. Oct. 18– Dec. 30. Exh. cat. by R. Pickvance, p. 142, no. 77, color repr.

1987–88a. New York, Solomon R. Guggenheim Museum.

1989. New York, Solomon R. Guggenheim Museum.

1990. New York, Solomon R. Guggenheim Museum.

1990. Venice, Palazzo Grassi. Pp. 82–83, no. A14, color repr.

1992. New York, Solomon R. Guggenheim Museum.

2000. Detroit, The Detroit Institute of Arts. *Van Gogh: Face to Face*. Mar. 12–June 4. P. 128, fig. 111, and p. 267. Traveled to Boston, Museum of Fine Arts, July 2–Sep. 24, and Philadelphia Museum of Art, Oct. 22, 2000–Jan. 14, 2001.

REFERENCES
Berger, K. *Französische Meisterzeichnungen des Neunzehnten Jahrhunderts*. Basel, 1949, pp. 30 and 88, no. 54, repr.

de la Faille. 1970, p. 516, repr., and p. 665, no. 1482a (*The Zouave: Head and Shoulders*, June 1888).

Elgar, F. *Van Gogh*. Trans. J. Cleugh. New York, 1958, p. 154, repr., and p. 183.

Erpel, F. *Vincent van Gogh: Lebensbilder, Lebenszeichen*. Berlin, 1989, pp. 158, fig. 324, pp. 159 and 300, no. 324 (*Der Zuave*).

————. *Vincent van Gogh: Die Rohrfederzeichnungen*. Munich, 1990, pl. 37, pp. 23 and 170–71, cat. no. 79, repr. (*Ein Zuave, Kopfstudie*).

Galleria Nazionale d'Arte Moderna, Rome. *Vincent van Gogh*. Milan, 1988, p. 204.

Graber, H., ed. *Vincent Van Gogh: Briefe an Emile Bernard, Paul Gauguin, John Russell, Paul Signac und Andere*. Basel, 1941, opp. p. 44, repr.

Solomon R. Guggenheim Museum. 1972, p. 34, repr.

Hulsker. 1980, pp. 344, 346, and 352, no. 1535, repr.

————, ed. *Van Gogh's "Diary": The Artist's Life in His Own Words and Art*. New York, 1971, pp. 112, repr., and 168.

Lecaldano, P. *L'opera pittorica completa di Van Gogh*. Milan, 1971, vol. II, pp. 206–07, fig. 504B (*Busto di Zuavo {Trombettiere degli Zuavi}*, June 1888).

Leymarie, J. *Who Was van Gogh?* Trans. J. Emmons. Geneva, 1968, p. 107, repr.

Lord, D. (pseud. for D. Cooper). "Letter: Van Gogh and John Russell." *The Burlington Magazine*, vol. LXXIII, Nov. 1938, p. 227 (correcting identification of the Zouave).

Rewald. 1962, p. 262, repr. (*Portrait of a Zouave Bugler*).

Sachs, P. J. *Modern Prints and Drawings*. New York, 1954, p. 50, pl. 41.

Thannhauser, H. "Documents inédits: Vincent van Gogh et John Russell." *L'Amour de l'Art*, XIX^e année, no. 7, Sept. 1938, p. 281, repr., and p. 284 (*Le Zouave Milliet*, ex. coll. John Russell).

————. "Van Gogh and John Russell: Some Unknown Letters and Drawings." *The Burlington Magazine*, vol. LXXIII, Sept. 1938, p. 94, repr., and p. 104 (private collection, France).

van der Wolk, J., R. Pickvance, and E. B. F. Pey. *Vincent van Gogh: Drawings*. Exh. cat., Rijksmuseum Kröller-Müller, Otterlo, 1990, pp. 232–33.

Wadley, N. *The Drawings of van Gogh*. London, 1969, p. 37 and pl. 92 (*The Zouave Milliet*).

68.
MOUNTAINS AT SAINT-RÉMY (MONTAGNES À SAINT-RÉMY)
July 1889

Oil on canvas, 71.8 x 90.8 cm (28 ¼ x 35 ¾ inches)
Thannhauser Collection, Gift, Justin K. Thannhauser
78.2514.24

Not signed or dated.

PROVENANCE
Sent by the artist to Theo van Gogh, Sept. 1889 (Letter 607); acquired in exchange by Eugène Boch, Monthyon (Seine-et-Marne), June 1890, and still in his possesion in 1908; Galerie E. Druet, Paris, by 1912; Walther Halvorsen, Paris, from 1918; Trygve Sagen, Oslo; Galerien Thannhauser, Berlin, by 1927; J. K. Thannhauser.

CONDITION
Lined with aqueous adhesive at an unknown date prior to 1965. Some flattening of the impasto resulted, and two tears in the lower right were repaired. In 1986 some local cleavage was set down. Old glue residues were cleaned out of the deep impasto. Some old unfilled losses were filled and inpainted. Some thicker areas of the uneven, somewhat yellowed varnish were thinned, and old discolored retouching was adjusted to better match the surrounding paint (Mar. 1992).

EXHIBITIONS
1908. Paris, Galerie E. Druet. *Vincent van Gogh*. Jan. 6–18. No. 3 (*Collines à Arles*, lent by E. Boch).

1913. New York, Armory of the Sixty-ninth Infantry. *International Exhibition of Modern Art*. Feb. 15–Mar. 15. No. 424 (*Collines à Arles*, lent by E. Druet). Traveled to the Art Institute of Chicago, Mar. 24–Apr. 16, no. 408, repr.; and Boston, Copley Hall, Apr. 28–May 19, no. 213, repr.

1923–24. Prague, Spolku Vytvarnych Umelcu Mánes. *Exhibition of French Art*. Dec.–Jan. (?). No. 55 (*Landscape of Arles*, oil, 93 x 73 cm).

1927. Berlin, Künstlerhaus (organized by Galerien Thannhauser, Berlin). *Erste Sonderausstellung in Berlin*. Jan. 9–Feb. 15. No. 117, repr. (*Berglandschaft*).

1939. New York, The Museum of Modern Art. *Art in Our Time*. May 10–Sept. 30. No. 70, repr. (*Hills at Saint-Rémy*). On loan to the Museum of Modern Art until Apr. 1941.

1940. Cincinnati Modern Art Society. *Paintings of School of Paris*. Apr. 12–May 12.

1940. San Francisco, Palace of Fine Arts. *Golden Gate International Exposition*. May 25–Sept. 29. No. 272, repr.

1941. The Detroit Institute of Arts. *Modern Paintings from the Museum of Modern Art*. Jan. 3–Feb. 2.

1942. The Baltimore Museum of Art. *Paintings by van Gogh*. Sept. 18–Oct. 18. No. 18. Traveled to Worcester Art Museum, Oct. 28–Nov. 28.

1943. Pittsburgh, Carnegie Institute Museum of Art. *Modern Dutch Art*. Feb. 5–Mar. 1. No. 24G (*Hills at Saint-Rémy*).

1948. The Cleveland Museum of Art. *Work by Vincent van Gogh*. Nov. 3–Dec. 12. No. 20, repr.

1955. The Art Institute of Chicago. May–Aug.

1964. New York, Solomon R. Guggenheim Museum. *Van Gogh and Expressionism*. July 1–Sept. 13.

1965. New York, Solomon R. Guggenheim Museum. P. 29, no. 19, color repr.

1978. New York, Solomon R. Guggenheim Museum.

1986–87. New York, The Metropolitan Museum of Art. *Van Gogh in Saint-Rémy and Auvers*. Nov. 25–Mar. 22. Exh. cat. by R. Pickvance, p. 117, cat. no. 20, color repr., pp. 118–19 and 297, cat. no. 20, repr.

1987–88a. New York, Solomon R. Guggenheim Museum.

1989. New York, Solomon R. Guggenheim Museum.

1990. New York, Solomon R. Guggenheim Museum.

1990. Venice, Palazzo Grassi. Pp. 88–89, no. A17, color repr.

1992. The Montreal Museum of
Fine Arts. Pp. 64–65, no. 5,
color repr.

1990. New York, The
Metropolitan Museum of Art.
Loan exhibition. May 4–
Aug. 13.

1992. New York, Solomon R.
Guggenheim Museum.

REFERENCES
Barnett. 1980, p. 14, fig. 4.

Brown, M. W. *The Story of the
Armory Show.* Greenwich, 1963,
p. 246, no. 424.

CLVG. Vol. III, pp. 193, 195–96,
216–17, and 573.

Coquiot, G. *Vincent van Gogh.*
Paris, 1923, p. 317 (*Vue de
montagnes, avec une cabane
noirâtre, dans les oliviers*).

Daulte, F. "Une Donation sans
précédent: la collection
Thannhauser." *Connaissance des
Arts*, no. 171, May 1966, p. 64,
color repr. (*Collines à Saint-
Rémy*; erroneously states that it
was the only painting van
Gogh sold during his life).

de la Faille. 1928, vol. I, p. 175,
and vol. II, pl. clxxii (*Collines à
Saint-Rémy*).

———. 1939, p. 427, no. 619,
repr. (*Collines à St.-Rémy*).

———. 1970, p. 248, repr.,
pp. 249 and 635, no. 622 (*The
Alpilles with Dark Hut*).

Elgar, F. *Van Gogh.* Trans. J.
Cleugh. New York, 1958,
pp. 168–69, repr., and p. 222.

Solomon R. Guggenheim
Museum. 1972, p. 35, repr.

Guggenheim Museum. 1992,
p. 263, color repr.

Hildebrandt, H. *Die Kunst des
19. und 20. Jahrhunderts.*
Potsdam, 1924, pl. xiv
(*Arlesische Landschaft*, Galerie
Thannhauser).

Hulsker. 1980, pp. 403 and 408,
no. 1766, repr. (*Mountains with
Dark Hut*, dated first half of
July).

———. *Lotgenoten: Het leven
van Vincent en Theo van Gogh.*
Weesp, 1985, p. 537.

———. *Vincent and Theo
van Gogh: A Dual Biography.*
Ed. J. M. Miller. Ann Arbor,
1990, p. 365.

Jirat-Wasiutynski, V. "Vincent
van Gogh's Paintings of
Olive Trees and Cypresses
from Saint-Rémy." *Art Bulletin*,
vol. 75, no. 4, Dec. 1993, p. 656,
fig. 10.

Kuhn-Foelix, A. *Vincent van
Gogh.* Bergen, 1958, p. 200 and
pl. 46 (*Hügellandschaft bei St.
Rémy*).

Lamberto, V. *Vincent van Gogh.*
Milan, 1936, pl. xx.

Lecaldano, P. *L'opera pittorica
completa di Van Gogh.* Milan,
1971, vol. II, pp. 219–20, fig. 675
(*Veduta delle Alpilles {con
capanna scura}*).

Mathews, P. "Aurier and Van
Gogh: Criticism and
Response." *Art Bulletin*,
vol. LXVIII, no. 1, Mar. 1986,
pp. 95 and 97, repr.

The National Museum of Art,
Osaka. *Vincent van Gogh from
Dutch Collections.* Exh. cat., 1986,
p. 138.

Nordenfalk, C. "Van Gogh
and Literature." *Journal of
the Warburg and Courtauld
Institutes*, vol. X, 1947, p. 145
and pl. 38e.

Osborn, M. "Klassiker der
Französischen Moderne."
Deutsche Kunst und Dekoration,
vol. 59, Mar. 1927, p. 338, repr.

Rewald. 1962, p. 359, color repr.

Scherjon, W. *Catalogue des
tableaux par Vincent van Gogh*

décrits dans ses lettres. Utrecht,
1932, p. 25, no. 14, repr. (*La
Montagne* {Livre de Rod *Le Sens
de la vie*}).

———, and J. de Gruyter.
*Vincent van Gogh's Great Period:
Arles, St. Rémy and Auvers sur
Oise.* Amsterdam, 1937, p. 215,
repr., and p. 217, no. 14.

Seznec, J. "Literary Inspiration
in Van Gogh." *Magazine of Art*,
vol. 43, Dec. 1950, p. 286.

Stein, S. A., ed. *Van Gogh: A
Retrospective.* New York, 1986,
p. 19, repr. (*Mountains with
Dark Hut*).

Testori, G., and L. Arrigoni.
*Van Gogh: Catalogo completo dei
dipinti.* Florence, 1990, p. 301,
color repr., and p. 302, no. 675
(*Veduta delle Alpilles*).

Treble, R. *Van Gogh and His
Art.* London, 1975, p. 104, pl. 84
(*The Alpilles with Dark Hut*).

Walther, I. F., and R. Metzger.
*Vincent van Gogh: Sämtliche
Gemälde.* Cologne, 1989, p. 529,
color repr. (*Berglandschaft in
Saint-Rémy*).

Zurcher, B. *Van Gogh: Vie et
oeuvre.* Fribourg, 1985, pp. 239,
243, pl. 165, and p. 300, repr.
(detail). English ed.: *Vincent
Van Gogh: Art, Life, and Letters*,
trans. H. Harrison, New York,
1985 (*Mountains*).

69.
LETTER TO JOHN PETER RUSSELL
late January 1890

Ink on laid paper, 17.8 x 22.5 cm
(7 x 8 ⅞ inches)
Thannhauser Collection, Gift,
Justin K. Thannhauser
78.2514.25

Watermark of a shield with
word below: UNIVERSAL

Signed at end of letter:
Vincent van Gogh
Not dated.

PROVENANCE

Received from the artist by
John Peter Russell (d. 1931),
1890; inherited from Russell by
his daughter, Jeanne Jouve,
Paris, probably 1931–32;
acquired from Jouve by J. K.
Thannhauser, Paris, probably
1938–39.

CONDITION

At the moment the three
letters by van Gogh in the
Thannhauser Collection are
encapsulated and framed
together onto the same mat.
Previous exposure to light,
the kind of ink (probably iron
gall ink), and the kind of paper
make these sheets extremely
fragile. The three letters had
been mounted on silk. Splits
along the folds (horizontal and
vertical) were reinforced in
1984 (Aug. 1999).

EXHIBITIONS

1955. New York, Wildenstein
and Co. *Van Gogh*. Mar. 24–
Apr. 30. No. 110.

1965. New York, Solomon R.
Guggenheim Museum. P. 27,
no. 20, repr.

1978. New York, Solomon R.
Guggenheim Museum.

1987–88a. New York, Solomon
R. Guggenheim Museum.

REFERENCES

Bernard, B. *Vincent by Himself:
A selection of his paintings and
drawings together with extracts
from his letters.* London, 1985,
p. 208.

CLVG. Vol. III, Letter 623a,
pp. 249–50 (end of Jan. 1890).

Galbally, A. "Amitié: Russell
and Van Gogh." *Art Bulletin of
Victoria*, 1976, pp. 36–37.

Graber, H., ed. *Vincent Van
Gogh: Briefe an Emile Bernard,
Paul Gauguin, John Russell, Paul
Signac und Andere.* Basel, 1941,
pp. 124–26.

Solomon R. Guggenheim
Museum. 1972, p. 30, repr.

Hulsker, J. "Van Gogh's
Bedreigde Leven in St. Rémy
en Auvers." *Maatstaf*, jg. 8, Jan.
1961, p. 664 (end of Jan.).

Pickvance, R. *Van Gogh in
Saint-Rémy and Auvers.* Exh.
cat., The Metropolitan Museum
of Art, New York, 1986, p. 62
(ca. Feb. 1).

Thannhauser, H. "Documents
inédits: Vincent van Gogh et
John Russell." *L'Amour de l'Art*,
XIXᵉ année, Sept. 1938, p. 286
(end of Jan. 1890).

———. "Van Gogh and John
Russell: Some Unknown Letters
and Drawings." *The Burlington
Magazine*, vol. LXXIII, Sept.
1938, p. 103.

Welsh-Ovcharov, B. *Vincent van
Gogh: His Paris Period 1886–88.*
Utrecht and The Hague, 1976,
p. 56, fn. 28.

Edouard Vuillard holding his Kodak
camera, 1900, photographed by Pierre
Bonnard.

EDOUARD VUILLARD
1868–1940

Edouard Vuillard was born on
November 11, 1868, in Cuiseaux,
France. In 1878 his family
moved to Paris, where
Edouard attended the Lycée
Condorcet. There he met his
future brother-in-law, K.-X.
Roussel, as well as Maurice
Denis. In 1888 he and Roussel
attended the Académie Julian,
where they joined forces with
the artists who would soon
call themselves the Nabis
(after *nabi*, the Hebrew word
for prophet): Pierre Bonnard,
Denis, Paul Ranson, and Paul
Sérusier. The Nabis used
arbitrary color, inspired in
large part by Paul Gauguin,
whom they revered. They
sought practical application for
their art beyond easel painting
to realms such as stage design

and architectural decoration.
Vuillard began exhibiting
with them in 1891 at Le Barc
de Boutteville.

In the early years of his
career Vuillard designed
theatrical sets and programs,
posters, and illustrations.
Ambroise Vollard
commissioned him to do an
album of color lithographs
in 1896. The Natanson
brothers and Lucy Hessel
(wife of art dealer Jos Hessel)
were Vuillard's close friends
and important patrons. He
accepted commissions to
decorate homes and public
buildings; the decorations
completed in 1913 for the foyer
of the newly built Comédie des
Champs-Elysées are still in
existence. Vuillard exhibited
often at the Salon des
Indépendants until 1910 and
at the Salon d'Automne until
1912. Until the late 1930s his
work was rarely shown,
except at Bernheim-Jeune,
where he exhibited regularly.
He executed many paintings of
his mother and the interior
of the apartment they shared
until her death in 1928.
The artist continued to live
quietly in Paris until the end
of his life.

In the late 1930s Vuillard
completed decorations for the
League of Nations in Geneva
and for the Palais de Chaillot in
Paris. In 1938 he was given a
major retrospective at the
Musée des Arts Décoratifs in
Paris. Vuillard died on June 21,
1940, in La Baule.

70.

PLACE VINTIMILLE

1908–10

Distemper on cardboard, mounted on canvas; two panels: 200 x 69.5 cm (78 ¾ x 27 ⅜ inches) and 200 x 69.9 cm (78 ¾ x 27 ½ inches)
Thannhauser Collection, Gift, Justin K. Thannhauser
78.2514.74

Not signed or dated.

PROVENANCE
Acquired from the artist by Henry Bernstein, Paris; purchased from the family of Bernstein by J. K. Thannhauser, New York, 1948.

CONDITION
The canvas mounts are not identical: the canvas on the left panel has a fine texture whereas that of the right panel is relatively coarse. Tack holes at the corners and along the vertical edges of both panels penetrate the cardboard and canvas. There are scattered losses in each panel. The condition of the left panel is good and generally stable. The right panel is fragile. Local consolidation of recurring active cleavage in the green area of lawn and adjacent yellow tree was carried out in 1987 (Mar. 1992).

EXHIBITIONS
1944–45. Paris, Galerie Charpentier, *Paris*. Dec. 1– Mar. 1. Nos. 214 and 215, repr. left panel.

1965. New York, Solomon R. Guggenheim Museum. P. 51, no. 47, color repr.

1978. New York, Solomon R. Guggenheim Museum.

1987–88a. New York, Solomon R. Guggenheim Museum. No. 38, color repr.

1989. New York, Solomon R. Guggenheim Museum.

1990. New York, Solomon R. Guggenheim Museum.

1992. New York, Solomon R. Guggenheim Museum.

REFERENCES
Arnason, H. H. *History of Modern Art*. New York, 1968, pp. 97–98, fig. 141.

Barnett. 1980. pp. 32–33, no. 4, color repr.

Daulte, F. "Une Donation sans précédent: la collection Thannhauser." *Connaissance des Arts*, no. 171, May 1966, pp. 68–69, color repr. both panels (ca. 1910).

Dugdale, J. "Vuillard the Decorator; The Last Phase: The Third Claude Anet Panel and the Public Commissions." *Apollo*, vol. LXXXVI, Oct. 1967, pp. 272 and 274, figs. 5 and 6.

Dumas, A., G. Cogeval, A. Chastel, et al. *Vuillard*. Exh. cat., Musée des Beaux-Arts, Lyon, Fondation Caixa de Pensions, Barcelona, and Musée des Beaux-Arts, Nantes; Paris, 1990, pp. 223 and 232.

Groom, G. *Edouard Vuillard: Painter-Decorator, Patrons and Projects, 1892–1912*. New Haven and London, 1993, p. 173, figs. 275 and 277, and pp. 172–77.

Solomon R. Guggenheim Museum. *Masterpieces*, 1972, pp. 38–39, repr. (ca. 1908).

Haus der Kunst, Munich, and Musée de l'Orangerie, Paris. *Edouard Vuillard—K.-X. Roussel*. Exh. cat., 1968, pp. 110–11 (after 1907).

L'Oeil, no. 36, Dec. 1957, p. 78, repr. right panel.

Preston, S. *Vuillard*. New York, 1971, p. 39, fig. 54 (both panels; ca. 1908).

———. *Edouard Vuillard*. New York, 1985, p. 35, repr. both panels (ca. 1908, each panel 76 x 25 ½ inches, Collection J. K. Thannhauser, New York City).

Roger-Marx, C. *Vuillard et son temps*. Paris, 1945, pp. 140, 149, repr. both panels, and pp. 155–57 (1908).

———. *Vuillard*. Paris, 1948, p. 55, figs. 42 and 43 (1908).

Russell, J. *Vuillard*. Greenwich, 1971, p. 48, repr. both panels, and p. 226 (1907–08).

Salomon, J. *Vuillard, témoignage*. Paris, 1945, p. 57, repr. right panel (ca. 1910).

———. *Vuillard admiré*. Paris, 1961, pp. 98 and 101, repr. both panels (ca. 1910).

———. "Edouard Vuillard als Chronist seiner Epoch." *Du*, jg. 22, Dec. 1962, pp. 30 and 36, color repr. both panels (ca. 1910).

———. *Vuillard*. Paris, 1968, pp. 25, 108, 111, color repr. both panels, and p. 218 (ca. 1910).

Schweicher, C. *Die Bildraumgestaltung, das Dekorative und das Ornamentale im Werke von Edouard Vuillard*. Zurich, 1949, pp. 83–84 (1908).

———. *Vuillard*. Bern, 1955, p. 13.

Thomson, B. *Vuillard*. Oxford, 1988, pp. 86–87, nos. 72 and 73, color repr. both panels, and p. 96 (1909–10).

Wilson-Bareau, J. "Edouard Vuillard et les princes Bibesco." *Revue de l'Art*, no. 74, 1986, pp. 39, 45, fns. 8 and 11, and p. 46.

PHOTO CREDITS

BY CATALOGUE NUMBER:

1–3, 5–25, 27–29, 32, 34–38, 40–46, 48–54, 56–70, photos by David Heald; 4, 26, 31, photos by Ellen Labenski; 30, 47, photos by Carmelo Guadagno; 33, 55, photos by Sally Ritts.

BY PAGE NUMBER:

ii, 2 (top and bottom), 13 (top and bottom), 14, 15 (top), 16 (top and bottom), 17 (bottom), 18 (top and bottom), 282, Silva-Casa Foundation, Bern; 1, 19 (top and bottom), 21, Solomon R. Guggenheim Museum Archive, New York; 3 (top), photo by Stephanie Rosenthal; 3 (bottom), 20, photos by Peter Lauri, Bern; 5 (bottom), Stadtarchiv München; 6, photo by Malcolm Varon, © 1984 The Metropolitan Museum of Art, New York; 7 (left and right), Gabriele Münter-u. Johannes Eichner-Stiftung; 9, photo © 1996 The Metropolitan Museum of Art, New York; 10, photo by Bob Grove, © 1999 Board of Trustees, National Gallery of Art, Washington, D.C.; 12 (top), photo © Anne Gold, Aachen; 13 (bottom), photo © The Barnes Foundation, Merion, Pennsylvania; 17 (top), photo by Henri Manuel, courtesy Silva-Casa Foundation, Bern; 37 (top), 61 (top), 65 (bottom), 129, photos by Hervé Lewandowski, © Réunion des Musées Nationaux, Paris; 37 (bottom), photo by P. Bernard, © Réunion des Musées Nationaux, Paris; 38 (top), photo © 1993 The Metropolitan Museum of Art, New York; 49, photo by Hans Petersen; 50 (bottom), photo © 1992 The Museum of Modern Art, New York; 59, Bild-Archiv der Österreichische Nationalbibliothek, Vienna; 60 (bottom), photo by Lyle Peterzell, © 1999 Board of Trustees, National Gallery of Art, Washington, D.C; 61 (bottom), 142, 185 (left), photos © 1999 The Art Institute of Chicago; 62, 236, photo © 1999 The Museum of Modern Art, New York; 64 (bottom), photo © Museo del Prado, Madrid; 71 (top), photo by J. G. Berizzi, © Réunion des Musées Nationaux, Paris; 72 (top), Giraudon, Paris; 79, photo by Clive Cretney; 89 (right), photo by David Mathews, © President and Fellows of Harvard College, Cambridge, Massachusetts; 90, photo © 1983 The Metropolitan Museum of Art, New York; 111, photo by Richard Carafelli, © 1999 Board of Trustees, National Gallery of Art, Washington, D.C.; 117 (top), photo © Alinari/Art Resource, New York; 117 (bottom), Fine Arts Library, Harvard College Library, Cambridge, Massachusetts; 130, photo by Elke Walford; 161 (left), photo by J. Calafell; 163, Cacklegoose Press, Ltd., London; 185 (right), photo © 1999 Christie's Images Ltd.; 202, photo © 1997 The Metropolitan Museum of Art, New York; 209 (right), photo © 1985 Dallas Museum of Art; 210, Collection Chéreau, from *The Burlington Magazine* (May 1959); 248, photo by Malcolm Varon, New York; 256, The Museum of Modern Art, New York, Gift of James Thrall Soby, copy print © 2000 The Museum of Modern Art, New York; 259, 268, Roger-Viollet, Paris, © Collection Viollet; 264, 316, Musée d'Orsay, Paris, © Réunion des Musées Nationaux, Paris; 271, Solomon R. Guggenheim Museum, Gift, The Josef and Anni Albers Foundation; 273, 279, Caisse Nationale des Monuments Historiques et des Sites, Agence Photographique, Paris, © Arch. Phot. Paris / CNMHS; 278, Archives of The Museum of Modern Art, New York, print © 1999 The Museum of Modern Art, New York; 281, Roger-Viollet, Paris, © Martinie-Viollet; 301, Pissarro Family Archive, courtesy The Jewish Museum, New York; 303, The Museum of Modern Art, New York, Gift of Paul F. Walter, print © 1999 The Museum of Modern Art, New York; 305, Bibliothèque Nationale de France, Paris; 307, Van Gogh Museum (Vincent van Gogh Foundation), Amsterdam.

318

Art Center College